AIGA Graphic Design USA: 6

6

AIGA Graphic Design USA:

The American Institute of Graphic Arts

Watson-Guptill Publications

New York

The Annual of The American Institute of Graphic Arts

Written by Steven Heller

Designed by Miho

The following pieces originally appeared in PLAYBOY:
"Eye to Eye With Mr. T" by Brad Holland Copyright © 1983 by PLAYBOY
"The Double Life of Peter O'Toole" by Al Hirschfeld Copyright © 1982 by PLAYBOY
"Telly Loves Ya" by Herb Davidson Copyright © 1978 by PLAYBOY

"Goodnight, Sweet Prinze" by Allan Magee Copyright © 1977 by PLAYBOY
"Shadowboxer" by Brad Holland Copyright © 1983 by PLAYBOY
"Uncle Don" by Brad Holland Copyright © 1980 by PLAYBOY
"The Land of Cocaine" by Brad Holland Copyright © 1980 by PLAYBOY
"Citizen Hughes—Part I" by Don Ivan Punchatz Copyright © 1984 by PLAYBOY
"A Sea Change" by Don Ivan Punchatz Copyright © 1981 by PLAYBOY

ISBN 0-8230-2138-6
Printed in Japan by Dai Nippon Printing Co., Ltd. Set in Helvetica by U.S. Lithograph, Inc., New York, New York First Printing, 1985

Distributed outside the U.S.A. and Canada by Fleetbooks, S.A. c/o Feffer & Simons, Inc., 100 Park Avenue, New York, New York 10017

Contents

Acknowledgments

The title of the AIGA Conference held at MIT this fall, Toward a National Graphic Design Community, aptly states what this book makes evident: graphic design as a potent business, institutional, and personal statement is thriving across the United States. This fact is reflected in the rapid growth of AIGA chapters, which are now active in eight cities. Each is developing programs which strengthen the AIGA's ability to serve its members. The vitality and diversity of graphic design today are also reflected in the changing demographics of our membership, which now represents 48 states, Puerto Rico, Canada, and over 20 foreign countries.

The captions in this volume record the broad geographic range in which memorable graphic design is being produced. The captions also underscore the interdependency of the process through which graphic design takes place: clients, illustrators, photographers, typographers, paper manufacturers, and printers are an essential part of the professional mix.

Colin Forbes, president of the Board, has guided us with calm intelligence through a year of considerable expansion and growth. We are also indebted to the members of the AIGA Board, who engage and apply their expertise to our ongoing concerns. These include increased involvement in professional practice, the development of chapters, a developing dialogue with the educational community, and increased publication of the Journal. These programs are in addition to the traditional role of the AIGA in the implementation of competitions and exhibitions which form the basis for this volume.

To the chairmen and jurors of the exhibitions represented in this book, and to all the individuals who submitted their work for consideration, we are most grateful. We also owe our profound thanks to James Miho, the designer of the book, and Lou Dorfsman, who designed the jacket, whose talents represent the Institute's concern for excellence. We would also like to thank authors Steven Heller for his lucid, informative text, and Ralph Caplan for his essay on Herman Miller, Inc. Sophie McConnell, Shelley Bance, and Nathan Gluck of the AIGA staff shepherded this volume to publication, representing, on a tight schedule, grace under fire.

Last but not least, we appreciate the continuing encouragement and interest of our members, whose support makes our programs possible and worthwhile.

Caroline Hightower
Director

The American Institute of Graphic Arts

The American Institute of Graphic Arts is a national nonprofit organization of graphic design and graphic arts professionals. Founded in 1914, AIGA conducts an interrelated program of competitions, exhibitions, publications, educational and professional practice activities, and public service efforts to promote excellence in, and the advancement of, graphic design.

Members of the Institute are involved in the design and production of books, magazines, and periodicals, as well as corporate, environmental, and promotional graphics. Their contribution of specialized skills and expertise provides the foundation for the Institute's program. Through the Institute, members form an effective, informal network of professional assistance that is a resource to the profession and to the public. An important aspect of the organization is the activity of eight AIGA chapters across the United States. As a member of the Joint Ethics Committee, AIGA is part of a cooperative effort to uphold ethical standards in the field.

The exhibition schedule at the Institute's gallery includes our annual competitive exhibitions. Of these, the Book Show and a Communication Graphics exhibition are held each year. Other exhibitions may include Illustration, Photography, Covers (bookjackets, magazines, periodicals, record albums), Insides (design of the printed page), Signage, and Packaging. The exhibitions travel nationally and internationally and are included, in their entirety, in *AIGA Graphic Design USA*. Each year, the Book Show is donated to the Rare Book and Manuscript Library of Columbia University, which houses the AIGA collection of award-winning books dating back to the 1920's. Other exhibitions are sent to the Popular and Applied Graphic Arts Department of the Library of Congress.

AIGA publications include: *AIGA Graphic Design USA*; a quarterly *Journal of Graphic Design*; a voluntary *Code of Ethics and Professional Conduct* for AIGA members; *Symbol Signs Repro Art*, a portfolio containing 50 passenger/pedestrian symbols and guidelines for their use; the guide *Graphic Design for Non-Profit Organizations*; a *Graphic Design Education Directory*; and a *Membership Directory*.

This year, the first national AIGA graphic design conference—Toward an American Graphic Design Community—was held at the Massachusetts Institute of Technology.

Corporate Sponsors

American Broadcasting Co.
Anderson Lithograph
Apple Computer, Inc.
Arnold Saks, Inc.
Atlantic Richfield Co.
Avon Books
Baldwin Paper Co.
Bob Glassman Design
Burson-Marsteller
Carnegie-Mellon University
CBS Broadcast Group
Champion International Corp.
Chermayeff & Geismar Assoc.
Chesapeake Display & Pkg. Co.
Compendium, Inc.
Container Corp. of America
Cook and Shanosky Associates
Crafton Graphic Co., Inc.
Danne & Blackburn, Inc.
Digital Equipment Corp.
Donovan & Green
Doubleday & Co.
Dow Jones & Co.
E.F. Hutton & Co.
Exxon Corporation
General Foods, Inc.
George Rice & Sons
Group 243 Design, Inc.
Hennegan
Henry Dreyfuss Associates
Herman Miller, Inc.
Holt Rinehart Winston, Inc.

Houghton Mifflin Co.
IBM Corporation
International Typeface Corp.
J.C. Penney Co., Inc.
Knoll International
Lister Butler
Louey/Roberge Design Group, Inc.
McGraw-Hill Book Co.
Mead Paper
Metropolitan Museum of Art
Metropolitan Transportation Authority
Mohawk Paper Mills, Inc.
Monadnock Paper Mills, Inc.
Muir Cornelius Moore
N.W. Ayer, Inc.
Omnicomp
Parsons School of Design
Polaroid Corporation
Random House, Inc.
Rapid Typographers
Raychem Corporation
Shapiro Design Assoc., Inc.
SHR Communications
Siegel & Gale
Simon & Schuster
Simpson Paper Co.
Spartan Typographers

Marvin Kommel Productions
John Massey
Mead Paper
Frank Metz
Miho
Woody Pirtle
Greg Ragland
Rohner Printing Co.
Suzi Romanik
Roger Rosenblatt
RyderTypes
John Segal
Stephenson, Inc.
Strathmore Paper Co.
The Litho Concern, Inc.
U.S. Lithograph, Inc.
Westvaco

St. Martin's Press
Steelcase, Inc.
Sussman/Prejza & Co., Inc.
Takeo Corp., Ltd.
The Woods Group, Inc.
Time, Inc.
Town & Country
Vignelli Associates
Walker Group/CNI
Wang Laboratories, Inc.
Western Publishing Co.
Westvaco

Introduction

In 1913, members of the august National Arts Club in New York City proposed to form an organization to be known as The American Institute of Graphic Arts. The group's objective was to encourage the furtherance of graphic art through an appreciation of printing, typography, book design, and other printed materials for commerce. Its early leaders, elegant masters of the printing craft, included William Edwin Rudge, Frederic W. Goudy, and Hal Marchbanks. The group's constituency came from the finest print shops, type houses and paper mills on the Eastern seaboard. Also involved were the image makers—etchers, woodcutters and lithographers —ubiquitous in fine books. But, as new technologies advanced and new media developed, the boundaries of the profession grew to include a wider range of practitioners, and the AIGA also changed.

By the early 1950's, graphic design was a term in common usage and the graphic design universe was expanding to include magazine and advertising art directors, poster artists, book and record jacket designers, corporate designers, illustrators and others, not so easily categorized, in related fields. Furthermore, the *isms* of design had become varied, if not polarized. The traditionalists were at odds with the modernists, and a rift grew between classicism and romanticism that exists to this day. The very pluralism which enlivened postwar design also caused heated debate, and the AIGA offered platforms. The frequent design *clinics* sponsored by the AIGA were not only educational forums, but were

also arenas for practitioners, new and old, to thrash out differences and map out directions. The *AIGA Journal* (including staff writers such as Fritz Eichenberg, Alvin Lustig, and Tobias Moss) developed a new language of criticism and analysis virtually forgotten today.

Reading through the stacks of vintage AIGA periodicals and catalogues—particularly those published during the Fifties—is very humbling for one attempting to comment on contemporary achievements. History shows, and these publications prove, that much of what is considered new today was done before. Though the contemporary conceits and styles are decidedly more modern, the visual underpinning of the present was determined then. One striking déja-vu example is a schematic that appeared in a 1951 edition of the *AIGA Journal*, which wittily shows the formula for a successful magazine. It reads thusly: Use Bodoni. Ape Mondrian. Make it look Functional, or Arty. Bleed to death. This checklist definitely still applies.

As much as the past and present are shown to converge, this Annual also indicates some significant departures. Though each category examined this year, like any year, has its share of derivations (the easy solutions), there further appears to be a general rejection of trendiness for its own sake—and a reemphasis on design as a communicative tool. Some critics suggest that the very high level of professionalism mitigates against risk-taking, and therefore leap-making. But this professionalism also suggests greater visual literacy than ever before, and in literacy there is power.

Graphic design, in all its forms, is having a more powerful and lasting impact on society. In contrast to the arts and crafts philosophies of the past, successful graphic design is communication, not decoration. That is the most important statement made by this Annual.

The AIGA Medal

For 64 years, the Medal of The American Institute of Graphic Arts has been awarded to individuals in recognition of their distinguished achievements, services, or other contributions within the field of the graphic arts. Medalists are chosen by a committee, subject to approval by the Board of Directors. Past recipients have been:

Norman T.A. Munder, 1920
Daniel Berkeley Updike, 1922
John C. Agar, 1924
Stephen H. Horgan, 1924
Bruce Rogers, 1925
Burton Emmett, 1926
Timothy Cole, 1927
Frederic W. Goudy, 1927
William A. Dwiggins, 1929
Henry Watson Kent, 1930
Dard Hunter, 1931
Porter Garnett, 1932
Henry Lewis Bullen, 1934
J. Thompson Willing, 1935
Rudolph Ruzicka, 1936
William A. Kittredge, 1939
Thomas M. Cleland, 1940
Carl Purington Rollins, 1941
Edwin and Robert Grabhorn, 1942
Edward Epstean, 1944
Frederic G. Melcher, 1945
Stanley Morison, 1946
Elmer Adler, 1947
Lawrence C. Wroth, 1948
Earnest Elmo Calkins, 1950
Alfred A. Knopf, 1950
Harry L. Gage, 1951
Joseph Blumenthal, 1952
George Macy, 1953
Will Bradley, 1954
Jan Tschichold, 1954
P.J. Conkwright, 1955
Ray Nash, 1956
Dr. M.F. Agha, 1957
Ben Shahn, 1958
May Massee, 1959
Walter Paepcke, 1960
Paul A. Bennett, 1961
Willem Sandberg, 1962
Saul Steinberg, 1963
Josef Albers, 1964
Leonard Baskin, 1965
Paul Rand, 1966
Romana Javitz, 1967
Dr. Giovanni Mardersteig, 1968
Dr. Robert L. Leslie, 1969
Herbert Bayer, 1970
Will Burtin, 1971
Milton Glaser, 1972
Richard Avedon, 1973
Allen Hurlburt, 1973
Philip Johnson, 1973
Robert Rauschenberg, 1974
Bradbury Thompson, 1975
Henry Wolf, 1976
Jerome Snyder, 1976
Charles and Ray Eames, 1977
Lou Dorfsman, 1978
Ivan Chermayeff and
Thomas Geismar, 1979
Herb Lubalin, 1980
Saul Bass, 1981
Massimo and Lella Vignelli, 1982
Herbert Matter, 1983

The AIGA Medalist 1984: Leo Lionni

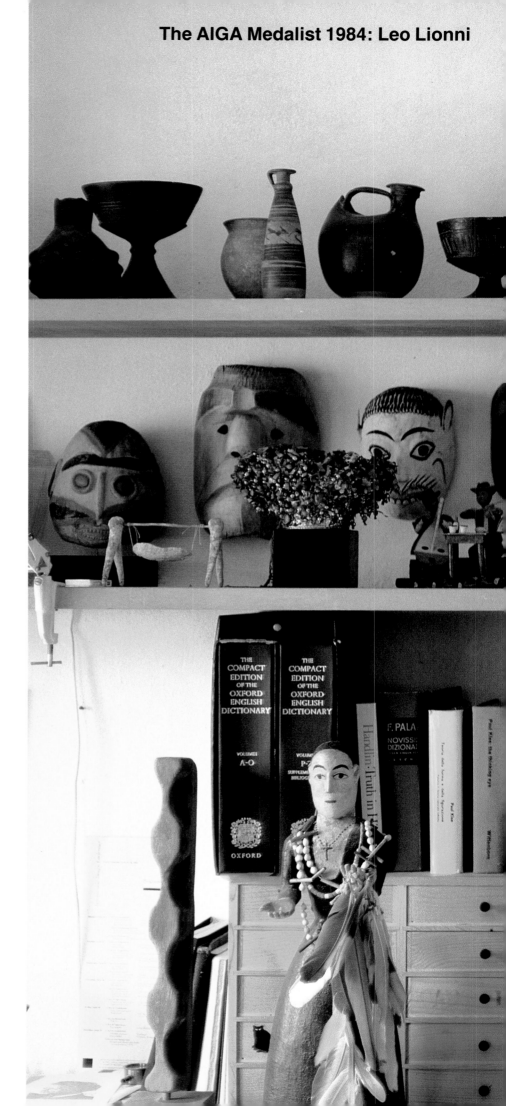

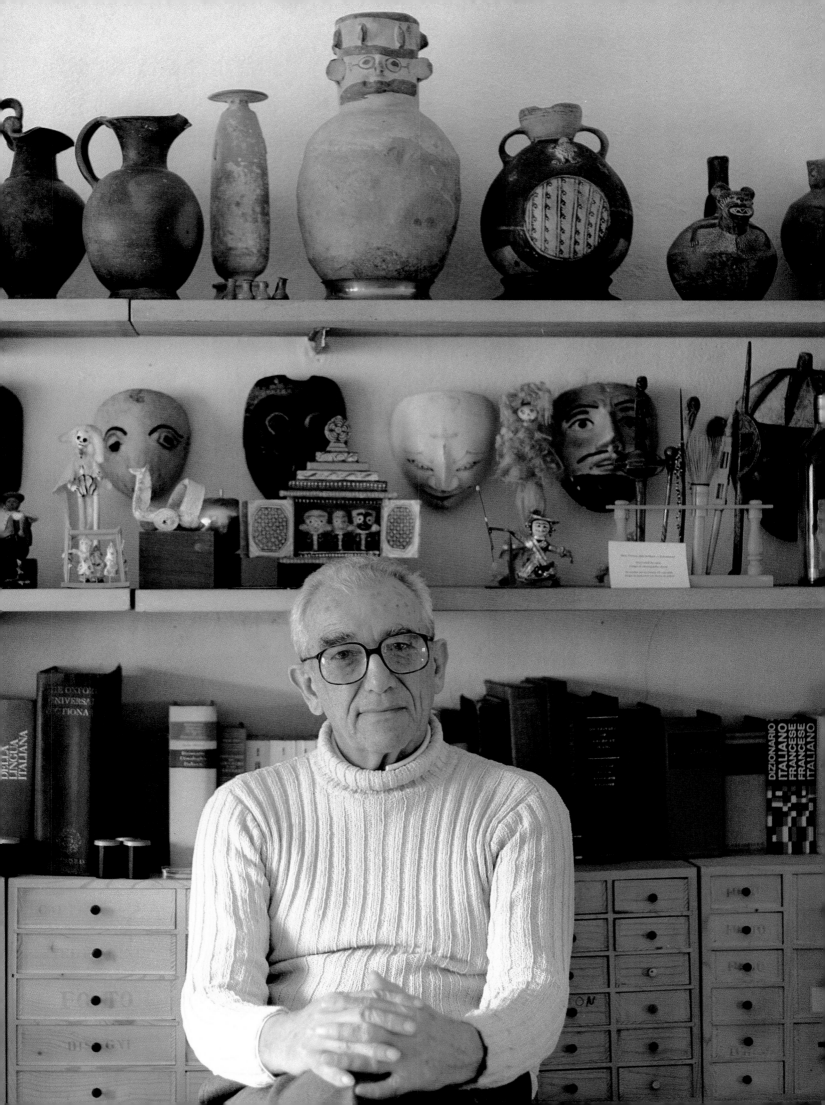

Leo Lionni

The name *Lionni* conjures many mental references: "The Family of Man," Swimmy the fish, Century Schoolbook Expanded, exotic flora, Olivetti, and more, because the man behind the name has affected our visual "landscape" for almost three generations. He has been a committed teacher, author, critic, editor, painter, sculptor, printmaker, designer, cartoonist, and illustrator.

Leo Lionni was born in Holland in 1910, into a world on the cusp of radical change—with cultural and political revolutions in the air and on the streets. His father was an artisan, a diamond cutter from a well-to-do Sephardic Jewish family, and his mother was a singer. Her brother, Piet, an architect, allowed his adoring, five-year-old nephew to play with his drafting supplies. And two other uncles, both collectors of modern art (whose extensive collections are now held by major museums), fed his artistic inclinations by osmosis. One uncle refused to pay taxes in Holland, and hence was only able to live in the country six months minus one day. Part of his collection was stored at Lionni's house, including Marc Chagall's "Fiddler" which hung outside his bedroom.

At that time, Amsterdam's government was influenced by a Socialist party whose ideas underpinned a progressive educational system. "There was great emphasis on nature, art and crafts," recalls Lionni. "In an early grade I was taught to draw from a big plaster cast of an ivy leaf; I remember rendering all of the shading with cross-hatched lines. There was something magical about it. I can still draw that leaf today, and probably not better than I did then."

He was given a permit to draw at the Rijksmuseum where he drew from casts. "Rembrandt, Van Gogh, Mondrian, design, architecture, even music," explains Lionni, "were one big *mood* to me. Except for brief periods of partisan enthusiasm, I have denied cultural hierarchies. Ancient art is as important to me as contemporary art. Art is as important as design."

Lionni moved to Philadelphia at 14, and in 1925 was transplanted again to Genoa, Italy. Unable to get into a "classical" high-school, he was enrolled in a "commercial" one (no Greek was taught in the latter). He learned Italian and became conversant in its art, literature and poetry. But most significantly, at the age of 16, Lionni discovered Italian politics through his friendship with Nora Maffi, who later became his wife and lifelong companion. Nora's father was one of the founders of the Italian Communist party, and was imprisoned in 1925 by the Fascists. Later he was placed under house arrest with six live-in Fascist policemen. "This was quite a shock, having come from a happy Philadelphia school, where I played basketball and went to proms. It fell on my head like a bomb, and conditioned my life enormously."

Lionni was conscious of wanting to become a graphic designer. He created signs for shops and produced his own *comp* advertisements for Campari, which were presented to Mr. Campari himself. But, most important, he came under the influence of Futurism, which as a movement of painting and graphic design was at its height.

By 1921, at the age of 21, Lionni was on the crest of the second Futurist wave. "I was living the life of the avant-garde: We had blue plastic furniture and Breuer chairs." He was painting turbulent abstract pictures typical of the era, but his work had a flair of its own—so much so that it caught the eye of F. T. Marinetti, codifier of the Movement, who pronounced the young Lionni to be 'A great Futurist.'

Thanks to Marinetti's support, Lionni's paintings were exhibited in shows throughout Italy. On the eve of one such exhibition, Marinetti received a portentous telegram announcing that the Bauhaus has been closed by the Nazis. "We sat up the entire night," recalls Lionni, "and decided to send a telegram back inviting all the Bauhaus artists to Italy, and offered our homes for them to stay in indefinitely." Not only was Lionni indignant and fearful about Nazi repression, but the Bauhaus teachings were deeply seeded—its rational philosophy his true underpinning. "I never really felt comfortable as a Futurist, even though Marinetti proclaimed me to be 'the heir of aero-dynamic painting.' I actually resented it; I had *never* even been in an *airplane* before. "I am really Dutch. I felt closer to DeStijl, and I responded to the patterns and symmetry of the tulip fields. In fact, I rarely ever put type or image on angles unless there was a good reason to do it. My ultimate design influence is the Bauhaus, although I've never been directly connected with them."

With the birth of the first of two sons, Lionni decided to move the family to Milan, the hotbed of the Italian avant-garde. "We were the first tenants to live in the first rationally designed apartment building in Milan. There I made a living doing graphic design, architectural photography and some advertising with a friend who was a German refugee."

Later in Milan, the earliest marriage of easel and applied art can be traced to ads Lionni did for a wool company, and ad pages done for *Domus* magazine. He also began writing architectural criticism for the renowned magazine, *Casabella*. He worked closely with Eduardo Persico, a hero in anti-Fascist circles, who had a marked influence on Lionni's writing and design. "Persico not only edited the magazine, he 'designed' it as well. It never looked more beautiful," remembers Lionni. "I watched him do layouts that, I would say, reflected rationalism—and rationalism has been the greatest influence on my life.

Lionni soon devoted himself to advertising design, "simply for the joy of putting good imagery onto pages," he says. He also attended the University of Genoa, from which he received a Doctorate degree in Economics in 1935. "I wrote my dissertation on the diamond industry, of course," he says. "I finished something for which I had no real use, but my obsessive necessity to finish what I begin caused me to do it."

When a darker specter of Fascism began to shroud Italy, Lionni, ordered by official decree to declare whether or not he was Aryan, opted instead to emigrate to the United States. He went to Philadelphia to N.W. Ayer, the advertising agency which handled the account for Atlantic Refining Company (the company for whom his father was working). A fortuitous meeting with Charles Coiner, vice president and art director, was the beginning of a career and a friendship. Coiner arranged for Leo to do some ads for *Ladies Home Journal*. Later he had Lionni teaching a layout course at the Charles Morris Prince School. "At the time I knew nothing about typography," he admits, "because in Italy all we had to do was indicate a block of text and the printer would fit in whatever was on hand."

The classic break came in the early Forties when N.W. Ayer was in the throes of crisis with its multimillion dollar Ford Motors account. Ford was not happy with the new ad proposals. All members in the creative pool were asked to offer solutions, so Lionni created a series of ads which were to be scrutinized by Edsel Ford. Word later came back that Lionni had the job. In one week, he went from a $50 a week assistant to a $50 a week art director on one of the largest accounts in the United States. Offers from prestigious New York agencies followed, but he stayed in Philadelphia until 1947. "It was the ideal place to be. Where we lived, I could go out at five o'clock in the morning to fish for trout before going to work." Challenging accounts came his way. Comptometer was one, for which he commissioned drawings by

Saul Steinberg. He hired a neophyte Andy Warhol to do sketches for Regal Shoes. And for Chrysler Plymouth, he developed a unique, teaser billboard presentation, which is still a model of creative marketing.

Among Lionni's most exciting endeavors was being the art director for the Container Corporation's "International Series." He returned to his Modernist roots, commissioning Moore, Calder, DeKooning and others to do posters and ads. For one such project, Léger, who was then living in New York, was asked to do a painting, which he did in color. When Lionni showed it to Walter Paepcke, he was asked if Léger would also do it in black and white as a newspaper ad. Lionni drew up a copy in line which he showed to Léger. Seeing the "rough," the painter said 'That's as good as I would do it,' and signed the Lionni sketch, which was later printed.

Lionni continued painting, and he took a year off to study and work on mosaics. But "in 1948 I started to get restless," he remembers. There was a subtle difference between being an advertising designer and a graphic designer, and Lionni wanted to become "a general practitioner of the arts." He left the agency, moved to New York, and opened a small office. "I called the promotion art director at *Fortune*, whom I had dealt with in the past, to ask for work. Instead, he told me that *Fortune* was looking for an art director and asked if I was interested." While it was an alluring offer, Lionni wasn't looking for a *job*. "I told them I would do it on a freelance basis, three days a week, and that I wanted an assistant who would go to all the meetings." *Fortune* readily agreed, and after a brief trout fishing vacation, Lionni began his 14-year relationship with Time/Life.

Lionni's feelings for magazine design are profound. Though he had never designed a magazine before, "it fit me like an old shoe, because it brought everything that I had learned with passion to some kind of concrete manifestation. I employed my rationality in designing its architecture. As with all the arts I'd been involved with, I defined exactly what *Fortune's* limitations were—what it was and wasn't. That to me is a real Bauhaus approach." Lionni redesigned *Fortune* two times. In each case, he eschewed cold functionality for a more human approach. He introduced Century Schoolbook, his favorite type. "I don't know much about type but Century Schoolbook is a human face."

From its inception, *Fortune* was known for its intelligent use of art, both fine and applied. During Lionni's tenure, painters were encouraged to do illustrations and picture essays, and illustrators were commissioned as graphic journalists—not as renderers of proscribed imagery, but free to draw upon and interpret firsthand experiences. Lionni urged artists "to do things which they were not accustomed to doing." Hence, many young talented practitioners, and quite a few masters of the pen and brush received globe-trotting assignments. Today many artists credit the nurturing Lionni as a seminal influence.

Lionni consulted with Henry Luce on many Time/Life projects, including a prototype design for *Sports Illustrated.* He also maintained outside clients, including The Museum of Modern Art, for whom he did The Family of Man catalogue design,and as design director for Olivetti, he did ads, brochures, and environmental (showroom) design. Also in the realm of the third dimension, Lionni designed the American Pavillion at the Brussels World's Fair. Sponsored by *Fortune* and titled "Unfinished Business," it was a long tunnel in which were shown images representing the unresolved problems of American society. Ironically, it was abruptly closed after a visiting Congressman objected to its controversial negative focus.

Perhaps the most satisfying accomplishment of Lionni's career was his short tenure as co-editor and art director of *Print.* During the mid-Fifties, he elevated graphic design commentary and criticism, offering a platform for varying disciplines and points-of-view. He opened up the design community—then as now polarized between the classicists and the modernists—to possibility and invention, through in-depth coverage of international trends and national currents. *Print* was an example of Lionni's rationalism in the service of his colleagues and his art. "I've looked back on those issues," he says proudly, "and they are very civilized."

The notion of creating "civilized and human" art became Lionni's obsession. After all his tangible accomplishments, "I felt the only way I could really reach my goal was by doing painting, sculpture, writing, and graphics the way I wanted to do it." His professional career, except for the few found moments to study mosaics, had been in the service of others. "Everything I had done was a happy compromise that I've never felt ashamed of in the least."

But the time had come for movement. At 50 years old, at the peak of his endeavor, Lionni left Time/Life. He moved to Italy where he owned a house and life was less expensive. "Everyone thought I was crazy because I had very little money, but it was what I needed to do."

Lionni's fate, however, was not sealed by a seemingly irrational act, for just before he was ready to leave on his new adventure, a remarkable accident took place while he was riding on a commuter train with his grandchildren. To entertain them, he tore little bits of colored papers from *Life* magazine and made a magical story. When Lionni returned home, he placed what he'd done into a book dummy. Fabio Coen, who had just become children's book editor of Obolensky Inc., published it as "Little Blue and Little Yellow," and Lionni became a picture book author. Now with 30 books to his credit, and a 75th birthday anthology that will be published this year, he is a household name among parents and children. For Lionni, the children's book is an organic synthesis of all his talents, beliefs and obsessions, wedding as it does his artistic sense of humor, color and abstraction with the desire to teach. Bruno Bettelheim states in an introduction to the recent anthology that Lionni "is an artist who has retained his ability to think primarily in images, and who can created true picture books." And he continues: "It is the true genius of the artist which permits him to create picture images that convey much deeper meaning than what is overtly depicted."

Despite his resolution to devote himself to painting and sculpture, Lionni agreed when Time/Life contacted him in Italy to become editor/art director of *Panorama*, a monthly general interest magazine, a collaboration between Time/Life in New York and Mondadori in Milan. He enjoyed being in charge, and hence published some extraordinary work. Yet the position was fraught with "political" problems from the outset. "Mondadori couldn't understand why Time/Life installed a *impaginatore* (layout man) as the editor of an important magazine," Lionni ruefully recalls, "and after a year and a half I was replaced, the American collaboration ceased, and the magazine was turned into a weekly, now one of the highest circulation journals in Italy."

From that time on, Lionni has taken advantage of his freedom. Living in Italy six months of the year, he continues to expand the boundaries of the children's book, while exploring the natural world through his drawings and sculpture. In recent years, he has cast in bronze a garden of strange flora, which was derived from his imagination. In 1977, he published "Parallel Botany," a satiric documentary account of his bizarre botanical discoveries.

Lionni has left an impressive mark. As an art director at N.W. Ayer, he wedded fine art to applied art. As co-editor of *Print*, he elevated the level of graphic design criticism. As art director of *Fortune*, he launched the careers of many formidable practitioners. As a children's book author and artist, he has engaged the minds and hearts of several generations. His own graphic endeavors are enlivened by youthful innocence, sagelike logic, and humor. His astute essays on the teaching and practice of graphic design are invaluable additions to the lexicon of the field. Moreover, in word and deed, he has been an unfaltering rationalist, a devout humanist, and a passionate artist.

Folder:
Motta
1934

Sampler:
Lane Rossi
1935

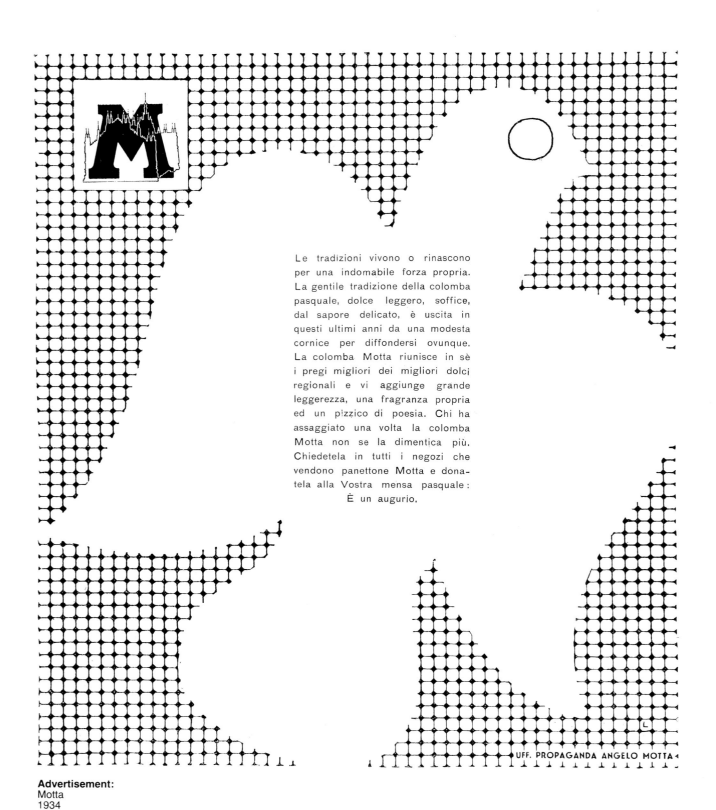

Le tradizioni vivono o rinascono per una indomabile forza propria. La gentile tradizione della colomba pasquale, dolce leggero, soffice, dal sapore delicato, è uscita in questi ultimi anni da una modesta cornice per diffondersi ovunque. La colomba Motta riunisce in sè i pregi migliori dei migliori dolci regionali e vi aggiunge grande leggerezza, una fragranza propria ed un pizzico di poesia. Chi ha assaggiato una volta la colomba Motta non se la dimentica più. Chiedetela in tutti i negozi che vendono panettone Motta e donatela alla Vostra mensa pasquale:
È un augurio.

UFF. PROPAGANDA ANGELO MOTTA

Advertisement:
Motta
1934

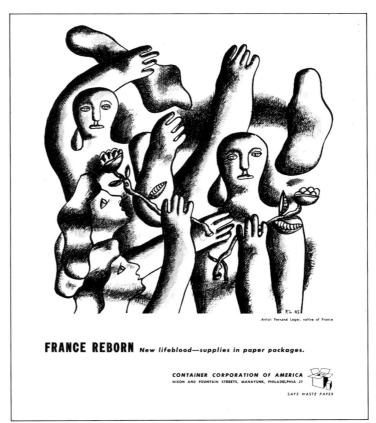

Advertisement:
Container Corporation
of America
Artist: Leger/Lionni
1955

Advertisement:
Comptometer
1942

Magazine Cover:
Exakta
1943

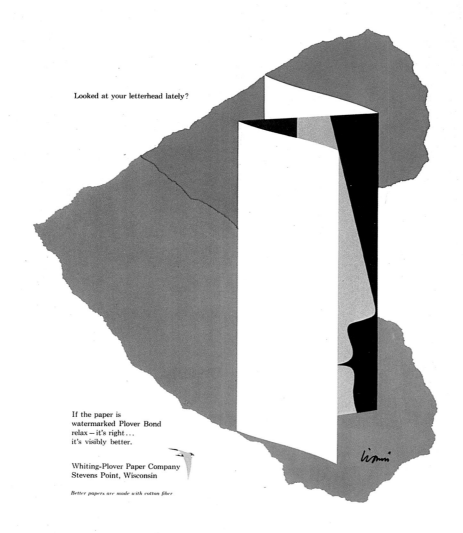

Looked at your letterhead lately?

If the paper is
watermarked Plover Bond
relax — it's right...
it's visibly better.

Whiting-Plover Paper Company
Stevens Point, Wisconsin

Better papers are made with cotton fiber

Advertisement:
Whiting-Plover Paper Co.
1952

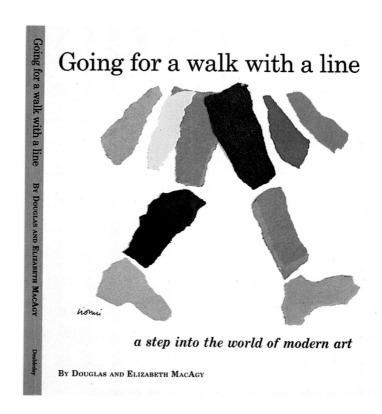

Going for a walk with a line

By Douglas and Elizabeth MacAgy

Doubleday

a step into the world of modern art

BY DOUGLAS AND ELIZABETH MACAGY

Book Cover:
Going for a walk with
a line
Doubleday & Co.
1958

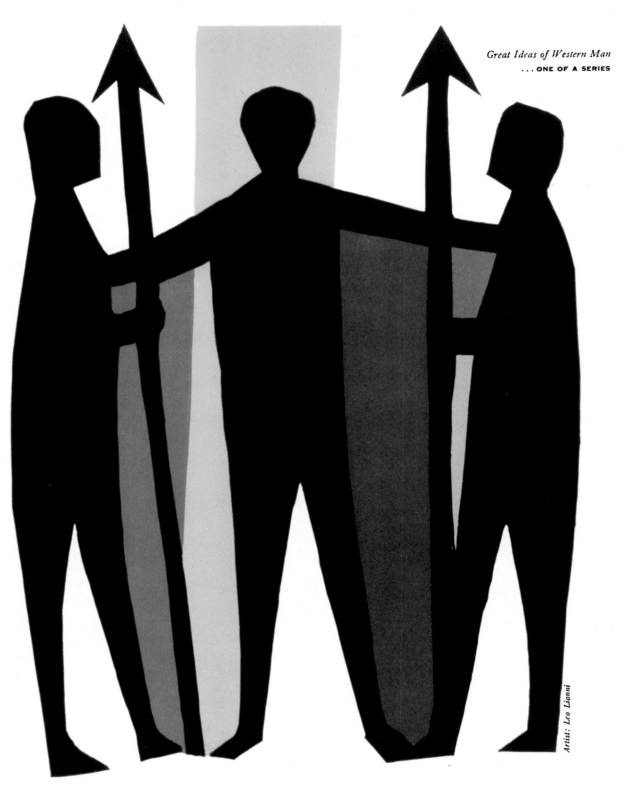

Artist: Leo Lionni

EPICTETUS
on Philosophy

Here is the beginning of philosophy:
 a recognition of the conflicts between men,
 a search for their cause,
 a condemnation of mere opinion . . .
and the DISCOVERY OF A STANDARD OF JUDGMENT.
 (*Discourses*, First Century A. D.)

CONTAINER CORPORATION OF AMERICA

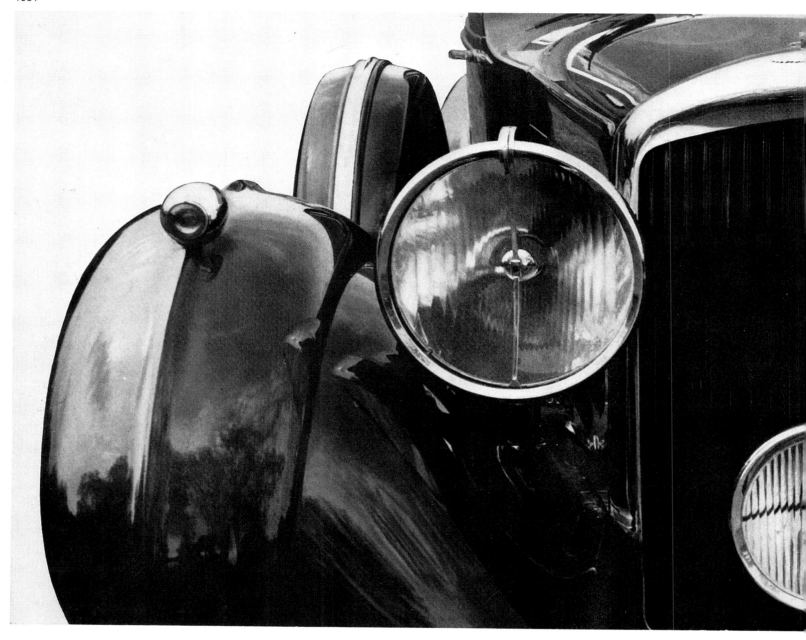

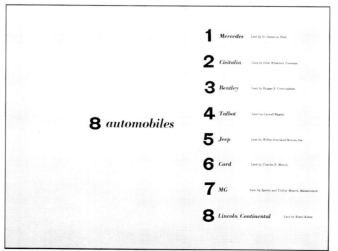

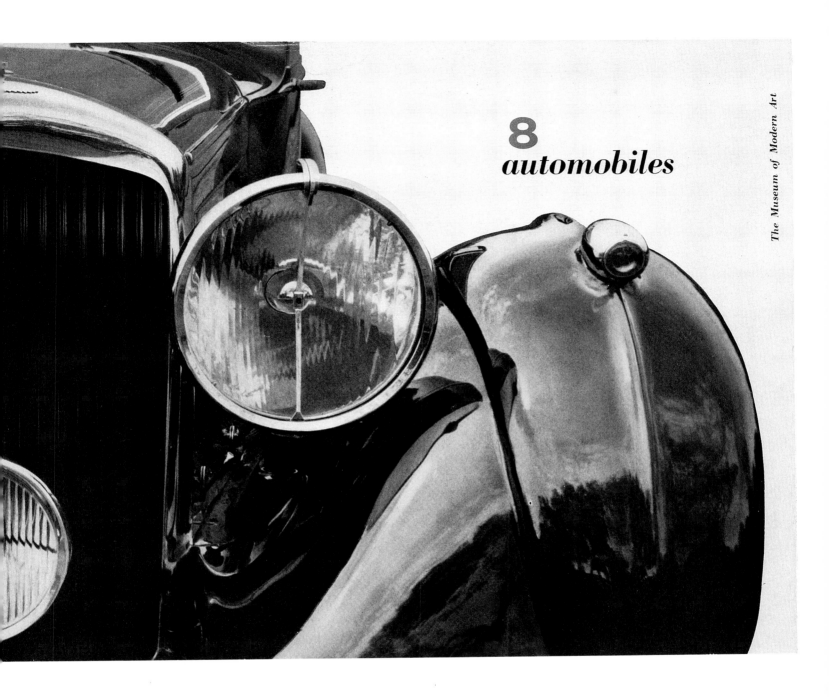

8
automobiles

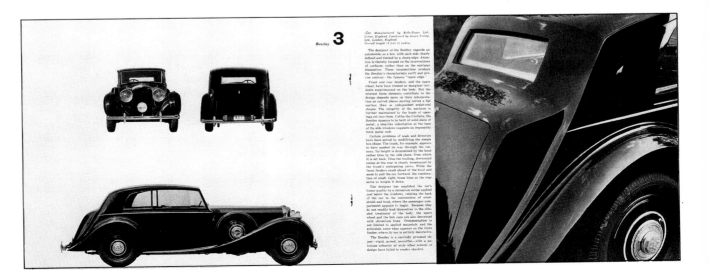

3
Bentley

*1948. Manufactured by Rolls-Royce Ltd.,
Crewe, England. Coachwork by James Young,
Ltd., London, England.
Overall length 15 feet 11 inches.*

The designer of the Bentley regards an automobile as a box, with each side clearly defined and limited by a sharp edge. Attention is thereby focused on the intersections of surfaces, rather than on the surfaces themselves. These intersections produce the Bentley's characteristic swift and precise contour—the famous "razor edge."

Front and rear fenders, and the spare wheel, have been treated as marginal incidents superimposed on the body. But the interest these elements contribute to the design depends more on their interpretation as curved planes moving across a flat surface than as independent sculptural shapes. The integrity of the surfaces is further maintained by the kinds of openings cut into them. Unlike the Cisitalia, the Bentley appears to be built of solid slabs of metal: a step-like indentation at the base of the side windows suggests an impossibly thick metal wall.

Certain problems of scale and direction have been solved by modifying the simple box shape. The trunk, for example, appears to have pushed its way through the tonneau. Its height is determined by the hood rather than by the side plane, from which it is set back. Thus the trailing, downward sweep at the rear is clearly terminated by the trunk's contrasting curve. While the front fenders reach ahead of the hood and seem to pull the car forward, the combination of small, tight, tense lines at the rear serve to weight it down.

The designer has amplified the car's linear quality by a chromium stripe applied just below the windows, relating the back of the car to the intersection of windshield and hood, where the passenger compartment appears to begin. Because they do not readily lend themselves to the chiseled treatment of the body, the spare wheel and the hub caps are also decorated with chromium lines. Ornamentation is not limited to applied materials, and the articulate razor edge appears on the front fender, where its use is entirely decorative.

The Bentley is a carefully groomed object—rigid, brisal, powerful—with a patrician urbanity of style other schools of design have failed to render obsolete.

Fortune

January 1955

1930 1955 1980

Fortune's Twenty-Fifth Anniversary Year
Beginning Three Series on "The American Breakthrough"
The New Economy The New Management The New Goals

Also in this issue, twenty other timely articles—See page 1

Magazine Cover:
Fortune
1955

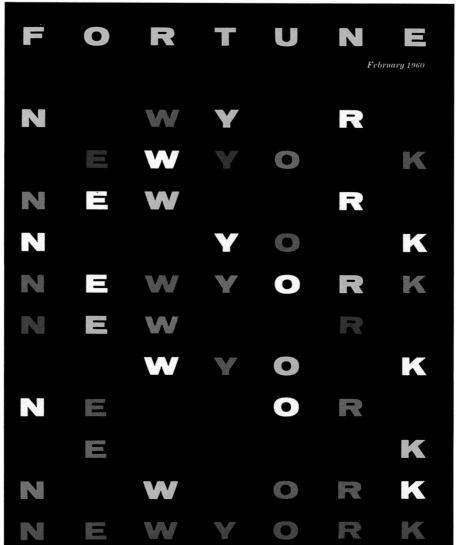

Magazine Cover:
Fortune
1960

Magazine Covers:
Fortune
1960

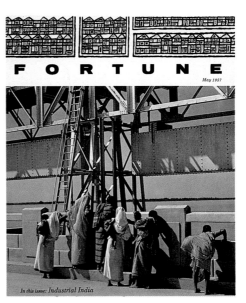

Magazine Cover:
Fortune
1957

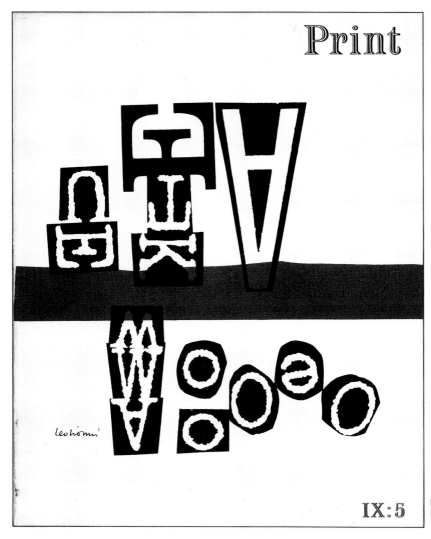

Magazine Cover:
Print
1955

Magazine Cover:
Print
1955

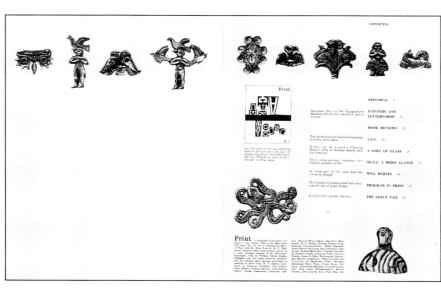

Table of Contents:
Print
1955

International Design Conference

Program

Aspen, Colorado, June 21-28, 1953

Monday, June 22	**9:30 a.m. Amphitheater**	
	Walter P. Paepcke	Address of Welcome
	Leo Lionni	Introduction
	Buckminster Fuller	"Geodesic Domes"
	2:30 p.m. Amphitheater Grounds	
	Erection of a Geodesic Dome by students of the University of Minnesota	
	5:30 p.m. Hotel Jerome	
	Reception at the Open-air Swimming Pool	
Tuesday, June 23	**9:30 a.m. Amphitheater**	
	Max Bill	"Art, Business, Culture, Design"
	Roundtable	"Idea and Form"
	2:30 p.m. Amphitheater	
	Dave Chapman	"Getting Things Done"
	Charles Eames	*
	Roundtable	"Specialization-Integration-Experimentation"
Wednesday, June 24	**9:30 a.m. Amphitheater**	
	Gyorgy Kepes	"The New Landscape"
	Roundtable	"Art and Science"
	8:30 p.m. Opera House	
	Bill, Kepes, Peressutti	Slides
	Buckminster Fuller	"Industrial Prototyping"
Thursday, June 25	**9:30 a.m. Amphitheater**	
	Otto Spaeth	"An Art Program for Business"
	Roundtable	"Artist-Designer-Businessman"
	2:30 p.m. Amphitheater	
	Enrico Peressutti	"The Young Designer in Italy"
	Wallace K. Harrison	*
	Student Roundtable	"What We Want"
	8:30 p.m. Opera House	
	Charles and Ray Eames	Films-Slides-Comments
	Xanti Schawinsky	"Spectodrama"
Friday, June 26	**9:30 a.m. Amphitheater**	
	René d'Harnoncourt	*
	Roundtable	"The Designer and the Social Climate"
	1:00 p.m. Maroon Lake	
	Fish Fry	
	8:30 p.m. Opera House	
	Roundtable	"Good Design Can Be Better"
Saturday, June 27	**9:30 a.m. Amphitheater**	
	Nikolaus Pevsner	"Fallacies"
	Roundtable	"Fashion, Economics, Design"
	8:30 p.m. Four Seasons Club	
	Masquerade Dance and Buffet "Design Follies of 1953"	

 The names of panel chairmen and members as well as all further notices regarding the Conference will be posted in the Lobby of the Hotel Jerome.

*Title to be announced at the Conference.

Program:
Aspen International
Design Conference
1953

Trademark:
American Craftsmen's
Council
1955

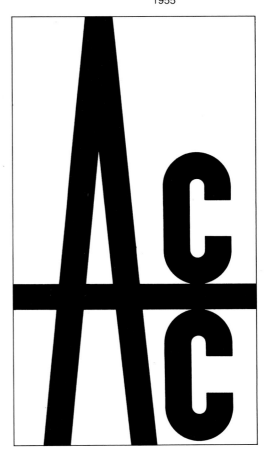

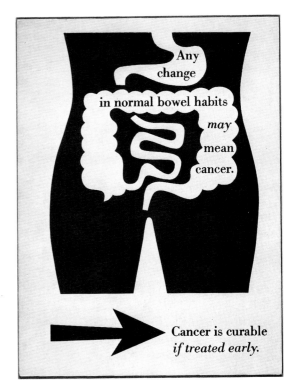

Any change in normal bowel habits may mean cancer.

Cancer is curable if treated early.

Poster:
American Cancer Society
1950

Design is form. Sometimes it is decorative form, and has no other function than to give pleasure to the eye. Often it is expressive form, related to conceptual content, to meaning. It is always abstract; but like a gesture or a tone of voice it has the power to command and hold attention, to create symbols, to clarify ideas. At the hands of the graphic designer it can be manipulated to express precisely defined moods—a quality which is important to those who use the printed page competitively to communicate, to convince, to sell.

For the advertiser, design performs in many useful ways. It is called upon to catch the eye, to implement copy, to set the stage for illustrations, to establish identity, or simply to get the most out of the physical limitations of the magazine page. It is an intuitive language, difficult to speak, yet easily understood. Few fail to recognize a strong composition, an intriguing arrangement, an arresting color invention. Few are insensitive to the qualities that make a page forceful or gentle, solemn or frivolous, assertive or timid, serious or playful.

One purpose of this book is to remind advertisers that design is a seemingly inexhaustible source of visual excitement. Its pages will take you from the explosive vitality of free shapes to the compelling stillness of bilateral symmetry, from the daringly generous use of white space to the complex involutions of multicolored shapes, from the meticulousness of precise geometry to the charm of the free-flowing human gesture.

But to be meaningful, design must originate from specific problems. Clearly then, the pages in this book have not been designed as mere eye-catchers for just any block of advertising copy. They are intended to indicate, instead, the immense variety and pliability of the language of design, and the power of the printed page to evoke a multitude of moods with over unexpected means.

Leo Lionni

*Designs
for the
printed page*

Promotional Brochure:
Designs for the Printed
Page
1958

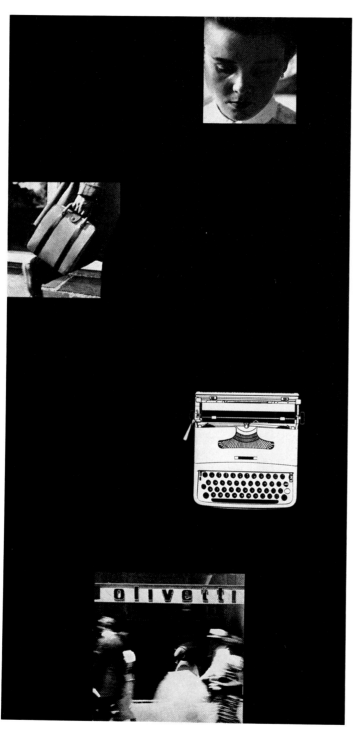

Advertisements:
Olivetti
1955

Direct Mail Brochures:
Olivetti
1956

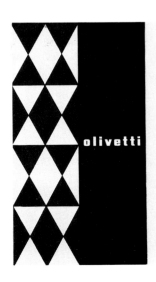

Founded in 1908 in Italy, Olivetti is today a world-wide organization, with factories in Italy, Spain, Scotland, South Africa, Argentina and Brazil; altogether, Olivetti products are sold and serviced in 106 countries. In the United States, Olivetti calculating and bookkeeping machines are sold and serviced by more than 550 authorized dealers; Olivetti typewriters are sold and serviced by more than 1000 dealers. Olivetti maintains its own showrooms at 584 Fifth Avenue, New York; 332 North Michigan Avenue, Chicago; and 17 Second Street, San Francisco. Headquarters of the Olivetti Corporation of America is at 580 Fifth Avenue, New York 36.

Store:
Olivetti
San Francisco
Architect:
Giorgio Cavaglieri 1955

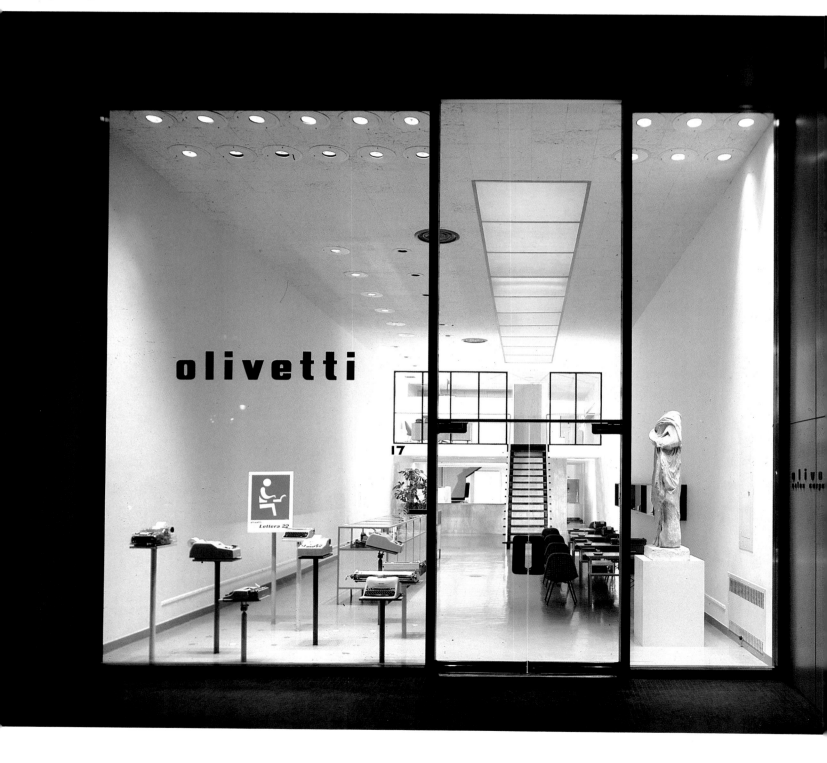

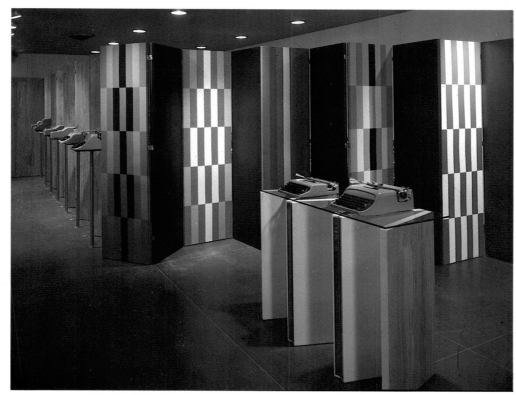

Store:
Olivetti
Chicago
1956

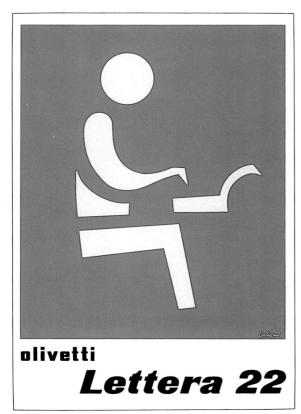

Poster:
Olivetti
1954

Advertisement:
Olivetti
1954

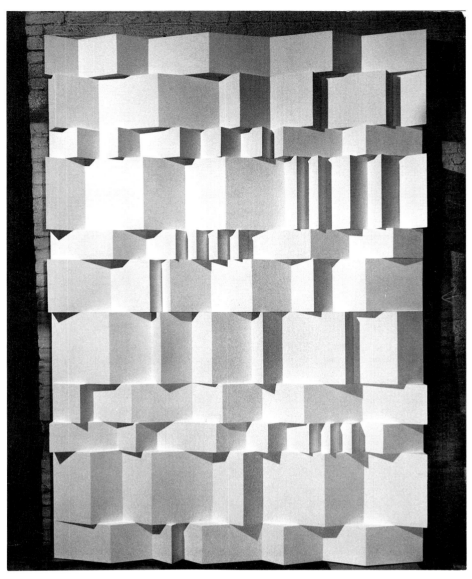

Sculpture:
Olivetti
1956

Store:
Olivetti
Chicago
Architect:
Giorgio Cavaglieri
1956

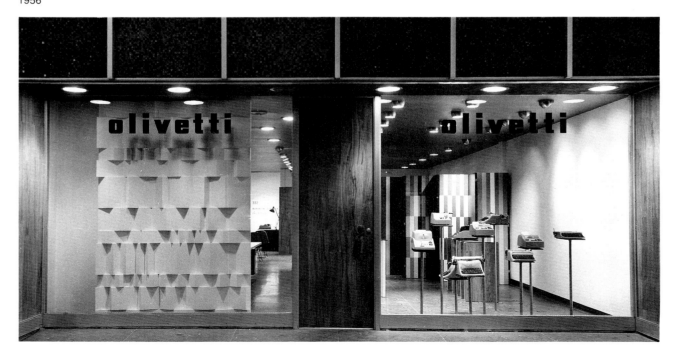

Philip C Johnson

New Canaan Connecticut Telephone 9 9593

we are sending you

☐ *herewith*
☐ *under separate cover*

☐ *tracings*
☐ *blueprints*
☐ *specifications*

☐ *for your information*
☐ *for your files*
☐ *for checking*
☐ *for revision and resubmission*
☐ *for approval as corrected*

■ *if enclosures are not as listed above kindly notify at once*

Philip C Johnson

by

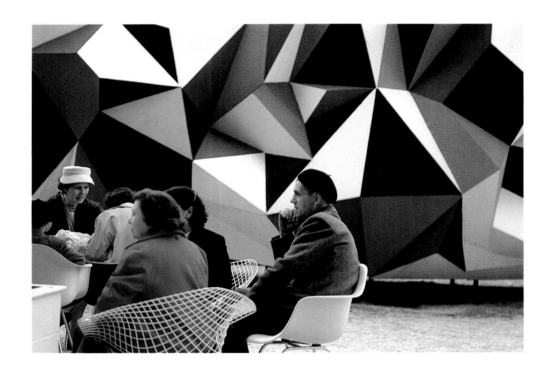

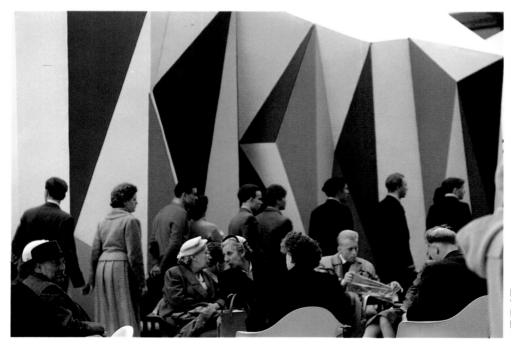

Pavilion:
"Unfinished Business"
U.S. Government
Brussels World's Fair
1958

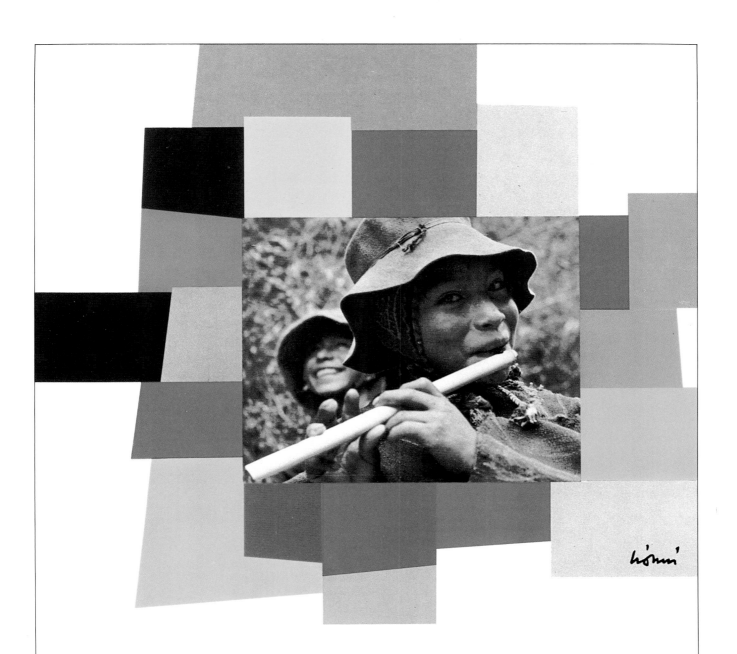

The Family of Man

The greatest photographic exhibition of all time—503 pictures from 68 countries—

created by Edward Steichen for The Museum of Modern Art

Prologue by Carl Sandburg

Book:
The Family of Man
The Museum of Modern
Art
1955

Record Covers:
Nature Songs
Motivation Records
1960

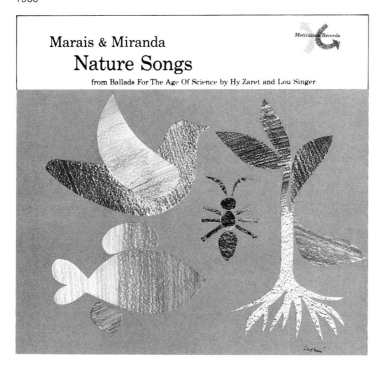

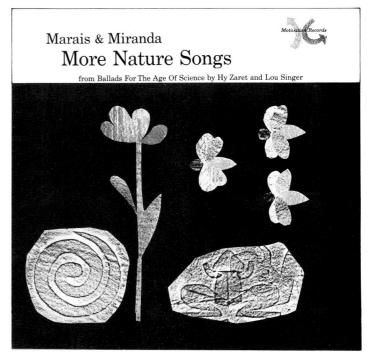

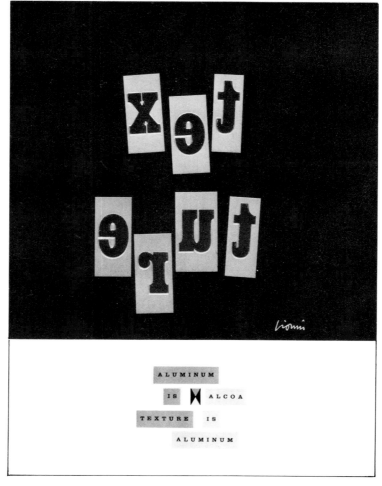

38

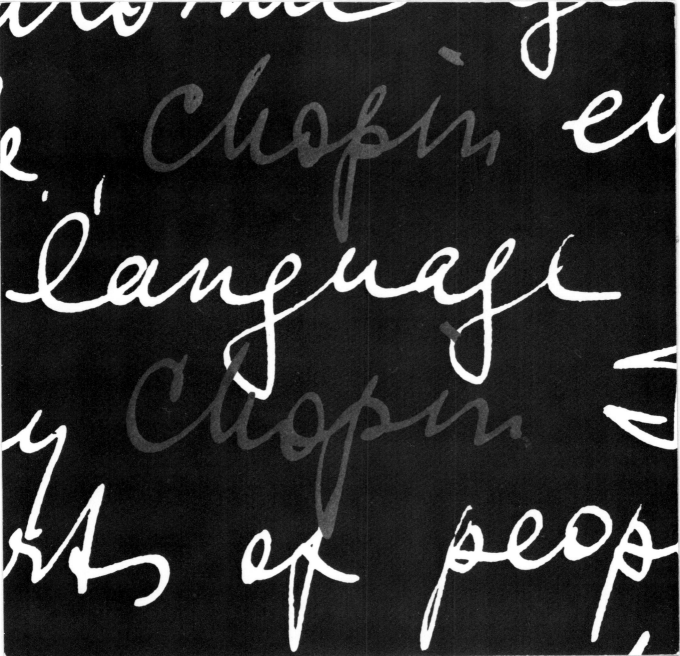

Book:
Chopin
Angel Records
1955

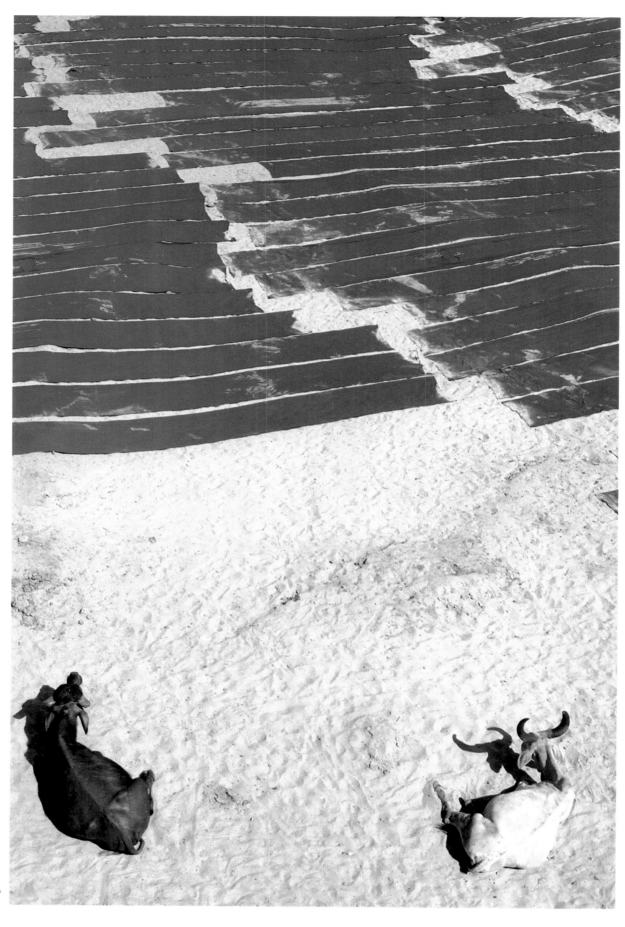

Photograph:
Ahmedabad
1967

40

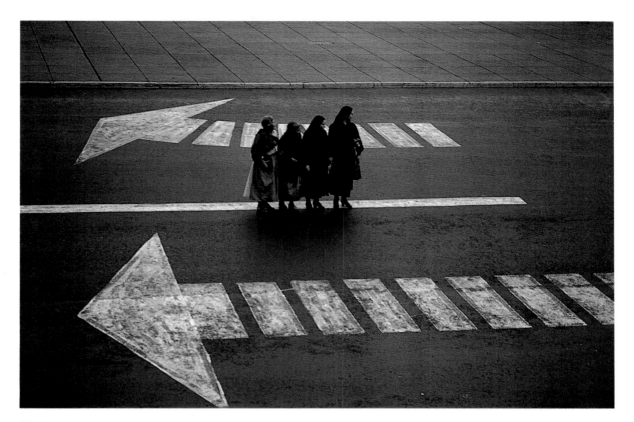

Photograph:
Mexico City
1962

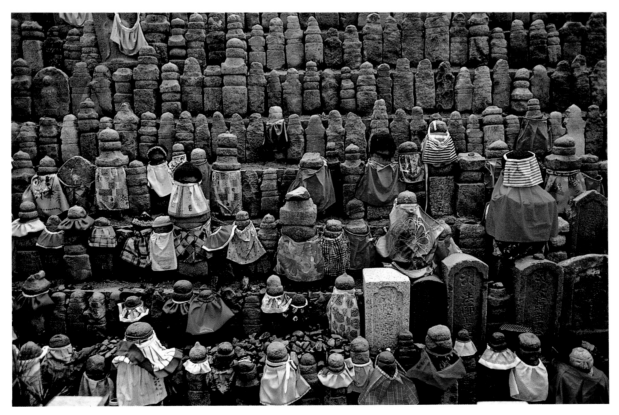

Photograph:
Koyasan Tombs
1981

ever since
the birth of sea and
wind and moon—endlessly—
the surf has rolled pebbles in
its foam to make a billiard ball.
ever since the birth of sea and wind and
the surf has rolled pebbles in its foam
billiard ball. ever since the birth of sea and wind
endlessly—the surf has rolled pebbles in
make a billiard ball. ever since the birth of sea
and moon—endlessly—the surf has rolled pebbles
foam to make a billiard ball. ever since the birth
and wind and moon—endlessly—the surf has rolled
pebbles in its foam to make a billiard ball. ever since
birth of sea and wind and moon—endlessly—the surf
rolled pebbles in its foam to make a billiard ball.
since the birth of sea and wind and moon—endlessly
the surf has rolled pebbles in its foam to make a billiard
ball. ever since the birth of sea and wind and moon
endlessly—the surf has rolled pebbles in its foam to make
billiard ball. ever since the birth of sea and wind and
moon—endlessly—the surf has rolled pebbles in its foam
make a billiard ball. ever since the birth of sea and
and moon—endlessly—the surf has rolled pebbles
to make a billiard ball. ever since the birth
and moon—endlessly—the surf has rolled
to make a billiard ball. ever has rolled
moon—endlessly ball. ever since the birth
endlessly—the surf has rolled since the birth of sea and wind
make a billiard ball. ever since the surf has rolled pebbles in its
and moon—endlessly—the surf has billiard ball. ever since the birth of sea
in its foam to make a billiard ball. ever endlessly—the surf has rolled pebbles
of sea and wind and moon—endlessly—the billiard ball. ever since the birth
rolled pebbles in its foam to make a billiard ball moon—endlessly—the surf has
since the birth of sea and wind and moon—end a billiard ball. ever since
surf has rolled pebbles in its foam to make a moon—endlessly—the surf
ball. ever since the birth of sea and wind and a billiard ball. ever
endlessly—the surf has rolled pebbles in its moon—endlessly—the
make a billiard ball. ever since the birth of sea a a billiard ball. ever
and moon—endlessly—the surf has rolled pebbles moon—er
foam to make a billiard ball. ever since the
wind and moon—endlessly—the surf has
its foam to make a billiard ball. ever
and wind and moon—endlessly—the surf
its foam to make a billiard ball
and wind and moon—endless
its foam to make a b
and wind and

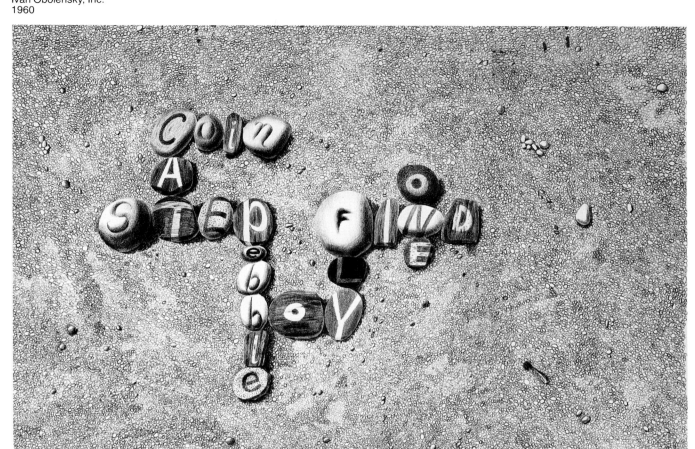

LEO LIONNI *new drawings*

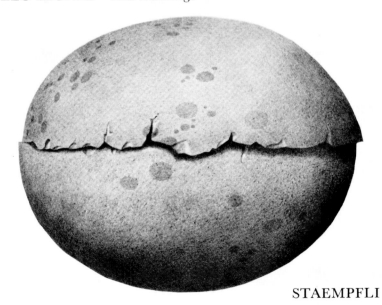

STAEMPFLI

Children's Book:
Little blue and little yellow
Ivan Obolensky, Inc.
1959

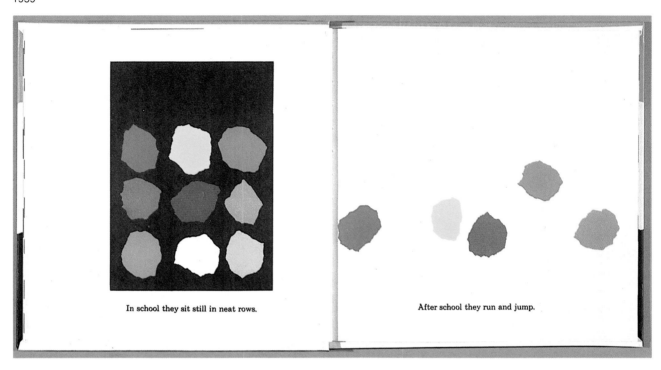

In school they sit still in neat rows.

After school they run and jump.

Children's Book:
Letters
Pantheon Books
1984

Children's Book:
What?
Pantheon Books
1983

Children's Book:
Fish is Fish
Pantheon Books
1970

Children's Book:
It's Mine
Pantheon-Knopf
1984

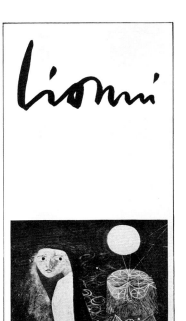

Exhibition Catalog:
Norlyst Gallery
1947

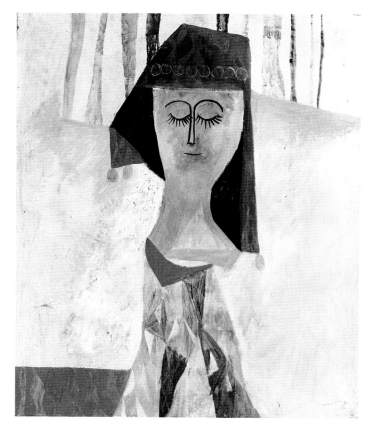

Painting:
Gypsy
1947

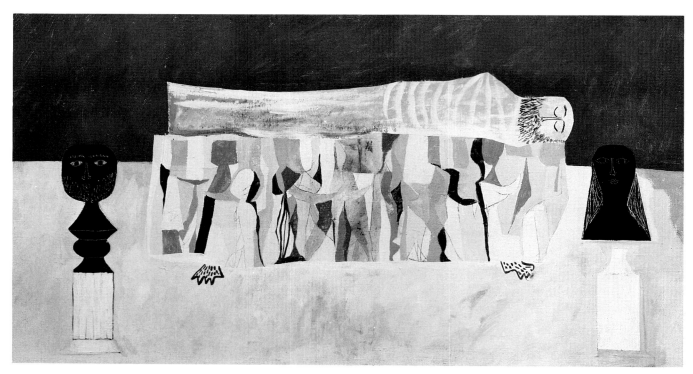

Painting:
Sarcophagus
1947

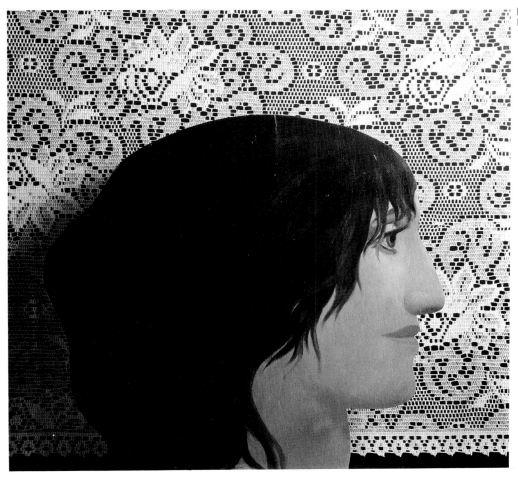

Painting:
Imaginary Portrait
1955

Painting:
Profile
1965

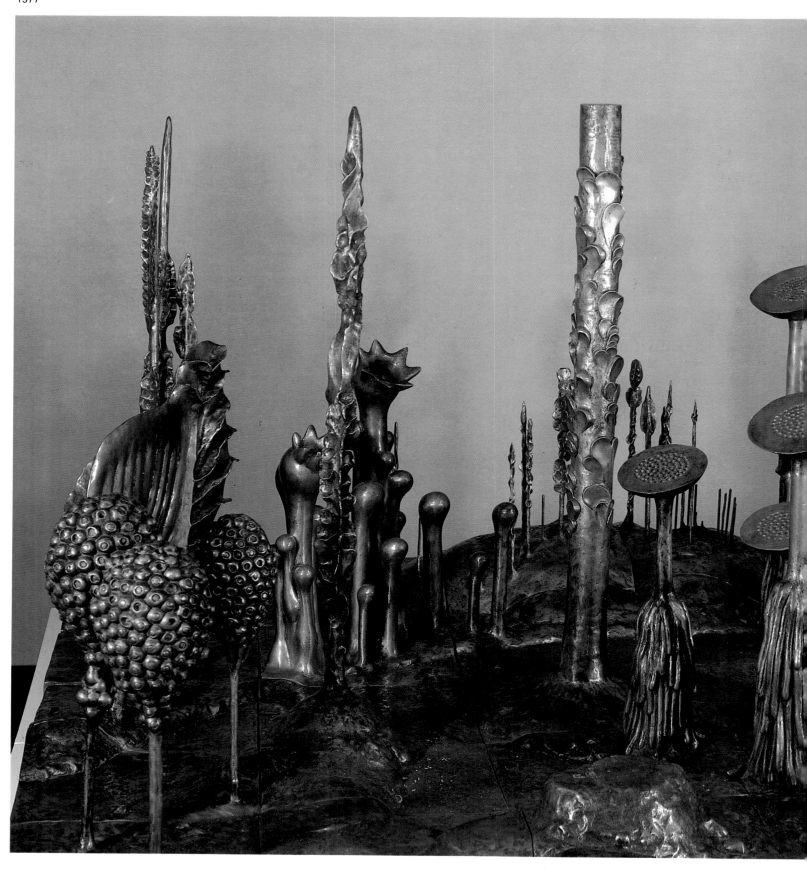

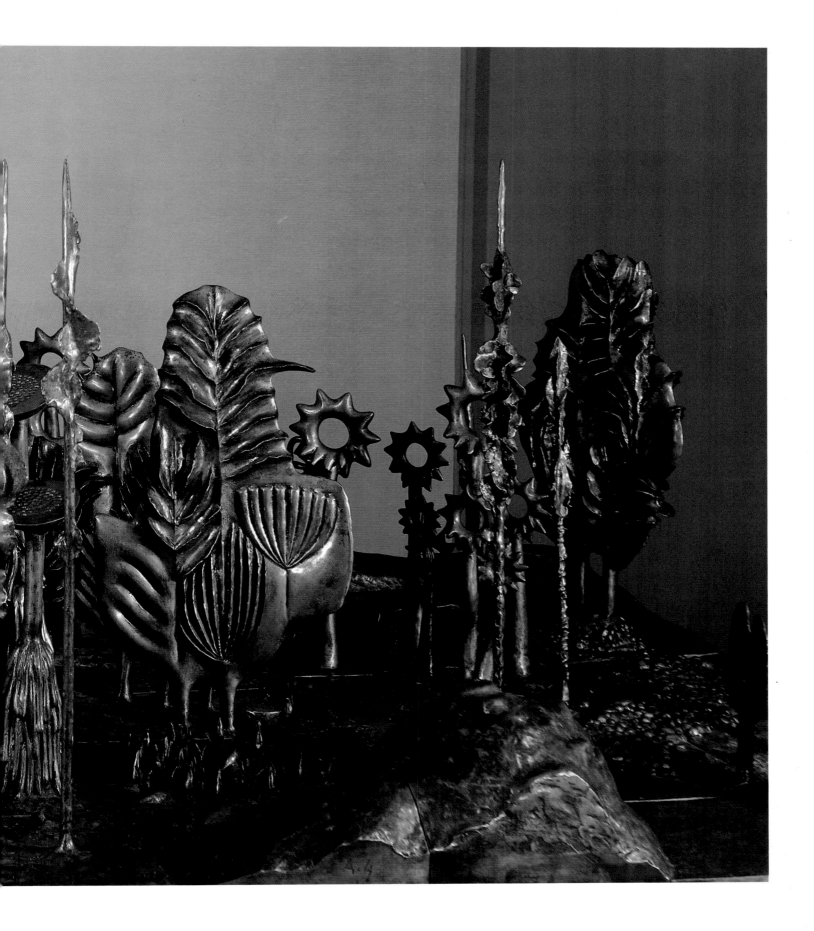

Exhibition Catalog:
Project for an imaginary
garden
Verona 1978
Köln 1978
New York 1979

Book:
La Botanica Parallela
Adelphi, Milano
1976

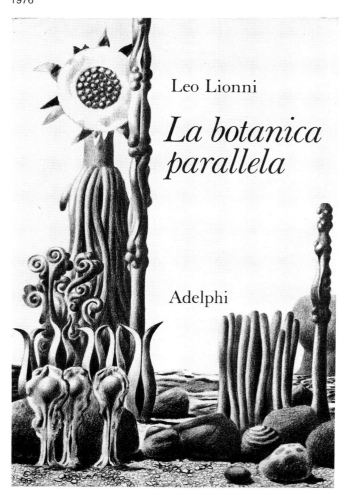

Leo Lionni

Progetto per un giardino immaginario	Projekt für einen imaginären Garten	Project for an imaginary garden
Museo di Castelvecchio Verona Agosto Settembre 1978	Baukunst Galerie Köln November 1978	Staempfli Gallery New York March 1979

Leo Lionni

La botanica parallela

Adelphi

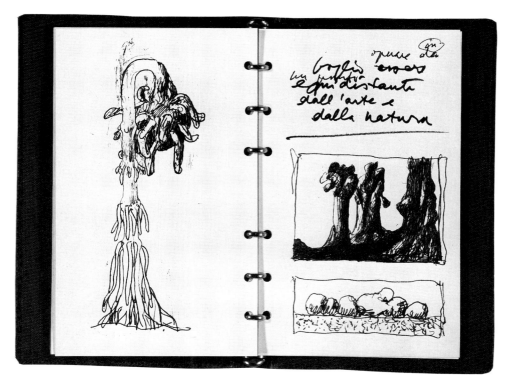

Book:
Taccuino di Leo Lionni
Electa, Venice
1972

Bronze Sculpture:
Moonflowers
Venice Biennale
Photograph: Ugo Mulas
1972

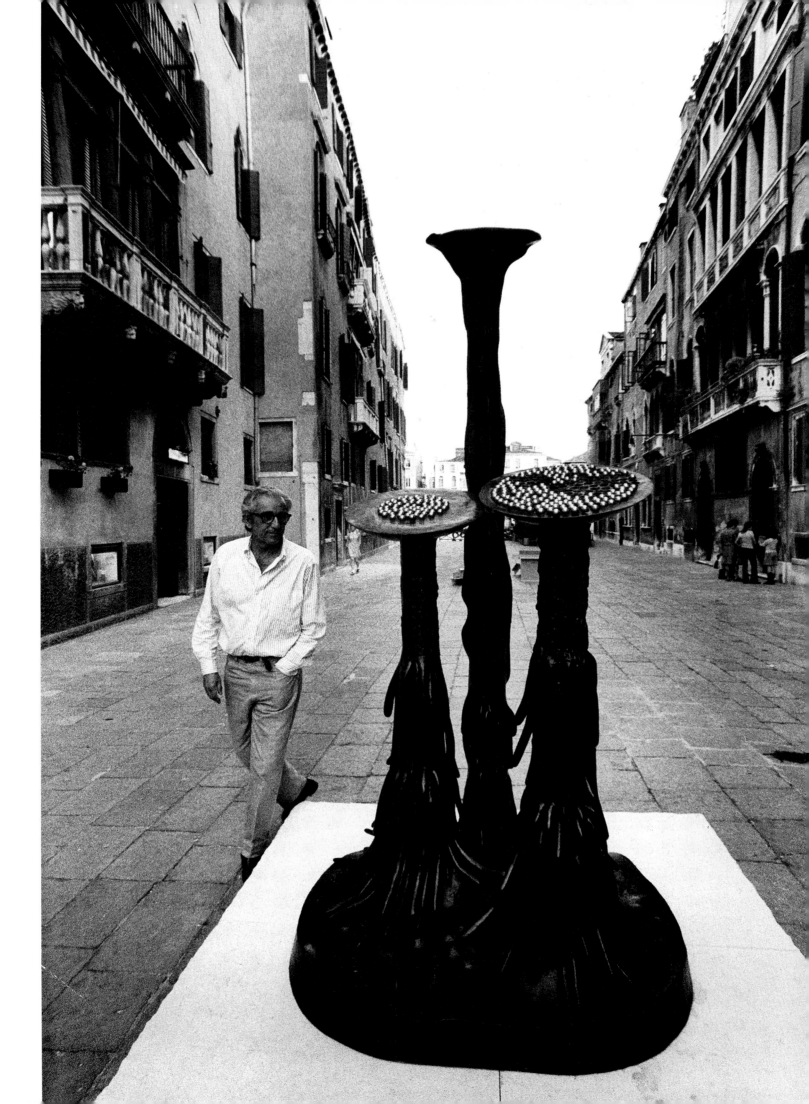

The AIGA
Design Leadership Award
1984:
Herman Miller, Inc.

**The Design Leadership Award of
The American Institute of Graphic Arts
has been established to recognize
the role of the perceptive and forward-
thinking client who has been instrumental
in the advancement of design by
application of the highest standards,
as a matter of policy, to all its visual
communications. Recipients are chosen
by a committee, subject to approval
by the Board of Directors.**

Past recipients
IBM Corporation, 1980
Massachusetts Institute of Technology, 1981
Container Corporation of America, 1982
Cummins Engine Company, Inc., 1983

Chairman
David Brown
Vice President
Communications
Champion International Corporation

Committee
Gene Federico
Vice Chairman
Lord, Geller, Federico, Einstein, Inc.

Tom Geismar
Partner
Chermayeff & Geismar Associates

John Massey
President
John Massey, Inc.

Michael Vanderbyl
Principal
Vanderbyl Design

Poster:
1984
Design Firm:
Casado, Inc.
Designer:
John Casado

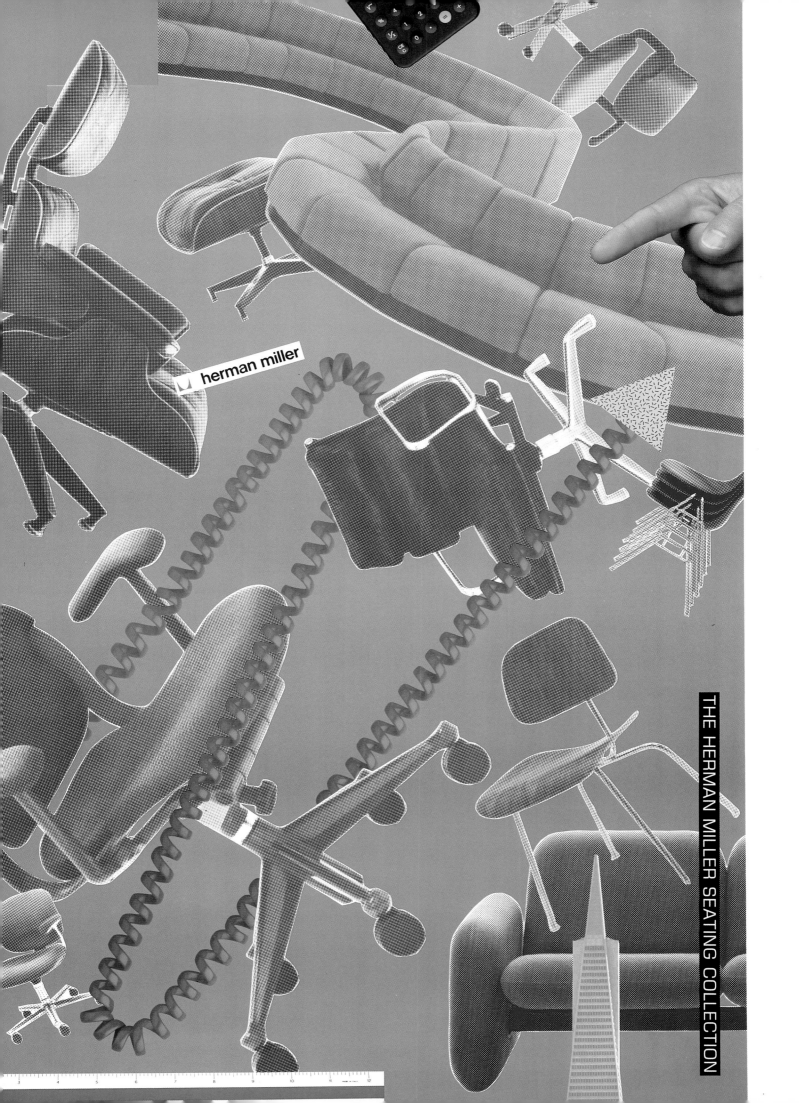

herman miller

The AIGA Design Leadership Award celebrates design excellence over time. One of the Award's early objectives was to single out corporations whose design achievements were inadequately publicized. The same few names, however, kept rising predictably to the surface. The industrial corporations honored so far are IBM, Container Corporation, Cummins Engine, and now Herman Miller. George Lois, a member of the original jury, objected prophetically that the effect each year would be like waiting for another shoe to drop.

And yet, given the terms of the Award, how could it be otherwise? Design excellence is a tradition that relatively few companies have been able to sustain. Since the 1940's Herman Miller has been one of them.

As a self-confessed, paid consultant to Herman Miller, I am not to be trusted as an objective commentator. On the other hand, my bias may not be what you think. I know what you may never have suspected: not all the design at Herman Miller is great. Part of my job as consultant is to point that out from time to time. I know where the bodies are buried – I see the work that doesn't get into publications like this one. On the *other* other hand, only a company deeply committed to design would retain impudent outsiders to review what they design and urge its improvement. And commitment is the name of the game – or would be if this were a game instead of the adventure in high seriousness we all know corporate design to be.

To gauge the depth of that commitment, it is useful to look at Herman Miller, Inc. when they think no one is watching, to listen when they are talking to themselves. Whenever I read a thoughtful, socially aware corporate statement, I wonder whether it's good because the company is or because the copywriter is. The most impressive thing about Herman Miller's communication is that its internal messages and external messages are generally the same in substance and quality.

Take the prizewinning picnic posters designed by the company's creative director, Stephen Frykholm. Every summer Herman Miller has a picnic in Zeeland, Michigan. Nothing unusual about that – a lot of companies have picnics. But this is no ordinary company picnic; it has the flavor and spirit of a family outing. A family outing doesn't require a poster – you just pile into the car and go. The Herman Miller picnic doesn't require a poster either, at least not functionally. After all, everyone knows where and when the picnic is going to be. And even if they didn't, the poster wouldn't help anyway, because Frykholm is notorious for not meeting that particular deadline. In some years, the poster arrived from the printer just as the potato salad came from the side dish committee. But the poster is essential as an expression of both the festivity and the kind of company being festive. The commitment to design, in other words, pervades the corporation; it is not confined to advertising and promotional literature.

That goes for architectural design too. When Herman Miller built a plant at Bath, England, chief executive officer Max De Pree wrote the design brief. "Our goal," Max wrote, "is to make a contribution to the landscape of an aesthetic and human value... We wish to create an environment...open to surprise...that will encourage fortuitous encounter. The facility must be able to change with grace, be flexible and nonmonumental."

△
Mark designed by Irving Harper in 1946 as it appeared in *The Herman Miller Collection*, 1948.

That last injunction is a pretty good description of the company's own aspirations and the graphics which reflect it. In some 40 years, Herman Miller has changed from a small company that made beautiful pieces for home and office to a large company that makes systems and related furniture for offices, factories, hospitals and laboratories, airports and other public spaces. Comparable changes in complexity and sophistication had to be made, also nonmonumentally, in graphics.

This has often led to graphically innovative approaches. *Ideas,* a quarterly magazine (page 81), was not a glossy, four-color promotional piece, but a seriously researched journal of ideas about the interior environment, edited in-house by Debra Wierenga and designed in-house by Linda Powell. Its purpose was promotional, but its style was editorial. Similarly, a series of notebooks I wrote for designers was minimally designed by John Massey to be typed and handwritten in keeping with the content, which consisted of personal observations. The vitality of the graphics has always taken its nourishment from unconventional design. The lyrical stock certificate (page 64) designed by Deborah Sussman, then in the Eames office, is wittily evocative of the kind of company Herman Miller was then. Most of the early graphic design, including ads, came from the Eames and Nelson offices, which made for an unusual integration of product design and graphics. Some catalogs (written by George Nelson) were designed by both offices – each literally doing its own thing.

So much variety would lead to chaos in the absence of a committed client. Names like Charles and Ray Eames, George Nelson, Isamu Noguchi, Alexander Girard, Bob Propst, Bruce Burdick, Don Chadwick and Bill Stumpf are almost inextricably associated with Herman Miller products. In graphic design, the names are equally stellar and the styles equally dissimilar. They include Ivan Chermayeff, John Massey, Tomoko Miho, Don Ervin, George Tscherny, Jim McMullan, Lance Wyman, Hiro, Donovan and Green, Armin Hofmann, Isadore Seltzer, Seymour Chwast, John Casado, Robert Blechman, Henry Wolf, Art Kane, Pentagram, Ezra Stoller, Deborah Sussman.... And those are only the consultant designers.

Much – maybe most – of the work on these pages was done in-house by Stephen Frykholm, Linda Powell, Barbara Loveland, Rob Hugel, and other staff designers. Good as they all are, however, the work shown here might be less distinguished had it not been performed in a climate that welcomed and demanded distinction. Irving Harper, who designed the Herman Miller symbol in 1946, says: "From that first effort to 1963, when I left the George Nelson office... the sole demand of our client was for professional excellence even when inconsistent with conventional market wisdom."

As it turns out, professional excellence was consistent with *un*conventional market wisdom, and Herman Miller has prospered through design. Although that design is most visibly recorded in graphics and products, it is no less a force in management. Ultimately, Herman Miller's design excellence is expressed in the continual design of the company itself.

– Ralph Caplan

John Massey's logotype of 1969 is still used.

Catalog:
1956
Design Firm:
George Nelson
Associates
Designers:
Irving Harper
Carl Ramirez
Charles and Ray Eames
Deborah Sussman
Photographers:
John Stewart
Midori
Dale Rooks
Lionel Freedman
George Nelson
Charles Eames

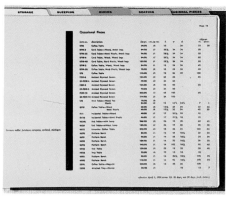

Catalog:
1964
Design Firm:
George Nelson
Associates
Designers:
Tomoko Miho
Roger Zimmerman
Photographers:
Lester Bookbinder
Charles Eames
David Attie
Lionel Freedman
Hiro

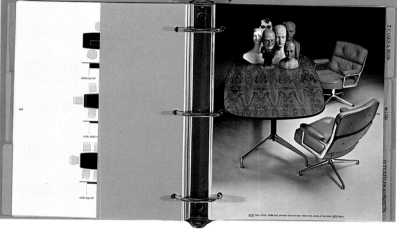

Catalog:
1969
Design Firm:
Center for Advanced
Research in Design
Design Director:
John Massey
Designers:
Peter Teubner
Tomoko Miho
Steve Keller
Terry Waln
Carol Zayauskas
Photographers:
Dale Bullock
Myles De Russey
Charles Eames
Steve Keller
Terry Waln

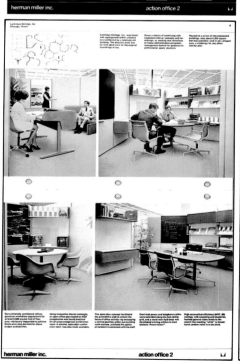
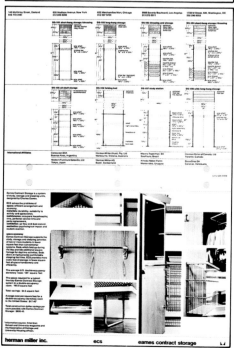
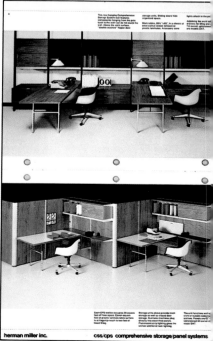

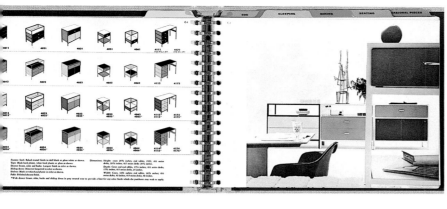

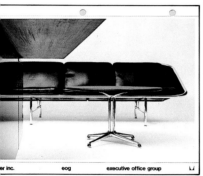

herman miller inc. eog executive office group

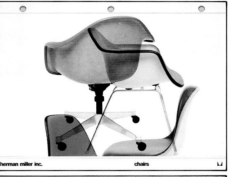

herman miller inc. chairs

herman miller inc. library group

herman miller inc. tab

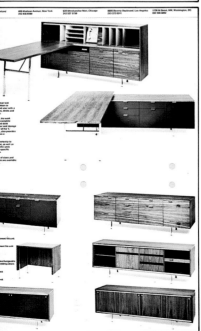

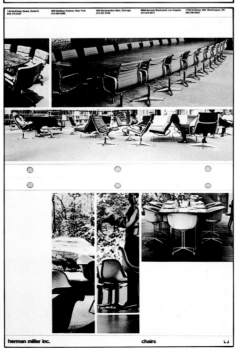

herman miller inc. chairs

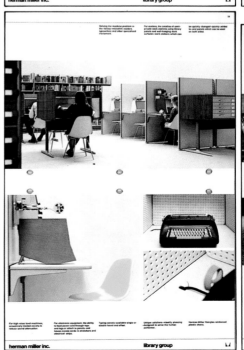

herman miller inc. library group

herman miller inc. tab

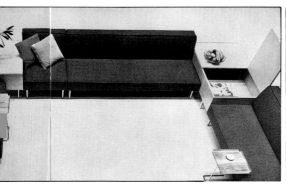
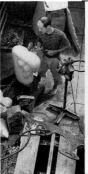

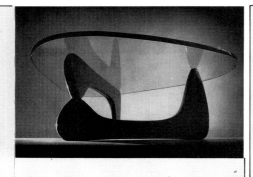

ofa Compact

Comfortable. Striking. Durable. Adaptable. Functional.

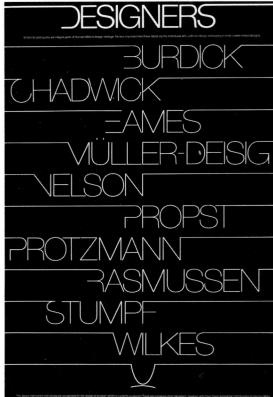

DESIGNERS

Simplicity and quality are integral parts of Herman Miller's design heritage. No less important than these ideals are the individuals who, with our design philosophy in mind, create honed designs.

BURDICK
CHADWICK
EAMES
MÜLLER-DEISIG
NELSON
PROPST
PROTZMANN
RASMUSSEN
STUMPF
WILKES

The above-mentioned individuals are recognized for the design of product which is currently produced. There are numerous other designers, however, who have made substantial contributions to Herman Miller. Among them: William Rudolph, Freda Diamond, Alexander Girard, Alan Gould, Fritz Hapler, Peter Hvidt, Poul Kjaerholm, Paul Laszlo, O M Nielsen, Isamu Noguchi, Verner Panton, Gilbert Rohde, and Jan Ruthenburg.

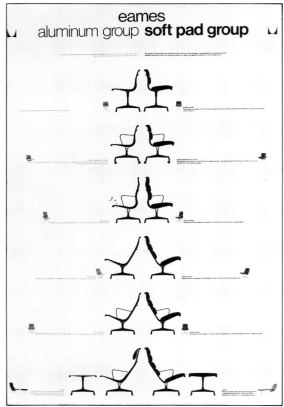

eames
aluminum group **soft pad group**

The Eames Soft Pad chairs, an extension of the aluminum Group design, incorporate direct cushions and flat padded textured leather. An ability to quickly adapt to user management, extension, and lounge chairs.

T · A · N
S · E · A

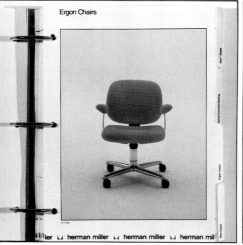

Ergon Chairs

herman miller herman miller herman mil

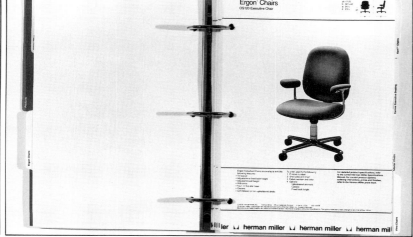

Ergon Chairs
OS120 Executive Chair

Ergon Deluxe Chairs are available with the following features:
1 Product number
2 Seat color and finish
3 Fabric number and color
4 Options
5 Casters
6 Upholstered armrests
7 Fixed back height

To order, specify the following:
1 Product number
2 Seat color and finish
3 Fabric number and color
4 Options
5 Upholstered armrests
6 Casters
7 Fixed back height

For detailed product specifications, refer to the current Herman Miller Specifications Manual. For current product options, ordering instructions, prices and finishes, refer to the Herman Miller price book.

iller herman miller herman miller herman mil

Sample Elevation

ler herman miller herman miller her

58

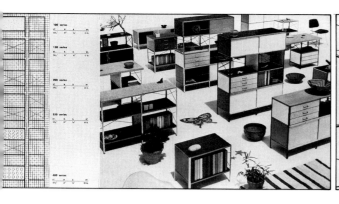

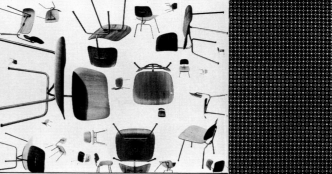

Catalog:
1952
The Herman Miller Collection
Design Firm:
George Nelson Associates
Designers:
George Nelson
Ernest Farmer
Irving Harper
Charles and Ray Eames
Charles Kratka
Photographers:
Dale Rooks
Ezra Stoller
Midori
William Vandivert
Charles Eames

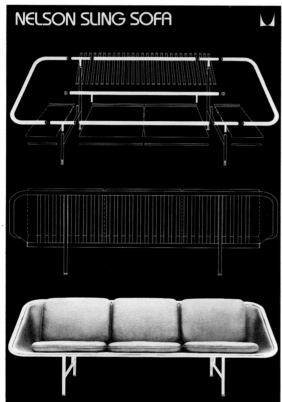

NELSON SLING SOFA

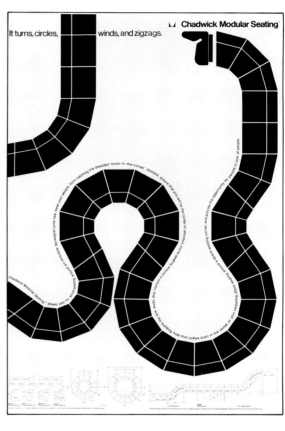

It turns, circles, winds, and zigzags.
Chadwick Modular Seating

Wall Catalog:
1981
Designers:
Stephen Frykholm
Rob Hugel
Barbara Loveland
Linda Powell
Barbara Herman
Patti Levenberg
Kathy Stanton

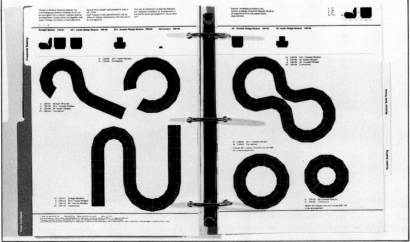

Catalog and Planning Guide:
1978
Designers:
Stephen Frykholm
Barbara Loveland
Photographer:
Earl Woods

Advertisement:
1954
The new chaise…
Design Firm:
George Nelson
Associates
Designer:
George Tscherny

Advertisement:
1950
Executive Office Group
Design Firm:
George Nelson
Associates
Designer:
Irving Harper

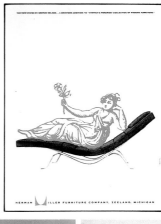

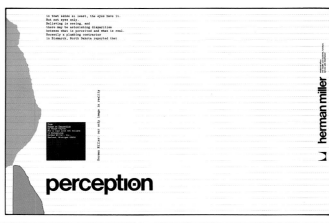

perception

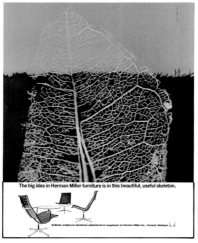

The big idea in Herman Miller furniture is in this beautiful, useful skeleton.

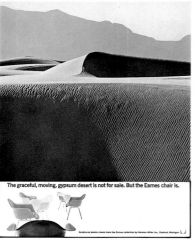

The graceful, moving, gypsum desert is not for sale. But the Eames chair is.

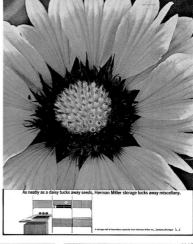

As neatly as a daisy tucks away seeds, Herman Miller storage tucks away miscellany.

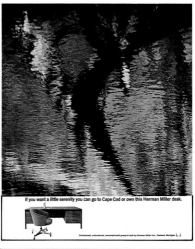

If you want a little serenity you can go to Cape Cod or own this Herman Miller desk.

Advertisements:
1960
The big idea…
The graceful moving…
As neatly as a daisy…
If you want…
Design Firm:
George Nelson
Associates
Designer:
Irving Harper
Photographer:
Art Kane

Advertisement:
1961
Illustrative literature…
Design Firm:
George Nelson
Associates
Designer:
Don Ervin

Advertisement:
1978
An office should
recognize the
peculiarities of its
inhabitants.
Design Firm:
Chermayeff and
Geismar Associates
Designer:
Ivan Chermayeff
Photographer:
Henry Wolf

Advertisement:
1984
His survival depends on
the distribution of
energy. So does yours.
Design Firm:
Chermayeff and
Geismar Associates
Designer:
Ivan Chermayeff
Photographer:
Francois Robert

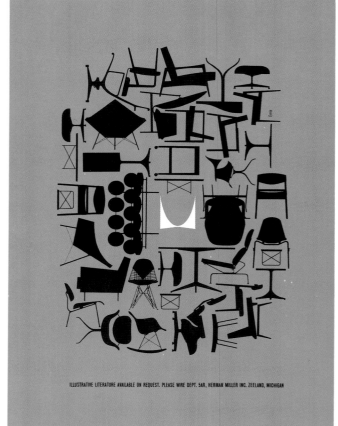

ILLUSTRATIVE LITERATURE AVAILABLE ON REQUEST. PLEASE WIRE DEPT. 5AR, HERMAN MILLER INC. ZEELAND, MICHIGAN

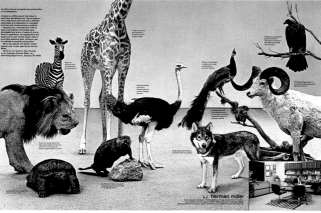

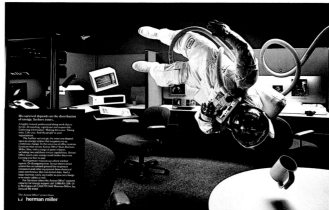

The Original Chair for the New World.

Today's professional is better educated, more sophisticated, a team player in whom the entrepreneurial spirit lives. Dedicated, demanding, men and women who will pursue a problem for the sake of accomplishment, regardless of the hours it takes.

Not surprisingly, such individuals deserve the best in contemporary office equipment—beginning with the Equa Chair, an egalitarian seating solution of extraordinary design. In the comfort of an Equa Chair, a person can work on into the night, oblivious to circumstance or the passage of time.

At the very least, a just reward.

Introducing
the Equa Chair

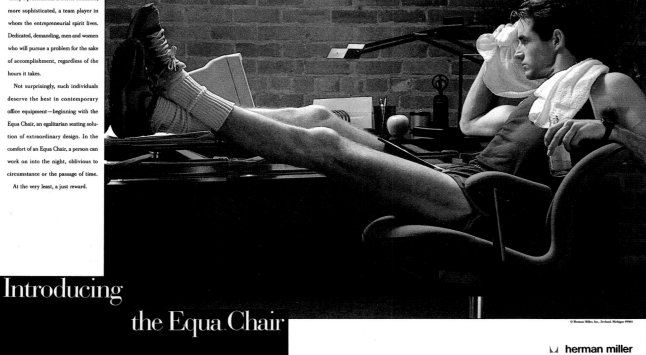

herman miller

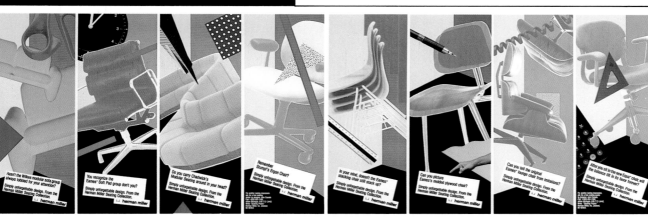

Any environment is wrong
 if you feel stuck in it.
No one anywhere wants to be nowhere,
 Or closed in.
 A sense of choice,
a sense of place,
 a sense of light and openness.
These are qualities we always look for
 in the places where we live.
And now can find
 in the spaces where we work.
For people who have been asking
about the office of the future,
 we have the answer.

Ethospace™ interiors from

herman miller
Zeeland, Michigan 49464

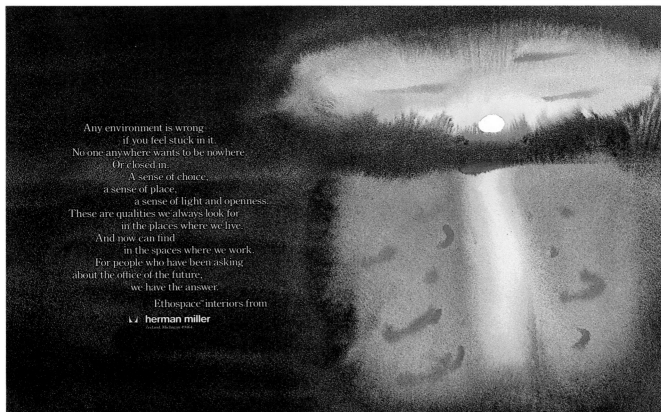

◁

Advertisement:
1978
perception
Design Firm:
John Massey, Inc.
Designer:
John Massey

Advertisement:
1984
The original chair…
Design Firm:
Casado, Inc.
Designer:
John Casado
Photographer:
Rudi Legmani

Advertisements:
1984
Seating Collection
Design Firm:
Casado, Inc.
Designer:
John Casado

Advertisement:
1984
Any environment…
Design Firm:
Chermayeff and
Geismar Associates
Designer:
Ivan Chermayeff
Illustrator:
James McMullan

Advertisement:
1953
Item: fabric collection
Design Firm:
George Nelson
Associates
Designer:
George Tscherny

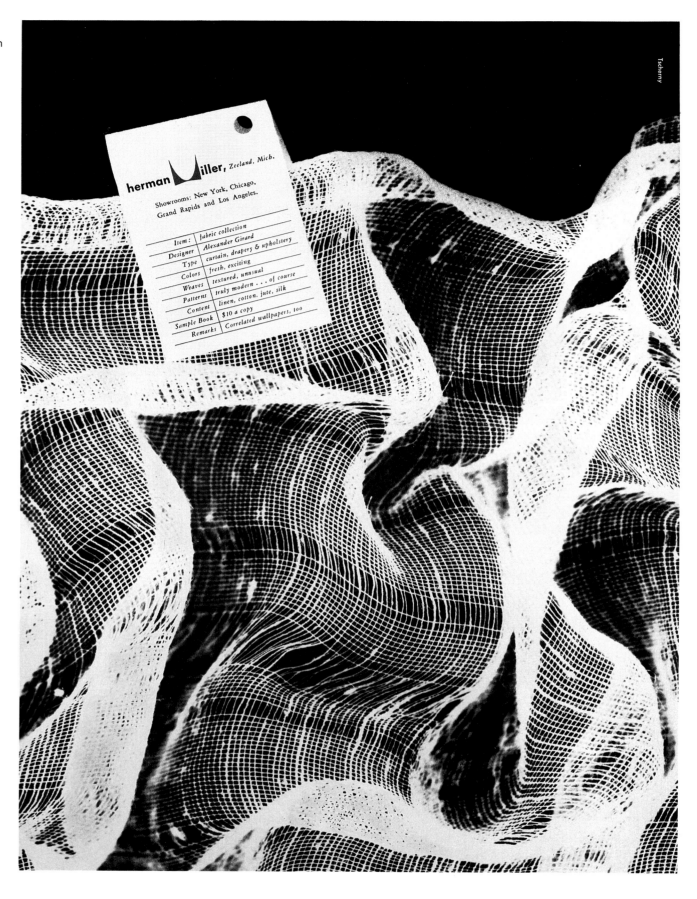

Tscherny

herman **Miller,** Zeeland, Mich.

Showrooms: New York, Chicago,
Grand Rapids and Los Angeles.

Item:	fabric collection
Designer	Alexander Girard
Type	curtain, drapery & upholstery
Colors	fresh, exciting
Weaves	textured, unusual
Patterns	truly modern . . . of course
Content	linen, cotton, jute, silk
Sample Book	$10 a copy
Remarks	Correlated wallpapers, too

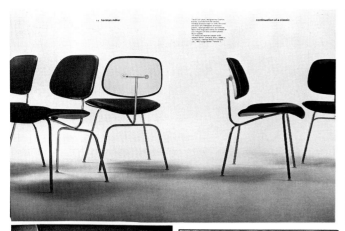

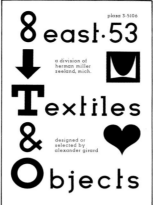

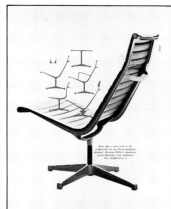

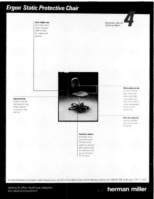

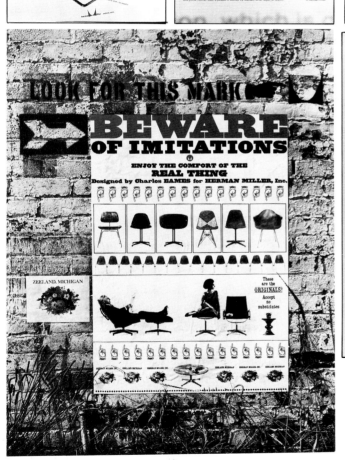

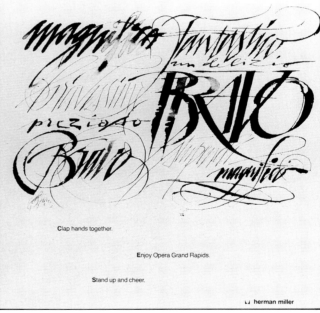

Advertisement:
1970
Continuation of a classic
Designer:
Stephen Frykholm
Photographer:
Earl Woods

Advertisement:
1961
Textiles & Objects
Design Firm:
Alexander Girard A.I.A.
Designer:
Alexander Girard

Advertisement:
1962
Ever take a close look…
Design Firm:
George Nelson
Associates
Designer:
Irving Harper

Advertisement:
1950
Truly new…
Design Firm:
George Nelson
Associates
Designer:
Irving Harper

Advertisement:
1983
A photographer…
Designer:
Rob Hugel

Advertisement:
1984
Ergon Static…
Design Firm:
Mark Anderson Design
Designer:
Mark Anderson

Advertisement:
1950
Exclusively ours…
Design Firm:
George Nelson
Associates
Designer:
Irving Harper

Advertisement:
1963
Beware of imitations
**Design Firm and
Art Direction:**
Charles and Ray Eames
Designer:
Deborah Sussman
Photographer:
Charles Eames

Advertisement:
1982
Clap hands together
Designer:
Rob Hugel
Calligrapher:
Tim Girvin

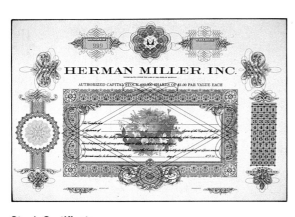

Stock Certificate:
1962
**Design Firm and
Art Direction:**
Charles and Ray Eames
Designer:
Deborah Sussman

Annual Report:
1970
Design Firm:
Center for Advanced
Research in Design
Design Director:
John Massey
Designer:
Joe Hutchcroft

Annual Report:
1976
Designers:
Stephen Frykholm
Linda Powell
Photographers:
Various contributors

⊔ herman miller president's report 1970

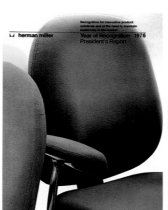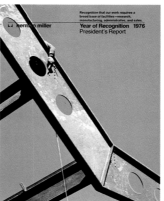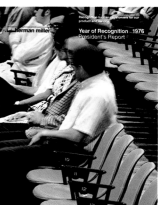

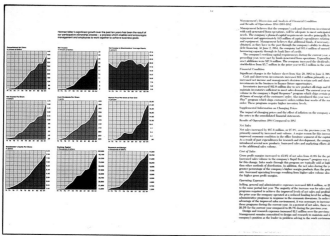

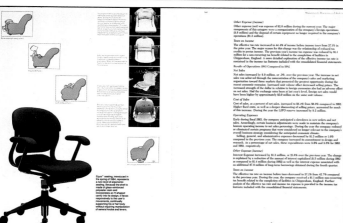

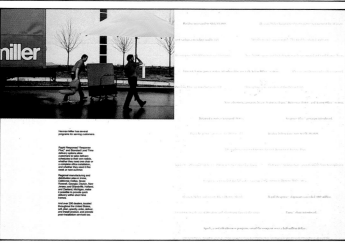

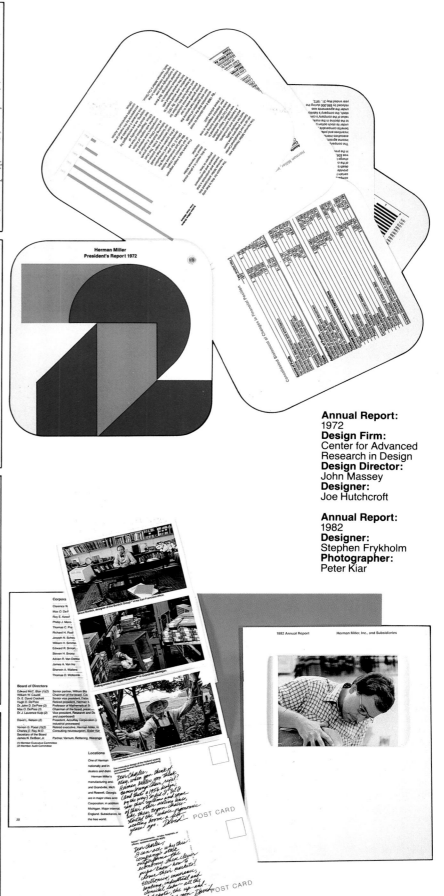

Annual Report:
1972
Design Firm:
Center for Advanced
Research in Design
Design Director:
John Massey
Designer:
Joe Hutchcroft

Annual Report:
1982
Designer:
Stephen Frykholm
Photographer:
Peter Kiar

◁
Annual Report:
1984
Designer:
Stephen Frykholm
Photographers:
Various contributors
Illustration:
Various contributors

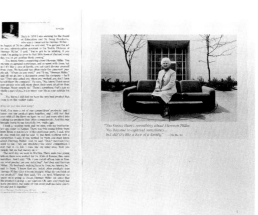
Herman Miller People Report to the Stockholders

Yes, Virginia, it does rain on picnics —
even Herman Miller picnics!

Annual Report:
1974
Design Firm:
Center for Advanced
Research in Design
Design Director:
John Massey
Designer:
Janet Podjesek

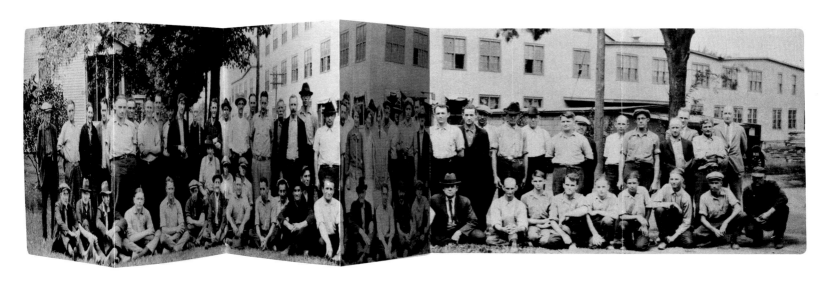

Annual Report:
1969
Design Firm:
Center for Advanced
Research in Design
Designer:
John Massey
Photographers:
Various contributors

Annual Report:
1983
Designer:
Stephen Frykholm
Photographer:
Joe Baraban

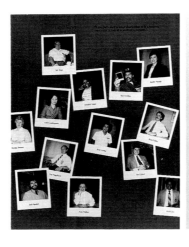

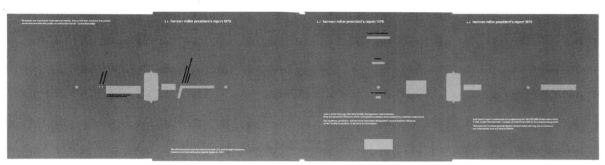

Annual Report:
1979
Designers:
Stephen Frykholm
Gary Cronkhite
Photographers:
Various contributors

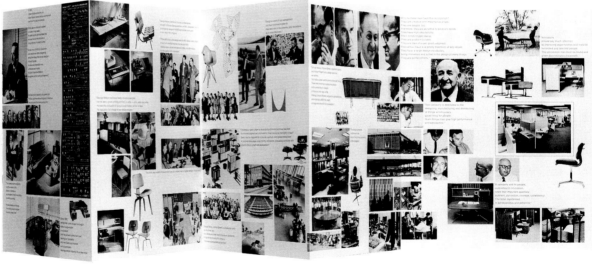

Posters:
Summer Picnic

1971
Designers:
Stephen Frykholm
Philip Mitchell

1975, 1976, 1977, 1980
Designer:
Stephen Frykholm

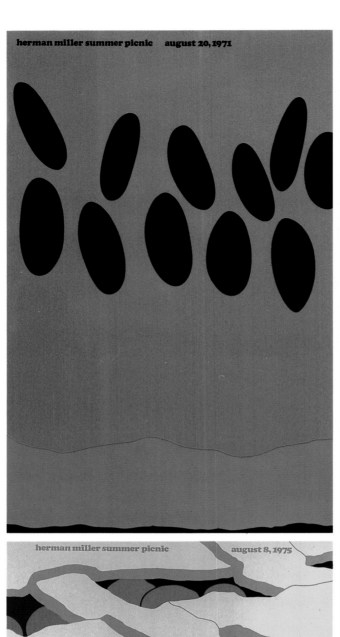

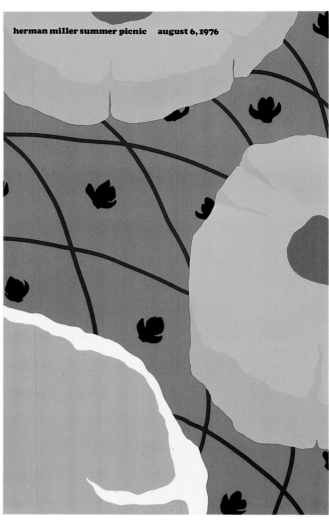

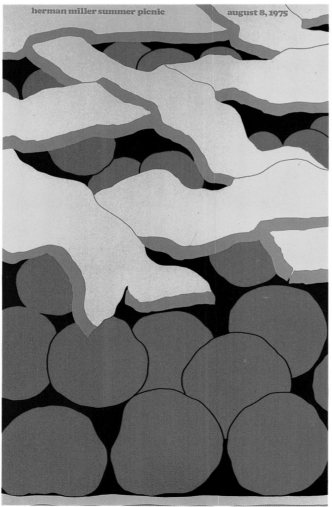

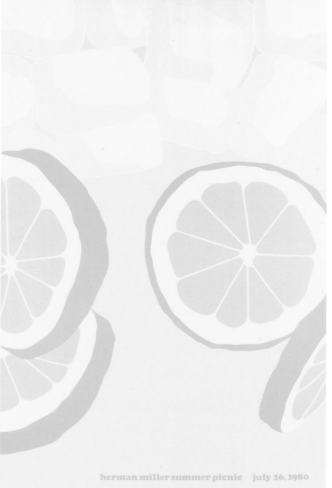

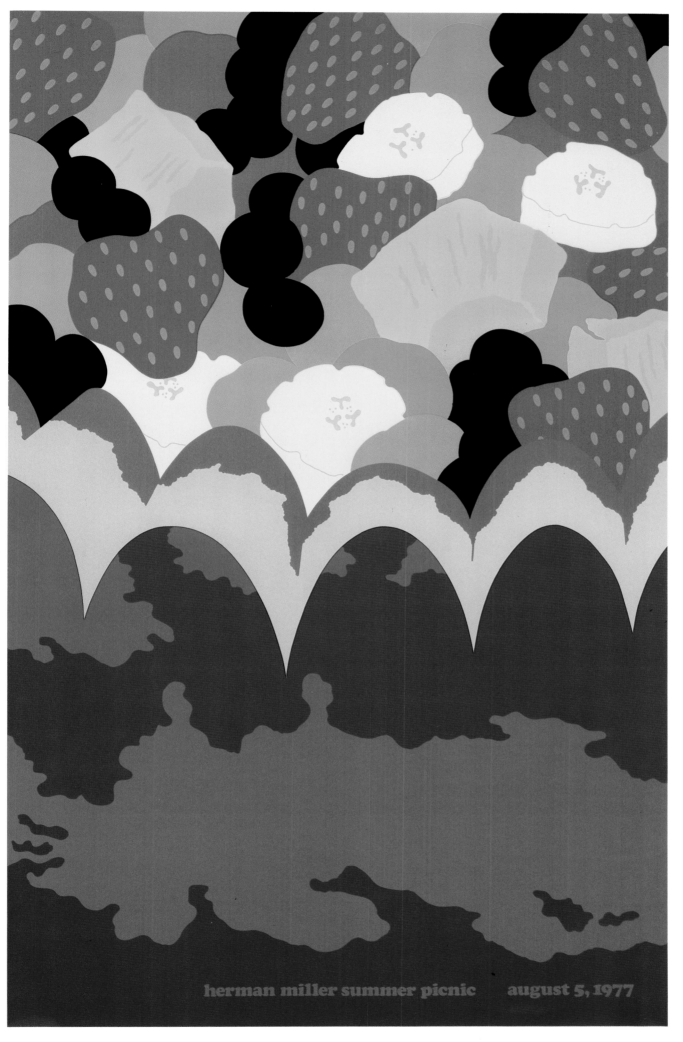

herman miller summer picnic august 5, 1977

Entwurf A. Hofmann Druck Wassermann A.G.

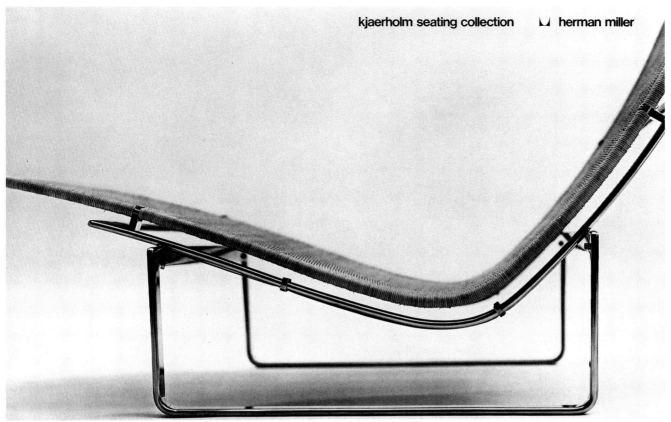

kjaerholm seating collection ⋃ herman miller

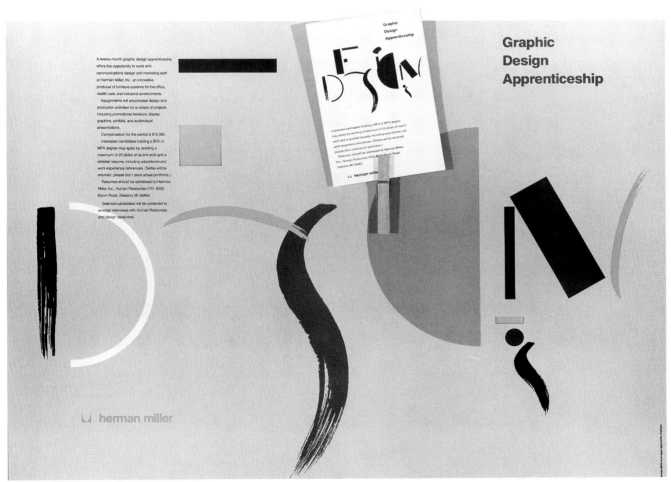

A twelve-month graphic design apprenticeship offers the opportunity to work with communications design and marketing staff at Herman Miller, Inc., an innovative producer of furniture systems for the office, health care, and industrial environments.

Assignments will encompass design and production activities for a variety of projects including promotional literature, display graphics, exhibits, and audiovisual presentations.

Compensation for the period is $16,000.

Interested candidates holding a BFA or MFA degree may apply by sending a maximum of 20 slides of recent work and a detailed resume, including educational and work experience references. (Slides will be returned, please don't send actual portfolios.)

Resumes should be addressed to Herman Miller, Inc., Human Resources C161, 8500 Byron Road, Zeeland, MI 49464.

Selected candidates will be contacted to arrange interviews with Human Resources and design personnel.

Graphic Design Apprenticeship

⋃ herman miller

Poster:
1977
Portrait of a Chair
Designer:
Per Arnolde

Poster:
1969
Action Office 2
Design Firm:
Center for Advanced
Research in Design
Designer:
John Massey

Poster:
1979
Christmas Party
Designer:
Linda Powell

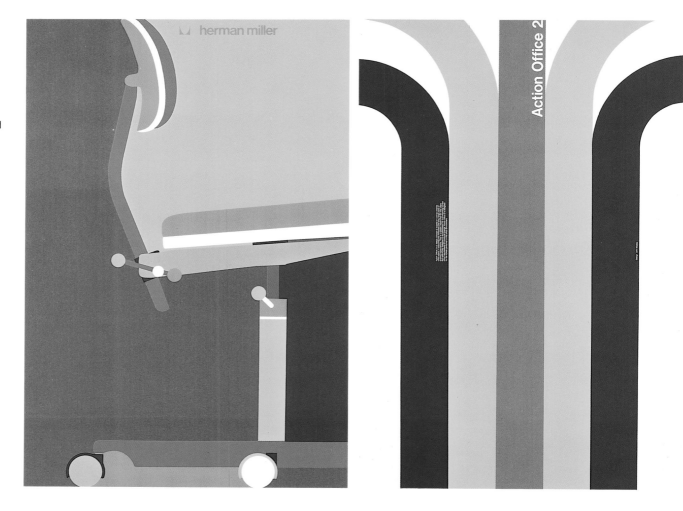

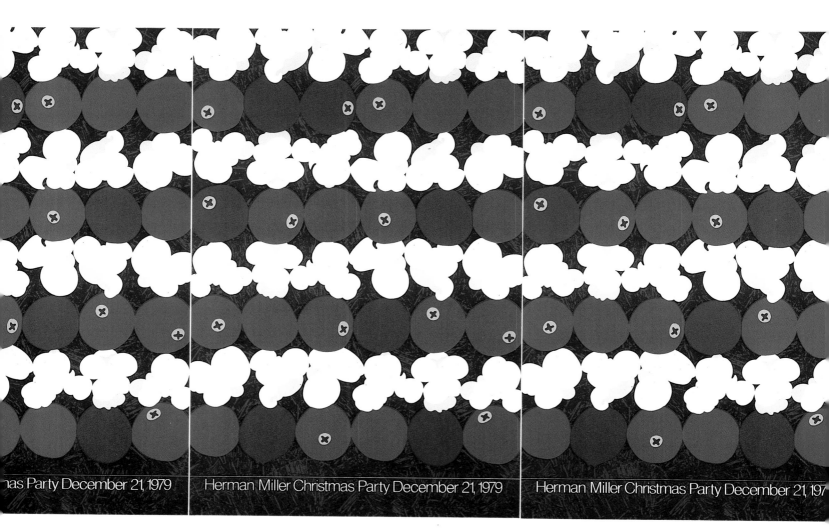

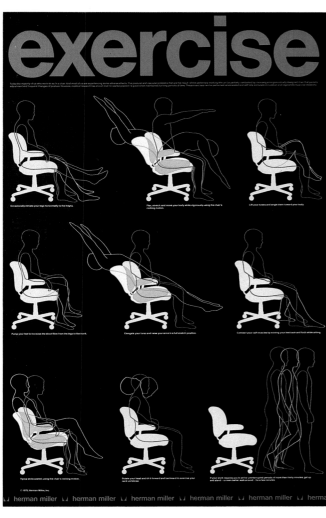

Objects selected by Alexander Girard for Herman Miller, Inc.

Textiles & Objects, 8 E. 53rd St., New York City: 555 Pacific Ave., San Francisco: 8806 Beverly Blvd., Los Angeles: 622 Merchandise Mart, Chicago: 1733 Chestnut St., Philadelphia

Poster:
1979
Exercise
Designer:
Linda Powell
Illustrator:
Gary Cronkhite

Poster:
1962
Objects selected...
Design Firm:
Alexander Girard A.I.A.
Designer:
Alexander Girard
Photographer:
Todd Webb

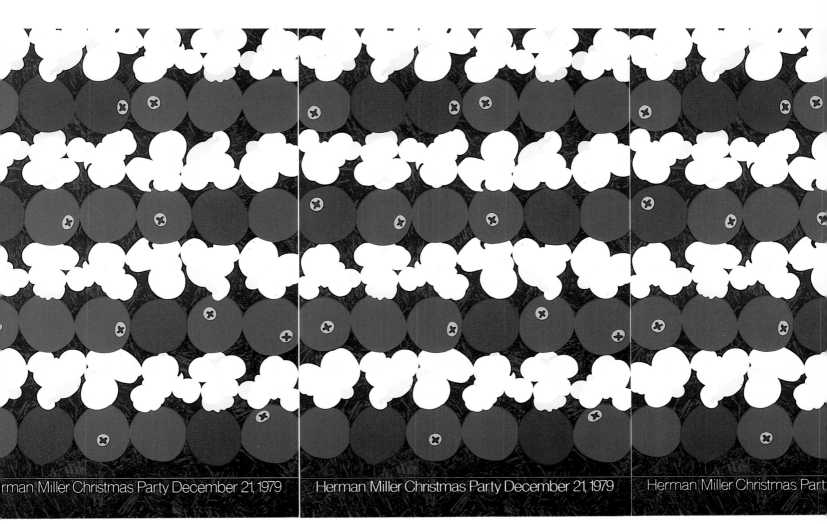

rman Miller Christmas Party December 21, 1979 Herman Miller Christmas Party December 21, 1979 Herman Miller Christmas Part

plywood and upholstered chair
secretarial chair and stool

aluminum group

panton chair

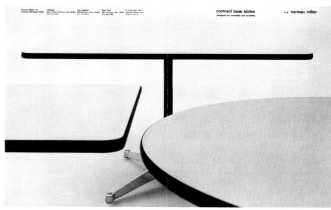

contract base tables

Brochure Series:
1973-76
Designers:
Stephen Frykholm
Mark Sturzenegger
Photographer:
Earl Woods

▷
Color Library:
1984
Designers:
Barbara Loveland
Linda Powell
Barbara Herman
Clino Castelli
Stephen Frykholm
Calligraphy:
Holly Dickens

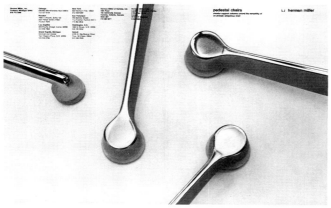

pedestal chairs

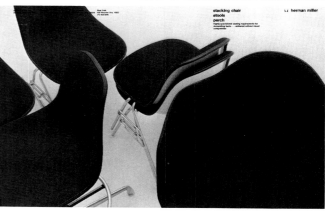

stacking chair
stools
perch

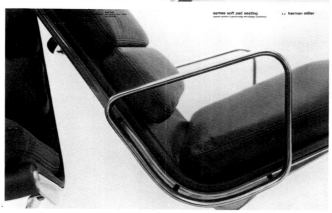

eames soft pad seating

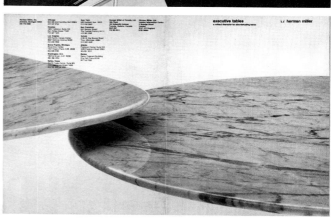

executive tables

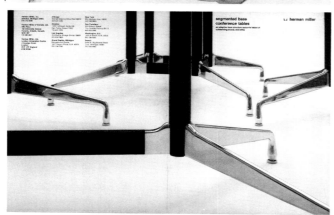

segmented base
conference tables

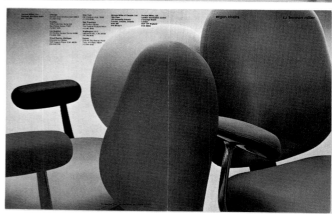

ergon chairs

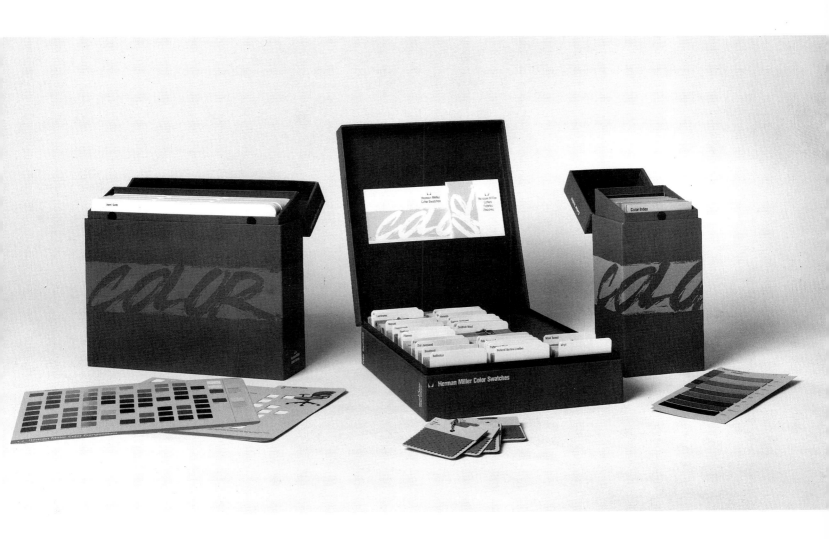

Announcement:
1983
Designer:
Barbara Loveland
Photographer:
Bill Sharpe

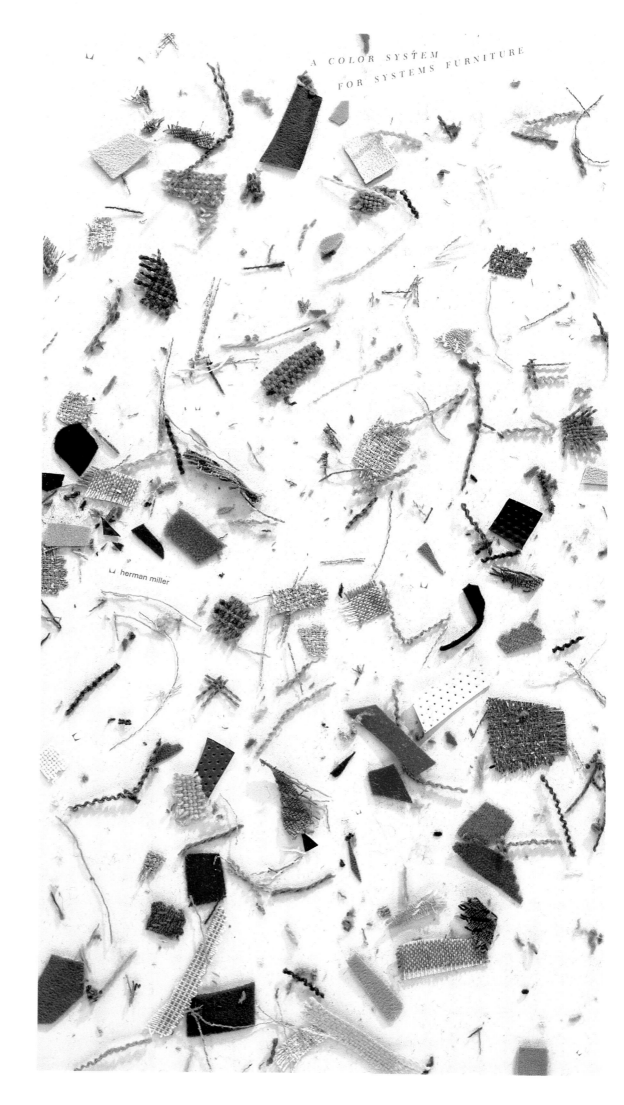

A COLOR SYSTEM FOR SYSTEMS FURNITURE

herman miller

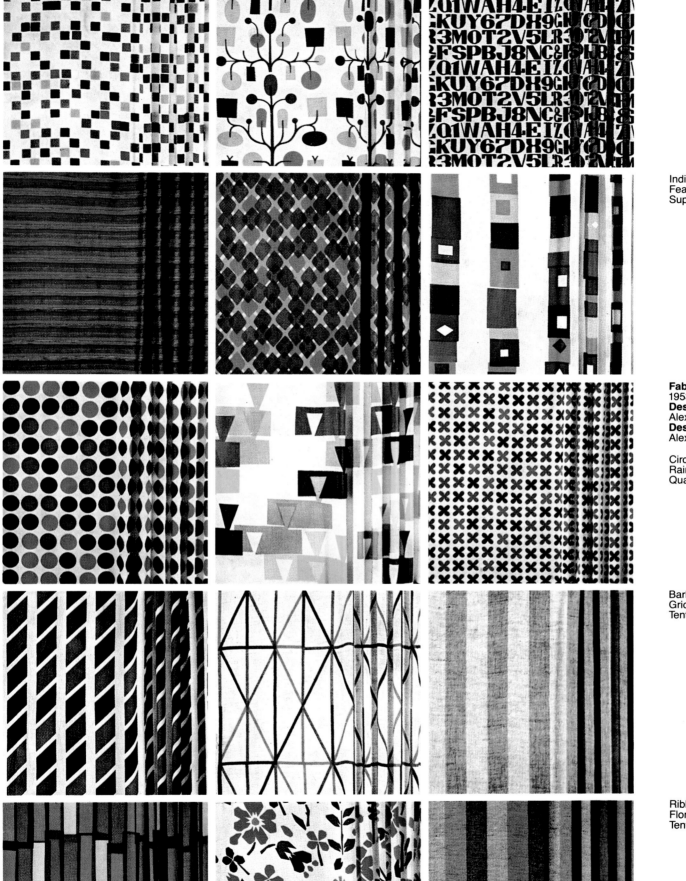

Small Squares 1953
Fruit Tree 1961
Alphabet 1960

Indian Silk 1958
Feathers 1957
Super Stripe 1955

Fabric Design:
1953-1961
Design Firm:
Alexander Girard A.I.A.
Designer:
Alexander Girard

Circles 1953
Rain 1953
Quatrefoil 1954

Barber Pole 1961
Grid 1958
Tent 1960

Ribbons 1957
Flores 1960
Tent 1960

Brochure:
1978
Action Office
Design Firm:
Pentagram
Designer:
Alan Fletcher
Photographer:
Tim Street-Porter

Brochure:
1954
The Steelframe
Collection
Design Firm:
George Nelson
Associates
Designer:
George Tscherny

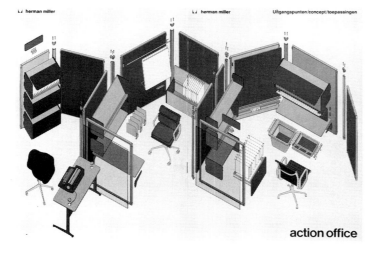

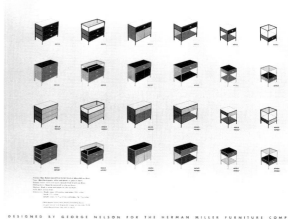

Price List:
1962
Design Firm:
George Nelson
Associates
Designers:
Irving Harper
Don Ervin
Tomoko Miho
Antony Zamora

Price List:
1983
Designer:
Rob Hugel
Linda Powell
Kathy Stanton

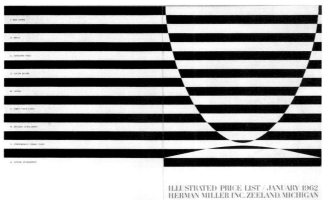

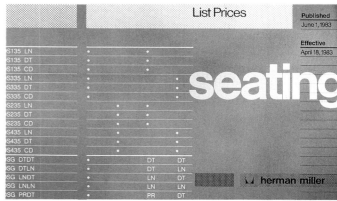

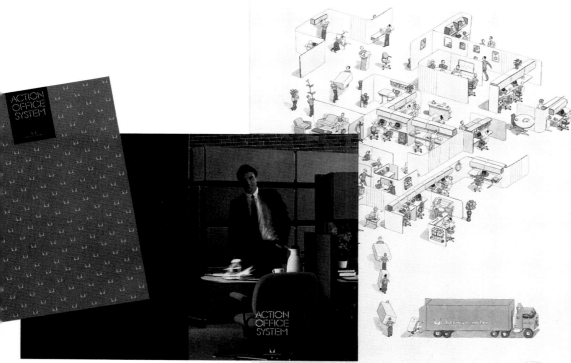

Brochure:
1984
Action Office System
Design Firm:
Sara Giovanitti Design
Designer:
Sara Giovanitti
Photographer:
Susan Wood
Illustrator:
Steven Guarnaccia

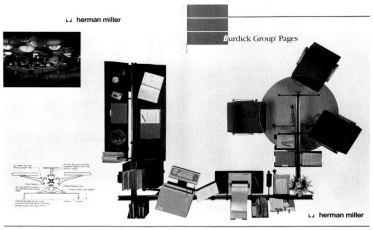

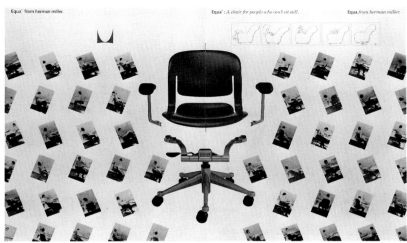

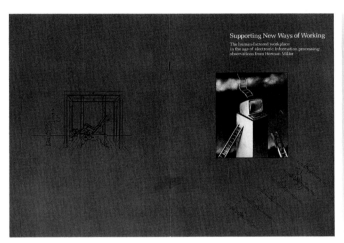

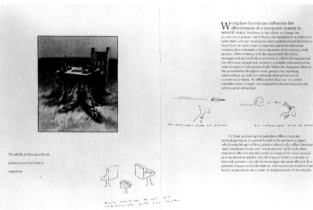

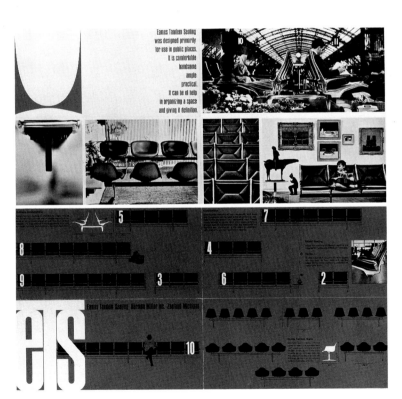

Brochure:
1984
Burdick Group Pages
Designer:
Kathy Stanton
Photographers:
John Ladislaus
Bill Sharpe
Bill Lindhout
Illustrators:
Susan Kosakowsky
Eric Schroder

Brochure:
1984
Equa – a chair for
people who can't sit still
Designers:
Rob Hugel
Sherry Miller
Photographers:
Peter Kiar
Bill Lindhout
Bill Sharpe
Jim Ter Keurst
Kaz Tsuruta
Earl Woods
Illustrators:
Gahan Wilson
Jim Johnson
Pam Van Dyken

Brochure:
1982
Supporting New Ways
of Working
Designer:
Rob Hugel
Illustrators:
R.O. Blechman
Jan Faust

Brochure:
1962
Eames Tandem Seating
**Design Firm and
Art Direction:**
Charles and Ray Eames
Designer:
Deborah Sussman
Photographer:
Charles Eames

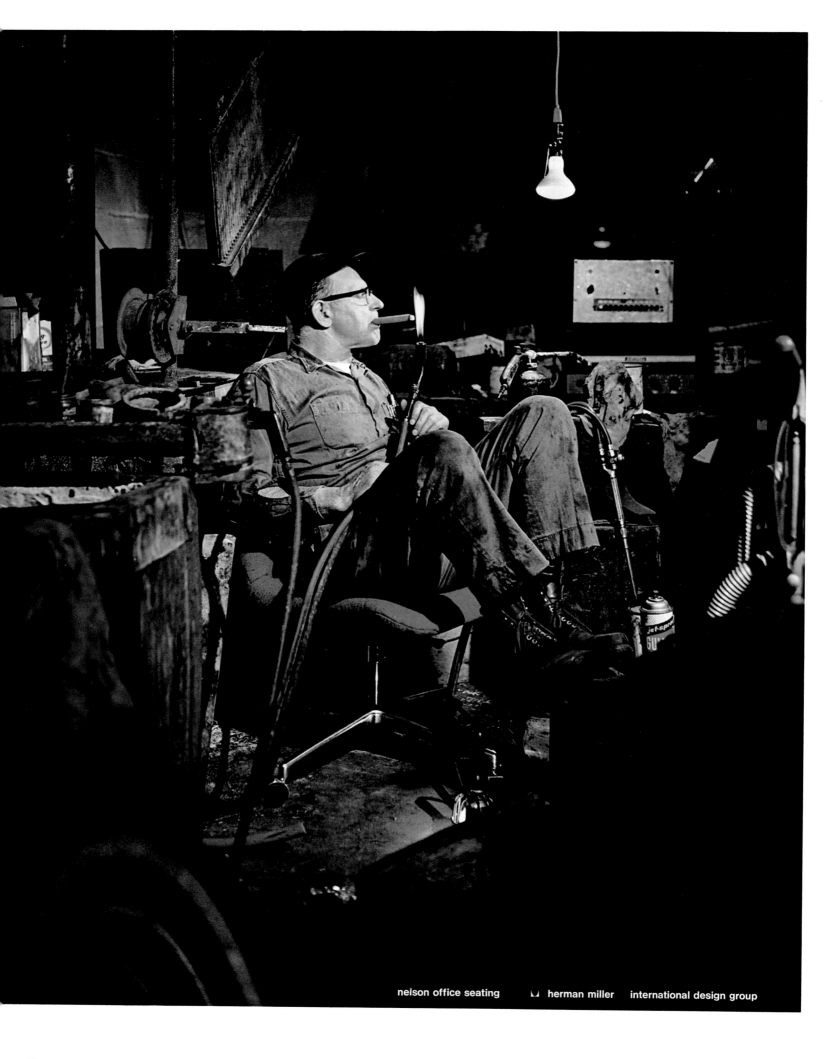

nelson office seating herman miller international design group

80

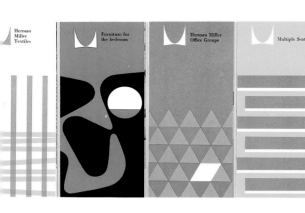 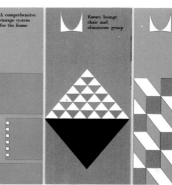

Brochures:
1960
Design Firm:
George Nelson
Associates
Designers:
Irving Harper
Don Ervin
Dick Schiffer
Anthony Zamora
Photographer:
Dale Rooks

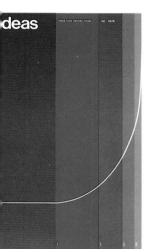 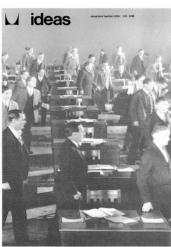

Magazine:
Ideas
1978-1981
Designer:
Linda Powell
Photographers:
Various contributors
Illustrators:
Various contributors

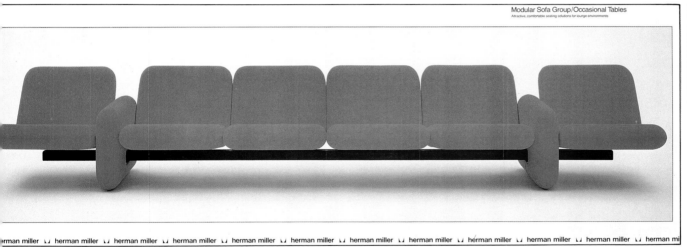

Modular Sofa Group/Occasional Tables
Attractive, comfortable seating solutions for lounge environments

herman miller ⊔ herman miller ⊔ herman miller ⊔ herman miller ⊔ herman miller ⊔ herman miller ⊔ herman miller ⊔ herman miller ⊔ herman miller ⊔ herman miller ⊔ herman miller ⊔ herman mi

Brochure Series:
1979-1982
Designers:
Stephen Frykholm
Linda Powell
Barbara Loveland
Rob Hugel
Photographers:
Earl Woods
John Boucher

ng the interior environment
Managing the work environment

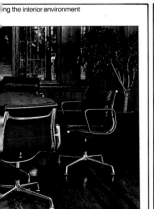 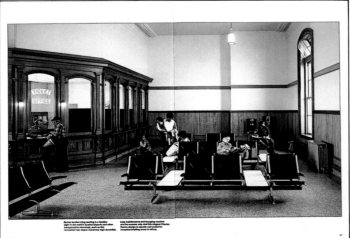 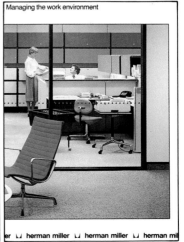

erman miller ⊔ herman miller ⊔ herman mil
er ⊔ herman miller ⊔ herman miller ⊔ herman mi

◁

Brochure/Poster:
1971
Nelson Office Seating
Designers:
Stephen Frykholm
Philip Mitchell
Photographer:
Earl Woods

Now to the first speech.

The Millwright Died.

My father is 91 years old.
He is the founder of the company,
 and much of the value system and impounded energy
of the company that sustain us today
 are a part of his contribution.
 When he was a relatively young man in industry,
the machines of most factories
were not run by electric motors as they are today,
 but were run by pulleys
 from a central drive shaft.
The central drive shaft was run by the steam engine.
 The steam engine got its steam from the boiler.
 The boiler, in our case,
 got its fuel from the sawdust
and other waste coming out of the machine room —
 a beautiful cycle.

In those days,
 one of the key persons in the company was
 the millwright.
The millwright was the person who oversaw that cycle
 and on whom
the entire activity of the operation depended.

In those days, in fact,
the millwright was more important than the designers —
 partly because we didn't know any designers.

One day the millwright died.
 This, of course,
caused an instant operational problem,
 but that is not my story.

My father, being a young manager,
 didn't particularly know what he should do
 when a key person died,
but thought he ought to go visit the family.
 He went to the house
 and was invited to join the family in the living room.
 There was some awkward conversation —
 the kind with which many of us are familiar.

Then the widow asked my father if it would be all right
 if she read aloud some poetry.
 Naturally, he agreed.
She went into another room, came back with a bound book,
 and for many minutes
read selected pieces of beautiful poetry.
 When she finished, my father commented
 on how beautiful the poetry was
and asked who wrote it.
 She replied that her husband had written it.

It is now 50 years since the millwright died,
 and my father and many of us at Herman Miller
continue to wonder:
 Did we have a poet who did millwright's work,
 or did we have a millwright who wrote poetry?

(4)

(5)

In our effort to understand corporations,
 what is it we should learn from this story?
 First of all, in addition to all of their
ratios and goals and parameters and bottom lines,
 it is fundamental that corporations
 have a concept of persons.
In our company
 this begins with an understanding of
 the diversity of people's gifts.

Understanding the diversity of our gifts
 enables us to begin taking the crucial step
of trusting each other.
 It also enables us to begin to think about
being abandoned to the strengths of others.

 The simple act of recognition
of our diversity in corporate life
 helps us to connect the great variety of gifts
that people bring to the corporation.

Recognizing diversity
 helps us to understand the needs of
 opportunity, equity, and identity
and how to fulfill these needs that we all share.
Recognizing diversity
 gives us a chance to provide
 meaning, fulfillment, and purpose,
 which are essential in corporate life.
These are not to be relegated solely to private life
 any more than are such things as love, beauty, and joy.
 It also helps us to understand that for many of us
 there is a fundamental difference
between goals and rewards.

And so — diversity is not only real in our corporate groups but,
as with the millwright, it is frequently subtle.

 Diversity is not just a fact; it is in need of nurture.

 Diversity is not just another "social given";
it is essential to our being —
 in the sense of being a corporation of people.

When we think about corporate leadership
 and the art of management,
look for a recognition and nurturing
 of the millwright-poet;
 it is what I would call
 the gift-polishing process.

(6)

(7)

GIANT TALES

Pink Ice in the Urinal

Brochure:
1984
Five speeches by
Max DePree
Designer:
Rob Hugel

"Whatever we do must be
constructively involved
with the neighbourhood
and civic community"

"The environment should
encourage fortuitous encounter
and open community"

Brochure:
1978
"A statement of
expectations"
Design Firm:
Pentagram
Designer:
Alan Fletcher
Photographer:
John Donat

Books:
1985
*Everybody's Business
The ABECEDARIAN
Office*
Design Firm:
Sara Giovanitti Design
Designer:
Sara Giovanitti
Photographers:
Enrico Ferorelli
Camille Vickers
Various contributors
Illustrators:
Alan Cober
Seymour Chwast

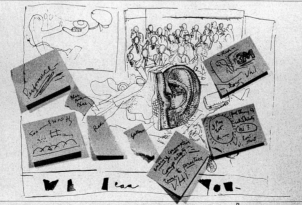

THE
ABECEDARIAN
OFFICE:
An impudent
look at
white-collar
work

HERMAN MILLER RESEARCH CORPORATION

q is for quickly,
the most popu-
lar adverb in
the office,
used mostly to answer the question
"When do you want it?" Queries
are never answered, and quarterly
reports never ready, quickly enough.
Since the supply of time has re-
mained constant and the demand
for it has increased, it's no wonder
time has gotten more valuable.

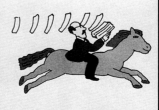

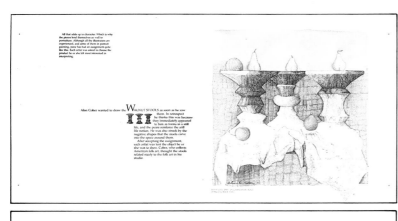

All that adds up to character. Which is why the pieces lend themselves as well to portraiture. Although all the illustrators are experienced, and some of them in portrait painting, none has had an assignment quite like this. Each artist was asked to choose the product he or she felt most interested in interpreting.

Alan Cober wanted to draw the **W**ALNUT STOOLS as soon as he saw them. In retrospect he thinks this was because they immediately appealed to him as forms in a still life notion. He was also struck by the negative shapes the stools carve into the space around them. After accepting the assignment, each artist was lent the object he or she was to draw. Cober, who collects American folk art, thought the stools related nicely to the folk art in his studio.

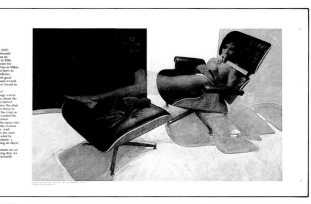

The **E**AMES LOUNGE CHAIR AND OTTOMAN has had universal recognition ever since its introduction in 1956, when it won the Triennale Prize in Milan. The chair has been so often used to connote excellence, luxury, quality, comfort and good living that, as one writer said several years ago, "it seems to have found its way into all the prestige advertisements of our lives."

Robert Heindel's challenge was to find something new to say about the chair in graphic terms. He elected to say it not by how he drew the chair but through the person he chose to put in it. Because he sees the chair as essentially masculine, he wanted the contrapuntal effect of a woman. Because the chair breaks the space into the cushioned segments, the woman also breaks at these points. And because Heindel considers the chair "classic," he has included what he considers symbols of the classic: a nose, and a clock, suggesting an object that outlasts time.

The black chair and ottoman are set among earth tones, implying that, for all its chic, this is a down-to-earth piece of furniture.

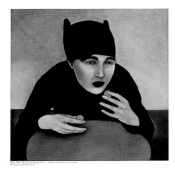

In approaching the **N**ELSON TABLES Dagmar Frinta was intrigued by the contradiction between the contoured top and the spike-like base. Her "very personal interpretation" is expressed in a painting relating the table top and base to a human top and base: her own. In this self portrait, "I tried to capture the roundness and the spikiness," she says, "rounding my shoulders and exaggerating my fingers and putting projectiles in my hat."

Why is she holding those two apricots? "Because when I held two eggs, the picture looked washed out."

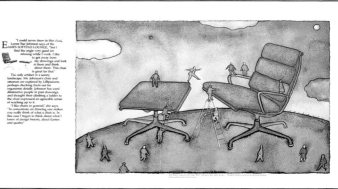

"I could never draw in this chair," Lorna Sue Johnson says of the **E**AMES SOFTPAD LOUNGE, "but I find the angle very good for relaxing while I work. I like to get away from my drawings and look at them and think about them. This chair is great for that."

The only artifacts in a sunny landscape, Ms. Johnson's chair and ottoman are explored by Lilliputians, perhaps checking them out for ergonomic details. Johnson has used diminutive people in past drawings, and thought their climbing a ladder to the chair expressed an agreeable sense of reaching up to it.

"I like chairs in general," she says. "To concentrate on drawing one makes you really think of what a chair is. In this case I began to think about what I knew of design history, about Eames and quality."

By definition, classics are not common. But furniture designed by Charles Eames is so commonly called classic that it is easy to forget that. Also by definition, classics are not new, since they must have stood the test of time to earn that designation. The **E**AMES SOFA is new. Nevertheless Fred Otnes perceives it already in the context of classical columns, and historic art.

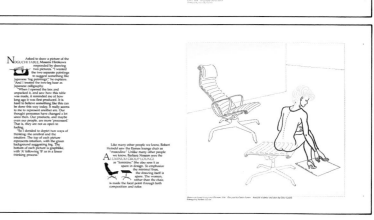

After using a scratchboard technique to scrawl the **E**AMES CHAISE diagonally across the page, Vivienne Flesher added a border of fish. Why?

"No reason. I just like fish. It could have been loaves of bread or lightbulbs."

"On second thought, I think of the chaise as flowing. Maybe that suggested water, which in turn suggested fish. But that's stretching."

Asked to draw a picture of the **N**OGUCHI TABLE, Masami Hirokawa responded by drawing two pictures. "I wanted the two separate paintings to suggest something like Japanese 'fog paintings'," he explains. "And I treated the two-leg base as Japanese calligraphy.

"When I opened the box and unpacked it, and saw how this table was made, it reminded me of how long ago it was first produced. It is hard to believe something like this can be done this way today. It really seems to me to represent another era. Our thought processes have changed a lot since then. Our products, and maybe even our people, are more 'processed.' That is, they are not as open to feeling.

"So I decided to depict two ways of thinking: the cerebral and the intuitive. The top of each picture represents intuition, with the green background suggesting fog. The bottom of each picture is graphiclike, with 'A' following 'B' as in a linear thinking process."

Like many other people we know, Robert Heindel sees the Eames lounge chair as "masculine." Unlike many other people we know, Barbara Nessim sees the **A**LUMINUM GROUP LOUNGE as "feminine." She also sees it as spare in design. To emphasize the minimal lines, the drawing itself is spare. The woman, rather than the chair, is made the focal point through both composition and color.

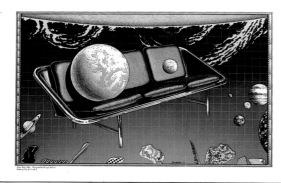

In Austin, Texas, Ed Lindlof works on a grand scale. At least that's how he saw the **N**ELSON SLING SOFA, placing it in outer space surrounded by satellites. After living with the sofa for awhile Lindlof came to regard it as compatible with many styles of interior, so he freed it from any interior context and made some map-like collages vaguely connoting several environments in which the sofa might be used.

"I saw the sofa in space as soon as I unpacked it," Lindlof says. "All I could see at first was deep black velvety leather....It looked like a black hole until I unwrapped more of it and the chrome frame emerged. But by that time I was already thinking about the atmosphere.

"When we moved it into the studio I was amazed at how heavy the piece was. It seemed unlike most contemporary furniture in its sturdiness," a feature he chose to emphasize by seating the whole earth on it.

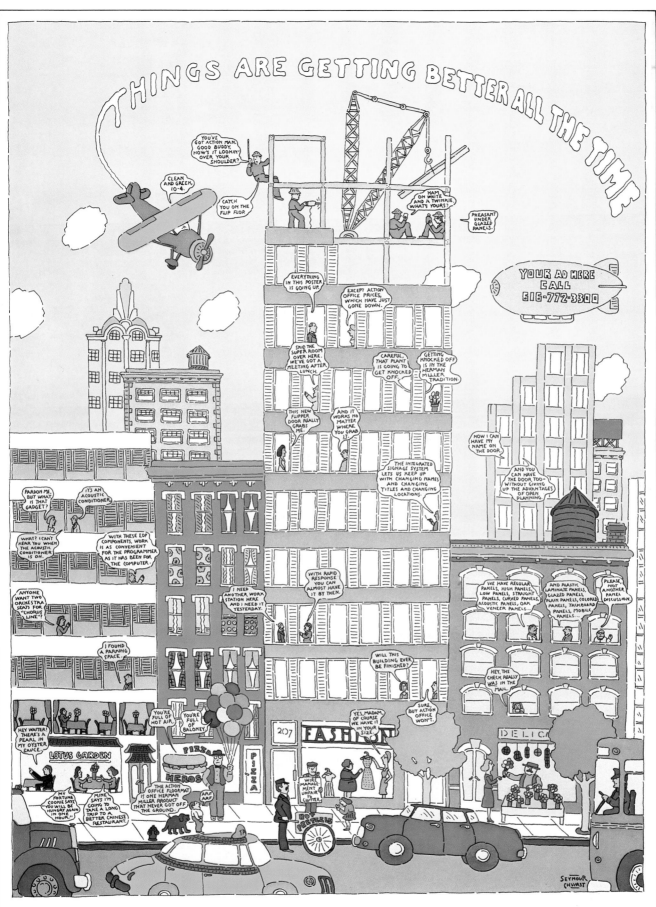

Brochure:
1984
Reference Points
Designer:
Barbara Loveland
Illustrators:
Alan Cober
Vivienne Flesher
Dagmar Frinta
Robert Heindel
Masami Hirokawa
Lonni Sue Johnson
Ed Lindlof
Barbara Nessim
Fred Otnes

Poster:
1976
Designers:
Stephen Frykholm
Ralph Caplan
Illustrator:
Seymour Chwast

Traditionally, Herman Miller is known for major design innovations, such as the 1976 Ergon® seating. But behind that tradition is one equally rich: once we make a significant contribution, we keep making it better and better. And better.

Action Office is a case in point. In 1964 we introduced that landmark system as a management planning tool adaptable to the work requirements of various kinds of people, various kinds of tasks, various kinds of organizations. In 1968 we brought out a vastly improved system, far ahead of anything the industry had ever seen or even thought of.

But we didn't stop there. Or then. Designed from the start as an open-ended system, Action Office has undergone a steady series of refinements, additions and modifications to meet new needs. Some of these product improvements, such as Super Room and Low Profile, are themselves major innovations. Others, such as the swingaway telephone stand, are modest but welcome details. And the same system is adaptable to libraries, word processing units, and technical work stations of all kinds.

By now the original Action Office has been enriched by lateral files, a sub-system of EDP components, counter caps, sound-absorbing panels, curved panels with work surfaces to fit them, door panels, acoustic conditioners, flipper doors that glide on a synchronizing mechanism, transaction counters, versatile connection hardware, deep drawers, Rapid Response service, new finishes, wire managers. . . .

The list could go on and on. And it will. Things from Herman Miller are getting better all the time.

herman miller action office

Special Citation for the
Los Angeles 1984 Olympics

The Jerde Partnership
Robert Miles Runyan & Associates
Sussman/Prejza & Co., Inc.

Chairman
David Brown
Vice President/
Communications
Champion International Corporation

Committee
Gene Federico
Vice Chairman
Lord, Geller, Federico, Einstein, Inc.

Tom Geismar
Partner
Chermayeff & Geismar Associates

John Massey
President
John Massey, Inc.

Michael Vanderbyl
Principal
Vanderbyl Design

With the decision of the Los Angeles Olympic Organizing Committee not to build new stadia, and reuse existing structures—some from the 1932 Olympiad—an enormous financial burden was lifted off its shoulders, but an equally difficult problem surfaced: the one of image. How to unify its multiple event sights and bring its aged facilities into the 1980's. And how to continue tradition, while injecting a spirit of the new. As collaborators coordinating structural and graphic design were the Los Angeles architect Jon A. Jerde (of The Jerde Partnership) and design consultants Deborah Sussman and Paul Prejza (of Sussman/Prejza & Co.). Jerde's task was to "retrofit" and facelift 28 event sights—not only bring them up to current Olympic standards, but to radically change the ambiance within a tightly proscribed budget. As creative directors of the graphic design program, Sussman/Prejza developed the unique form language for the all-important graphic displays, including buntings, banners, flags, balloons, signage, and print materials. Together they developed a "graphic architecture."

Robert Miles Runyan's dynamic "Star-in-Motion" was selected as the official logo of the Olympics in a competition in 1980. It was used to great effect in promoting both the Olympics and the products of Olympic sponsors during that time preceding the games. It was also incorporated into the "look" of the Olympics while the games were in progress.

Given the Olympiad's history, the results were delightfully unpredictable. Exit the mythic heroicism of the past, and enter the lively fairgrounds ambiance, so emblematic of the southern California spirit. Even the once-sanctified medalists' pedestals were washed in vibrant colors and stenciled with modern type. One critic likened it to the look of a medieval jousting tournament. Another said with the playful confluence of modern and classical design elements, it was a postmodern Disneyland. Ultimately, though, it was a tribute to that old idea of form following function.

Even the most ephemeral design provided a three-part service—to unify, inform and entertain. Because of the temporary nature of the games, it was necessary to create "an overlay of festivity" that could eventually be dismantled. Toward this end, the design team developed a "kit of parts" that was easily applied to any need. Movable and erectable items such as scaffolding, tents and *Sonotubes* could be transformed into gateways, towers, and booths. Directional signs and landmarks were created for ritual spaces. Color was the key to success, with vibrant pastels and lighter 'Mediterranean' colors wed in infinite geometries, transforming, as if by magic, the otherwise stolid environment. For home viewers, the pageant of color made the TV screen glow, contributing to a nationwide party mood.

Its designers dubbed it "Festive Federalism." Its admirers called it a carnival atmosphere. And, the AIGA, by bestowing this special award to the 1984 Olympics for graphic achievement, concurs that it was the most inventive design program of the year. Indeed, it brightened the landscape, heated the summer, enhanced the games, and exemplified the infinite possibilities of graphic design.

Olympic Medal
Design:
Dugald Stermer

*Photography directed by
Annette Del Zoppo for
top illustrations on
pages 90 and 91 and
all illustrations on
pages 92 through 95.
Photographers include:
Beck & Graboski,
Annette Del Zoppo, Ave
Pildas, Marvin Rand,
Jim Simmons, Steve
Slocomb, Rick Steadry,
and Tim Street-Porter.*

Horizontal Olympic poster
Design:
Robert Miles Runyan &
Associates

Design Guide for the 1984
Summer Olympics
Art Director:
Deborah Sussman
Designer:
Debra Valencia

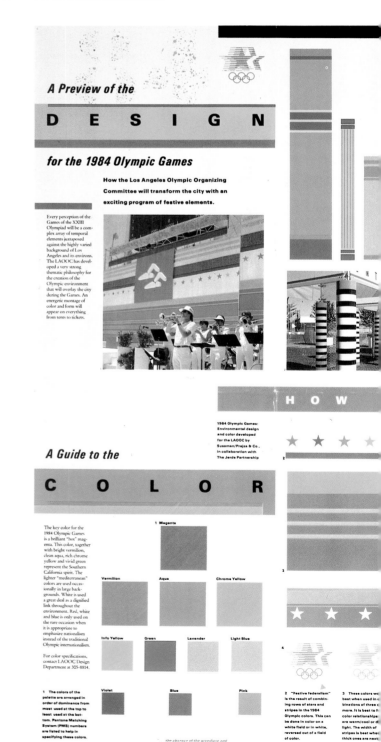

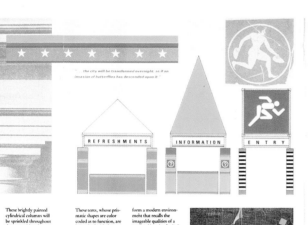

"the city will be transformed overnight, as if an invasion of butterflies has descended upon it."

REFRESHMENTS INFORMATION ENTRY

These brightly painted cylindrical columns will be sprinkled throughout the competition sites. Bands of brilliant color combined in different ways produce their playful quality.

These tents, whose prismatic shapes are color coded as to function, are intermixed with the other design elements to form a modern environment that recalls the imageable qualities of a medieval jousting festival.

Painted scaffold assemblies will be enriched with color and graphics to form monumental gateways, towers and walls.

VIP RECEPTION

2

The association of bunting with stadia is a long-standing one. A carefully chosen set of colors, not associated with any one country, has been developed in miles of fabric and paper that will ring the fields of play.

"A city that has both Whittier Boulevard and Rodeo Drive ought to be able to do a hell of a decorating job."

All these elements and more not shown here are designed and brought together with a spirited attitude we have dubbed "festive federalism"— that is, an absolute celebration of the festive qualities of the Games coupled with a design palette that is very American in its conception, yet intriguingly international in its imagery.

It's not just the colors themselves, but how they're used.

The kids wore red, white and blue but oh, the confetti.

HOW NOT TO

OLYMPIC SPIRIT TEAM

These design concepts presented here are for informational purposes, not for reproduction.

$¥ fr£

XXIII
© 1983 LA Olympic Organizing Committee
Olympic Arts Festival Los Angeles 1984

1984
XXIIIrd Olympiad

↑ Main Gate
Ticket Sales
Information

ABCDEFGHIJKLMNOPQRSTUVWXYZ
abcdefghijklmnopqrstuvwxyz1234567
890?%,.:;!

ABCDEFGHIJKLMNOPQRSTUVWX
YZabcdefghijklmnopqrstuvwxyz12
3456789012 ...'

ABCDEFGHIJKLMNOPQRSTUV
WXYZabcdefghijklmnopqrstuv
wxyz1234567

Message Center

4 The Star-in-Motion may appear in any of the 1984 Olympic colors or white on a strong color in addition to the red, white and blue scheme.

5 When enlarged, the Star-in-Motion creates a strong graphic pattern. These uses include the copyright and trademark designations.
Original Star-in-Motion design by Robert Miles Runyan & Assoc.

6 When used officially, sports pictograms and symbol signs will always appear in white on a magenta field. The magenta pictogram may also be combined with an additional field of color such as yellow.

7 The dominant typeface is the Univers Series. Univers 56 (italic) is used in conjunction with official LAOOC marks. Univers 67 (regular) is used for general signage and headline needs, while Univers 68 (italic) is used as a supplement. The Garamond Type family is used when a classic face is more appropriate, as in text.

8 Typography appears flush left in upper and lower case and can easily be combined with the "festive" stars and stripes.

9 The "festive federal" colors and elements such as stars, stripes, confetti, spray and abstracted Star-in-Motion pattern have been adapted for multiple uses.

10 Do not use red, white, and blue as a decorative color scheme The Star-in-Motion in red, white, and blue should always be used small and in a dignified manner.

11 Do not use light and dark combinations of the same color or the colors in a "rainbow" arrangement. When using stripes, do not make them all the same width.

Contributors to the design program:
Pictograms:
Keith Bright & Assoc.
Printed Graphics:
Arnold Schwartzman
Jerlin Design
Robert Design Assoc., Inc.
Franz Furnbau
Torch:
Another Design Sanchez
Scofield Design
John Aleksich & Assoc.

Photography:
Annette Del Zoppo
Steve Smith (P. 12)
Tim Street-Porter (L 11)
The Deluxe Watson Collection (8)

Design Guide Poster:
Saussman Prensa & Co., Inc.
Debra Valencia
Printing:
Sales Corporation of America
Southern California Office
Stanton, California 95402

One in series of signs for variety stores at UCLA Village
Design:
Sussman/Prejza & Co.

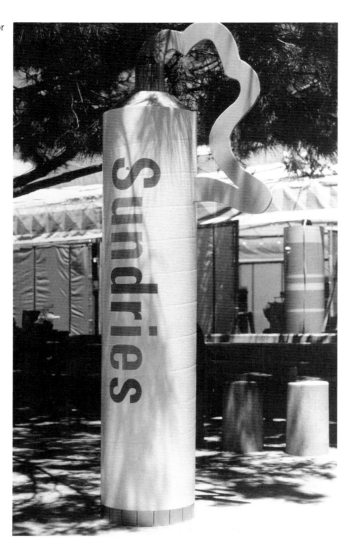

Page from Olympic Graphics Manual
Design:
Robert Miles Runyan & Associates

Graphic Standards　　　　*Los Angeles*　　　　*1984 Olympic Games*

ⓒ 1980 L.A. Olympic Committee　　　　　　　TM

Legal Markings
Star in Motion

A copyright line and trademark symbol must appear on every item or printed material on which the Star in Motion is reproduced.

The copyright line must appear below the Stars, to the left. It should read in one of the following fashions, depending on available space:

ⓒ 1980 Los Angeles (or L.A.) Olympic Organizing Committee
ⓒ 1980 Los Angeles (or L.A.) Olympic Committee
ⓒ 1980 L.A. Oly. Org. Com.
ⓒ 1980 L.A. Oly. Com.

Section 2

The trademark symbol appears to the right, under the Stars, and is presently "TM". As the Star in Motion is registered by LAOOC Corporate Sponsors in appropriate classifications in various jurisdictions, LAOOC will so advise, and an ® must replace the TM for uses in such jurisdictions.

The Olympic rings appear below the Stars and the legal markings. The Star in Motion symbol is reproduced above in a legally correct manner.

When the Star in Motion is reproduced on a useful article, i.e., neckties, scarves, mugs, t-shirts, hats, etc., the year—1980—may be omitted, but all other information must remain.

If placement of the Star in Motion on a useful article (outlined above) does not permit a legible reproduction of the legal copyright and trademark symbols, this information must appear on another visible portion of the article. Some examples of this placement include:

Hats or t-shirts: legal markings and information can be placed on a permanent tag visible on the hat band or inside on the neck portion of the t-shirt.

Mugs, cups, plates: on the bottom portion.

90

Pictogram cube at
Volleyball
Design:
Sussman/Prejza & Co.
Pictogram:
Bright and Associates

Olympic tickets
Design:
Robert Miles Runyan &
Associates

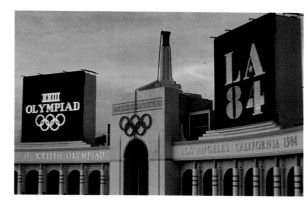

Gateway to Exposition Park
Design:
Sussman/Prejza & Co.
Archisystems

Coliseum Peristyle
Design:
Sussman/Prejza & Co.
The Jerde Partnership

Detail of Exposition Park Tower
Design:
Sussman/Prejza & Co.
Archisystems

Arts Festival—Fisher Art Gallery, USC
Design:
Sussman/Prejza & Co.

Flag ceiling and shade structure at Shooting
Design:
Victor Schumacher and Associates
Sussman/Prejza & Co.
The Jerde Partnership

Arts Festival—Entrance to the Los Angeles County Museum of Natural History
Design:
Sussman/Prejza & Co.

Colonnade and high fence at Boxing
Design:
Sussman/Prejza & Co.

Entrance to preliminary Fencing area
Design:
Sussman/Prejza & Co.

Gymnast's bridge in UCLA Village
Bridge:
The Jerde Partnership
Graphics and Color:
Sussman/Prejza & Co.

Volunteers at Gymnastics
Design:
Sussman/Prejza & Co.
Uniforms:
Levi Strauss & Co.
Albert Wolsky, Consultant

Entrance to Archery
Design:
Sussman/Prejza & Co.
The Jerde Partnership
Scaffolding:
John Aleksich

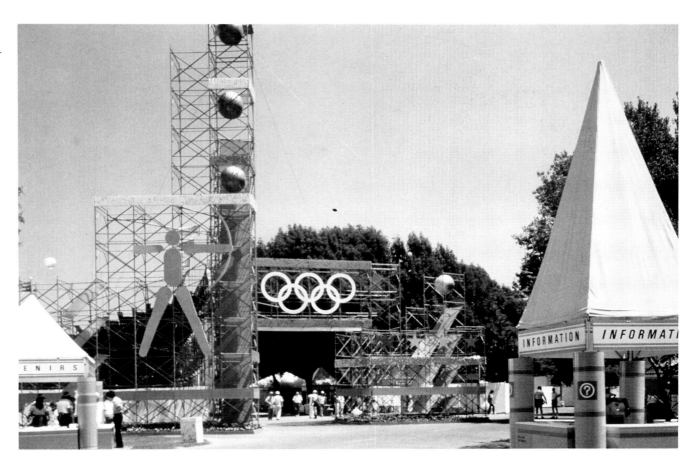

Colonnade approach to Archery
Design:
Sussman/Prejza & Co.
Beck and Graboski

Entrance to Shooting
Design:
Victor Schumacher
Associates
Sussman/Prejza & Co.

Entrance to Swimming
Design:
The Jerde Partnership
Sussman/Prejza & Co.
Daniel Benjamin

The American
Institute
of Graphic
Arts
Communication
Graphics
1984-1985

Communication Graphics

Communication Graphics lays the groundwork for future historiography, while it also serves as a creative resource for today's practitioners. In this regard, it is a Darwinian competition: natural selection always occurs in which the *best* survive.

Call for Entry:
Communication Graphics
Designer:
Bruce Blackburn
Typographer
CT Typografix, Inc.
Printer:
Stephenson, Inc.
Paper:
Mead Paper

Chairman
Bruce Blackburn
Principal
Danne & Blackburn, Inc.

Jury
Cipe Pineles Burtin
Director of Publication Design
Parsons School of Design

Roger Cook
President
Cook and Shanosky Associates, Inc.

Joseph Michael Essex
Vice President/
Director of Visual Communications
Burson-Marsteller

Peter Good
Principal
Peter Good Graphic Design

Ron Sullivan
President
Sullivan Perkins

Deborah Sussman
President
Sussman/Prejza & Co., Inc.

Communication Graphics is a show of shows—a survey of the most significant styles, trends and inventions in print and three-dimensional graphic design produced during the past year. Though quantitatively limited, the work reflects a pervasive design awareness throughout American business, and suggests that more professionals are entering the field than ever before, in virtually all of the United States.

Once called "Design and Printing for Commerce," the original intent of the show's organizers was to survey and celebrate the various business-oriented design accomplishments (including advertising) with heavy emphasis on printing quality. Today this is not simply a business for business show. It was renamed Communication Graphics 18 years ago in response to the increasingly active role of graphic designers in corporate and institutional life, whose aesthetic requirements, in contrast to the earlier printing shows, differ considerably. Over the years, it has become *the* arena in which designers can strut what's best of that ofttimes anonymous stuff, which comprises the proudest output of creative graphic endeavor. Hence, if we accept that the purpose of all graphic design is to communicate, this show could more aptly be called "Design for Designers."

In the past, CG has been criticized as being a potpourri of visual ephemera, a catchall for those high-budgeted or otherwise unconstricted pieces that have no place under the guidelines of the more specialized shows. Moreover, it has been argued repeatedly that to judge annual reports, for example, in the same show as birth announcements (although they are judged in separate categories) trivializes the former and elevates the latter. However, based on the unprecedented number of entries—over 5000 received this year—it appears that despite the clamour of the critics, designers from across the nation believe that this is a forum in which to see and be seen; its virtue is that we *are* speaking to ourselves. Ultimately, the salutory response from peers is a great motivating force.

Additionally, CG provides other long and short term benefits for the designer, teacher and historian alike. Since the purpose is to celebrate excellence, CG lays the groundwork for future historiography, while it also serves as a creative resource for today's practitioners. In this regard, CG is a Darwinian competition: natural selection always occurs in which the *best* survive. Repetitive methodologies are severely judged, and new approaches invariably replace tired practices. Hence, by leafing through the past five Annuals, one can track the ebb and flow of waves, the growth and decline of movements, and the popularity of certain conceits. Moreover, CG invariably recognizes the work of creative individuals, measuring consistent development against standstill procedure. As Bruce Blackburn, principal of Danne and Blackburn and chairman of the show states: "CG is a collection of beautiful opportunities that represents a reach beyond to the highest level of problem solving."

To fairly judge this range of material is difficult at best, and this year, because of the extraordinarily high number of entries, selection was made even more arduous, taking three full days. Curiously, though, about the same 3.8 percent ratio of inclusions to submissions as last year remained.

The material is divided and initially scrutinized in distinct categories (i.e., annual reports, catalogues, promotion, etc.), so that annual reports are not, in fact, competing with birth announcements. However, Blackburn admits, "This is the only show where, in the final analysis, a business card is given the same *attention* as a package design or catalogue. Because what is being judged is surface quality—whether it is well designed, regardless of the specific problem."

Does this suggest that jury members concurred on the sphinxlike riddle of "What is good design?" Apparently not. "The jurors (representing a broad spectrum of interests and endeavor) were independent," continues Blackburn. "Nobody jumped on a bandwagon, and few things received the full seven votes." However, a consensus of choices emerged that addressed and pinpointed the following issues: current hotbeds of American design; stylistic and technological directions; and inventiveness or lack of it during the calendar year. And, of course, through the sin (or virtue) of omission, former trends are desanctified. "Regardless of who's on the jury, the show has its own momentum," says Blackburn, "which causes a singling out of those styles or approaches that are just beginning to make a mark."

One wonders, though, if the CG judgement results also have negative effects. If this show influences direction, doesn't it help to stylistically flood the market as well? The chicken versus the egg dilemma may best be answered by analyzing the developments past and present. In previous shows, the "new wave" vocabulary was ubiquitous, while this year the most obvious *reaction* is a rejection of Constructivist derivation and the conceit sometimes known as the "circle, dot and arc school." Austere, Swiss-influenced design is also minimal, and new-Bauhaus is gone. "There are no distinct directions except to say that more is more," responds Blackburn. "The majority of pieces chosen suggest that, if the designers had eight cylinders to work with, they used them all."

Printing quality is high, as usual, with an apparent trend toward multiple, glossy varnishes in evidence —so striking that the viewer could be blinded by the glare. However, the virtues of a few unslick, low-budget items did not go unsung: the La Jolla Playhouse was one such strikingly conceived newsprint item.

In the race to the top, the collective Herculean design achievements of the 1984 Olympics swept up the accolades. "In terms of CG charting future directions," says Blackburn, "the excellent example of Olympics design might influence other sports

impresarios to improve their graphics." Other leaders in the current field include The Good Earth Brand Bill of Fare, The Town Club, The MCI Annual Report, Times Mirror Annual Report, The Formica (Sample Box) and the Herring Group brochure. In each case, the unique problems were solved differently all along the line—from type to illustration to printing, there were no trends here. Yet, the common thread is that each has an understanding of the client's needs and an inventiveness in serving same. "While the credit goes to the good designers," says Blackburn, "even more importantly, we must thank the good clients."

Eighteen states and Canada are represented. Some designers quite familiar to past CG shows are again included: others equally well-known are noticeably absent. Ultimately, the show is underscored by tough standards that reject a cult of personality, and, as the low percentage of acceptances to entries suggests, CG is a tough gauntlet to pierce.

Poster:
Infoworks
Designers:
Woody Pirtle
Illustrators:
Woody Pirtle
Jeff Weithman
Design Firm:
Pirtle Design
Dallas, TX
Client:
Dallas Market Center
Typographer:
Southwestern
Typographics
Printer:
Harvey Du Priest

InfoWorks

Information that Works...
Design, Technology and Productivity

ARCHIFÊTE

la CÉLÉBRATION POPULAIRE DE L'ARCHITECTURE AU QUÉBEC

84

26 MAI - **2** JUIN

Poster:
Archifête 84
Designer:
Danielle Roy
Design Firm:
Danielle Roy Design
et Communication
Montreal, CAN
Client:
Corporation de l'Archifête
Typographer:
M&H Ltee.
Printer:
Atelier des Sourds

Inauguration officielle
à Québec

Grande fête d'ouverture
à Montréal
Le pique-nique des bâtisseurs
Concours Architecture en reliefs
Concours d'ornement pour
les enfants
Théâtre pour les enfants
(Fondation Girardin-Vaillancourt)

Architours
Montréal, cité financière
Les beaux ensembles ruraux
Dix belles demeures de Montréal
Québec, toutes portes ouvertes
Rallye architectural piétonnier
Beauport et l'île d'Orléans .
Trois-Rivières, la ville et ses
quartiers

Festival de films d'architecture

Cliniques d'architecture

Expositions
Montréal, ville d'ornements
Les 105 musées d'art
contemporain de Montréal
Nouvelles habitations
Architectures de terre
Gustave Eiffel et son temps
Architectures en France:
modernité et post-modernité
(Octobre)
Trois-Rivières, bâtie et à bâtir
L'architecte à l'oeuvre

Conférences publiques

Colloques

Débat public sur l'habitation

Forum 84
Ordre des architectes
du Québec

Renseignements
Montréal
(514) 288-1983

Québec
(418) 667-9147

Trois-Rivières
(819) 378-6131

Chicoutimi/Jonquière
(418) 545-7358

Sherbrooke
(819) 562-1270

Un événement parrainé
par l'Ordre des architectes
du Québec, conçu et réalisé par
La Corporation de l'Archifête
3666, boul. St-Laurent, Montréal,
Québec, H2X 2V4

Conception graphique
Danielle Roy Beaudoin

Exhibition Catalogue
Mark Lere, New and
Selected Work
Designers:
Laura Haycock
Tom Kienberger
Artist:
Mark Lere
Design Firm:
Haycock Kienberger
Design Office
Los Angeles, CA
Client:
The Museum of
Contemporary Art,
Los Angeles
Printer:
Castle Press

Essays by Frances Colpitt and Kerry Brougher
The Museum of Contemporary Art, Los Angeles

MARK LERE

New and Selected Work

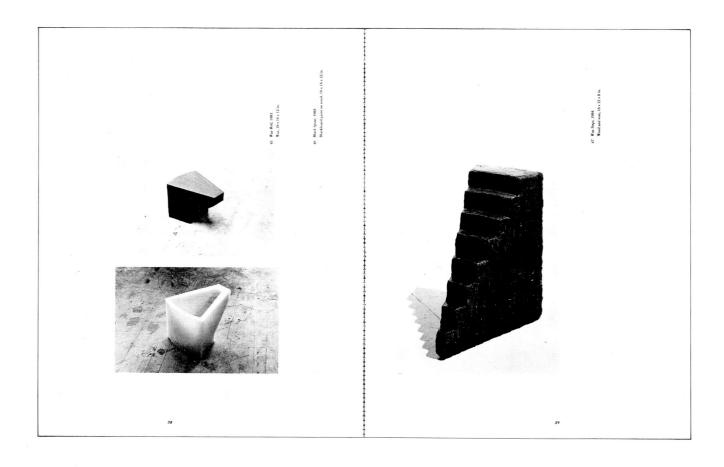

45 *Wax Wall*, 1983
Wax, 18 × 16 × 12 in.

46 *Black Spout*, 1983
Blackboard paint on wood, 16 × 16 × 12 in.

47 *Wax Steps*, 1984
Wood and wax, 16 × 12 × 8 in.

38

39

Poster:
Museum of Transportation
Art Director:
Frank Glickman
Designer:
Patrick Blackwell
Artist:
Patrick Blackwell
Design Firm:
Frank Glickman, Inc.
Boston, MA
Publisher:
The Mall at
Chestnut Hill
Typographer:
Typographic House
Printer:
Artco Offset

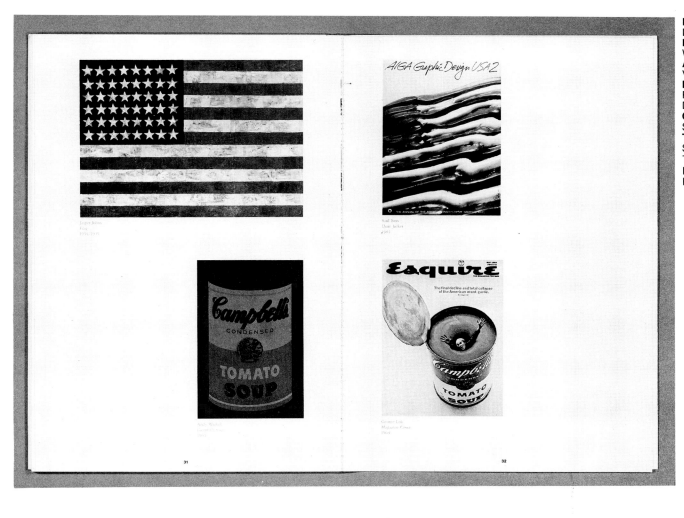

Brochure:
Dimensions 84
Designer:
Woody Pirtle
Artists:
Various
Design Firm:
Pirtle Design
Dallas, TX
Client:
Simpson Paper Co.
Typographer:
Southwestern
Typographics
Printer:
Heritage Press

Booklet:
The Barney Schools
Designer:
Dennis Russo
Design Firm:
Wondriska Assoc.
Farmington, CT
Client:
University of Hartford
The Barney Schools
Typographer:
Eastern Typesetting Co.
Printer:
Allied Printing Services

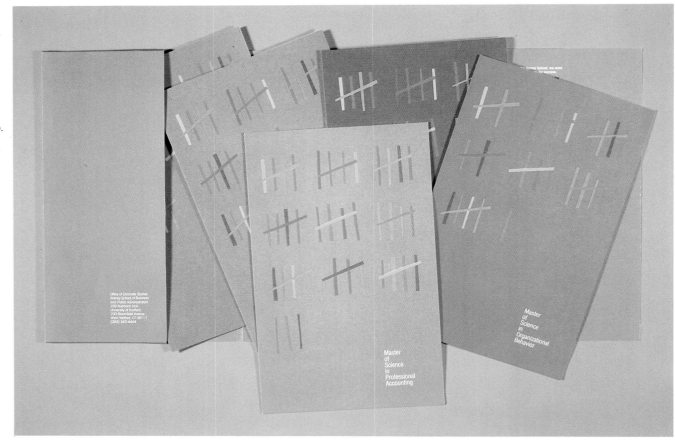

Brochure:
ISC Pinnacle(TM)
Terminal System
Art Director:
Jerry Leonhart
Designer:
Nicolas Sidjakov
Illustrators:
David Stevenson
Nicolas Sidjakov
Photographer:
Nicolay Zurek
Design Firm:
Sidjakov Berman &
Gomez
San Francisco, CA
Agency:
Livingston/Sirutis
Advertising
Client:
ISC Systems Corp.
Printer:
George Rice & Sons

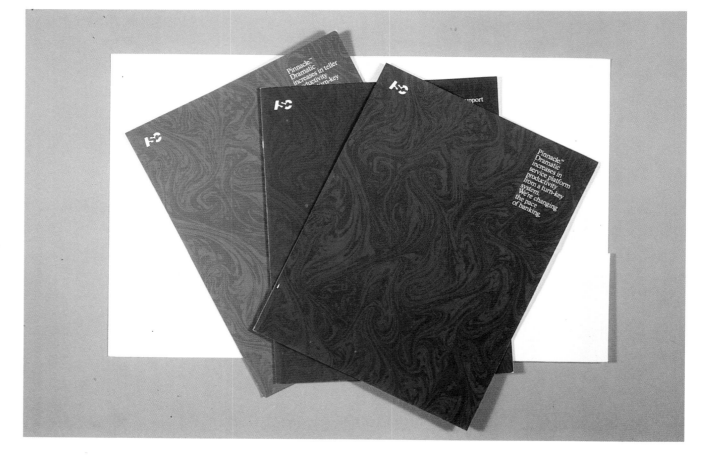

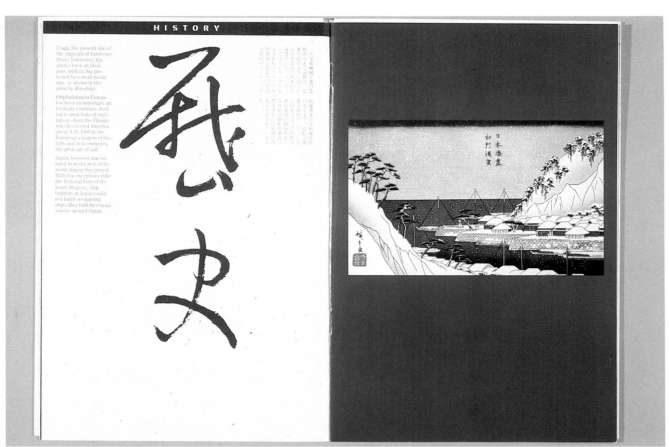

Booklet:
Nippon Maru
Art Director/Designer:
Martin B. Pedersen
Design Firm:
Jonson Pedersen
Hinrichs & Shakery
New York, NY
Client:
IBM World Trade
Typographers:
Boro Typographers
Printer:
George Rice & Sons

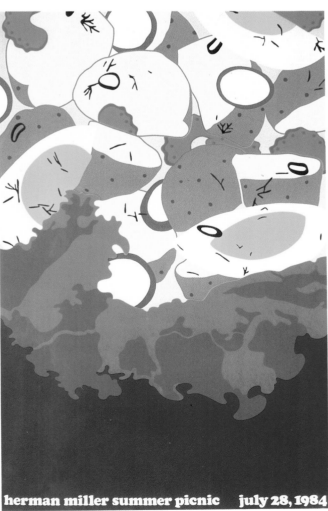

Brochure:
Chambray Animals
Art Directors:
Martin B. Pedersen
Adrian Pulfer
Designer:
Adrian Pulfer
Design Firm:
Jonson Pedersen
Hinrichs & Shakery
New York, NY
Client:
Georgia-Pacific Corp./
Hopper Papers
Typographer:
Boro Typographers
Printer:
L. P. Thebault Co.

Poster:
1984 Herman Miller
Summer Picnic
Designer:
Stephen Frykholm
Design Firms:
Corporate
Communications
Design & Development
Herman Miller, Inc.
Zeeland, MI
Client:
Herman Miller, Inc.
Typographer:
Type House, Inc.
Printer:
Continental Identification
Products

Public Service Newsletter:
Zoo Quarterly
Art Director:
Lowell Williams
Designers:
Lowell Williams
Lana Rigsby
Bill Carson
Denise Pollack
Artists:
Various
Photographer:
Michael Bowerman
Design Firm:
Lowell Williams Design
Houston, TX
Client:
Zoological Society
of Houston
Typographer:
Typeworks, Inc.
Printer:
Handi-Ad Printing

TO BREED
OR NOT TO BREED

By Rhona Schwartz

With all the emphasis placed on obtaining rare animals and the breath-holding that occurs when an especially extraordinary or long-barren creature finally shows signs of *maybe* being pregnant, one overlooked but very important job is keeping certain animals from breeding.

The head of the Houston Zoo's Research Department, Dr. Terry Blasdel, spends much of her time working on just that problem. For example, there is no demand among zoos for tigers and lions, due to the fact that the extent of their breeding far outweighs the ability to properly house them. Therefore, zoos take great pains to keep the existing populations from breeding. Males are given vasectomies in some cases; in others the males and females are separated. Other animals, such as the bears, are given hormone implants to stop their reproductive cycles.

An animal kept on contraception too long may encounter problems in the reproductive system, Blasdel says, which ultimately may make the animal unable to reproduce at all once the implant is removed. Therefore, she adds, further research into this type of animal management is necessary, as is finding other means of birth control which will enable animals to return to a normal reproductive state.

Embryo implants are one area under Blasdel's scrutiny. "I see this as an ultimate goal for, say, clouded leopards," she says. "The males kill the females in captivity. In the wild they are solitary animals which get together only when they breed. With breeding [in captivity] you have to make the conditions the way they are in the wild."

Zoos are, according to Blasdel, experimenting with all sorts of ways to simulate conditions in the wild. Houston's white rhinos are posing a particularly interesting problem.

"White rhinos are the social ones," Blasdel explains. "Unlike black rhinos they like having other rhinos around while mating. In Japan they concocted a papier-maché rhino for their pair, but I don't know if it resulted in calves.

"The pair here have never been bred. I sprinkled feces and urine from another zoo in their pen [to create the aura of nearby rhinos] but that didn't work. But just because it didn't work the first time doesn't mean it won't another time. I have been collecting urine from the female to watch her cycle. Some zoos have put black and white rhinos together, but we don't have any [black rhinos]."

Blasdel says that the trend in zoos today is toward a more cooperative effort among the different facilities. "Zoos try to get animals to the best place for them to reproduce. There is a greater effort to shift them around." For example, polar bears have been taken out of the Southwest and placed in a cooler climate. One lesson learned at the Houston Zoo is to leave animals alone if they're breeding. "The St. Vincent parrots were moved to new, bigger facilities and they didn't breed," Blasdel says. "We don't understand these environmental triggers."

Sometimes a little environmental manipulation is in order to set the scene for breeding. In the Reptile House, Blasdel explains, snakes are put in a hibernaculum (a room whose temperature is kept at about 55 degrees Fahrenheit) so that they will hibernate and, hopefully after about three months, be ready to breed. Amphibians and Houston toads are rained upon to simulate conditions in the wild and get them in an amorous mood. One drawback to these procedures is that the animals can get pneumonia from too much of a good thing.

Each species of birds has a maximum period of exposure to daylight which gets their motors running. Starting in about February this exposure can be increased for 15 minutes each day, thus making the birds think that it is spring, when in reality it is still winter. How long certain birds are exposed to more light and the time increments involved depends on the species, Blasdel says, adding that the problem with using this method at Houston's zoo is that there are mixed species exhibits.

Monitoring animals closely can reveal a wealth of information. After taking serum from elephants for the last three years Blasdel can, by checking weekly blood samples, tell if an elephant is cycling, where in the cycle she is and if she is pregnant. And because of her painstaking records, anyone wishing to do a retrospective has the data with which to work. "Through keeping track of pulse rates and blood counts we're adding information to the baseline," she says.

Blasdel, who is involved in a number of artificial insemination studies, says the zoo has successfully used this procedure on snakes. Other on-going research projects include treating monkeys with diabetes (they respond as humans do), a condition which Blasdel says can be found in monkeys in the wild. One reason there are so many diabetic primates here is that many of them are geriatric.

The older one gets, Blasdel points out, the more one becomes susceptible to diabetes.

Blasdel is also studying the Red Birds of Paradise, which die of a rare disease caused by an accumulation of iron in the liver. "The birds are gone but we have the livers," she says.

A 1980 graduate of Texas A&M's veterinary school, Blasdel first worked as the zoo's relief veterinarian for three months. The research department position was vacant for two and a half years before she took over. "I still do certain clinical things and techniques," she says. "And I have more time now for pathology, which I like."

Asked what else she enjoys about her job, the West Texas native thinks for a moment and says, "The beautiful setting and working with exotic animals. I have always wanted to do this." ■

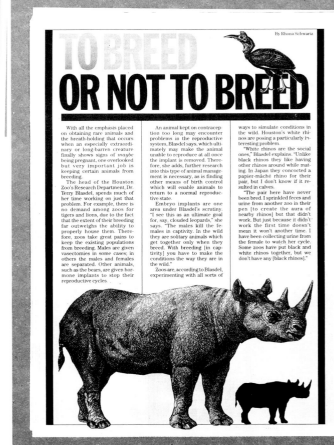

Invitation:
The Princess and
The Baker
Art Directors:
Dick Mitchell
Chris Rovillo
Danny Kamerath
Designer:
Robin Ayres
Artist:
Robert Forsbach
Design Firm:
Richards Brock Miller
Mitchell & Assoc.
Dallas, TX
Client:
The Women's Auxiliary
of The March of Dimes
Birth Defects Foundation
Typographer:
Chiles & Chiles
Printer:
Darrell Wood/
Heritage Press

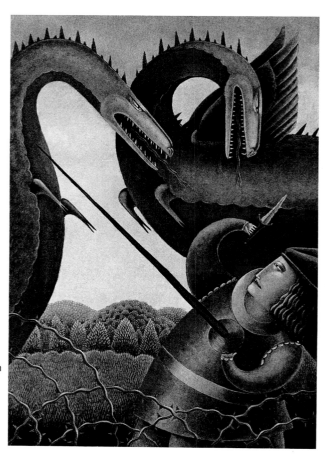

"The King is in good spirits tonight."

"Yes," the Princess smiled, "He's been looking forward to your dessert." Then Paul would smile, for they had the same conversation every week.

"Nonsense," he contradicted lightly, "it's your presence that cheers him so."

"How kind, but I know my Father. Every Thursday, you are all he thinks about."

"Thank you for saying so, Princess. I hope you enjoy it."

"I'm sure I will. Good evening, Paul."

"Good evening, Princess."

At that Paul would turn away, overjoyed at this brief moment with the Princess. And she, in turn, looked sweetly upon him as he joined the King in cutting the night's dessert.

Now, the Princess was very beautiful. Black flashing hair and opaline skin. And cherry lips that easily leaped into a smile or laughter. Everyone said that she was a sweet tempered girl, but neither was she anyone's fool.

The practical young Princess refused to marry.

And that, in a word, made the King furious. Her maidenhood wasn't for lack of suitors. On the contrary, they came from all over the land. Hundreds of them. Daily. And to each proposal she had the same answer: "No, thank you."

The reason the King was so angry was that the suitors simply cluttered up the Palace. They hung about the Princess' Chambers. Loitered in the Palace Gardens. Dawdled in the Royal Lobby. Everywhere he turned the King was tripping over some young puppy with a paw full of roses. And, what's worse, he had to listen to them prattle on about themselves at dinner. Jousting in Spain, battles in Asia and, of course, they had all slaughtered several dragons and assorted deadly beasts. Really! Hardly the subject for supper! It quite gave the King indigestion.

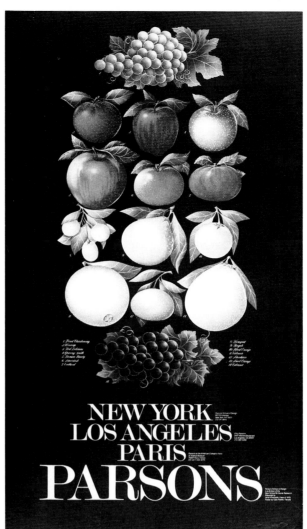

Stationery:
C. Vee Woodworking, Inc.
Art Director:
Michael R. Abramson
Designers:
Michael R. Abramson
Claire Hess
Photographer:
Amos Chan
Design Firm:
Michael R. Abramson +
Assoc.
New York, NY
Client:
C. Vee Woodworking, Inc.
Typographer:
Concept Typographic
Services, Inc.
Printer:
Thorner Sidney Printing

Poster:
Parsons:
New York,
Los Angeles, Paris
Designer:
Cipe Pineles
Artist:
Janet Amendola
Design Firm:
Parsons Publication
Design
New York, NY
Client:
Parsons School of Design
Typographer:
Tom Carnase
Printer:
Robert Greene/
Conceptual
Litho Reproductions

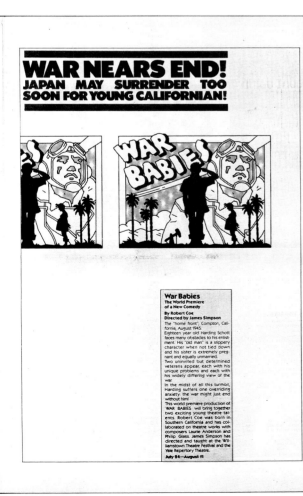

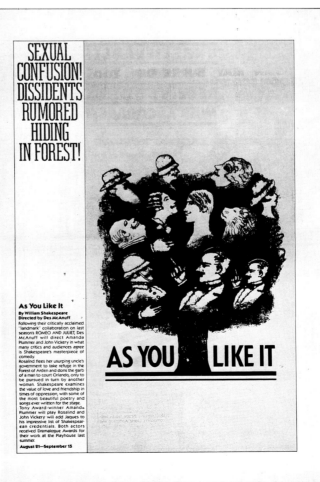

Brochure:
La Jolla Playhouse
2nd Season
Art Directors:
Doug Johnson
Anne Leigh
Designers:
Doug Johnson
Anne Leigh
Artist:
Doug Johnson
Design Firm:
Performing Dogs
New York, NY
Client:
La Jolla Playhouse

Brochure:
Fidelity Capital
Corporation
Designers:
Chris Hill
Joe Rattan
Photographer:
Mike Schneps
Design Firm:
The Hill Group
Houston, TX
Client:
Fidelity Capital Corp.
Printer:
Heritage Press

Invitational Item:
While you're in Atlanta…
Art Director:
Jack Anderson
Designers:
John Hornall
Jack Anderson
Cliff Chung
Design Firm:
Hornall Anderson
Design Works
Seattle, WA
Client:
Weyerhaeuser
Typographer:
Type Gallery

Promotional Folder:
Tools for Living
Art Director:
Martin B. Pedersen
Designer:
Adrian Pulfer
Artist:
Daniel Pelavin
Design Firm:
Jonson Pedersen
Hinrichs & Shakery
New York, NY
Client:
Tools for Living
Printer:
L. P. Thebault Co.

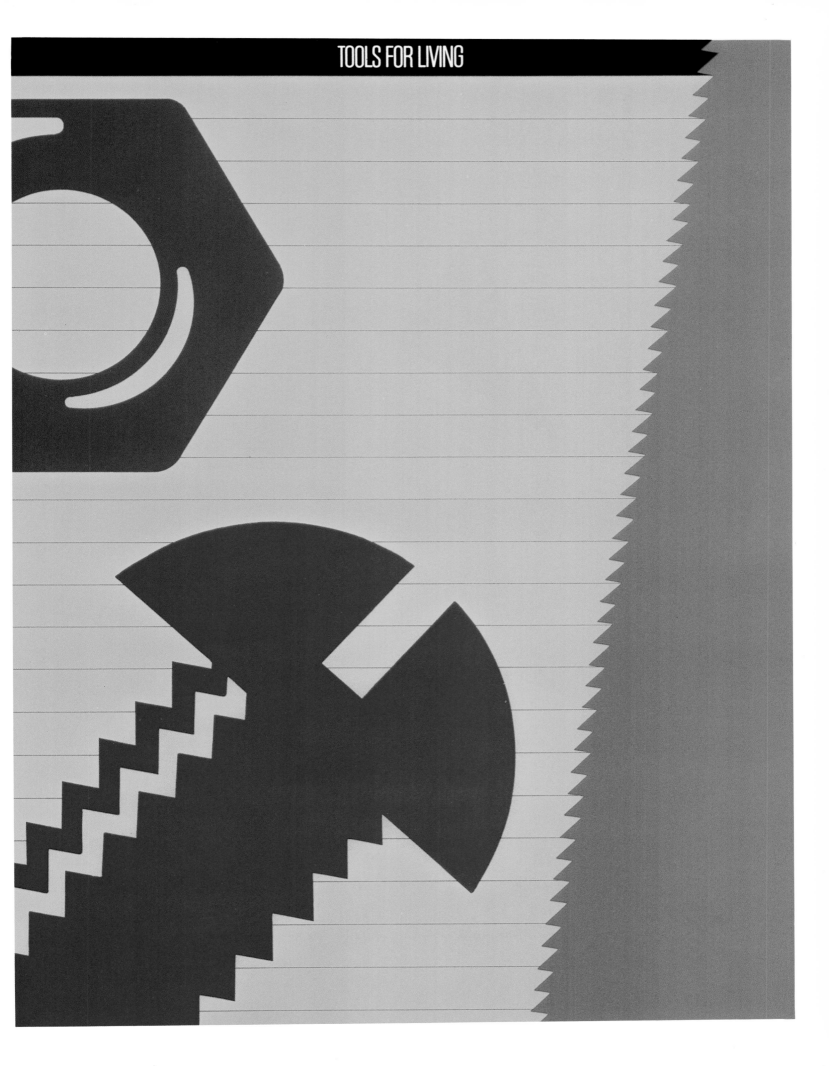

Poster:
Mill Valley Film
Festival '84
Designer:
John Casado
Design Firm:
Casado Design
San Francisco, CA
Client:
Mill Valley Film Festival
Printer:
Seriphics

Invitation:
Dust Has Settled...
Designers:
John Hornall
Jack Anderson
Design Firm:
Hornall Anderson
Design Works
Seattle, WA
Client:
Hornall Anderson
Typographer:
Type Gallery

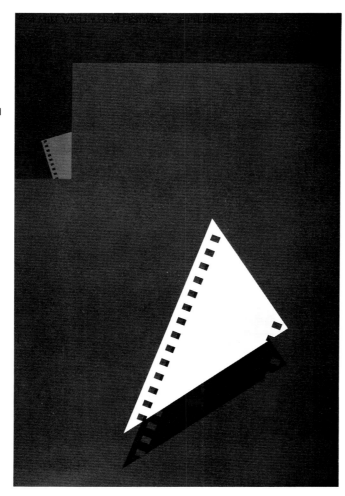

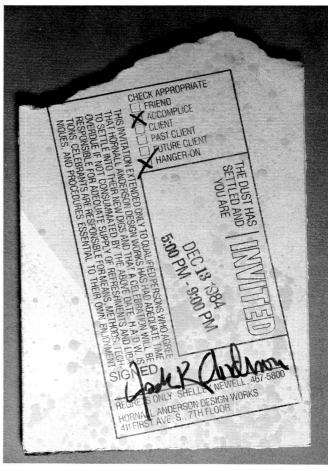

Booklet:
Towne Club
Art Director:
Lowell Williams
Designers:
Lowell Williams
Bill Carson
Artist:
Sandy Kinnee
Design Firm:
Lowell Williams Design
Houston, TX
Client:
Towne Club
Typographer:
Professional
Typographers
Printer:
Heritage Press

Poster:
Double Shakespeare
Designer:
Woody Pirtle
Artist:
Woody Pirtle
Design Firm:
Pirtle Design
Dallas, TX
Client:
Shakespeare Festival
of Dallas
Typographer:
Southwestern
Typographics
Printer:
Williamson Printing Co.

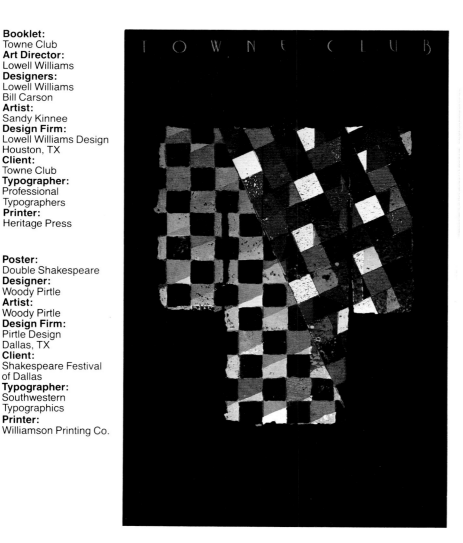

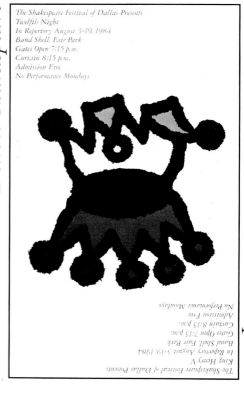

THE METAMORPHOSIS

1919

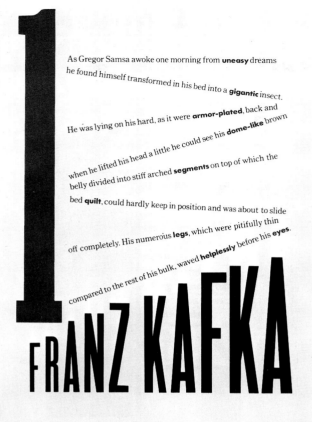

As Gregor Samsa awoke one morning from **uneasy** dreams he found himself transformed in his bed into a **gigantic** insect.

He was lying on his hard, as it were **armor-plated**, back and when he lifted his head a little he could see his **dome-like** brown belly divided into stiff arched **segments** on top of which the bed **quilt**, could hardly keep in position and was about to slide off completely. His numerous **legs**, which were pitifully thin compared to the rest of his bulk, waved **helplessly** before his **eyes**.

FRANZ KAFKA

Brochure:
Great Beginnings
Designers:
Mantel, Koppel & Scher
Design Firm:
Mantel, Koppel & Scher
New York, NY
Publisher:
Mantel, Koppel & Scher
Typographer:
Haber Typographers

Faust

1832

DEDICATION

You come back, wavering shapes,
out of the past
In which you first appeared to
clouded eyes.
Should I attempt this time to
hold you fast?
Does this old dream still thrill a
heart so wise?
You crowd? You press? Have, then,
your way at last.

As from the mist around me you arise;
My breast is stirred and feels
with youthful pain
The magic breath that hovers
round your train.

With you return pictures of
joyous days,
Shadows that I once loved again
draw near;
Like a primeval tale, half lost
in haze,
First love and friendship
also reappear;

GOETHE

Poster:
MOVING
Art Directors:
Mark Geer
Richard Kilmer
Designers:
Richard Kilmer
Mark Geer
Photographer:
Arthur Meyerson
Design Firm:
Kilmer/Geer Design
Houston, TX
Client:
Typeworks, Inc.
Typographer:
Typeworks, Inc.
Printer:
Chas. P. Young

Advertisement:
212-354-5540
Designer:
Susan Slover
Design Firm:
Susan Slover
New York, NY
Client:
Offset Separations
Typographer:
Expertype
Printer:
Offset Separations

Press Kit Folder:
Westweek '84
Art Directors:
Harold Matossian
Takaaki Matsumoto
Designer:
Takaaki Matsumoto
Design Firm:
Knoll Graphics
New York, NY
Publisher:
Knoll International
Typographer:
Susan Schechter
Printer:
Cristofer G. Sterling, Inc.

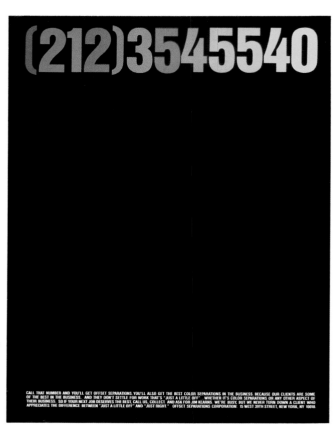

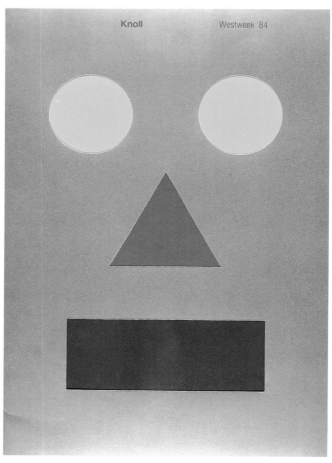

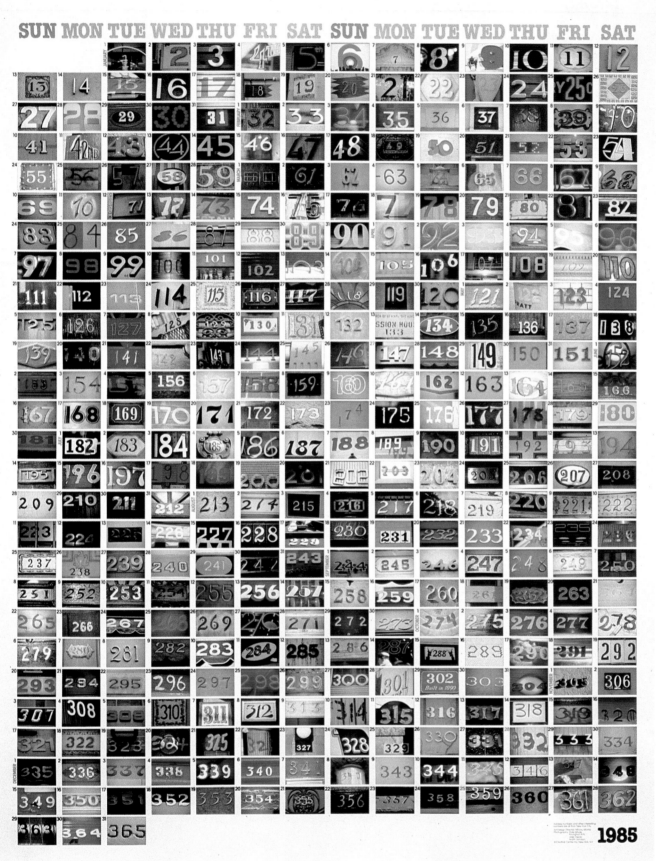

Calendar:
Big Apple
Address Calendar
Designer:
Minoru Morita
Photographers:
D. Whyte
Kyunghun Koh
Design Firm:
Creative Center, Inc.
New York, NY
Client:
Creative Center, Inc.
Printer:
Toppan Printing Co., Ltd.

Logo:
The Highlands
Designer:
Woody Pirtle
Artist:
Jeff Weithman
Design Firm:
Pirtle Design
Dallas, TX
Client:
Kelton Mathes

Logo:
The Hibernia Bank
Designer:
Michael Carabetta
Design Firm:
Landor Assoc.
New York, NY
Client:
The Hibernia Bank
Calligrapher:
John Watson

Logo:
EVE
Art Director:
Michael Orr
Designer:
Robert K. Cassetti
Design Firm:
Michael Orr & Assoc.,Inc.
Corning, NY
Client:
IBM Corp.

Logo:
Railex
Designer:
Woody Pirtle
Artist:
Kenny Garrison
Design Firm:
Pirtle Design
Dallas, TX
Client:
Railex

Brochure:
Jespersen
Construction
Designer:
Blake Miller
Photographer:
Wayne Jespersen
Design Firm:
Miller Judson and Ford,
Inc.
Houston, TX
Client:
Jespersen Construction
Co.
Letterer:
Blake Miller
Printer:
Superb Litho Co.

Package:
Macy's Hand & Bath
Body Lotion . . .
Art Director:
Richard Nodine
Designer:
David Larson
Design Firm:
Macy's Graphic Design
Dept.
San Francisco, CA
Client:
Macy's
Typographer:
Reardon & Krebs

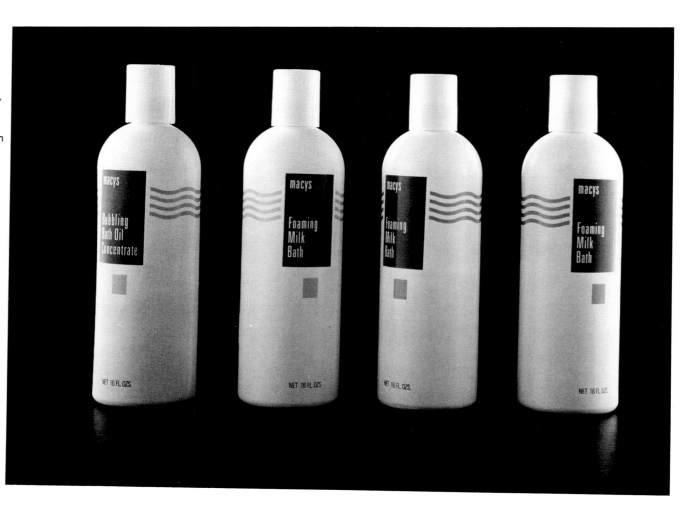

114

森林

惠好公司在美国境内拥有二百四十万公顷的商业用林地。年伐量在太平洋西北岸及南方的总和是两千五百万立方米的原木。此外,在加拿大我们有三百三十万公顷的伐采权。本公司远在一九四一年就建立了美国第一个工业用人工林,我们的非产林作业法据估计可以使每公顷的产量最少加一倍。

Weyerhaeuser owns 2.4 million hectares of commercial timberlands in the United States and has an annual harvest of 25 million cubic meters in the U.S. Pacific Northwest and South. The Company also has harvest rights on 3.3 million hectares in Canada. Weyerhaeuser founded the first U.S. industrial tree farm in 1941, and our High Yield Forestry program has more than doubled our outlook for production per hectare.

Brochure:
Weyerhaeuser in China
Art Director/Designer:
John Van Dyke
Photographer:
David Watanabe
Design Firm:
Van Dyke Co.
Seattle, WA
Client:
Weyerhaeuser Co.
Typographers:
Typehouse
AD-EX Translations
Printer:
GraphiColor

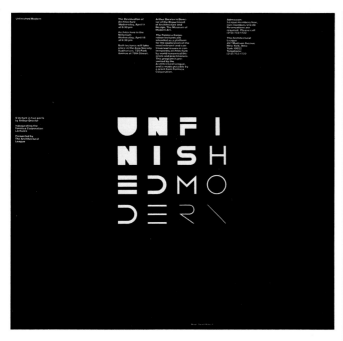

Poster:
Unfinished Modern
Designers:
Massimo Vignelli
Michael Bierut
Design Firm:
Vignelli Associates
New York, NY
Client:
The Architectural League
Typographer:
Concept Typographics
Letterer:
Michael Bierut
Printer:
Ambassador Arts

Stationery:
Bradco International, Ltd.
Art Director:
Gerald Olson
Designer:
Julian Naranjo
Artists:
Eric Olson
Julian Naranjo
Harry Shio
Design Firm:
Julian Naranjo
Del Mar, CA
Agency:
Olson Design, Inc.
Client:
Bradco International. Ltd.
Typographer:
Central Graphics
Printer:
Side Kick Printer

Environmental Graphics:
Los Angeles Olympics
Art Director:
Deborah Sussman
Design Firms:
Sussman/Prejza & Co., Inc.
The Jerde Partnership
Santa Monica, CA
Balloon Design:
Doron Gazit
Client:
Los Angeles Olympic Organizing Committee
Fabricators:
Various

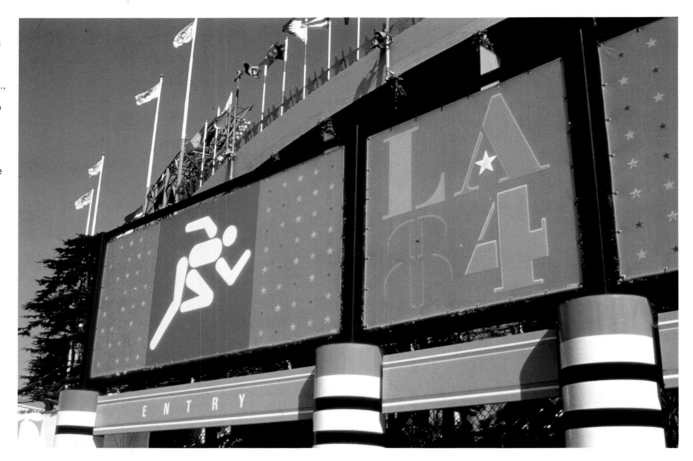

Corporate Newsletter:
Knoll: Newsletter Spring 1984
Art Directors:
Harold Matossian
Takaaki Matsumoto
Designer:
Takaaki Matsumoto
Design Firm:
Knoll Graphics
New York, NY
Publisher:
Knoll International
Typographer:
Susan Schechter
Printer:
Cristofer G. Sterling, Inc.

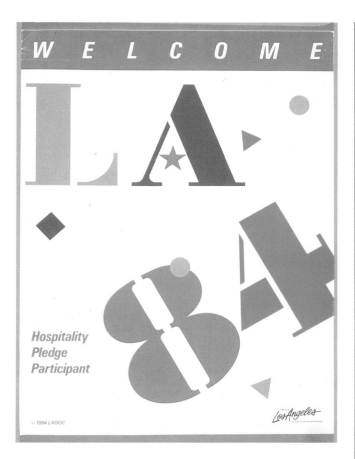

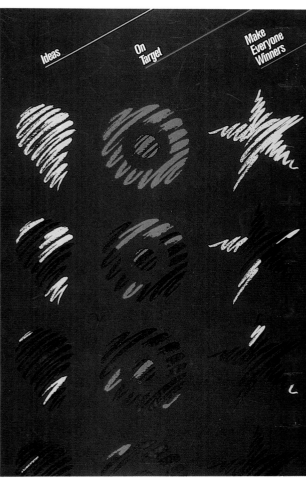

Promotional Kit:
Welcome L.A. '84
Design Director:
Larry Klein
Darrell Hayden
Art Director/Designer:
Hinsche + Associates
Design Firm:
Hinsche + Associates
Santa Monica, CA
Client:
Los Angeles Olympic
Organizing Committee
Typographer:
Skil-Set Typographers
Printer:
Jefferies Litho.

Poster:
Ideas on Target
Suggestion/Excellence/
Emphasis
Art Directors:
Michael Orr
Debbie Payne
Designers:
Ava DeMarco
Michael Orr
Design Firm:
Michael Orr & Assoc., Inc.
Corning, NY
Client:
IBM Corp.
Printer:
Signage Systems

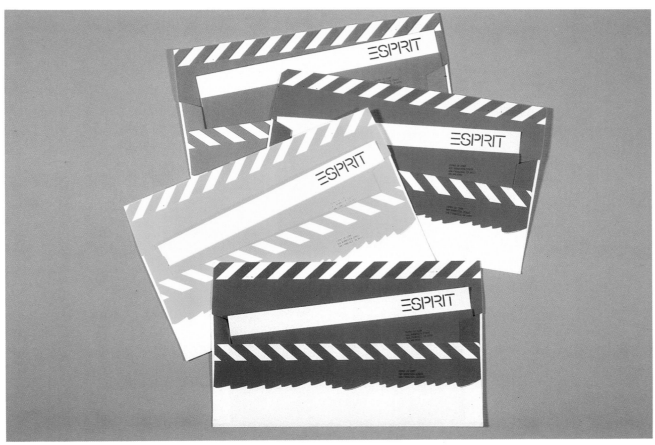

Stationery:
Esprit de Corp
Designer:
Tamotsu Yagi
Design Firm:
Esprit Graphic
Design Studio
San Francisco, CA
Client:
Esprit de Corp
Typographer:
Display Lettering
& Copy
Printer:
Nissha Printing Co., Ltd.

Invitation:
In creating, the only hard thing . . .
Art Director
Frank C. Lionetti
Designers:
Diane J. McNamee
Sydney J. Young
Design Firm:
Frank C. Lionetti Design
Old Greenwich, CT
Client:
Connecticut Art
Directors Club
Typographer:
Pastore DePamphilis
Rampone
Printer:
Stevens Press

"In creating,
the only hard thing
is to begin."

James Russell Lowell *A Fable for Critics*

Promotional Kit:
National Geographic
Society
Art Director/Designer:
Takaaki Matsumoto
Artists:
Lonni Sue Johnson
Takaaki Matsumoto
Design Firm:
Takaaki Matsumoto
New York, NY
Client:
National Geographic
Society
Typographer:
JCH Graphics, Ltd.
Printer:
C.G.S., Inc./Crafton
Graphic Co., Inc.

Promotional Kit:
Three Crowns Galleria
Designers:
Karen Salsgiver
Katy Homans
Design Firm:
Homans/Salsgiver
New York, NY
Client:
Lindenmeyr Paper Corp.
Typographer:
Trufont Typographers
Printer:
Fred Weidner & Sons

Flyers:
Unique
Designers:
Roger Cook
Don Shanosky
Design Firm:
Cook & Shanosky Assoc.,
Inc.
Princeton, NJ
Client:
RH Development
Typographer:
Optima Typographers
Printer:
Beaver & Son

Promotional Place Mat:
Home Entertaining:
Every Spring, Every Fall
Art Director/Designer:
Ellen Kier
Artist:
Richard Osaka
Design Firm:
The New York Times
Creative Services Dept.
New York, NY
Publisher:
The New York Times
Typographer:
Franklin
Typographers, Inc.
Printer:
Reehl Litho, Inc.

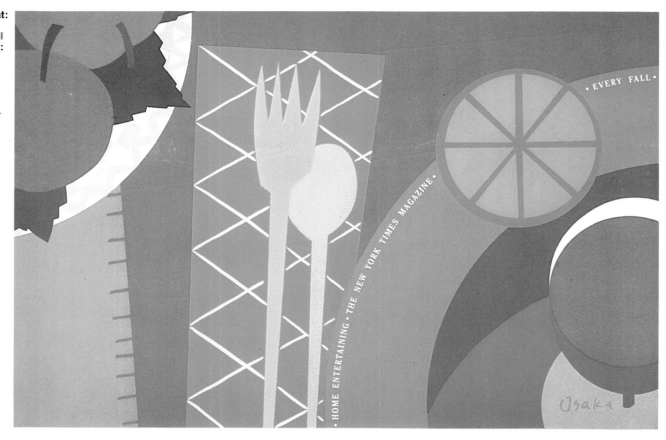

Brochure:
Custer Creek
Art Director:
Steve Connatser
Designers:
Steve Connatser
Brian Morrison
Artists:
Steve Connatser
Brian Morrison
Design Firm:
Connatser & Co
Dallas, TX
Client:
Beeson-Stone Properties
Calligrapher:
Brian Morrison
Printer:
Monarch Press

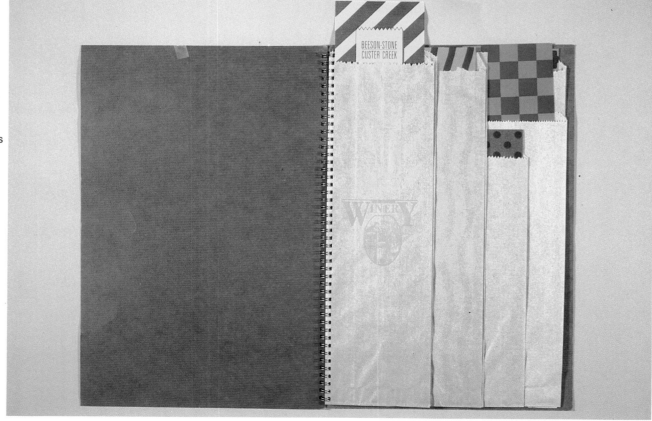

Menu:
Good Earth
Designer:
Rex Peteet
Artists:
Jerry Jeanmard
Rex Peteet
Don Sibley, Ken Shafer
Design Firm:
Sibley/Peteet Design, Inc.
Dallas, TX
Client:
Good Earth Restaurants
Typographer:
Southwestern
Typographics
Printer:
Graphic Enterprises

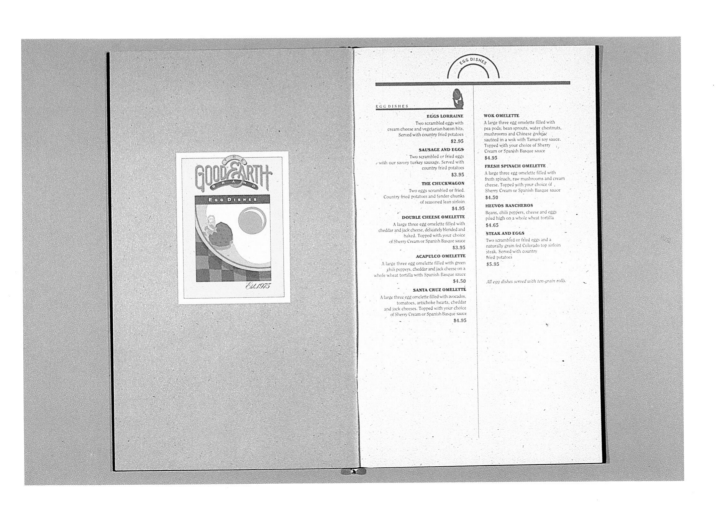

Promotional Item:
Formica Primary Metals
Art Director:
Larry Wolfson
Designers:
Michael R. Abramson
Claire Hess
Larry Wolfson
Agency:
Michael R. Abramson +
Assoc.
New York, NY
Client:
Formica International
Typographer:
Concept Typographic
Services, Inc.
Printer:
Thorner Sidney Printing

Packaging:
Assimilation, Inc.
Art Director:
Toni Hollander
Designer:
Ellen Gartland
Design Firm:
The Design Works
Los Angeles, CA
Client:
Assimilation, Inc.
Letterer:
Ellen Gartland
Printer:
Anderson Lithography

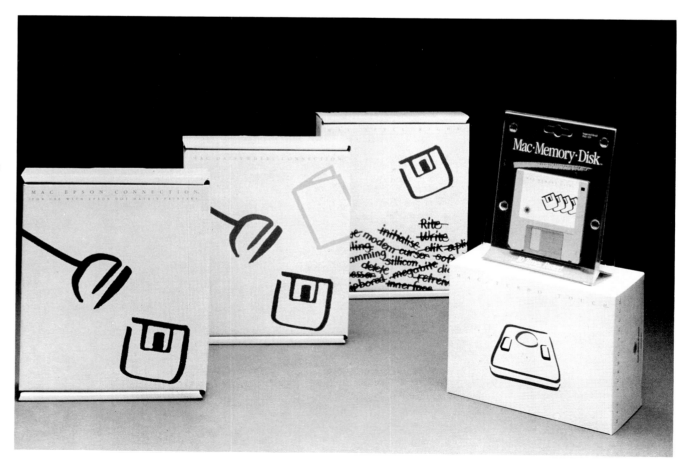

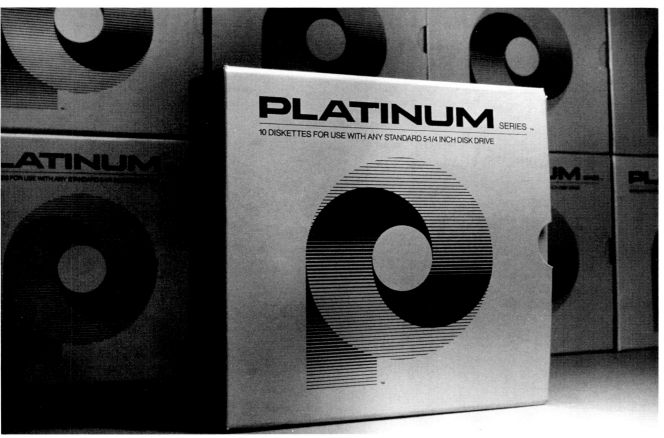

Package:
Platinum Diskettes
Art Director:
Saul Bass
Designers:
Art Goodman
G. Dean Smith
Saul Bass
Design Firm:
Bass/Yager & Assoc.
Los Angeles, CA
Client:
Capitol Data Systems

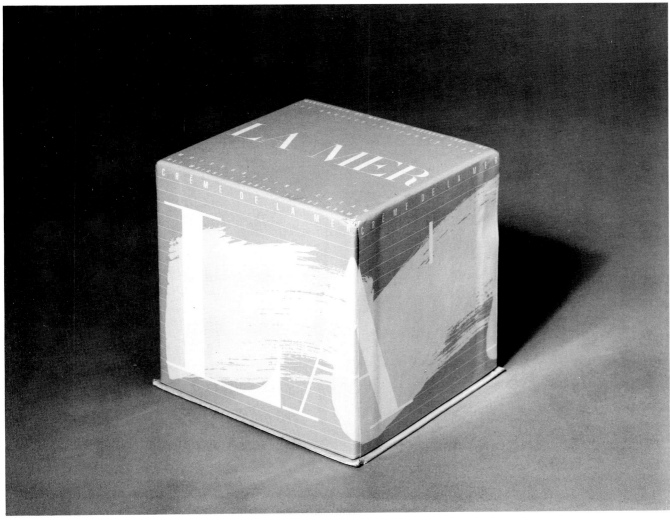

Package:
Creme de la Mer
Designer:
Michael Vanderbyl
Design Firm:
Vanderbyl Design
San Francisco, CA
Client:
Max Huber Research
Labs., Inc.

Package:
Athletes' and Staff
Lunch Box
Art Directors:
Keith Bright
Larry Klein
Art/Olympic Star:
Robert Miles Runyan &
Assoc.
Design Firm:
Bright & Assoc.
Los Angeles. CA
Client:
Los Angeles Olympic
Organizing Committee
Printer:
Pacific Coast Packaging
Corp.

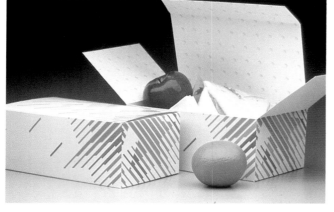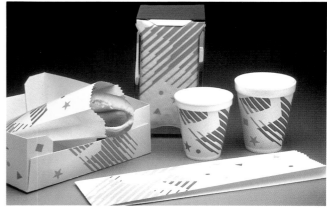

Package:
Venue Concession Stand
Food Wrap Packaging
Art Directors:
Keith Bright
Larry Klein
Designers:
Gretchen Goldie
Kimberlee Keswick
Art/Olympic Star:
Robert Miles Runyan &
Assoc.
Design Firm:
Bright & Assoc.
Los Angeles, CA
Client:
Los Angeles Olympic
Organizing Committee
Printers:
Various

**Promotional
Package:**
International Paper Co.
Fortune Cookie Package
Designer:
David Feinberg
Design Firm:
David Feinberg Design
New York, NY
Client:
International Paper Co.
Typographer:
Set-Rite Typographers
Printer:
ARG Graphics, Inc.

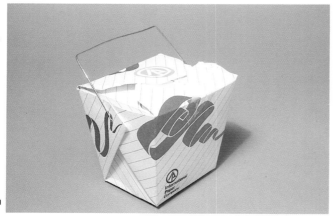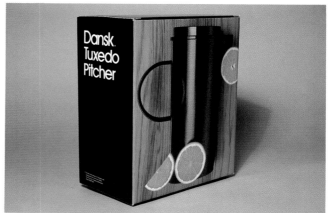

Package:
Dansk:Tuxedo Collection
Pitcher
Creative/Art Director:
Lon Scolnik
Photographer:
Sally Andersen-Bruce
Milford, CT
Client:
Dansk International
Design, Ltd.

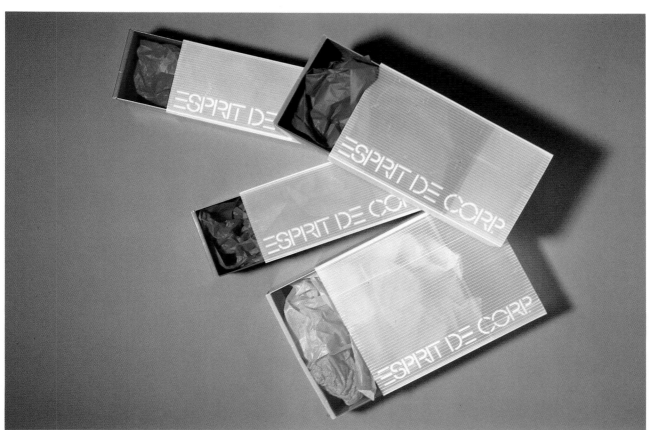

Package:
Esprit de Corp Shoe
Boxes
Designer:
Tamotsu Yagi
Design Firm:
Esprit Graphic
Design Studio
San Francisco, CA
Client:
Esprit de Corp
Typographer:
Display Lettering & Copy
Printer:
Nissha Printing Co., Ltd.

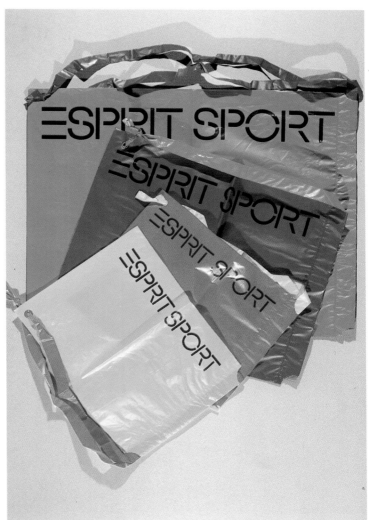

Shopping Bag:
Esprit Sport
Designer:
Tamotsu Yagi
Design Firm:
Esprit Graphic
Design Studio
San Francisco, CA
Client:
Esprit de Corp
Typographer:
Display Lettering & Copy
Printer:
Nissha Printing Co., Ltd.

Package:
Chow
Art Director:
Arthur Eisenberg
Designer:
Linda Eissler
Design Firm:
Eisenberg, Inc.
Dallas, TX
Client:
Chow Catering
Letterers:
Linda Eissler
Mark Drury
Printer:
Williamson Printing Co.

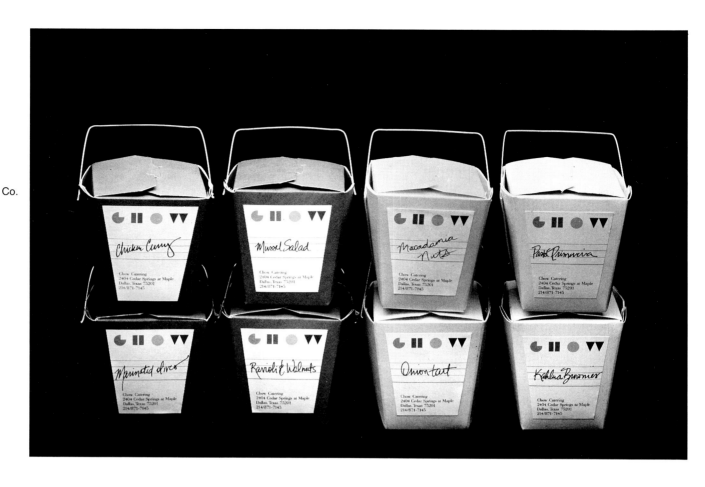

Corporate Employee Brochure:
About Your Company
Art Director:
Bruce Blackburn
Designers:
Bruce Blackburn
Margaret Wollenhaupt
Michael Gilbreath
Photographer:
Burt Glinn
Design Firm:
Danne & Blackburn
New York, NY
Client:
IBM Corp.
Typographer:
CT Typografix, Inc.
Printer:
Williamson Printing Corp.
Slipcase Manufacturer:
IBM Boulder

Package:
Ability
Designers:
Gary Ludwig
Paul Hodgson
Engineering Consultant:
Michael Hetherington
Design Firm:
Spencer/Francey, Inc.
Toronto, CAN
Client:
Xanaro Technologies
Fabricator:
Romac

**Environmental
Graphics:**
Chow Catering
Art Director:
Arthur Eisenberg
Designer:
Linda Eissler
Design Firm:
Eisenberg, Inc.
Dallas, TX
Client:
Chow Catering
Letterers:
Linda Eissler
Mark Drury

Shopping Bag:
Chow
Art Director:
Arthur Eisenberg
Designer:
Linda Eissler
Design Firm:
Eisenberg, Inc.
Client:
Chow Catering
Letterers:
Linda Eissler, Mark Drury
Printer:
Williamson Printing Co.

Package:
Dansk:Tuxedo Collection
Smorgasbord Tray
Creative/Art Director:
Lou Scolnik
Photographer:
Sally Andersen-Bruce
Milford, CT
Client:
Dansk International
Design, Ltd.

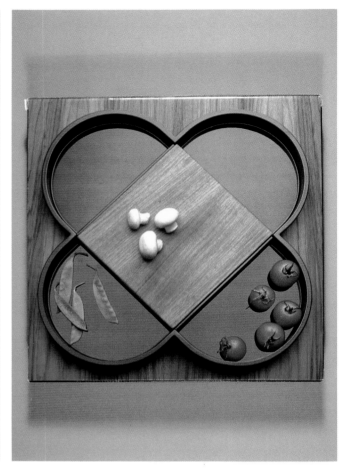

Package:
Mainstreet Filer
Template Package
Art Director:
Michael Osborne
Designer:
Bill Reuter
Artist:
Michael Osborne
Design Firm:
Michael Osborne Design,
Inc.
Client:
Mainstreet Software
Typographer:
Hester Typography

Promotional Kit:
Alexandria Mall
Designer:
Rex Peteet
Artist:
Rex Peteet
Design Firm:
Sibley/Peteet Design, Inc.
Dallas, TX
Client:
The Herring Group
Typographer:
Robert J. Hilton
Typographers
Printer:
Harp Press

Magazine Advertisement:
Cole Haan unveils a new showroom
Designer:
Mark Kent
Photographer:
Al Fisher
Design Firm:
Cipriani Advertising, Inc.
Boston, MA
Client:
Cole-Haan
Typographer:
Typographic House
Printer:
Smithgraphics

Brochure:
Herring Design Quarterly
#12: Snow Domes
Designer:
Jerry Herring
Photographer:
Joe Aker
Design Firm:
Herring Design
Houston, TX
Client:
Herring Design
Typographer:
Professional Typographers
Printer:
Grover Printing

Promotional Item:
AIGA Texas T-Shirt
Designer:
Michael Vanderbyl
Design Firm:
Vanderbyl Design
San Francisco, CA
Client:
AIGA Texas Chapter

Poster:
Le Shopping Bag
Art Director/Designer:
Frédéric Metz
Artist:
Alain Pilon
Design Firm:
Bretelle-UQAM
Montreal, CAN
Client:
Centre de Création
et de Diffusion en Design
Calligrapher:
Alain Pilon
Printer:
Les Ateliers des Sourds

Package:
Dansk:Tuxedo Collection
Hors d'Oeuvre Tray
Creative/Art Director:
Lou Scolnik
Photographer:
Sally Andersen-Bruce
Milford, CT
Client:
Dansk International
Design, Ltd.

Package:
Dansk:Crystal Bowls
Creative/Art Director:
Lou Scolnik
Designer:
Eric Overkamp
Photographer:
Sally Andersen-Bruce
Milford, CT
Client:
Dansk International
Design, Ltd.

Packaging:
Girl Scout Cookies
Art Director:
Art Goodman
Designers:
Saul Bass
Art Goodman
Artists:
Mamoru Shimokochi
Karen Lee
Design Firm:
Bass/Yager & Assoc.
Los Angeles, CA
Client:
Girl Scouts of
the U.S.A.
Production Supervisor:
Nancy Von Lauderback

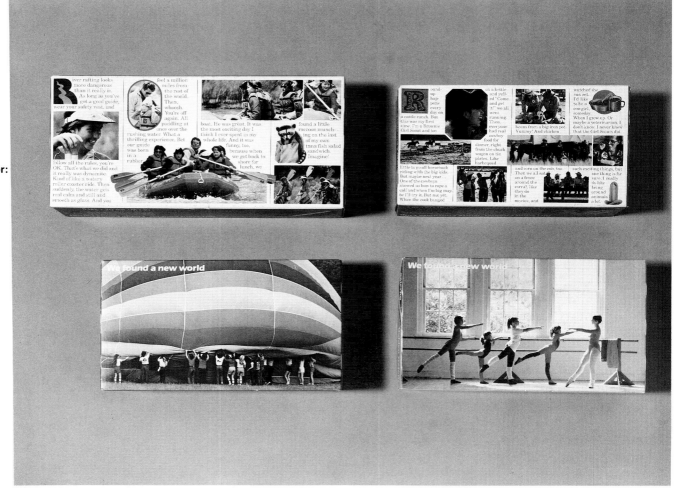

Shirt Bag:
Outfitters
Art Director/Designer:
Carol Burke
Artist:
Carol Burke
Dallas, TX
Design Firm:
Pannell/St. George
Dallas, TX
Client:
Outfitters
Printer:
Clair Pakwell

Shopping Bag:
Joponesque
Designer:
Gaku Ohta
Artist:
Gaku Ohta
San Francisco, CA
Client:
Japonesque
Printer:
Light Printing Co.

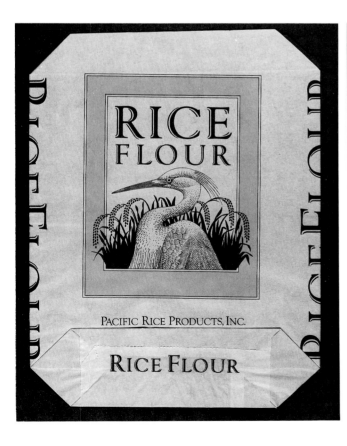

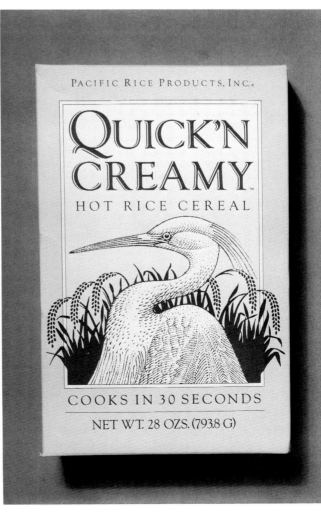

Package:
Pacific Rice Products
Rice Flour Sack
Designers:
Michael Mabry
Noreen Fukumori
Artists:
Michael Bull
Noreen Fukumori
Design Firm:
Michael Mabry Design
San Francisco, CA
Client:
Pacific Rice Products
Typographer:
Petrographics
Printer:
The Printer/Sacramento

Package:
Pacific Rice
Quick'n Creamy
Designers:
Michael Mabry
Noreen Fukumori
Artists:
Michael Bull
Noreen Fukumori
Design Firm:
Michael Mabry Design
San Francisco, CA
Client:
Pacific Rice Products
Typographer:
Petrographics
Printer:
The Printer/Sacramento

Booklet:
Sears House
Designer:
Kathleen Sullivan Kaska
Photographer:
Carol Highsmith
Design Firm:
Burson-Marsteller
Chicago, IL
Client:
Sears, Roebuck & Co.
Typographer:
Masters Typographers
Printer:
The Hennegan Co.

*When the white oak
wainscoting was restored,
missing pieces were
replaced with exact repli-
cas so that the original
ambience could be car-
ried throughout the lobby.*

*The original bannister
and the original glass
footlights grace the
marble staircase lead-
ing down from the lobby.*

Annual Report:
Fayette Manufacturing
1983 Annual Report
Art Director:
Mark Anderson
Designers:
Paul Schulte
Sue Cretarolo
Photographer:
Thomas Braise
Design Firm:
Mark Anderson Design
Palo Alto, CA
Client:
Fayette Manufacturing
Typographer:
Spartan Typographers
Printer:
Color Graphics

SKALD

PREMIER ISSUE THE PUBLICATION FOR ROYAL VIKING LINE'S SKALD CLUB MEMBERS VOL. 1, ISSUE 1 FALL, 1984

Corporate Magazine:
SKALD
Art Director:
Kit Hinrichs
Designers:
Karen Berndt
Kit Hinrichs
Artists/Photographers:
Various
Design Firm:
Jonson Pedersen
Hinrichs & Shakery
San Francisco, CA
Client:
Royal Viking Line
Typographer:
Petrographics
Printer:
Graphic Arts Center

Poster:
"I've broken a lot of
hearts in Stride Rite"
Designer:
Cheryl Heller
Photographer:
Chuck Baker
Design Group:
HBM/CREAMER
Advertising
Boston, MA
Client:
Stride Rite
Shoe Corp.
Typographer:
Typographic House
Printer:
National Bickford
Foremost, Inc.

Catalogue:
Stride Rite Spring
Catalogue 85
Designer:
Cheryl Heller
Photographers:
Fashion: Chuck Baker
Product: Al Fisher
Design Firm:
Design Group
HBM/CREAMER
Advertising
Boston, MA
Client:
Stride Rite Shoe Corp.
Typographer:
Typographic House
Printer:
Acme Printing Co.

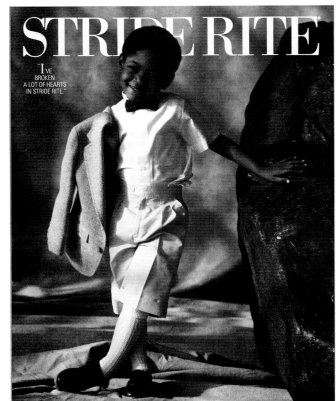

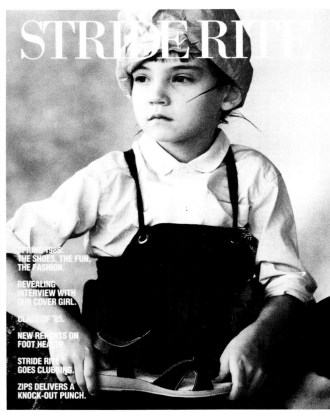

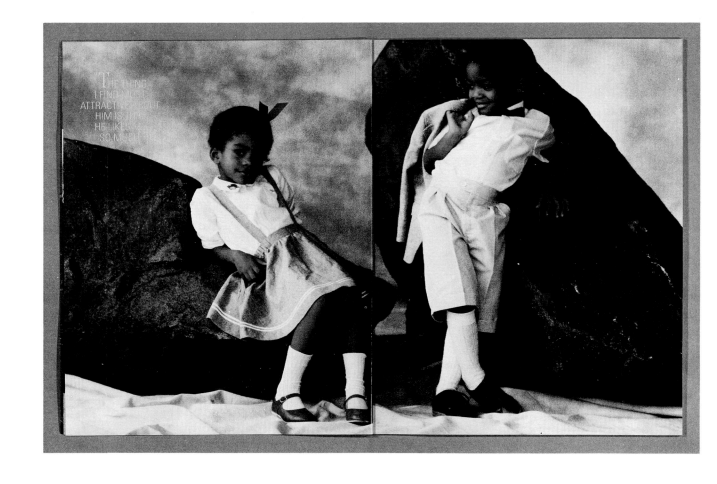

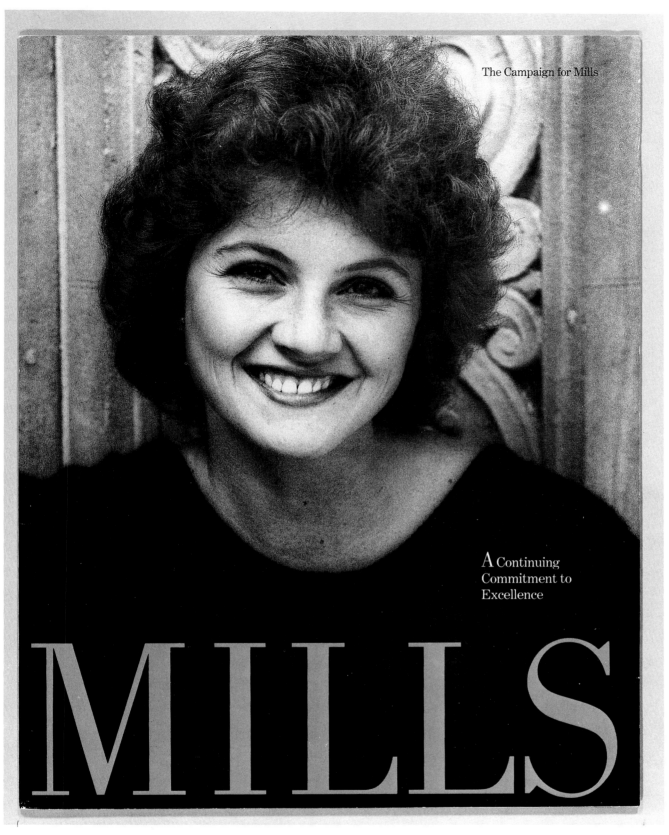

The Campaign for Mills

A Continuing
Commitment to
Excellence

MILLS

Brochure:
Mills College
Designer:
Michael Mabry
Photographer:
Dana Gluckstein
Design Firm:
Michael Mabry Design
San Francisco, CA
Client:
Mills College
Typographer:
Headliners
Printer:
Alan Lithograph Co.

Annual Report:
Luby's Cafeterias, Inc.
1984 Annual Report
Designer:
Janis Koy
Photographer:
Steve Brady
Retoucher:
Raphael
Design Firm:
Koy Design, Inc.
San Antonio, TX
Client:
Luby's Cafeterias, Inc.
Typographer:
ProType of San Antonio
Printer:
Heritage Press

Promotional Book:
Lady Pepperell
Designer:
David Kreuz
Photographer:
George Kleiman
Stylist:
Charles Riley
Design Firm:
West Point Pepperell
Advertising Dept.
New York, NY
Client:
Lady Pepperell
Printer:
Watt/Peterson, Inc.

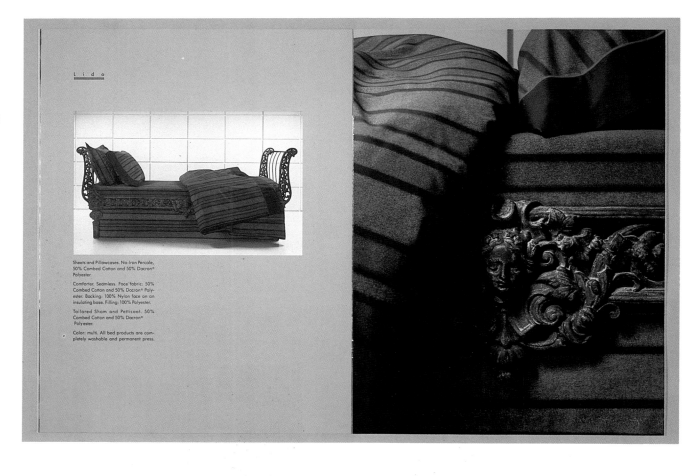

Times Mirror 1983 Annual Report

Annual Report:
Times Mirror
1983 Annual Report
Designer:
Jim Berte
Photographer:
Bruce Davidson
Design Firm:
Robert Miles Runyan
& Assoc.
Playa del Rey, CA
Client:
Times Mirror
Typographer:
Composition Type
Printer:
George Rice & Son

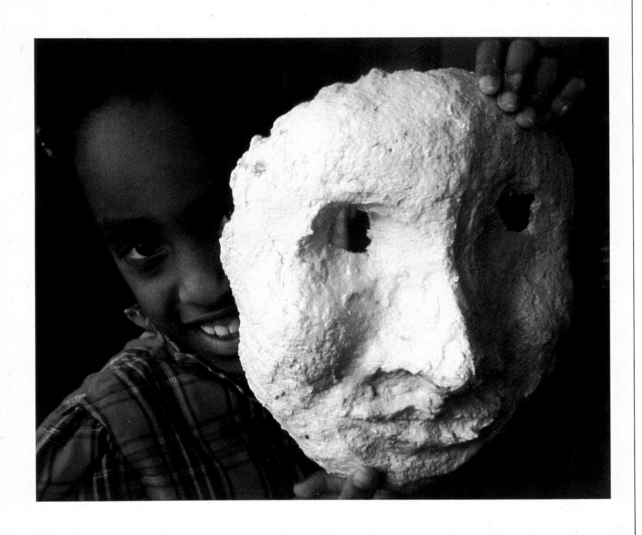

Corporate Magazine:
World, Vol. 18, #3, 1984
Art Director:
Anthony Russell
Designers:
Anthony Russell
Casey Clark
Photographers:
Various
Design Firm:
Anthony Russell, Inc.
New York, NY
Client:
Peat Marwick/
Jerry Bowles
Printer:
Southeastern Printing

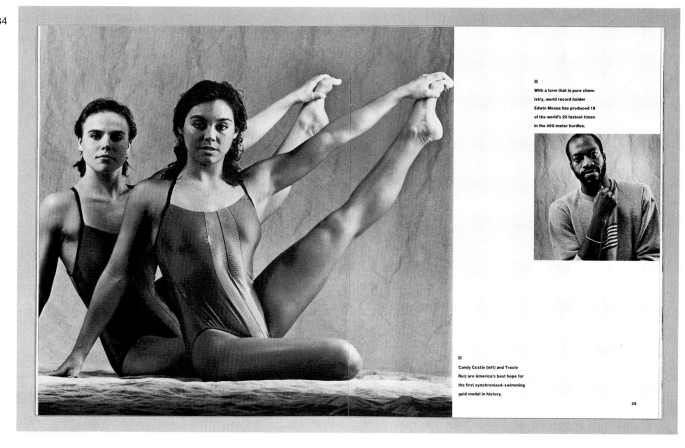

With a form that is pure chemistry, world record holder Edwin Moses has produced 18 of the world's 20 fastest times in the 400-meter hurdles.

Candy Costie (left) and Tracie Ruiz are America's best hope for the first synchronized-swimming gold medal in history.

29

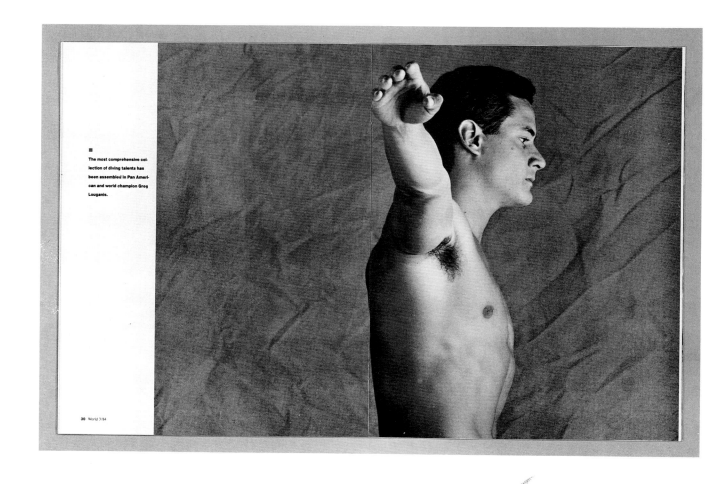

The most comprehensive collection of diving talents has been assembled in Pan American and world champion Greg Louganis.

30 World 3/84

138

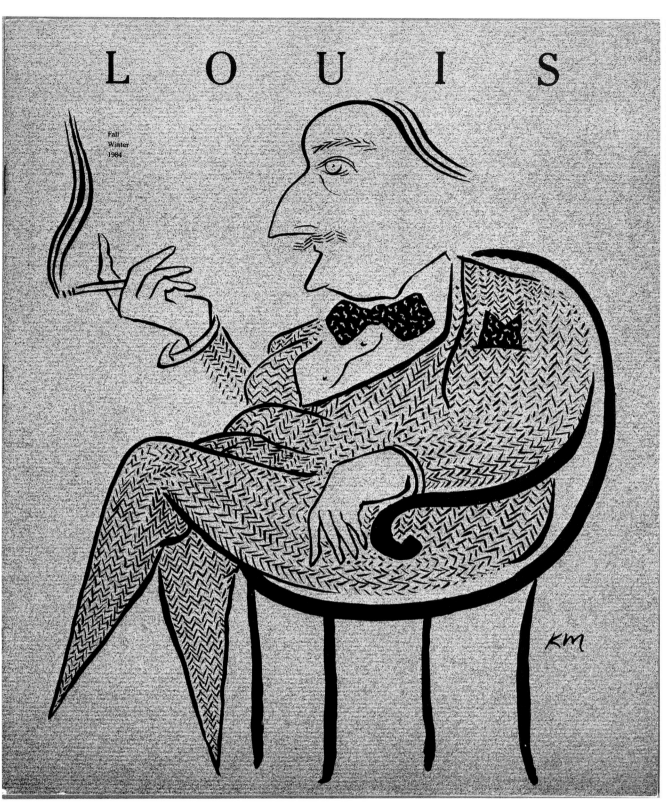

LOUIS

Fall
Winter
1984

KM

Catalogue:
Louis:Fall/Winter
Art Director/Designer:
Tyler Smith
Illustrator:
Ken Maryanski
Photographers:
Myron
Chris Brotherton
Design Firm:
Tyler Smith
Providence, RI
Client:
Louis
Printer:
National Bickford
Foremost

Booklet:
Points of View
Art Director/
Designer:
Mona Fitzgerald
Illustrator:
Mona Fitzgerald
Photographer:
Craig Stewart
Design Firm:
Goswick & Assoc.
Houston, TX
Client:
The Shade Shop
Printer:
Wetmore & Co.

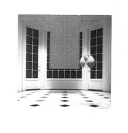

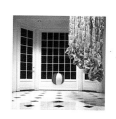

Annual Report:
Curtice-Burns, Inc.
1983 Annual Report
Art Director:
Julia Wyant
Designers:
Robert Miller
Julia Wyant
Photographer:
Ron Wu
Design Firm:
Robert Meyer Design,Inc.
Rochester, NY
Client:
Curtice-Burns, Inc.
Typographer:
Rochester
Mono-Headliners
Printer:
Canfield & Tack

18.

NATIONAL BRANDS BEVERAGE

With the acquisition this year of the 7-Up Bottling Company of Binghamton, Inc., National
Brands Beverage added a sixth major franchise area to its already substantial soft drink
business in central, up-state and western New York.

The division's sales and profit performance were the best in its history. The year was not
without challenge, however. "Like", 99% caffeine free cola, was confronted with the
introduction of "Pepsi Free" and withstood well its introductory marketing assault.

The Seagram company entered the soft drink business by launching a new line of mixes
into all of the division's "Canada Dry" marketing areas. Their entry was met with equal
aggression and Canada Dry's share of market was maintained.

Coca-Cola increased promotional spending levels on "Sprite" to compete against "7-Up"
but this too was rebuffed.

The latest incursion is by the Pepsi-Cola Company which has selected Rochester as a test
market for its new lemon and lime soft drink, "Slice." It is too early to tell if this competitor
to 7-Up can successfully establish itself in one of National Brands Beverage's major sales
areas. But the division is ready. Its past successes in repelling competitive invasions have
provided experience and know-how in protecting brand franchises.

19.

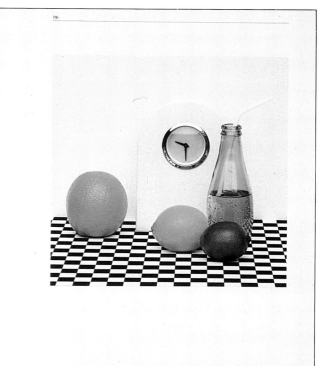

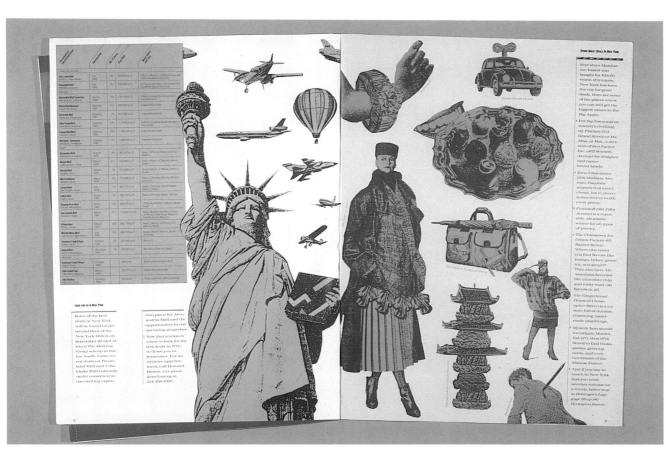

Corporate Newsletter:
The Herald
Art Directors:
Bob Dennard
Glyn Powell
Designer:
Glyn Powell
Artists:
Jan Wilson, Glyn Powell
Chuck Johnson
Paul Von Heeder
Design Firm:
Dennard Creative, Inc.
Client:
The Herring Group

Brochure:
One Clear Call
Designer:
McRay Magleby
Photographer:
John Snyder
Design Firm:
Brigham Young
University Graphic
Communications
Provo, UT
Client:
Brigham Young University
President's Office
Printer:
Paragon Press

WARREN LUSTRO GLOSS: A NEW CLASSIC

Brochure:
Warren Lustro Gloss
A new classic
Designer:
Cheryl Heller
Photographer:
Clint Clemens
Design Group:
HBM/CREAMER
Advertising
Boston, MA
Client:
S.D. Warren Paper Co.
Typographer:
Typographic House
Printer:
Lebanon Valley
Offset Co.

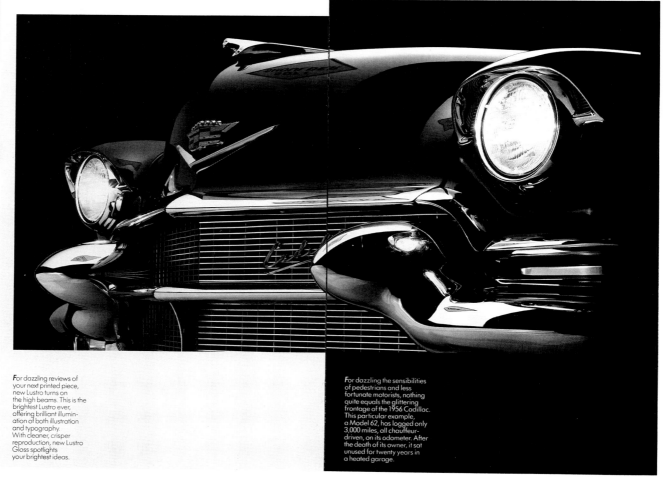

For dazzling reviews of your next printed piece, new Lustro turns on the high beams. This is the brightest Lustro ever, offering brilliant illumination of both illustration and typography. With cleaner, crisper reproduction, new Lustro Gloss spotlights your brightest ideas.

For dazzling the sensibilities of pedestrians and less fortunate motorists, nothing quite equals the glittering frontage of the 1956 Cadillac. This particular example, a Model 62, has logged only 3,000 miles, all chauffeur-driven, on its odometer. After the death of its owner, it sat unused for twenty years in a heated garage.

OBERL!N

1984-1985

PLANT SYSTEMATICS/ BIOGEOGRAPHY AND NATURAL HISTORY IN BRITAIN/EARLY CHRISTIAN AND BYZANTINE ART/THEATER MANAGEMENT/THEORIES OF THE IMAGE/SOVIET FILM/AFRO-AMERICAN HISTORY/CRYSTALLOGRAPHY/PERSPECTIVES ON THE HOLOCAUST/THE FUNGI/HAPPENINGS: THEIR HISTORY AND LEGACY/PLANETS, MOONS AND METEORITES/THUCYDIDES/ORGANIC CHEMISTRY/ANIMAL MOVEMENT/NONVERBAL COMMUNICATION/WOMEN IN GREECE AND ROME/THE ARTS OF IMPERIAL CHINA/MASTERPIECES OF THE JAPANESE CINEMA/AFRICAN LIBERATION MOVEMENTS/NINETEENTH-CENTURY MISCHIEF/BIO-MECHANICAL BASES OF PHYSICAL ACTIVITY/POLITICAL CONSCIOUSNESS AND SYMBOLISM/LE BON USAGE: LANGUE ET CIVILISATION ACTUELLES/POVERTY AND AFFLUENCE/ANIMAL BEHAVIOR/PHYSIOLOGICAL PSYCHOLOGY/PLAYWRITING/THE BLACK CHILD/PETRONIUS AND OVID/THE CONCEPT OF THE AVANT GARDE/ GEOLOGY OF NATURAL HAZARDS/METALOGIC/ PERSUASION/THE LIED/ STAGE MAKEUP/LASERS AND APPLICATIONS/THE COLD WAR/SOLID STATE PHYSICS/PSYCHOHISTORY/ PRICES AND THE MARKET MECHANISM/AMERICAN HISTORY/DENOTATIONAL SEMANTICS/THE ULYSSES MYTH/DEDUCTIVE LOGIC/ FRENCH CONVERSATION/ LANGSTON HUGHES AND THE BLACK AESTHETIC/ U.S. ENERGY POLICY

Catalogue:
Oberlin College:
College of Arts & Science
Designer:
Domenica Genovese
Artist:
Michael David Brown
Photographer:
Bill Denison and others
Design Firm:
The North Charles St.
Design Organization
Baltimore, MD
Client:
Oberlin College
Typographer:
Typeworks
Printer:
Lezius-Hiles

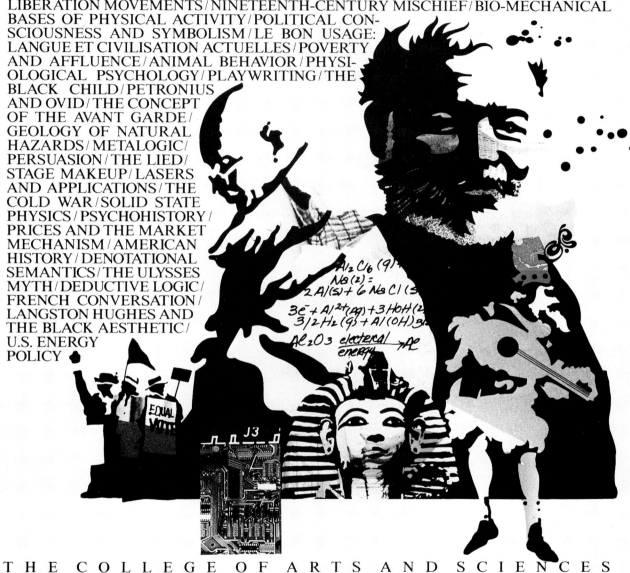

THE COLLEGE OF ARTS AND SCIENCES

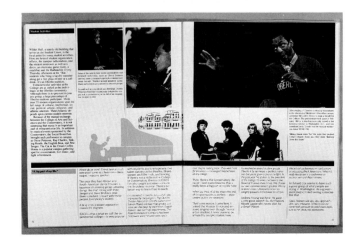

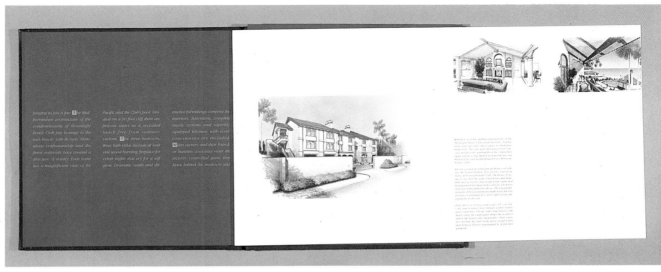

Brochure:
Moonlight Beach
Designer:
Walter Horton
Photographers:
Various
Design Firm:
Sibley/Peteet Design,Inc.
Agency:
The Williams Group
Client:
Moonlight Beach
Development
Typographer:
Southwestern
Typographics
Printer:
Williamson Printing Co.

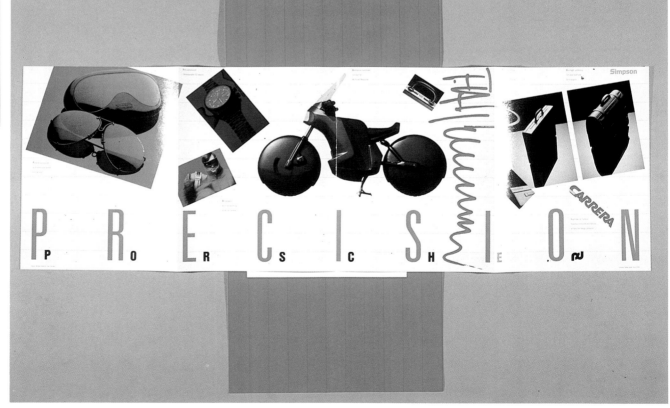

Promotional Booklet:
Simpson on Quality
"Precision"
Designer:
Michael Vanderbyl
Photographer:
Roger Lee
Design Firm:
Vanderbyl Design
San Francisco, CA
Client:
Simpson Paper Co.
Printer:
Williams Litho.

Boy Scouting

Boy Scouting is an experience for young men (ages 11 to 18) with its ever-popular call of outdoor activities and its challenge of gaining knowledge, through merit badges earned, that could become interests for a lifetime.

"Diplomats in short pants and knee socks," is the way a national television news reporter described Scouts at the *XV World Scout Jamboree* in July in Kananaskis Country, Calgary, Alberta, Canada. When 15,000 Scouts from 102 countries get together in fellowship, they send a message around the globe. They show that people from a variety of cultures and different political persuasions can get along together — that the fields of war should not be the way to settle differences.

The BSA contingent numbered 3,750 Scouts and leaders.

Varsity Scouting offers older boys (ages 14 to 18) exciting, fun-filled, challenging activities designed to help the young men in their character, physical, mental, and social development. Varsity Scouting is designed to encourage:

Advancement leading to Eagle Scout rank

High-adventure beyond the reach of younger Scouts

Personal development in leadership, physical development, citizenship, as well as things social and cultural.

Service to people and organizations.

Participation in special programs and events on council, regional, and national levels.

Thirty Eagle Scouts, each year, now have the opportunity to apply for a $3,000 *tuition scholarship* to an accredited college or university because of the generosity of former Governor of Texas William P. Clements, Jr., himself an Eagle Scout and recipient of our Distinguished Eagle Scout Award. Additional funds will be sought to add to the Clements $1 million endowment to extend the opportunity to more Scouts.

Alpha Phi Omega, a national service fraternity, was founded in 1925. Originally, its members were college students who were or had been Boy Scouts. Now on 600 campuses and with 180,000 alumni and members, service to BSA councils and troops continues to be a principal goal. APO describes itself as Scouting's "college connection."

The *National Order of the Arrow (OA) Conference* was held at Rutgers University in New Brunswick, New Jersey, in August with 3,318 Arrowmen attending. These events are planned and conducted by youth leaders.

As described by OA founder E. Urner Goodman (1891-1980), the Order of the Arrow is a thing of the individual rather than the masses; a thing of the outdoors rather than the indoors; a thing of the spirit rather than mechanics; and the things of the spirit are brotherhood, cheerfulness, and service.

The Florida National High Adventure Sea Base is now accepting 13-year-old and older Boy Scouts into its Scuba certification course. Scuba certification is given through these agencies: YMCA, PADI (Professional Association of Diving Instructors), and NAUI (National Association of Underwater Instructors).

In the summer, 19,034 youth leaders had a *high-adventure experience* at one of our five bases: Philmont Scout Ranch, Northern Tier National High Adventure Programs (Sommers and Northern Wisconsin bases combined), Maine National High Adventure Area, Adirondack High Adventure Area, and the Florida National High Adventure Sea Base.

Another experience of a lifetime awaits one of 55,000 eligible Eagle Scouts. He will be a crew member on a U.S. Coast Guard polar icebreaker. For eight months, from September 1984 to May 1985 and will participate in a *scientific expedition to Antarctica*.

Under the auspices of the National Science Foundation, this Eagle Scout will follow the "trail" made in 1928 by Paul Siple. Siple was the first of three Eagle Scouts to have such an experience. He was on Commodore Richard Byrd's 2-year expedition to the South Pole Region. Other Eagle Scout explorers were Richard Chappell in 1957 and Mark Leinmiller in 1978.

13

Annual Report:
Boy Scouts of America
Annual Report 1983
Designer:
Alan Colvin
Illustrators:
Alan Colvin
Kenny Garrison
Mike Schroeder
Design Firm:
Pirtle Design
Dallas, TX
Client:
Boy Scouts of America
Typographer:
Southwestern
Typographics
Printer:
Heritage Press

Among the many resources available to its clients, "master servicing" is unique to Farmers Savings Bank. Provided to institutional investors, master servicing leaves the management of mortgage investments in the Bank's professional care. Farmers supervises the performance of each sub-servicer and follows

up on delinquencies. Each investor receives a comprehensive monthly report on the status of their portfolio and the single, monthly earnings check sent by Farmers simplifies their accounting and recordkeeping.

The Bank is developing many new networks to support its activities. In 1983, Farmers expanded its computer capabilities with the installation of a sophisticated Alpha Micro system. This year the Bank also began to develop proprietary loan processing software. In 1984, Farmers will bring this software as well as a powerful IBM mainframe on-line to expand its servicing capacity.

In the last year, Farmers Savings Bank has become an influential member of the secondary market community. The opportunities in 1983 were great, and Farmers consistently and profitably positioned itself as an aggressive participant in the rapidly shifting marketplace.

In the coming year, Farmers will break ground in many new areas. There are no existing formulas on which to rely. The Bank will continue to respond with innovative alternatives to meet the challenges that lie ahead.

Fifteen

Annual Report:
Farmers Savings Bank
Annual Report 1983
Designers:
Michael Patrick Cronan
Barbara Edquist
Artist:
Michael Patrick Cronan
Design Firm:
Michael Patrick Cronan
San Francisco, CA
Client:
Farmers Savings Bank
Typographer:
Omni Comp
Printer:
Graphic Arts Center

Brochure:
Heritage Press
Art Director:
Lowell Williams
Designers:
Lowell Williams
Bill Carson
Photographer:
Arthur Meyerson
Design Firm:
Lowell Williams Design
Houston, TX
Client:
Heritage Press
Typographer:
Typeworks, Inc.
Printer:
Heritage Press

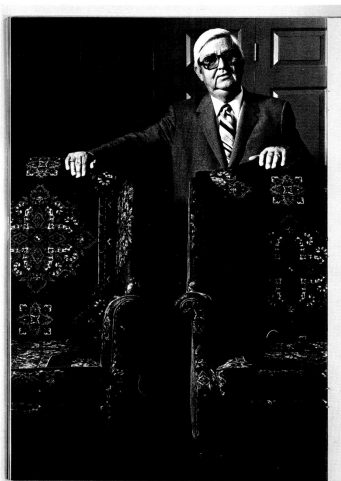

"We attempt to make our customers feel like their job is the only job we have in the plant. We strive for that kind of personal attention.

Sometimes it's difficult to maintain a production schedule with that attitude, but we feel that that is what has gotten Heritage where it is today. People know they can count on us: on our quality, on our delivery, on our word."

A.B. Curry
Co-founder and
Ex-officio member of
the Board of Directors

Annual Report:
St. Francis
Medical Center
Art Director:
Emmett Morava
Designer:
Douglas Oliver
Photographer:
Rumio Sato
Design Firm:
Morava & Oliver
Design Office, Inc.
Santa Monica, CA
Client:
St. Francis
Medical Center
Typographer:
Central Typesetting Co.
Printer:
Lithographix

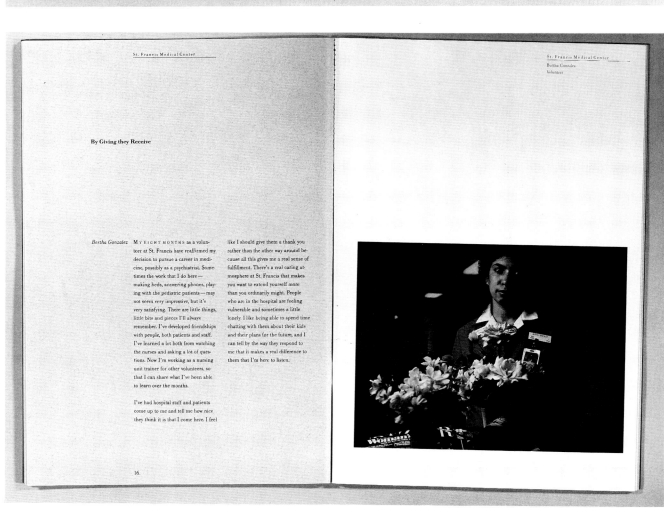

St. Francis Medical Center

By Giving they Receive

Bertha Gonzalez MY EIGHT MONTHS as a volunteer at St. Francis have reaffirmed my decision to pursue a career in medicine, possibly as a psychiatrist. Sometimes the work that I do here—making beds, answering phones, playing with the pediatric patients—may not seem very impressive, but it's very satisfying. There are little things, little bits and pieces I'll always remember. I've developed friendships with people, both patients and staff. I've learned a lot both from watching the nurses and asking a lot of questions. Now I'm working as a nursing unit trainer for other volunteers, so that I can share what I've been able to learn over the months.

I've had hospital staff and patients come up to me and tell me how nice they think it is that I come here. I feel like I should give them a thank you rather than the other way around because all this gives me a real sense of fulfillment. There's a real caring atmosphere at St. Francis that makes you want to extend yourself more than you ordinarily might. People who are in the hospital are feeling vulnerable and sometimes a little lonely. I like being able to spend time chatting with them about their kids and their plans for the future, and I can tell by the way they respond to me that it makes a real difference to them that I'm here to listen.

16.

St. Francis Medical Center
Bertha Gonzalez
Volunteer

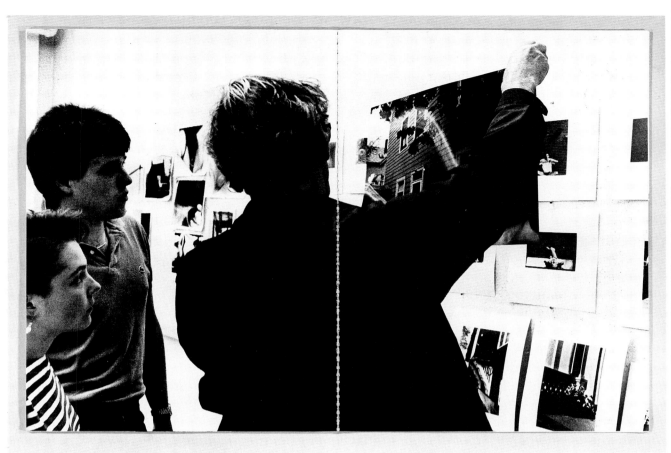

Catalogue:
Rhode Island School
of Design,
1984—85
Art Director:
Joseph Gilbert
Designers:
Joseph Gilbert
Melissa Moger Gilbert
Cover Photographer:
Gary Gilbert
Design Firm:
Gilbert Assoc.
Providence, RI
Client:
Rhode Island School
of Design
Printer:
Eastern Press

Inertial Instruments
Avionics/Fiber Optical Gyro. The Laboratory is
engaged in high performance passive resonant ring
fiber optic gyro research and development programs.
Both IR&D and industry sponsored, these programs
are to develop instruments for avionics, strategic
missile boost and reentry guidance and autonomous
undersea vehicle navigation applications. Experimen-
tal work, encompassing both the complete gyro and
critical components, continues and deep resonant
dips, crucial to the opera-
tion of the gyro, have "The team concept is not
been achieved. Assembly limited to one depart-
and subsystem integra- ment. In many applica-
tion of a proof-of-concept tions, we'll call on
passive resonant ring people from various dis-
fiber optic gyro is in pro- ciplines and different
cess. Modeling efforts are companies to address a
addressing the technology issues which are the key to specific problem."
the development of very high performance, low
power and low cost gyros.
Reaction Wheel Assembly/Momentum Wheel
Assembly. The Laboratory continues to supply high
reliability momentum wheel assemblies (MWAs) with
a proven record for long life (up to 10 years) for com-
munications satellites. Additional contracts were
received for MWAs for communications satellite
applications and for reaction wheel assemblies
(RWAs) for meteorological satellite programs. CSDL
is addressing the challenging needs for longer life,
high reliability and higher energy MWAs and RWAs.
Laser Gyro Modeling. Under the sponsorship of the
Air Force Office of Scientific Research, performance
modeling studies of both conventional ring-laser and
passive-optical gyros were conducted.
Advanced Instrumentation
Aerial Profiling Of Terrain System (APTS). Develop-
ment of the APTS for the Department of the Interior,
U.S. Geological Survey, was completed during the
past year. Designed to perform a variety of surveying

tasks from an aircraft, APTS incorporates an inertial
navigator, computer, laser terrain profiling, and a
laser tracker for acquiring and tracking retroreflec-
tors located at presurveyed points on the ground.
After ground testing in the survey aircraft, APTS
operation was checked and refined in a series of
shake-down flights over a test range west of Boston.
Performance evaluation flights demonstrated the
capability of APTS to meet established performance
goals. Now CSDL is supporting the Geological Survey
in the APTS applications testing phase, performing
various surveys in the New England area.
Muon Detector Drift Chamber. The search for elemen-
"Inertial instruments are tary particles by physicists
complex, precise electro- poses the challenge of
mechanical devices, precise spatial positioning
requiring the joint (approximately 50 parts
efforts of mechanical, per million) of detector
electronics, and electro- chambers within a
magnetic engineers, plus magnetic field. Such a
laser and semiconductor detector and magnetic
physicists. The excite- structure, weighing
ment comes when we approximately 7000 tons,
transfer the technology will be installed at the
to industry...and the European Organization
instruments become a for Nuclear Research at
working system." Geneva, Switzerland by
 about 1987. CSDL, in collaboration with MIT, has
Inertial Instrumenta- designed and is now constructing a prototype support
tion Design and Devel- structure, called an Octant, for detection chambers
opment Team. Back for test and evaluation at the Harvard University
(L to R): Neil Barbour, Cambridge Electron Accelerator. Sixteen identical
Chet Brown, Bob Octants, each weighing four tons and containing five
Collins, Charlie Atkins, muon detector chambers, will be required to com-
Robert Taylor. Front plete the detector. European members of the collabo-
(L to R): Byong-Ho ration will fabricate and install working hardware by
Ahn, Ann Hynes. about 1987.
 Physical Oceanographic Instrumentation. The first
"Our progress is based MkII Profiling Current Meter (PCM) performed well
on performance, on how in a six month Tropic Heat experiment in the Pacific
well we do this type of
work. We don't produce
something you can mea-
sure in numbers, it's
quality rather than
quantity."

Annual Report:
The Charles Stark Draper
Labs. Inc. Annual Report
Designer:
Robert Cipriani
Photographer:
Steve Dunwell
Design Firm:
Cipriani Advertising, Inc.
Boston, MA
Client:
The Charles Stark
Draper Labs., Inc.
Typographer:
Typographic House
Printer:
Acme Printing

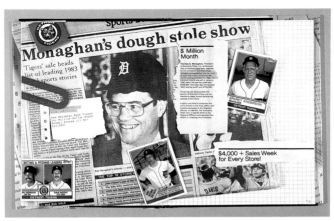

Annual Report:
1984 Domino's Pizza
Annual Report
Art Director:
Ernie Perich
Designers:
Ernie Perich
Wayne Perderson
Jeanette Dyer
Photographer:
Ann DeLaVergne
Design Firm:
Group 243 Design, Inc.
Ann Arbor, MI
Client:
Domino's Pizza, Inc.
Color Separations:
Village Graphics
Printer:
EPI Printing

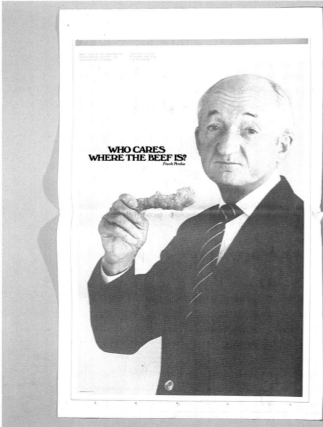

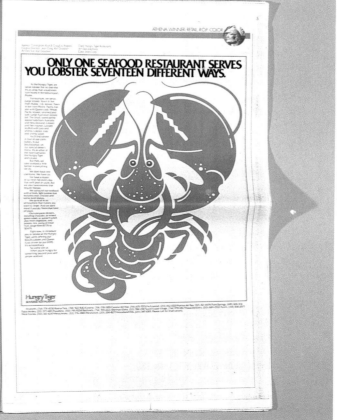

Corporate Newspaper:
Creative Newspaper 9
Art Director:
Tom Clemente
Artist:
Robert Heindel
Design Firm:
Newspaper Advertising
Bureau
New York, NY
Publisher:
Newspaper Advertising
Bureau
Typographer:
Cardinal Type Services,
Inc.
Printer:
Orlando Newspapers

Cracker Barrel Old Country Store

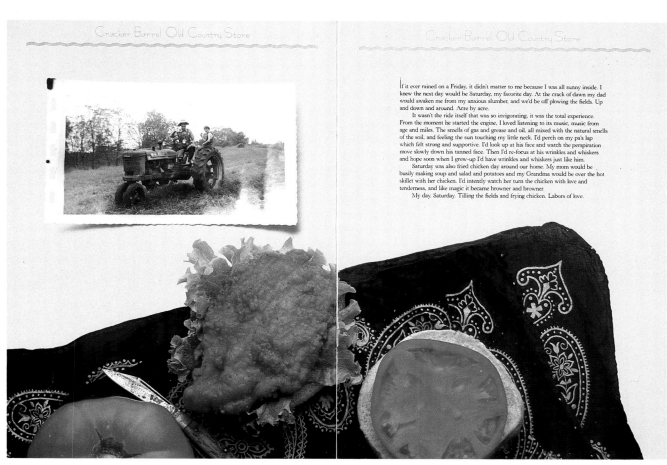

If it ever rained on a Friday, it didn't matter to me because I was all sunny inside. I knew the next day would be Saturday, my favorite day. At the crack of dawn my dad would awaken me from my anxious slumber, and we'd be off plowing the fields. Up and down and around. Acre by acre.

It wasn't the ride itself that was so invigorating, it was the total experience. From the moment he started the engine, I loved listening to its music, music from age and miles. The smells of gas and grease and oil, all mixed with the natural smells of the soil, and feeling the sun touching my little neck. I'd perch on my pa's lap which felt strong and supportive. I'd look up at his face and watch the perspiration move slowly down his tanned face. Then I'd re-focus at his wrinkles and whiskers and hope soon when I grew-up I'd have wrinkles and whiskers just like him.

Saturday was also fried chicken day around our home. My mom would be busily making soup and salad and potatoes and my Grandma would be over the hot skillet with her chicken. I'd intently watch her turn the chicken with love and tenderness, and like magic it became browner and browner.

My day. Saturday. Tilling the fields and frying chicken. Labors of love.

Annual Report:
Cracker Barrel
1984 Annual Report
Designer:
Thomas Ryan
Photographer:
McGuire
Design Firm:
Thomas Ryan Design
Nashville, TN
Client:
Corporate
Communications, Inc.
Typographer:
Total Communication
Services, Inc.
Printer:
Color Graphics, Inc.

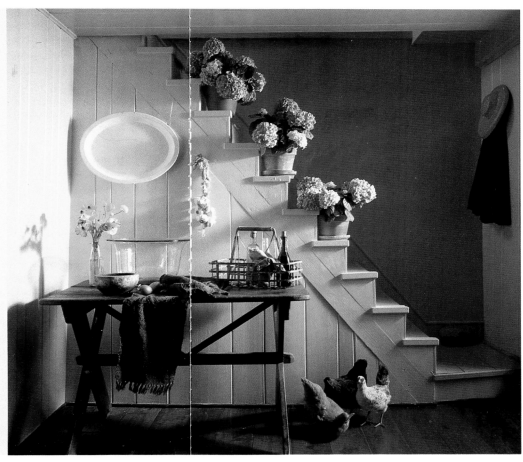

Catalogue:
Special Places
Art Director:
James Sebastian
Designers:
James Sebastian
Jim Hinchee
Michael McGinn
Photographer:
Bruce Wolf
Interior Designer:
Bill Walter/West
Point Pepperell
Design Firm:
Designframe, Inc.
New York, NY
Client:
Martex/West Point
Pepperell
Typographer:
M.J. Baumwell
Printer:
The Hennegan Co.

Poster:
Cordage Paper
Art Director:
Julius Friedman
Designers:
Julius Friedman
Page Penna
Photographer:
Michael Brohm
Design Firm:
Images
Client:
Cordage Paper Co.
Typographer:
Adpro
Printer:
Fetter Printing Co.

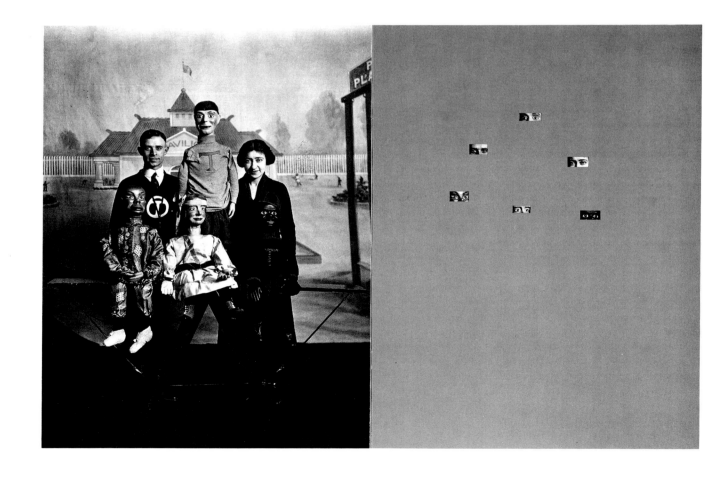

Annual Report :
Apple 1984
Annual Report
Creative Director:
Tom Suiter
Art Director:
Clement Mok
Designers:
Clement Mok
Susan Kare
Photographers:
Cheryl Rossum
Norman Seef
Will Mosgrove
John Greenleigh
Design Firm:
Apple Computer, Inc.
Cupertino, CA
Client:
Apple Computer, Inc.
Typographer:
Vicki Takala
Printer:
Anderson Lithography Co.

The L&N School is for children from six weeks to six years old whose parents are part of the Lomas & Nettleton family.

The school will be housed in the new ServiceCenter at 1600 Viceroy in Dallas, Texas, next door to Lomas & Nettleton Information Systems.

Caring for infant, toddler, pre-school and kindergarten age children, The L&N School offers a balanced program of activities, it will enrich young children and allow Lomas & Nettleton parents to be closely involved with their child's daily care.

What children need, they have a right to: security, compassion, challenge, and respect. Most of all, children are entitled to individual attention.

The individual child is at the heart of The L&N School program.

Teachers and caregivers at the school are committed to providing children with the opportunity to become themselves. The school wants to nurture, to begin with each child's natural gifts, and to enhance natural development.

The L&N School pursues a balanced developmental program, understanding that there are norms for development and that such norms can also be objectives, adjusted for each child individually.

The school plans its activities carefully to ensure that every child masters the variety of skills necessary for further development. Physical skills, social skills, language skills. Each child is different, but the sequence of skills acquired is orderly and predictable. New skills are taught based on previously acquired ones, in a structure that allows children to emerge with real competencies, with real self-esteem, and with appetites whetted for learning more.

Learning should be a pleasure; at The L&N School, it will be. The school fosters creativity, encourages children to explore, allows them to make discoveries. We also set limits and encourage self-discipline, because boundaries reassure young children, and because order and stability are as important to a child as freedom.

Child care is not meant to be a substitute for the family or the parent; it supports the families it serves. The L&N School encourages parents to be very involved in school activities. Observing their children during the day. Meeting the school's Director and teachers. Participating in school programs and attending special lunch-time presentations on parenting.

*"Lig a loggie, dig a poggie,
a la boggie, poggie boggie."
Toddler's song*

Pre schooler: Someone who likes hangerburgs and pisghetti

Brochure:
The L & N School
Designer:
Ron Sullivan
Photographer:
Jim Sims
Design Firm:
Sullivan Perkins
Dallas, TX
Client:
Lomas & Nettleton School
Typographer:
Chiles & Chiles
Printer:
Artesian Press

The Mark Twain Memorial presents
Hal Holbrook in Mark Twain Tonight

*Mark Twain
Alive*

In celebration of Mark Twain's
150th birthday

Monday, January 28, 1985
Bushnell Memorial Hall, 8 p.m.

A benefit performance
made possible by Heublein Inc.

for one night only

THE BATHHOUSE THEATRE PRESENTS
THE WORLD PREMIERE OF

Eleanor Marx

BY LEONARD ANGEL
DIRECTED BY ARNE ZASLOVE
SEPTEMBER 14-OCTOBER 21, 1984
RESERVATIONS: 524-9108
MADE POSSIBLE, IN PART, BY A GRANT FROM THE
KING COUNTY ARTS COMMISSION

(a speech) We are told that socialists want to have women in common. Such an idea is possible only in a state of society that looks upon woman as a commodity. Today, alas woman is only that. She has only too often to sell her womanhood for bread. But to the socialist a woman is a human being, and can no more be 'held' in common than a socialistic society could recognize slavery. And these virtuous men who speak of our wanting to hold women in common, who are they? The very men who debauch your wives and sisters and daughters. Have you reflected, you workingmen, that the very wealth you create is used to debauch your own sisters and daughters, even your little children? That is to me the most terrible of all the miseries of our modern society; that poor men should create the very wealth that is used by the man of 'family and order' to ruin the women of your class. We socialists, want common property in all means of production and distribution, and as woman is not a machine, but a human being, she cannot be held by anyone as a piece of property. (More thunderous applause.)

Program:
Winning Moments/
Byron Nelson Tribute
Designer:
D.C. Stipp
Design Firm:
Richards Brock Miller
Mitchell & Assoc.
Dallas, TX
Client:
Abilene Christian
University
Typographer:
Chiles & Chiles
Printer:
Williamson Printing Co.

1951

After being off the tour for five years, Byron Nelson turned out for The Crosby. Unfortunately, so did the rain. Byron chipped over water on the greens to win the tournament. It was his last of 53 PGA championships. But not his last PGA honor. In 1953, the association named Byron Nelson to its Hall of Fame.

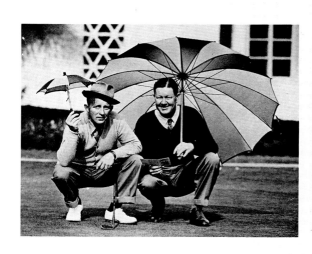

Brochure:
The Hurt That Does
Not Show
Designer:
Ellen Shapiro
Artist:
Steven Guarnaccia
Photographers:
Various
Design Firm:
Shapiro Design Assoc.,
Inc.
New York, NY
Client:
The Grace Foundation,
Inc.
Typographer:
Cardinal Type Services,
Inc.
Printer:
Lebanon Valley
Offset Co., Inc.

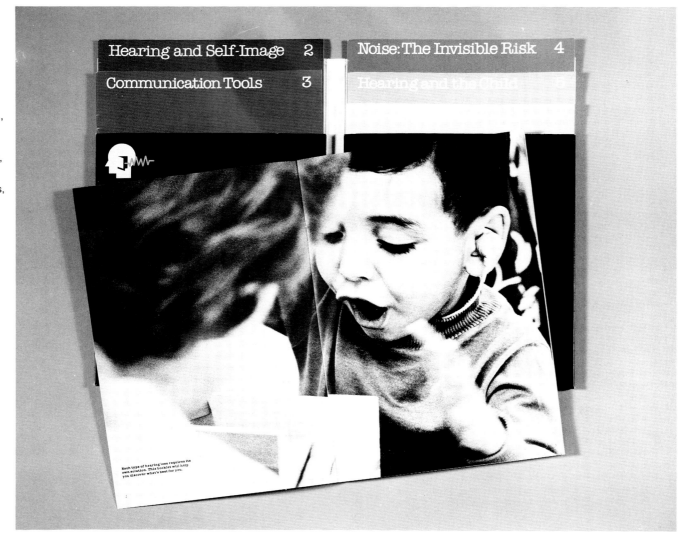

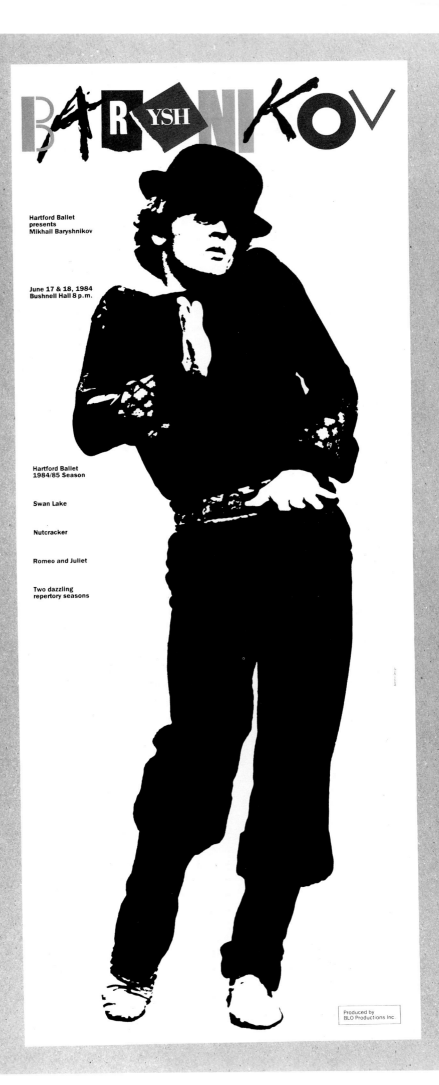

BAR RYSH NI KOV

Hartford Ballet
presents
Mikhail Baryshnikov

June 17 & 18, 1984
Bushnell Hall 8 p.m.

Hartford Ballet
1984/85 Season

Swan Lake

Nutcracker

Romeo and Juliet

Two dazzling
repertory seasons

Produced by
BLO Productions Inc

Poster:
Baryshnikov
Designer:
Bob Appleton
Design Firm:
Appleton Design
Hartford, CT
Client:
Hartford Ballet
Typographer:
Eastern Typesetting Co.
Printer:
Finlay Brothers

Catalogues:
Esprit 1985 Spring
Wholesale Catalogues
Designer:
Tamotsu Yagi
Photographers:
Oliviero Toscani, Uli Rose
Roberto Carra
Design Firm:
Esprit Graphic
Design Studio
San Francisco, CA
Client:
Esprit de Corp
Typographer:
Display Lettering & Copy
Printer:
Pacific Litho

Poster:
Pratt Talent Search:
Fashion
Art Director:
Michael McGinn
Designer:
Sharon Gresh
Artists:
Sharon Gresh,
Jim and Namiko Shefcik
Photographer:
Mikio Sekita
Design Firm:
Michael McGinn
Brooklyn, NY
Client:
Pratt Institute
Typographer:
JCH Graphics, Ltd.
Printer:
Crafton Graphic Co., Inc.

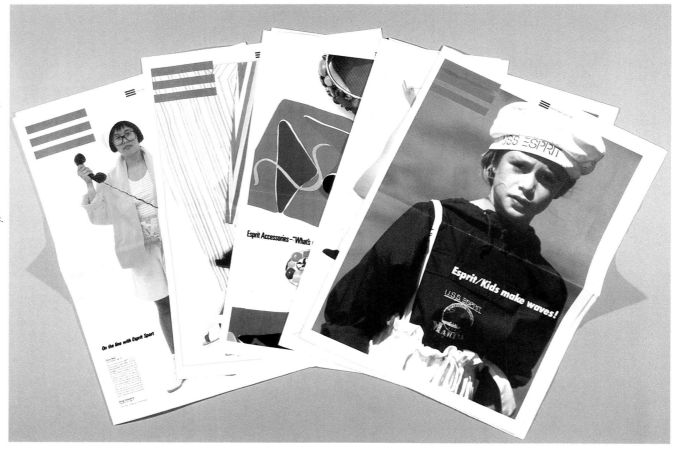

PRATT NATIONAL TALENT SEARCH

Pratt National Talent Search

Fashion

$100,000 in Scholarships

Scholarship Awards

One $30,000 four-year, full-tuition award

Three $10,000 four-year, $2,500 year awards

Two $6,000 awards for transfer students, $2,000 year

Eight $3,500 one-year awards for freshmen transfer students

Eligibility

The Fashion National Talent Search is open to all seniors in public and private high schools and transfer students in accredited colleges interested in a career in fashion design or merchandising.

Entry Requirements

1. All applicants are required to submit 10 to 20 slides of no less than 10 individual works of art design. Work may be fashion or non-fashion oriented. Slides must be submitted in 9˝ x 11˝ vinyl slide sheets. Include the following information on each slide: name, address, date of work, size (vertical dimension first), title, medium and top.

2. A completed entry blank should be clipped to the slide sheet.

3. Enclose a stamped, self-addressed envelope in which we may return your slides.

Calendar

February 1, 1985
Deadline for receipt of application and slides

February 15, 1985
Notification of pre-jury decisions

March 15, 1985
Deadline for receipt of original work from finalists

April 1, 1985
Notification of scholarship award winners

April 13, 1985
Reception for awards exhibition (Admissions Annual Open House)

April 1-16, 1985
Exhibition on view Pratt Institute Gallery

Awards Jury

Susan Jones
Chairperson
Fashion Design & Merchandising
Pratt Institute

Steve Leavitt
Design Staff
Anne Klein II

Laura Lukowski O'Brien
Merchandising
Account Executive
Perry Ellis Ltd.

Additional Information

For additional information and entry forms please contact:
Constance Bumgarner
National Talent Search
Pratt Institute
Brooklyn, New York
11205
(718) 636-3551

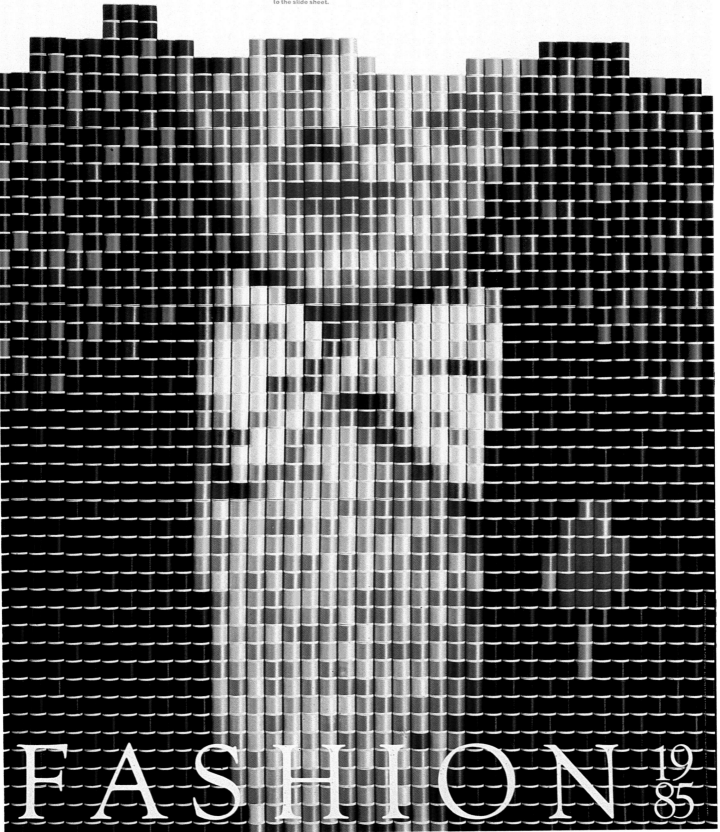

FASHION 19 85

**Construction Fence/
Environmental
Graphics:**
On Fifth Ave
and Around The World,
We Add Color . . .
Art Director:
John Luckett
Designer:
Wes Neal
Photographer:
Kelly Campbell
Design Firm:
Luckett & Assoc.
New York, NY
Client:
H. Stern Jewelers, Inc.
Letterer:
Active Signs
Printer:
Image Photo Service

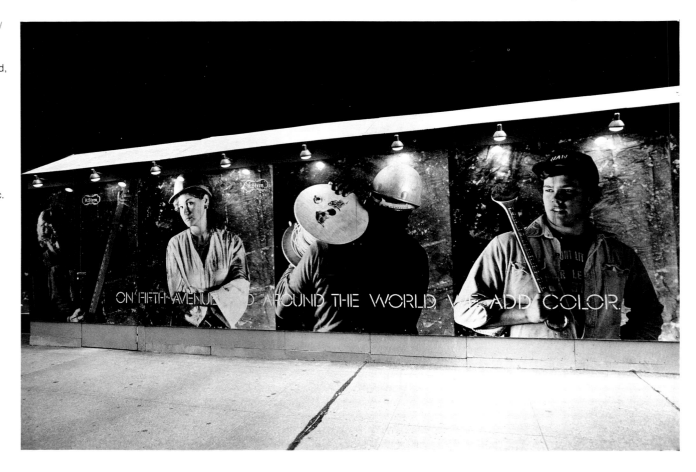

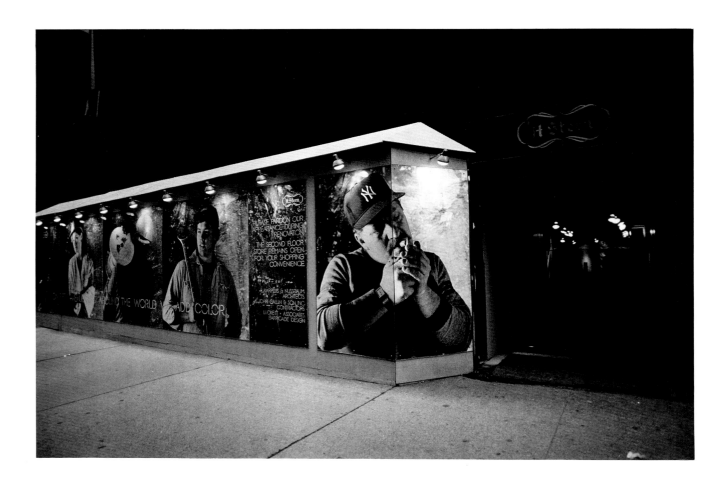

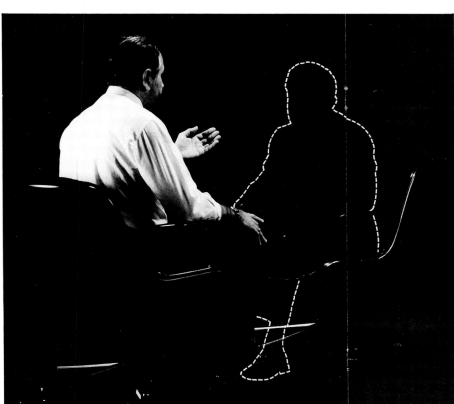

Learn to level with employees

Don't be afraid to tell
employees they're doing
something you don't like.

By Cheryl K. Needell
and George Alwon

Most managers are ambivalent about telling an employee that they do not like what he or she is doing. Many confuse assertiveness (the matter-of-fact verbalization of one's feelings) with aggression (attacking, loss of control, violence). But in fact, when aggression takes place, it is often because assertiveness has been avoided or because one was not skilled in effective confrontation.

How would you handle this situation? Barbara, a valued subordinate, has been arriving to work later and later over the past three months. This morning, you see her enter the office at 10 a.m., a full two hours late.

Would you feel inadequate or uncomfortable in dealing with Barbara? Would you be concerned that you will appear to be too aggressive or hostile, or that you will embarrass her? Would you have trouble getting psyched up to talk to her about her tardiness? Would you view confrontation as an obstacle to get over rather than as a challenge to meet?

Why we resist

If your answer to each of these questions is "yes," it's understandable. Like almost everyone else, you were brought up to avoid confrontation at all costs. How often have you heard, "That Janie is so nice to be around—never a nasty word about anything"? Many of us were brought up with the philosophy that it is best not to make waves.

Second, we all have a need to be liked, respected, and accepted by our peers. We are afraid that if we talk about things that others do not like, they will not like us.

Third, many of us mistakenly take responsibility for other people's feelings. When a friend does not like something we say, we ask ourselves, "Did we hurt his or her feelings?" We also often consider other people's feelings more important than our own. We often forget about our own hurt feelings when we do not say anything.

Fourth, our past plays a large part in a decision whether to confront someone in the present. If we had a bad experience because we either overreacted or were wishy-washy, we lose confidence in our ability to confront again. Or some past attempt may have been met with lack of support. For instance, did you once confront an employee for excessive absenteeism only to have your boss tell the worker not to worry about it?

Fifth, there is a fear of the negative consequences of one's actions—the "what if" syndrome: "what if... the situation gets worse instead of better; there are organizational repercussions and I lost my job; or the other person does something even worse to get back at me and I am blamed for the individual's behavior?"

Finally, wishful thinking and inertia allow us to procrastinate. We hope that the situation will improve on its own or we feel that this just isn't the "right" time. The longer we put the confrontation off, the more difficult it is to deal with, and the greater chance that we will overreact and experience negative consequences when we eventually say something.●

Corporate Magazine:
GTD Manager
Art Director:
Lloyd Banquer
Designer:
Wynn Medinger
Photographers:
Various
Design Firm:
Jones Medinger Kindschi, Inc.
Armonk, NY
Client:
IBM Corp.
Typographer:
Set to Fit
Printer:
Mill Printing, Inc.

Folder:
The Stendig Statement
Art Director:
Bridget DeSocio
Designer:
Bridget DeSocio
Photographer:
Henry Wolf
New York, NY
Design Firm:
Stendig International
Client:
Stendig International
Typographer:
Nassau Typographers
Printer:
Sterling Roman

Promotional Catalogue:
Rudolph de Harak &
Associates
Art Director/Designer:
Rudolph de Harak
Design Firm:
Rudolph de Harak &
Assoc.
New York, NY
Publisher:
Rudolph de Harak &
Assoc.
Printer:
Rapoport Printing

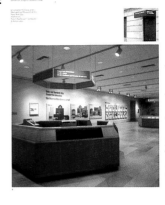

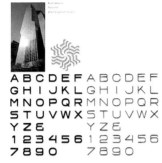

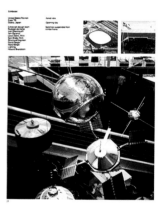
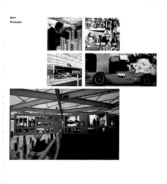

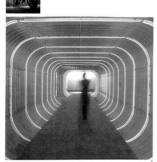

Poster:
AIGA San Francisco
Designer:
Michael Manwaring
Design Firm:
The Office of
Michael Manwaring
San Francisco, CA
Client:
AIGA San Francisco
Chapter
Printer:
Graphic Arts Center

Catalogue:
Esprit Sport
Fall 1984
Designer:
Tamotsu Yagi
Photographers:
Oliviero Toscani
Roberto Carra
Design Firm:
Esprit Graphic
Design Studio
San Francisco, CA
Client:
Esprit de Corp
Typographer:
Display Lettering & Copy
Printer:
Foote & Davies

Promotional Brochure:
Cordage Paper Graphics
Art Director:
Julius Friedman
Designers:
Julius Friedman
Walter McCord
Photographers:
Various
Design Firm:
Images
Client:
Cordage Paper Co.
Typographer
Adpro
Printer:
The Hennegan Co.

Exhibition Catalogue:
Slutzky
Art Director:
Rudolph de Harak
Designers:
Rudolph de Harak
Frank Benedict
Artist:
Robert Slutzky
Design Firm:
Rudolph de Harak &
Assoc.
New York, NY
Client:
Robert Slutzky
Printer:
Rapoport Printing

Brochure:
Herring Design Quarterly
#13: American Spirit
Designer:
Jerry Herring
Photographers:
Jerry Herring
Dick Spahr
Design Firm:
Herring Design
Houston, TX
Client:
Herring Design
Typographer:
Professional
Typographers
Printer:
Grover Printing

Dear Reader:
This has been an emotional, patriotic year for the U.S.A. Some of the patriotism has been overly commercial, but most of the displays have real substance and meaning. I have long been fascinated with public displays of patriotism, especially when practiced in an obvious way. The images I am offering you here come from people who feel good about their country and are not the least bit embarassed to say so. Hope you enjoy this little glimpse of American spirit.

J.H.

Annual Report:
Junior Achievement, Inc.
Annual Report 1984
Art Director:
Kenneth R. Cooke
Designers:
Courtney D. Reeser
Oscar Gonzalez
Photographer:
Tom Hollyman
Design Firm:
Landor Assoc./NYC
New York, NY
Client:
Junior Achievement, Inc.
Typographer:
Typogram
Printer:
Rapoport Printing Co.

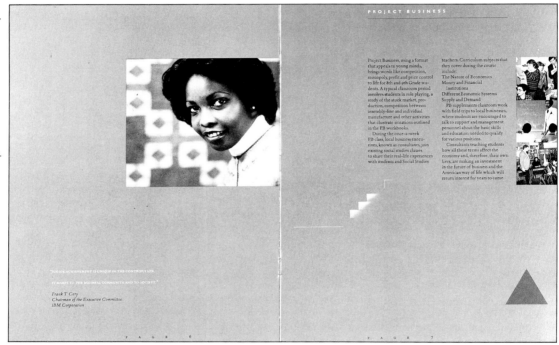

Brochure:
53rd at Third
Designer:
Jerry Herring
Photographers:
Michael Haynes
Steve Brady
Design Firm:
Herring Design
Houston, TX
Client:
Herring Design
Typographer:
Professional
Typographers
Printer:
Grover Printing

for Education, that identifies outstanding minority students—Blacks, American Indians, and Appalachian Whites—on the basis of seventh- and tenth-grade scores on statewide tests and gives them special attention. About 500 students have been identified to participate.

□ Xavier University of Louisiana's Project SOAR, now seven years old, which identifies Black high school seniors who are talented in the sciences and encourages them to pursue college-level studies in scientific fields, particularly premedical courses. Xavier is one of the nation's five leading sources of Black medical students.

□ A University of California at Berkeley professional development program that guides minority students from high school through graduate school in mathematics and science. The program's purpose is to increase minority participation at professional levels in these fields.

Clewell is examining these three programs to document their success and encourage their use as models for other programs. This year, she is conducting a survey of about 350 participants in the North Carolina program to assess their experiences.

For the Graduate Record Examinations Board, Clewell is also studying the persistence of Black and Hispanic doctoral students at six Eastern universities. In other words, she is attempting to determine what happens to Blacks and Hispanics once they are admitted to doctoral programs: Do they complete them or drop out? What factors influence them to continue or quit?

To find the answers, she is interviewing 60 Black and Hispanic students and 40 employees of the six universities. About the students, she is amassing data on personal characteristics, backgrounds, and educational experiences. About the institutions, she is gathering information on policies, practices, and other characteristics that may influence student persistence.

Language-Minority Students

"The more we know about the people who are being tested, the more surely we will be able to interpret the test results," says research scientist Richard Duran. "In fact, knowing more about the test takers is sound measurement science."

Few if any can match Duran's record for research into the characteristics of language-minority students, particularly Hispanics. During his years at ETS, he conducted a series of significant studies in this field. In the fall of 1984, he left to join the faculty of the University of California at Santa Barbara, but his work will continue to influence test development and interpretation.

In his final year, he completed a major project for the College Board, sketching a comprehensive profile of Hispanic college freshmen and the language factors that influence their performance. He also worked on two projects for the Graduate Record Examinations Board and one for the Policy Council of the Test of English as a Foreign Language, as well as working with Joan Baratz on the language-minority study for the National Assessment of Educational Progress (see page 8).

Meanwhile, at the ETS field office in Berkeley, researchers Rose Payan, Richard Peterson, and Mary Castille completed a study for the College Board of Mexican-American access to college in five states—Arizona, California, Colorado, New Mexico, and Texas. A similar study was conducted 10 years earlier, and this one attempted to measure progress during that period.

The research team found that Mexican-American college enrollments in the five states nearly doubled, but increased only 1 percent—from 10 to 11—as a

One scarcely need

be a vocalizing

feminist to observe

that women—along

with Blacks,

Indians, and . . .

other minorities—

have not been given

their due sufficiently

in American history.

Eve Merriam

Annual Report:
Educational Testing Service
1984
Art Directors:
Roger Cook
Don Shanosky
Designers:
Roger Cook
Don Shanosky
Rob Frankle
Design Firm:
Cook & Shanosky Assoc., Inc.
Princeton, NJ
Client:
Educational Testing Service
Typographer:
Elizabeth Typesetting
Printer:
Stephenson, Inc.

INVESTING IN BRIGHT PROMISES

The national and international reputation of PSR attracts a large number of qualified applicants for admission, more than we can accommodate. Thus, we can be selective, admitting a diversity of men and women who show bright promise. The composition of the student body has changed over the past decade. There is a greater proportion of women, the average age has increased, more are married when they come and many have children. More than 50 years ago the school's records show ethnic diversity among its students. Today, we continue this long tradition. Efforts to attract minority students must be sustained.

The presence of international students both enriches our common life and prepares leaders for Christian ministry with a more global perspective.

The presence of Asian students at PSR throughout our history is especially relevant to today's shrinking world. Our faculty is committed to the kind of teaching that fosters cross-cultural dialogue and that highlights Asia and the Pacific Basin. We have students who are training for leadership in their own countries and for service to the rapidly increasing number of Asian churches in this country.

In many ways, the need for additional financial support is felt most strongly among our students. Their commitment to serve religious institutions and non-profit agencies lies at the foundation of their professional and personal lives. And it also sets the potential of their future earnings at considerably lower levels than those of other professions.

The annual expense to each student of tuition, room, board and fees is more than $10,000. We cannot raise the tuition to the level of our costs and expect to enroll the range of students who wish to attend. To help ensure that PSR maintains diverse and highly qualified students, scholarships are needed for: international students who come for the education they need to become leaders in churches throughout the world; married students with young children who should not mortgage their futures beyond reason; single parents who have unique responsibilities and burdens; and minority students. To endow these scholarships, thereby ensuring that the talented and called can continue to receive quality education here, we are seeking to raise $1,200,000 for student support.

1916–1945

"We were made to feel that our Christian Faith must be made relevant and applicable to our day. And the hottest issue at the moment was: should we enter the Chaplaincy or take up some form of military service? Our nation was at war and singing its first great contest on foreign soil."

Letter from the Reverend Frederic W. Ellis '19.

The 1925 cornerstone laying ceremonies for the Charles Holbrook Library building (left). The building now houses the Bade Museum and the Howell Bible Collection.

From WWI through the Spanish Civil War, strife engulfed parts or all of the globe. Picasso's "Guernica," painted in 1937, stood as an ignored reminder of the horror and tragedy of it all.

Tycoons with tin cups, fireside chats and a song called "Brother Can You Spare a Dime," set the tone for the Depression years. The times also marked the end of Professor John Wright Buckham's PSR career, which began in 1903 in the chair of Christian Theology.

As WWII ended, veterans taking advantage of the GI Bill came to PSR. They added depth and power to the community.

Brochure:
Pacific School of Religion
Designer:
Michael Mabry
Photographers:
John McDermott
Michele Clement
Design Firm:
Michael Mabry Design
San Francisco, CA
Client:
Pacific School of Religion
Typographer:
Petrographics
Printer:
Interprint

Catalogue:
The Suit Book
Designer:
Arnold Goodwin
Photographer:
Jean Moss
Design Firm:
Arnold Goodwin Graphic Communications
Chicago, IL
Client:
Bigsby & Kruthers
Typographer:
Type Smith
Printer:
Bradley Printing Co.

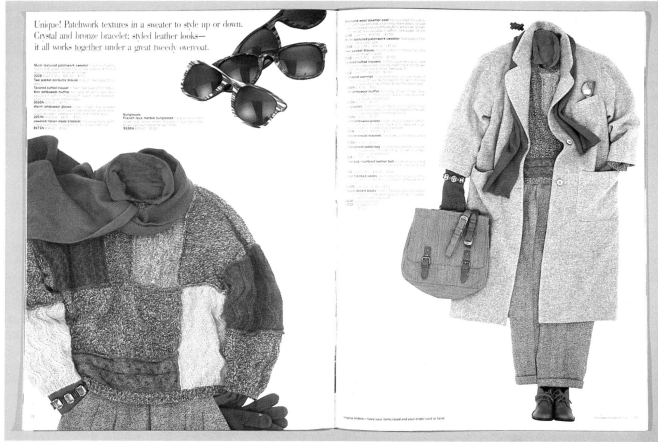

Catalogue:
Esprit Fall 1984
Designer:
Tamotsu Yagi
Photographers:
Oliviero Toscani
Roberto Carra
Design Firm:
Esprit Graphic
Design Studio
San Francisco, CA
Client:
Esprit de Corp
Typographer:
Display Lettering & Copy
Printer:
Foote & Davies

Stationery:
Sales Force
Art Director:
John Bielenberg
Designers:
John Bielenberg
Thurlow Washam
Design Firm:
The Marks Group
San Francisco, CA
Client:
Sales Force
Typographer:
Arrow Graphics
Printer:
Sales Force

Menu:
Galeto's Restaurant
Designer:
Jennifer Clark
Design Firm:
Jennifer Clark Design
New York, NY
Client:
Galeto's Restaurant
Calligrapher:
Jennifer Clark
Printer:
Land Litho.

Poster:
Seymour Chwast:
Munich
Designer:
Seymour Chwast
Design Firm:
Pushpin Lubalin
Peckolick
New York, NY
Client:
Bartsch & Chariau
Gallery

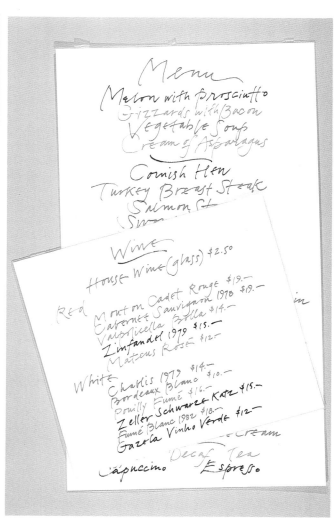

Seymour Chwast

5.6. – 28.7. ● 1984 Galerie Bartsch & Chariau Galeriestr. 2 8000 München 22

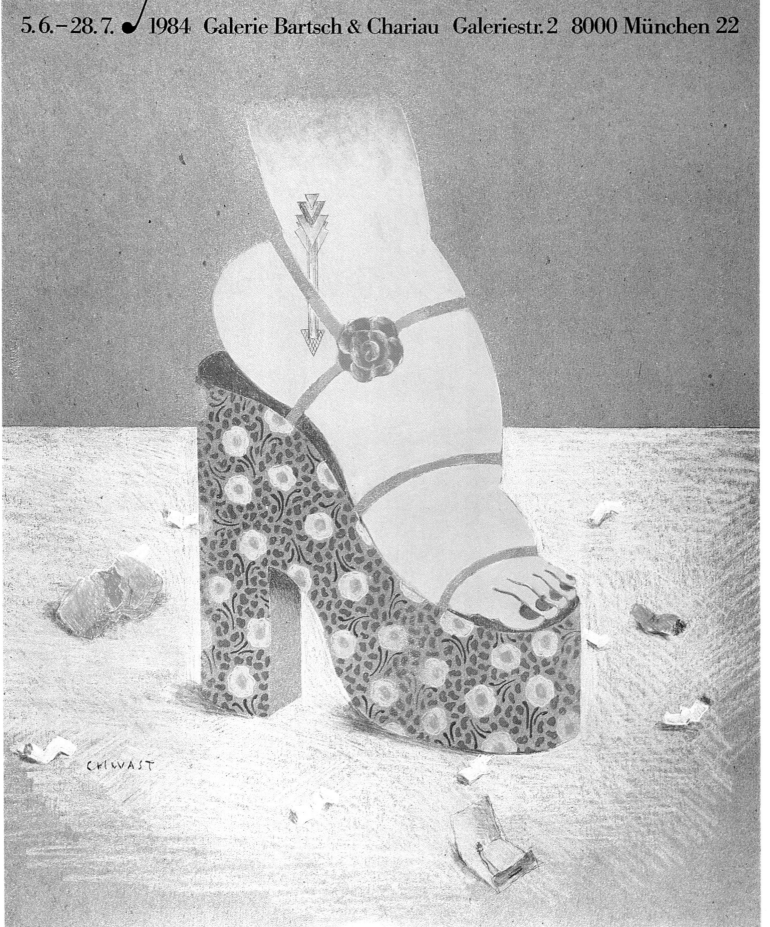

Promotional Booklet:
27 Chicago Designers #35
Art Director:
Joseph Michael Essex
Designers:
27 Chicago Designers
Photographers:
Tom Vack
Cory Pfister
Design Firm:
Burson Marsteller/
Americas
Chicago, IL
Client:
27 Chicago Designers
Printer:
Mossberg Co.

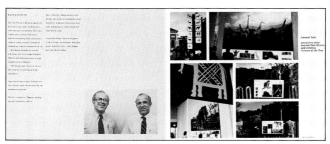

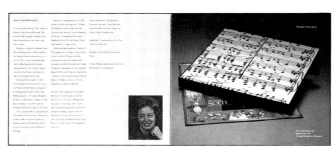

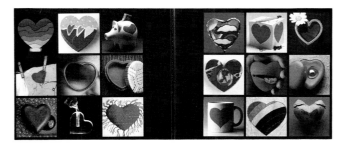

Brochure:
Jeffries Banknote
Company
Art Director:
Emmett Morava
Designer:
Douglas Oliver
Photographer:
Eric Myer
Design Firm:
Morava & Oliver
Design Office, Inc.
Santa Monica, CA
Client:
Jeffries Banknote Co.
Typographer:
Vernon Simpson
Typographers, Inc.
Printer:
Jeffries Litho. Co.

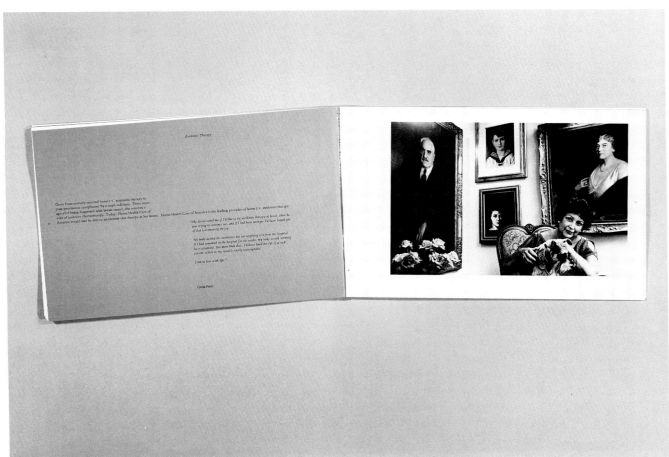

Annual Report:
Home Health Care of
America, Annual
Report 84
Designer:
Jim Berte
Photographer:
Deborah Meyers
Design Firm:
Robert Miles Runyan
& Assoc.
Playa del Rey, CA
Client:
Home Health Care
of America
Typographer:
Composition Type
Printer:
Lithographix

Annual Report:
Dow Jones Annual Report
1983
Designers:
Martin B. Pedersen
Adrian Pulfer
Design Firm:
Jonson Pedersen
Hinrichs & Shakery
New York, NY
Client:
Dow Jones & Co., Inc.
Typographer:
Boro Typographers, Inc.
Printer:
George Rice & Sons

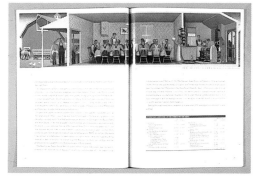

Annual Report:
Scouting 84
Art Director/Designer:
John Van Dyke
Photographer:
Bill Peterson
Design Firm:
Van Dyke Co.
Seattle, WA
Client:
Boy Scouts of America
Typographer:
Thomas & Kennedy
Printer:
Boeing Printing

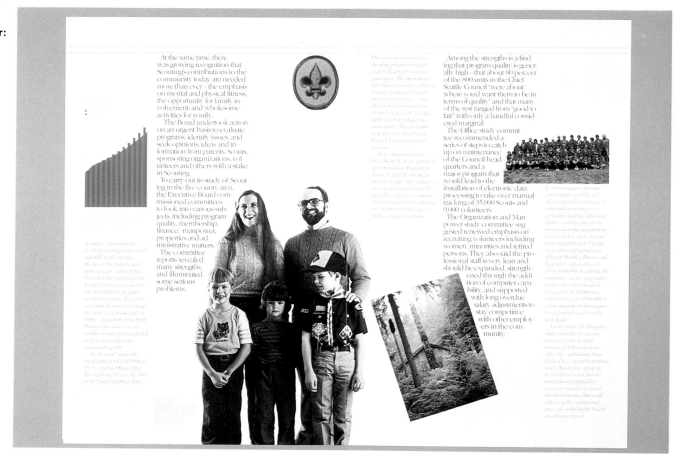

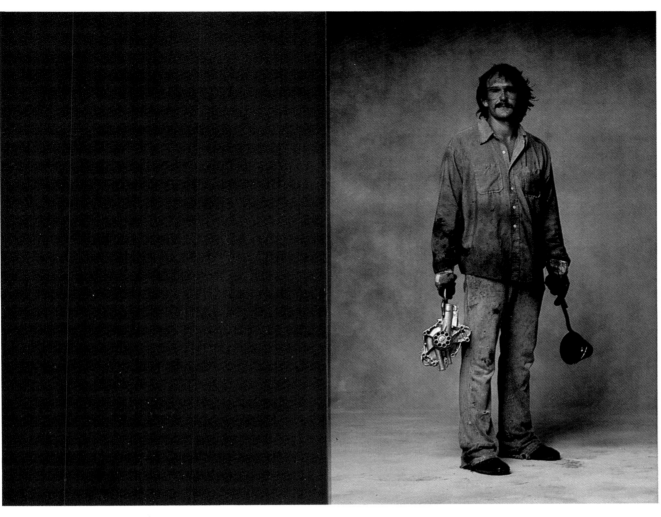

Brochure:
UIS, Inc.
Designers:
Martin B. Pedersen
Adrian Pulfer
Photographer:
Cheryl Rossum
Design Firm:
Jonson Pedersen
Hinrichs & Shakery
New York, NY
Client:
United Industrial
Syndicate
Typographer:
Boro Typographers, Inc.
Printer:
The Hennegan Co.

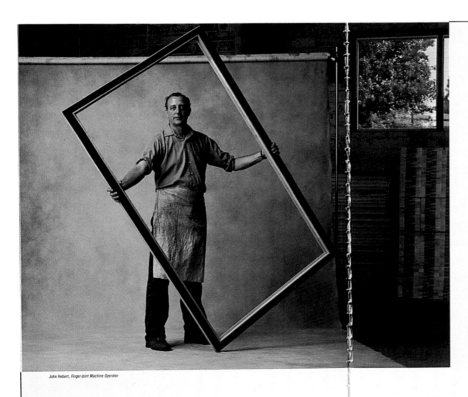

John Hebert, Finger-joint Machine Operator

HURD MILLWORK COMPANY

24

"In the past decade we've increased our sales volume five-fold....and we expect sales to double again in the next five years."

You might look for that kind of growth in the minicomputer field, but most people don't think of window frames as a growth industry. Yet, according to Ken Hallgren, president of Hurd Millwork, there has been lots of action in the highly competitive wood windowframe market.

It wasn't always that way: For nearly half a century, Hurd lumbered along making its standardized wood window frames and other commodity products. About 10 years after its acquisition by UIS in 1965, Hallgren joined the company as president, bringing an aggressive market-oriented approach to Hurd. As a result of his efforts, Hurd is today one of the leading manufacturers of frames, doors, and window units. Why the big change?

"Once I got here," says Hallgren, "we started to take a look at the marketplace and tried to predict what kinds of products might be popular in the future. We started listening to our field people who were saying 'Give us a maintenance-free unit'."

Hurd's timing was perfect in anticipating the market for an aluminum-clad window, a new product which was equally well-received by both the new housing and replacement markets. The success of other new products, including a "heat mirror" window which increases insulating value by 30 percent, has required some reevaluation of the company's manufacturing and marketing channels.

As a result of the impressive growth in this market, UIS acquired Wisconsin Window Unit Company of Merrill, Wisconsin in 1981. After a reconfiguration of the 200,000 square foot facility, the operation has doubled the manufacturing capacity of nearby Hurd Millwork.

"Our rapid growth has strained our own capital resources," says Hallgren, who funnels any excess cash flow into inventory expansion. "When greater production and new equipment were needed," he says, "UIS was ready to help. When we acquired Wisconsin Window Co. we added our products to their existing line. Today, we make a better product — stronger and more maintenance free — because we've been able to invest in more sophisticated manufacturing. It allows us to remain competitive with a higher quality product."

"It's a pleasure to work here compared with other large companies I've worked for. If something's a good idea, it gets done right away. We can assess the marketplace quickly and get a new product out while our competitors are still scheduling meetings to discuss the idea. We keep UIS appraised of our progress but it's a nice, informal environment. I like it here."

Builders and contractors are also served by Three States Supply Company of Memphis. Acquired in 1977 and managed by Charles Brejot, the company recently opened a branch in Nashville to expand the supply of steel and sheet metal products and building materials to some of the same types of customers served by Hurd.

25

83 Weyerhaeuser Report

Annual Report:
Weyerhaeuser
Annual Report 1983
Art Director/Designer:
John Van Dyke
Photographers:
David Watanabe
Steve Welsh
Steve Firebaugh
Design Firm:
Van Dyke Co.
Seattle, WA
Client:
Weyerhaeuser Co.
Typographer:
Paul O. Giesey
Printer:
Graphic Arts Center

Weyerhaeuser began 84 years ago as an owner of land and a buyer, seller and manager of timber. Through the decades it has added to its land base, intensified its forest management to make those lands more productive, and has increased the extent and the diversity of the products manufactured, distributed and marketed from the wood grown on those lands. Today, approximately 80 percent of the Company's business involves forest products in one form or another—from timber, log, and residual wood chips, through a vast array of building materials, pulp, paper, and packaging products, sold in more than 60 nations. The Company is the only major forest products firm having net self-sufficiency in raw material from its own lands, and normally is a net seller of raw materials. But, we are not "hostage" to our land base. We have access to government timber both foreign and domestic. And, in all U.S. locations we buy and sell raw materials.

Weyerhaeuser's forest products include such readily identified ones as logs and lumber (opposite and center bottom). But, the more rapidly growing family of products are those based on pulped wood. They include newsprint for West Coast and Japanese newspapers, and shipping containers for a vast variety of manufactured and agricultural goods, a basic essential for the shipment of products in national and world commerce. They also include paperboard cartons for liquids, making a comeback over plastic containers, and printing papers, as well as a myriad of chemical and plastic materials based upon wood pulp.

Some newer materials, such as Structurwood® top center, utilize wood fibers separated and recombined to make best use of their engineered properties. All of the wide range of basic forest products begin with tree seedlings grown into mature trees in managed forests.
With the startup of our Columbus, Mississippi, mill in August, 1982,

Weyerhaeuser has become a significant factor in one of the fastest-growing U.S. fine paper markets, that for lightweight coated papers, used to publish magazines, catalogues—and this Annual Report.

Brochure:
"7" Merrill Lynch
Bank Suisse (S.A.)
Art Director:
Kenneth Carbone
Designer:
Eric Pike
Photographers:
Various
Design Firm:
Carbone Smolan Assoc.
New York, NY
Client:
Merrill Lynch
Typographer:
Concept Typographers
Printer:
The Hennegan Co.

Merrill Lynch Bank (Suisse) believes that people are the most important element in a banking relationship. Superior service requires attention to detail and quality, and accommodation to the individual needs of the substantial investor. At Merrill Lynch Bank (Suisse) clients will find an expert staff that responds to your needs with flexibility and discretion in a very personal way.

As a client of Merrill Lynch Bank (Suisse) you may choose to deal exclusively with a dedicated and knowledgeable private banker in Geneva, who will coordinate and oversee your financial affairs. Your private banker will become intimately familiar with your investment objectives and will act in strict accordance with your instructions. If you wish to conduct your Swiss banking business from a location more convenient than

Geneva, you may authorize an experienced account executive in one of Merrill Lynch's offices worldwide to relay orders for your account. Your account executive or private banker will keep you abreast of changes within the economic environment in leading money centers, identifying opportunities that may be particularly relevant to your interests. They will monitor the continuing performance of your portfolio, and recommend strategies and actions that represent a prudent course for you to pursue.

Personal investment corporations can be structured to accommodate the specific requirements of the individual investor, whether he or she is concerned with confidentiality, tax advantages or the eventual distribution of assets to heirs.

Merrill Lynch Bank (Suisse) S.A. deals with each client individually and discreetly, recognizing that investment strategies and performance objectives, while unique for each investor, must be carried out with uniform expertise.

MERRILL LYNCH BANK (SUISSE) S.A.
Personal Service

Promotional Brochure:
The Art of the
Annual Report
Art Director:
Kit Hinrichs
Designers:
Kit Hinrichs
Lenore Bartz
Artists/Photographers:
Various
Design Firm:
Jonson Pedersen
Hinrichs & Shakery
San Francisco, CA
Client:
Northwest Paper Co.
Typographer:
Reardon & Krebs
Printer:
Anderson Lithograph

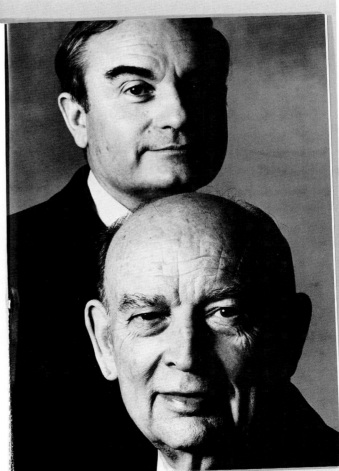

The View from 11 Wall Street

Over the past eight years, it has been our good fortune to work together toward the goal of making the New York Stock Exchange the highest-quality, most cost-effective marketplace in the securities industry. Now, as we prepare for an orderly transfer of leadership, it seems appropriate to examine how this institution has changed since 1975—the gloomiest of watershed years for the Exchange and the industry. Fundamental changes in the governing structure of the Exchange were adopted in 1972. But the Exchange, in 1975, was still widely viewed as a relic of an earlier era, concerned primarily with the economic interests of its members. Its prestige among corporate and government leaders, investors and academic economists had seriously eroded.

Years of sparring with government regulators had sapped much of the institution's strength and vitality. Inevitably, nearly a decade of destructive criticism had weakened the Exchange's confidence in its own economic relevance.

Public ownership of corporate equities had declined precipitously, reversing a generation of accelerating public participation in the market.

Although the Consolidated Tape began operating in 1975, and both the Composite Quotation System and a new small-order delivery system (DOT) were nearing implementation, critics complained about the Exchange's perceived reluctance to adapt technology to the needs of a modern securities marketplace.

Ill-wishers predicted that the abolition of fixed public commission rates—which also took effect in 1975—would create a competitive environment in which the Exchange would be unable to survive. And even if it did manage to adjust to the anticipated economic upheaval, they said, the Congressional call for a National Market System would soon make it obsolete anyway.

An air of doom and gloom pervaded the Exchange Community. Fear of unknown and unpredictable economic and technological challenges gripped much of the membership.

The task of reaffirming the pre-eminence of the New York Stock Exchange among the world's securities markets posed a three-fold challenge to the Board of Directors and senior management:

First, to change the perceptions and regain the confidence of customers and constituents whose faith in the Exchange as an integral part of our national economy had diminished.

Second, to strengthen the Exchange's role as a quasi-public, self-regulatory institution committed to serving and protecting the legitimate interests of all users of its marketplace.

And third, to maximize, through modern technology and even-handed application of fair and effective rules, policies and procedures, the efficient, cost-effective operation of the marketplace itself.

For us, it has been a privilege to work toward those goals with the Exchange's deeply committed, hard-working Board of Directors, with an increasingly dedicated Exchange membership, with scores of other concerned and knowledgeable constituents, and with a loyal, professional staff of officers and employees.

We have come a long way since 1975. The Exchange faces the future with confidence in its ability to meet whatever challenges may lie ahead.

Others will be the best judges of whether vigorous teamwork has reaffirmed the dynamic relevance of one of America's great financial institutions.

With the transfer of leadership just a few months away, we extend our sincere gratitude to everyone who has helped, over the past eight years, to revitalize the New York Stock Exchange and to assure that it continues to be the world's premier securities marketplace.

John J. Phelan, Jr.
John J. Phelan, Jr.
President and
Chief Operating Officer

W. M. Batten
W. M. Batten
Chairman and
Chief Executive Officer

2

Annual Report:
New York Stock Exchange
1983 Annual Report
Art Director:
Eugene Grossman
Designers:
Eugene Grossman
Richard Felton
Photographers:
Black & White: Irving Penn
Color: James Salzano
Design Firm:
Anspach Grossman
Portugal
New York, NY
Client:
New York Stock Exchange
Typographer:
Print & Design
Printer:
Sanders Printing Corp.

Corporate Magazine:
Potlatch Story, June 1984
Art Director:
Kit Hinrichs
Designers:
Kit Hinrichs
Lenore Bartz
Illustrators:
Colleen Quinn
Carol Vibbert
Tim Lewis
Hank Osuna
Photographers:
Henrik Kam
Tom Tracy
George Steinmetz
Design Firm:
Jonson Pedersen
Hinrichs & Shakery
San Francisco, CA
Client:
Potlatch Corp.
Typographer:
Spartan Typographers
Printer:
Graphic Arts Center

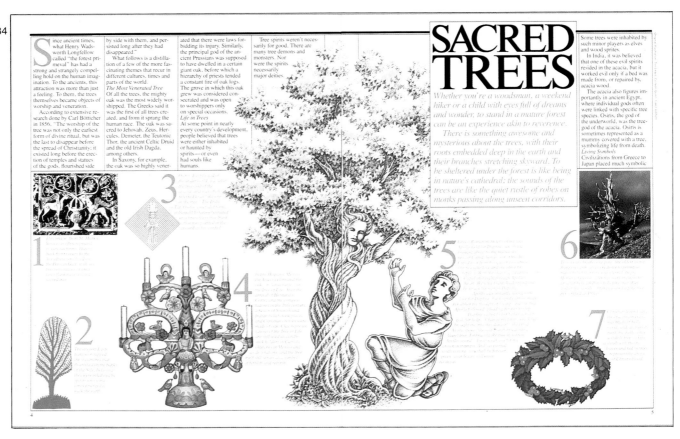

SACRED TREES

Whether you're a woodsman, a weekend hiker or a child with eyes full of dreams and wonder, to stand in a mature forest can be an experience akin to reverence.

There is something awesome and mysterious about the trees, with their roots embedded deep in the earth and their branches stretching skyward. To be sheltered under the forest is like being in nature's cathedral; the sounds of the trees are like the quiet rustle of robes on monks passing along unseen corridors.

Since ancient times, what Henry Wadsworth Longfellow called "the forest primeval" has had a strong and strangely compelling hold on the human imagination. To the ancients, this attraction was more than just a feeling. To them, the trees themselves became objects of worship and veneration.

According to extensive research done by Carl Bötticher in 1856, "The worship of the tree was not only the earliest form of divine ritual, but was the last to disappear before the spread of Christianity; it existed long before the erection of temples and statues of the gods, flourished side by side with them, and persisted long after they had disappeared."

What follows is a distillation of a few of the more fascinating themes that recur in different cultures, times and parts of the world.

The Most Venerated Tree
Of all the trees, the mighty oak was the most widely worshipped. The Greeks said it was the first of all trees created, and from it sprang the human race. The oak was sacred to Jehovah, Zeus, Hercules, Demeter, the Teutonic Thor, the ancient Celtic Druid and the old Irish Dagda, among others.

In Saxony, for example, the oak was so highly venerated that there were laws forbidding its injury. Similarly, the principal god of the ancient Prussians was supposed to have dwelled in a certain giant oak, before which a hierarchy of priests tended a constant fire of oak logs. The grove in which this oak grew was considered consecrated and was open to worshippers only on special occasions.

Life in Trees
At some point in nearly every country's development, people believed that trees were either inhabited or haunted by spirits—or even had souls like humans.

Tree spirits weren't necessarily for good. There are many tree demons and monsters. Nor were the spirits necessarily major deities.

Some trees were inhabited by such minor players as elves and wood sprites.

In India, it was believed that one of these evil spirits resided in the acacia, but it worked evil only if a bed was made from, or repaired by, acacia wood.

The acacia also figures importantly in ancient Egypt, where individual gods often were linked with specific tree species. Osiris, the god of the underworld, was the tree-god of the acacia. Osiris is sometimes represented as a mummy covered with a tree, symbolizing life from death.

Living Symbols
Civilizations from Greece to Japan placed much symbolic

Where did the arts begin? Their roots are so intertwined that their origins can only be imagined. However, the earliest printed images known to man were relief prints made from woodcuts.

The art form probably originated with the Chinese who invented paper in the second century and quickly found a way to make repeated images on it.

By the fourth century, the Chinese were turning out woodcut prints on the new paper, and by the year 1050, they were printing whole woodcut books. The neighboring Japanese borrowed the concept—along with the paper—from the Chinese, and by the year 770 were creating woodcut prints of their own.

Not until much later—after Marco Polo returned from the Orient at the end of the 13th century—were woodcuts produced in Europe. It was then that paper manufacturing was introduced to the West—the first mill was built in Germany in 1320—and that woodcuts began to appear.

By the 15th century, European craftsmen had refined the medium from simple "coloring-book" type heavy lines to finely detailed, shaded pieces. Most noteworthy was Albrecht Dürer, a German painter and printmaker who created the macabre *The Four Horsemen of the Apocalypse.*

Woodcut prints became the "pop" art of the medieval age. Never before had it been possible to make several thousand copies of an image. For a few pennies, anyone could purchase prints—mostly of Christian icons.

As mass print production improved, woodcut prints fell by the wayside. Although not a lost or dead art today, its pulse is barely perceptible, faded in the blurry panorama of "new" graphics. Contemporary woodcut prints are not easily found because the number of those with the combination of artist's talent and craftsman's skills grows smaller.

Interest in preserving and enhancing this art medium encouraged Potlatch to commission master woodcut artist Vincent Perez to produce a series of woodcuts depicting forest products activities in each of the company's three operating regions—Arkansas, Idaho and Minnesota. Potlatch saw the project as an opportunity to capture the color and drama of our industry, while paying tribute to a medium that uses both wood and paper.

Perez created a limited series of 400

Ancient Art of Woodcuts

Relief prints made from woodcuts were the first mass-produced images invented by man. Woodcuts survive today as a classic art form.

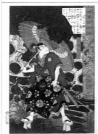

sets of six historic and contemporary Potlatch scenes—an Idaho log drive, an Arkansas mule skidding team, an early Minnesota logging sled, the modern-day Minnesota paper mill, the St. Maries, Idaho, plywood lathe, and the Warren, Ark., log merchandiser.

To put authenticity into his drawings, Perez toured Potlatch's operations to see the equipment and people firsthand, and studied material from Potlatch archives and other reference sources.

Perez's first step toward making the woodcuts was to draw a rough pencil sketch, based on what he had seen, read, and been told. For the contemporary scenes, he shot several rolls of film at the mills, which he had made into photo proof sheets. "I studied the proofs because the sequential frames showed activities that were both constant and moving. They were helpful in telling a story and making sense of the production process," Perez says.

"Most of the proofs showed fairly automated machinery at work, but occasionally I'd find a person in a location that would give scale to the scene and humanize the process," he adds. "That's what I'd grab onto." The results were "freeze-frame" images in his woodcuts.

Drawing with pencil or felt pen, Perez used tissue overlays as he continued correcting the scene. He worked to a finished but not final drawing. "I didn't want to go too far and have a really fine-tuned drawing because I wanted the gouges and the wood to do the drawing," Perez comments. "I could have taken it all the way but then all I'd be doing was copying. I wanted some of the character of the wood."

To complete the drawing, Perez reversed the image with carbon paper or another soft paper so the pencil wouldn't emboss the wood's surface. "I didn't want to damage the wood's surface," he emphasizes. The transfer drawing was finished with pen or brush and ink. Perez then stained the block with a dab of burnt sienna oil paint and a small amount of linseed oil before cutting.

His cutting tools are surprisingly few and simple. Perez works with a round magnifying lens with a fluorescent tube and three Japanese-made gouges he purchased in the 1950s.

The degree of fineness and detail is determined not only by the skill of the cutter but also by the quality and type of wood available.

Woodcuts are made using the grained or plank side of lumber. The coarseness and grain direction become major considerations for final results. Perez's preference is cherrywood "because it's tight and close-grained, as are pear and other fruitwoods." This permits intricate cutting both with and against the grain. "Oak is too open-grained, redwood is too soft and splintery, and in softer woods, such as pine or fir, the grain is more

On some Potlatch lands in Idaho, harvest time might come only once a century, since it can take nearly an average person's lifetime for a tree to reach sawlog-size maturity.

Rotation periods can be equally long in northern Minnesota, while lands in southern Arkansas produce sawlogs as often as every 35 years.

Growing and harvesting raw material is a complex task. Even before one tree is cut, woodlands experts devote many hours to studying the ramifications of a harvesting plan on overall forest management. They sometimes need to act as trustees for young stands of trees that will be bequeathed to another generation to harvest. At the same time, supplying sufficient raw materials to meet current demand is essential.

At Potlatch, each mill specifies how much wood fiber it will need to run its

Idaho

Of our three timberland regions, Idaho presents the most challenging logging conditions and grows the largest trees.

However, steep slopes normally require the use of cable systems to lift logs to loading areas.

In Idaho, Potlatch manufactures a variety of wood products, household tissue, and bleached pulp and paperboard.

logs to give better spacing to young stands. Selective harvesting and overstory removal take out designated trees which block light and rob nutrients and moisture from younger, faster-growing trees. Other areas may call for a clearcut—complete removal of a tract of timber, for economic or environmental reasons.

By implementing varied silvicultural, or "farming," methods, it is possible to achieve specific management objectives, while pulling together the sizes and species required by the mills.

Keeping all these factors in mind, logging managers

Harvesting Timber

manufacturing operations for the year. Specialists trained in logging and forestry analyze these budgets to determine how much wood to cut and in what sizes and species. With this information, they determine harvest sites, equipment mix, and a delivery schedule.

A key consideration in their calculations is the concept of sustained yield/allowable cut. This means that in establishing a harvest plan, managers must balance wood fiber needs, both current and future, with the rate of forest regeneration.

Arkansas

Temperate climate, abundant rainfall and relatively flat, fertile terrain give southern Arkansas productive timber growing and harvesting conditions.

Potlatch's Arkansas stands are mostly pine, with a mixture of hardwoods dominating the bottomlands.

While most tree harvesting is still done with chainsaws, mechanical equipment is coming into broader use on small diameter trees.

In Arkansas, Potlatch converts timber to construction lumber, specialty wood products and bleached paperboard.

In Arkansas, Idaho and Minnesota—Potlatch's three wood basket regions—the woodlands departments satisfy volume requirements through a combination of logging on company land, buying contracts to log on other ownerships, both public and private, and log purchases.

Economic considerations are basic to any harvest scheme, which also must consider terrain, timber size and conditions, stream and drainage patterns, soil types and wildlife protection.

Incorporated into the plan are a number of forest management options. For instance, some raw material can be secured from commercial thinning—the removal of small diameter

plot boundaries for stream buffer zones, skidding trails, yarding sites, and road construction that will protect the forest floor and prevent soil erosion.

From there, loggers determine the complement of equipment needed to carry out the operation efficiently and economically.

After the entire harvesting plan has been laid out, the logging crew is ready to move in. As part of the evolution of forest management into a science, logging has become less an occupation of brawn and daring, and more of an exacting skill. Over the years integrated forest products companies have learned to utilize parts and grades of logs that at one time had no market value. As a result, the logger's skill is more critical because it affects total wood fiber recovery and the products that can be made from the log.

In many ways, timber harvesting must be viewed as the essential preparatory step to a new growth cycle, as well as the culmination of the old. After all, timber management involves much more than cutting down trees and moving them out of the woods. The care that we take in managing our timber supply is our legacy to future generations.

Minnesota

Northern Minnesota's timber region is characterized by mixed hardwood/softwood stands, small diameter trees, and extreme seasonal temperature swings.

To utilize the local forest's special fiber qualities, Potlatch manufactures fine printing and business papers, oriented strand board and construction lumber in the state.

Since many of Minnesota's forests have small diameter trees and relatively flat terrain, they lend themselves to mechanical harvesting.

Annual Report:
Potlatch 1983 Annual Report
Art Director:
Kit Hinrichs
Designers:
Kit Hinrichs
Nancy Koc
Artists:
Will Nelson
Justin Carroll
Colleen Quinn
Photographer:
Tom Tracy
Design Firm:
Jonson Pedersen
Hinrichs & Shakery
San Francisco, CA
Client:
Potlatch Corp.
Typographer:
Reardon & Krebs
Printer:
Anderson Lithograph

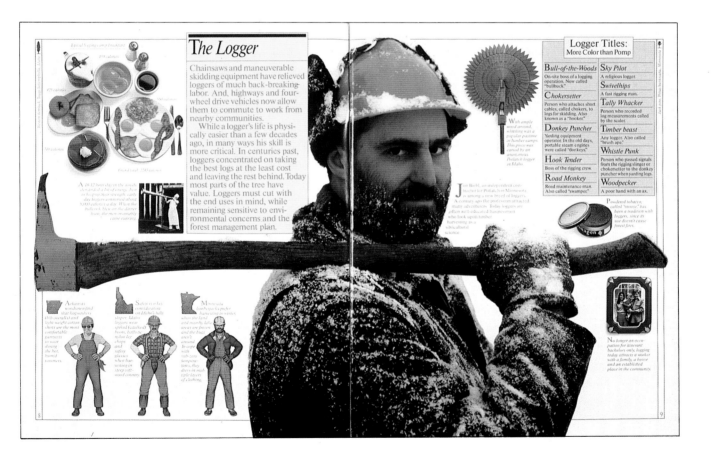

The Logger

Chainsaws and maneuverable skidding equipment have relieved loggers of much back-breaking labor. And, highways and four-wheel drive vehicles now allow them to commute to work from nearby communities.

While a logger's life is physically easier than a few decades ago, in many ways his skill is more critical. In centuries past, loggers concentrated on taking the best logs at the least cost and leaving the rest behind. Today most parts of the tree have value. Loggers must cut with the end uses in mind, while remaining sensitive to environmental concerns and the forest management plan.

Logger Titles: More Color than Pomp

Bull-of-the-Woods
On-site boss of a logging operation. Now called "bullbuck."

Chokersetter
Person who attaches short cables, called chokers, to logs for skidding. Also known as a "hooker."

Donkey Puncher
Yarding equipment operator. In the old days, portable steam engines were called "donkeys."

Hook Tender
Boss of the rigging crew.

Road Monkey
Road maintenance man. Also called "swamper."

Sky Pilot
A religious logger.

Swivelhips
A fast rigging man.

Tally Whacker
Person who recorded log measurements called by the scaler.

Timber beast
Any logger. Also called "brush ape."

Whistle Punk
Person who passed signals from the rigging slinger or chokersetter to the donkey puncher when yarding logs.

Woodpecker
A poor hand with an ax.

More than this, MCI's communications system is a basic resource that we can employ to bring ever more sophisticated services to our customers. With packet switching, for sending data in short bursts, and long distance digital transmission, we can deliver MCI Mail instantly across the country. As it costs us less to provide these higher value services, it costs our customers less to use them.

With capacity growth, MCI will reach an increasing number of new cities via its own network, rather than with leased lines. To take full advantage of equal access, MCI plans to be in a position to offer universal origination and termination to each of the regional calling areas established by divestiture. This will reduce our use of leased line facilities, and the costs we incur to provide universal termination.

MCI already is offering intrastate long distance service in Texas, Ohio, Florida, Maryland, Pennsylvania, New York and Iowa. In addition, California, West Virginia, Alabama and Indiana have authorized MCI to provide long distance service within the state, and applications are pending in 16 other states.

With new international switches located in the suburbs of Los Angeles and New York City, we are set to offer low-cost MCI service in all parts of the world.

SERVING A GROWING MARKET

MCI is offering an array of telephone services in the equal access environment. There is dial "1," which becomes available in each city as equal access is provided. We also are retaining 22-digit dialing in equal access markets, and we are offering a new dialing arrangement, known as 10222. People who are not MCI customers, but who want to choose MCI for specific calls, can dial 10222 and access our long-distance system at MCI prices.

This year we will eliminate subscription fees and special rates for calls terminating off the MCI network. We will offer 24-hour calling for all services, discounts for volume users and a new telephone credit card, which can be used virtually everywhere.

MCI is expanding its marketing dramatically through a new computerized telemarketing center. More than 1.5 million potential new customers are called each month.

During the year, MCI introduced the nation's first public telephones that can be activated by national credit cards—MasterCard or Visa. Card-caller public telephones will be introduced in airports and other busy locations in 1984. MCI also is pursuing cooperative arrangements with the local Bell operating companies, whereby customers can access MCI directly on public telephones. Mountain Bell, a division of U.S. West, has introduced the first equal access public telephones, "gold phones" at Denver's Stapleton International Airport. Boston's Logan Airport has more than 170 equal access phones in place.

For our business customers, MCI is offering an expanded WATS service and an improved corporate account service. A new T1 service, introduced in April for volume business applications, is a very cost-effective means to transmit large amounts of data. Later this year, we will introduce a software-defined network that will allow sophisticated users to have virtually a private network and cater to their own particular voice and data needs.

MCI "Advantage" offers maximum savings and convenience to small business customers. This "miracle in a small box"—in this case a microprocessor inspired by MCI, built to our specifications and installed at a customer's location—automatically dials the customer's access number and authorization code and can be used by rotary dial phones to access MCI. Advantage customers increased nearly five-fold last year, from 13,000 to 70,000.

MCI makes it a point to introduce innovative advertising and marketing promotions to the industry. Burt Lancaster joins Merv Griffin and Joan Rivers, all MCI customers, in our first use of celebrity spokespersons. This effort is supported by attention-getting and business-holding promotions. American Express has, for the past two years, marketed our services to its cardholders, and our American Express customers are now approaching 250,000. We also have reached an agreement with Sears, Roebuck and Co., whereby Sears Merchandise Group promotes our long distance service to its credit card customers.

MCI is the official supplier of telex and international electronic message services at the 1984 Olympic Games, and we will provide service for the press corps at the Democratic and Republican National Conventions.

Of the many and exciting prospects at MCI, none is more exciting than extending our reach internationally, as we introduce new technologies and our low prices to every part of the globe. This year will be a time of rapid movement toward MCI's goal to become an international communications company.

We have reached agreements with Australia and Belgium to inaugurate direct dial service later this year, after operational arrangements have been completed. This year, the Federal Communications Commission also approved testing of direct dial service to Greece and Spain, and we are in the midst of promising discussions with other countries in all parts of the world.

MCI began dial-up service to Canada last year, and this service has achieved levels of use that MCI and our Canadian partners did not expect to attain before 1985. We also offer dedicated, or leased private line, service to the United Kingdom and Belgium.

The extension of direct dial service overseas opens the way to dramatic expansion for MCI. MCI's purchase of Western Union International in 1982 gave a valuable understanding of the international marketplace, and an entry into a $4 billion market that we did not serve—a market which is growing at approximately 20 percent a year, faster even than the domestic long distance market.

INTRODUCING NEW SERVICES

Quality, cost-effective long distance service is the heart of MCI, but our goal is to become a full-service telecommunications company. As our customers become more sophisticated in the services and products of the information age, they will demand equal sophistication from us.

MCI is strongly positioned in the new areas of paging and cellular telephone service. In the next year, MCI will provide new cellular car telephone service in Minneapolis-St. Paul, Pittsburgh, Denver-Boulder and Cleveland. MCI also has received initial approval from the FCC to provide service in the greater Los Angeles area and has applications pending in other large metropolitan areas.

Cellular technology brings new advantages to car telephone service: clear transmission, greatly expanded capacity, a competitive price, and nationwide compatibility. As a result of these innovations, the mobile telephone market in the U.S. is expected to grow from less than 200,000 conventional mobile telephone users today, to more than one million cellular car telephone users by the end of the century.

Cellular technology also promises the truly portable phone. Within a few years, it will be as common to carry a portable phone in one's briefcase as it is now to carry a pocket calculator.

Paging is also undergoing dramatic change. It has evolved from a "locator" service to a message delivery service, where

12 13

Annual Report:
MCI Communications
Corp.
Annual Report 1984
Art Director:
Peter Harrison
Designer:
Susan Hochbaum
Artist:
Steven Guarnaccia
Design Firm:
Pentagram Design, Ltd.
New York, NY
Client:
MCI Communications
Corp.
Typographer:
CTC Typographers Corp.
Printer:
Stephenson, Inc.

Brochure:
67,455 solid reasons
to lease in
City Post Oak
Designer:
Jerry Herring
Photographer:
Steve Brady
Design Firm:
Herring Design
Houston, TX
Client:
Gerald D. Hines Interests
Typographer:
Professional
Typographers
Printer:
Grover Printing

74 law and accounting firms have a City Post Oak address. Together with numerous brokerage, architectural and other professional firms, they provide an unprecedented level of service to this dynamic business community.

9 full service commercial banks are located in City Post Oak. For businesses, that means quick turnaround on all banking transactions. And for individuals, it means a complete line of personal banking services just minutes away from work.

43 computer stores, copying centers, travel agencies, office supply and furniture stores: all are dedicated to taking care of business for businesses in the City Post Oak area.

58 great places to eat—from the Arbor Room to Zucchini's and everything in between—can all be found right here. Whether it's casual fare or continental cuisine, it's never more than minutes away in City Post Oak.

308 department stores and specialty shops offer everything from fine clothes to cameras, books to baggage, vitamins to valises, graphics to greenery and almost anything else required to support a business image or idea.

4,689 of Houston's finest hotel rooms are available in such respected hotels as the Guest Quarters, Holiday Inn, the Houstonian, the Inn on the Park, Intercontinental Houston, the Marriott, the Remington, the Grand, the Warwick Post Oak, the Westin Oaks and Westin Galleria.

YOUR OWN PRIVATE BANKING TEAM
Because we are totally committed to the concept of Private Banking, we limit the number of clients for which each Private Banker is responsible. Your Private Banker will handle all of your accounts, transactions and inquiries, making it unnecessary for you to stand in line or deal with many different people.

Each Private Banker is a member of a team composed of banking professionals. The Private Banking Team assures continuity. Each member of the team will be familiar with your financial affairs, and a team member will assist you in the absence of your Private Banker.

We consider your needs as unique. And they require the assistance of unique people.

ANSWERING YOUR CASH MANAGEMENT REQUIREMENTS
To simplify your cash management, we have designed a single account that eliminates the necessity for multiple accounts. This account yields high interest with insured safety and immediate liquidity.

Known as the Double Interest Checking Account, it pays interest at rates comparable to certificates of deposit at other banks. The account also provides immediate access to all your funds through unlimited check-writing and a bank card.

Double Interest Checking increases your interest in two ways:
The greater the balance, the higher the interest rate.
The longer the balance is maintained the higher the interest rate.

Your cash management needs are unique. And they require unique money management vehicles.

The Picnic - Carl Herpfer

3

Brochure:
Golden Gate Bank
Designer:
Michael Vanderbyl
Artists:
Various
Design Firm:
Vanderbyl Design
San Francisco, CA
Client:
Golden Gate Bank
Printer:
Cal Central Press

A Bright Past,
A Shining Future

A Campaign To Celebrate
Hamilton's 175th Anniversary
1812–1987

Brochure:
A Bright Past
A Shining Future
Art Directors:
Barbara Behrens
Shelly Creech
Designer:
Beau Gardner
Photographer:
Bill Ray
Design Firm:
Beau Gardner Assoc.
New York, NY
Client:
Hamilton College
Typographer:
Concept Typographic
Services, Inc.
Printer:
Acme Printing

Catalogue:
Cole-Haan Women's Fall
1984 Footwear
Designer:
Mark Kent
Photographer:
Al Fisher
Design Firm:
Cipriani Advertising, Inc.
Boston, MA
Client:
Cole-Haan
Typographer:
Wrightson Typographers
Printer:
Nimrod Press

Poster:
Nutcracker
Art Director:
Gordon Bowman
Designer:
Peter Good
Design Firm:
Peter Good Graphic
Design
Chester, CT
Client:
United Technologies
Publisher:
Hartford Ballet
Typographer:
Eastern Typesetting Co.
Printer:
National Bickford
Foremost, Inc.

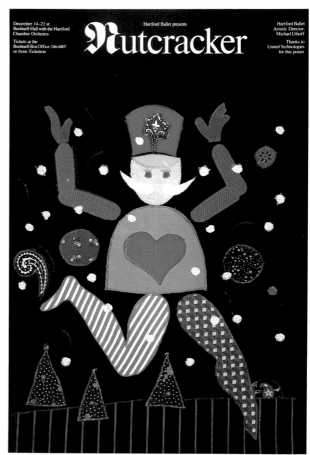

Poster:
What Has 300 Legs
and Goes Zoom Thud…
Art Directors:
Bob Dennard
Chuck Johnson
David Martin
Designer:
Chuck Johnson
Artist:
Chuck Johnson
Design Firm:
Dennard Creative, Inc.
Dallas, TX
Client:
Dallas Society of Visual
Communication

**Magazine
Advertisement:**
Grid
Art Director/Designer:
Jayne Burmaster
Photographer:
Michael Myers
Design Firm:
The Gunlocke Co.
Wayland, NY
Client:
The Gunlocke Co.
Typographer:
Rochester Monotype Co.
Printer:
G.M. Dubois

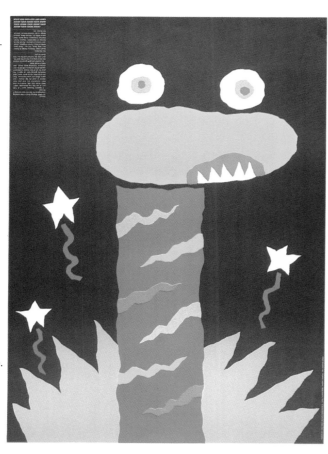

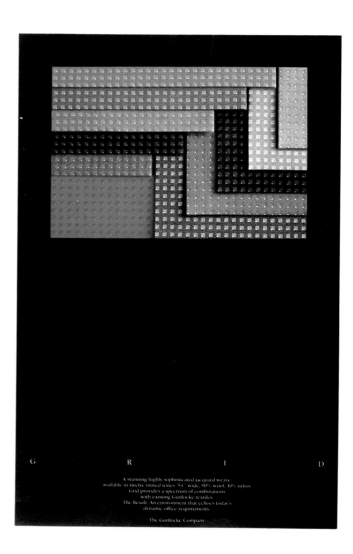

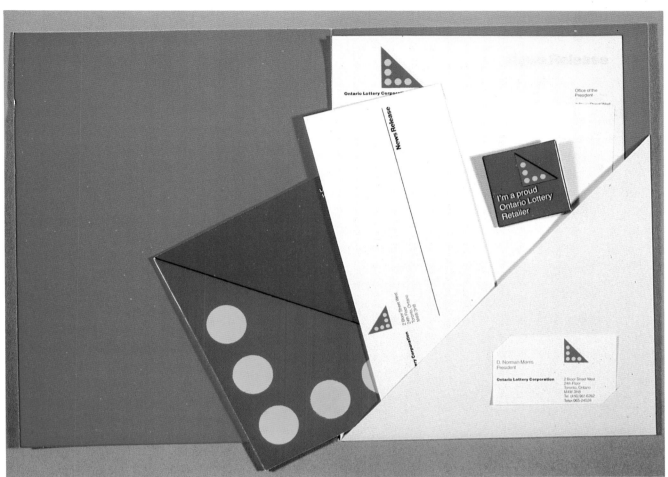

**Corporate
Identity/
Press Kit:**
Ontario Lottery
Corporation
Art Director:
Gottschalk + Ash Int'l.
Designers:
Richard Kerr
Jenny Leibundgut
Design Firm:
Gottschalk + Ash Int'l.
Toronto, CAN
Client:
Ontario Lottery Corp.
Printers:
Various

Calendar:
Esprit 1985 Agenda Book
Designer:
Tamotsu Yagi
Photographer:
Oliviero Toscani
Design Firm:
Esprit Graphic
Design Studio
San Francisco, CA
Client:
Esprit de Corp
Typographer:
Display Lettering
& Copy
Printer:
Pacific Litho

Brochure:
Falcon Ventures
Designer:
Mark H. Hanger
Photographer:
Howard Sokol
Design Firm:
Graphein: A Design Firm
Aurora, CO
Client:
Falcon Ventures
Typographer:
EB Typecrafter
Printer:
Communigraphics

A city never sleeps. Even at night, the streets are busy. The buildings, large and small, are swept and cleaned and readied for the next day. Every kind of business and commercial space must be maintained and managed —and managed well.

Falcon believes that good property management should be part of every business environment, in order for that space to function at the peak of its potential.

Naturally, a manager must solve problems and respond to individual needs. This is the minimum standard. Let's look beyond that, and imagine a manager who is a tenant advocate, who works to improve the working environment for the benefit of owner and tenant alike.

With property management functioning at this level, morale stays high. Occupancy stays high. And the quality and value of the environment is maintained and enhanced at every opportunity for the benefit of all.

Annual Report:
Statex Petroleum, Inc.
Annual Report 84
Designer:
Scott Eggers
Photographer:
Jim Sims
Design Firm:
Richards Brock Miller
Mitchell & Assoc.
Dallas, TX
Client:
Statex Petroleum, Inc.
Typographer:
Chiles & Chiles
Printer:
Heritage Press

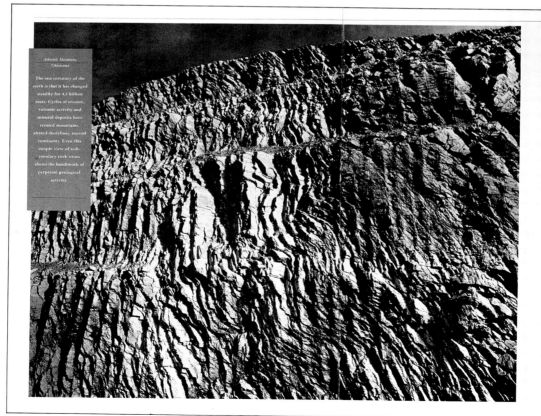

Arbuckle Mountains, Oklahoma

The one certainty of the earth is that it has changed steadily for 4.5 billion years. Cycles of erosion, volcanic activity and mineral deposits have created mountains, altered shorelines, moved continents. Even this simple view of sedimentary rock strata shows the handiwork of perpetual geological activity.

equivalent basis, increased to 83% from 69% in fiscal 1983.

Statex participated in a total of 17 wildcat wells in fiscal 1984, eight of which were successful. The pertinent discoveries are discussed below. As a result of these discoveries and the development of prior year discoveries, Statex increased its average daily oil production by 44% over fiscal 1983. Although gas production declined slightly over the same period due to pipeline curtailments, Statex's potential gas deliverability has increased significantly.

Activity was spread among several prospects, the most significant of which is the Sonora Canyon Sand project. In addition to fully utilizing two of our drilling rigs at rates sufficient to stem the contract drilling losses, the reserve and cash flow estimates on completed wells, as calculated by independent reservoir engineers, indicate that the wells provide attractive economics on their own merits. The average well will recover approximately 700,000 MCF over a 25 year period and will pay out in less than three years. At fiscal year end, 31 wells had been completed with nine additional wells in various stages of completion. Statex and its partners have committed to drill a minimum of 139 wells and have the opportunity to drill in excess of 220 wells in the project. It is anticipated that an additional 18 months will be required to complete the minimum program. Considering the long life of the wells, the project will provide a source of cash flow for many years to come.

Past year Oklahoma exploratory discoveries provided many development opportunities for Statex during the year. A total of nine development wells were drilled in 1984 on the Payne 20 Prospect, Payne County, Oklahoma, finding production in the Skinner, Red Fork and Bartlesville zones. The average well reaches payout in only 90 days. Current geology indicates that a minimum of three and as many as seven additional undeveloped locations remain on the prospect where drilling will continue during 1985.

Hollywood Presbyterian
Hospital, Expansion Site,
Hollywood, California

Robert C. Hill, Sr.
Honorary Chairman
Bateman Eichler, Hill Richards
Los Angeles, California

Charles A. Brown
First Vice President—Manager
Municipal Bond Department
Bateman Eichler, Hill Richards
Los Angeles, California

Hollywood Presbyterian Medical Center is the fifth largest non-government-owned hospital in the Greater Los Angeles area. The medical center, which serves approximately 100,000 in- and out-patients annually, has continually been awarded the highest level of accreditation by the Joint Commission of Hospitals.

In 1982 the medical center launched a $70 million capital-raising program to pay for a new hospital — a nine-story addition to replace services now housed in outdated facilities. The new building is being funded by a combination of $10 million to be raised by the Hollywood Presbyterian Medical Center Foundation, which was founded by Bateman Eichler, Hill Richards' Honorary Chairman Robert C. Hill, and a $50,850,000 tax-exempt bond issue arranged by Bateman Eichler, Hill Richards. The issue was co-managed by John Nuveen and Company and Bateman Eichler, Hill Richards, and was the largest debt issue ever managed or co-managed by our firm.

"We've raised $9.3 million of our $10 million goal, and the balance will be on hand by December 1984. The new hospital building will be complete — in operation — by year-end 1986."

Annual Report:
Bateman Eichler
Art Director:
Robert Miles Runyan
Designer:
Doug Joseph
Photographer:
Neil Slavin
Design Firm:
Robert Miles Runyan
& Assoc.
Playa del Rey, CA
Client:
Bateman Eichler
Hill Richards
Typographer:
Composition Type
Printer:
George Rice & Sons

Swensen's Ice Cream Parlor,
Westwood Village, California

Robert Puccio
Senior Vice President
Operations
Swensen's, Inc.
Los Angeles, California

Fred Krinm
First Vice President
Bateman Eichler, Hill Richards
Los Angeles, California

Bateman Eichler managed or co-managed over $500 million in public securities offerings in 1983, the most active year in our history. Among firms of its size, Bateman Eichler also has an outstanding record with respect to its participations in underwriting syndicates managed by other firms, totaling nearly $2 billion since 1979.

In late 1983, Swensen's, Inc., one of the five largest retail ice cream store chains in the U.S., was poised for growth, but required new capital to finance that growth. Bateman Eichler, Hill Richards was brought in to consult with management. Following an intensive analysis, it was determined that an initial public offering of securities would be the best course. On November 15, 1983, Swensen's, Inc., went public through sale of $5 million of new equity securities.

The company was founded in 1948 by Earle Swensen, who still owns his original store in San Francisco. The present owners purchased Swensen's in 1980 and relocated its headquarters to Phoenix. The funds raised in the company's initial offering reduced some indebtedness and provided new working capital to help fund Swensen's future growth.

"The people in our Corporate Finance Department have had a tremendous amount of experience in financing growing companies like Swensen's. I'm talking about the ability to raise capital, either publicly or privately. I'm talking about the ability to discreetly arranged appropriate mergers. We've been doing that successfully for years and years."

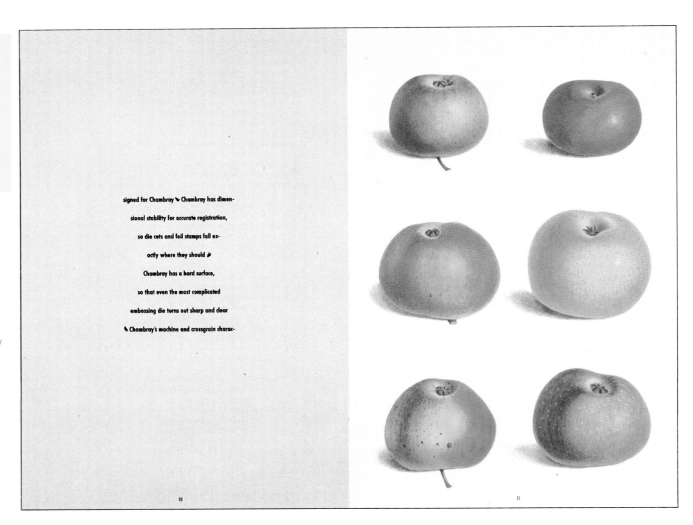

Brochure:
Chambray Apples
Art Directors:
Martin B. Pedersen
Adrian Pulfer
Designer:
Adrian Pulfer
Design Firm:
Jonson Pedersen
Hinrichs & Shakery
New York, NY
Client:
Georgia-Pacific Corp./
Hopper Papers
Typographer:
Boro Typographers
Printer:
L.P. Thebault Co.

Promotional Item:
Tricks of the Trade
Magic Book
Designer:
Rex Peteet
Artists:
Rex Peteet
Jerry Jeanmard
Michael Schwab
Louis Escobedo
Design Firm:
Sibley/Peteet Design,Inc.
Dallas, TX
Client:
International Paper Co.
Typographer:
Robert J. Hilton
Typographers
Printer:
Heritage Press

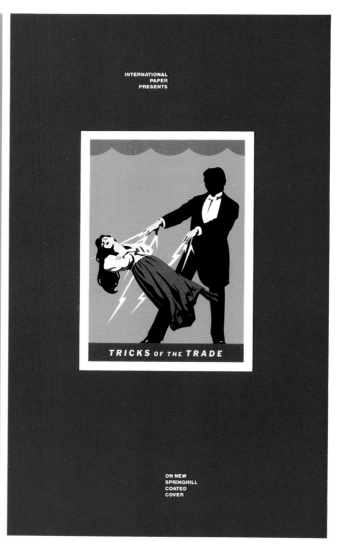

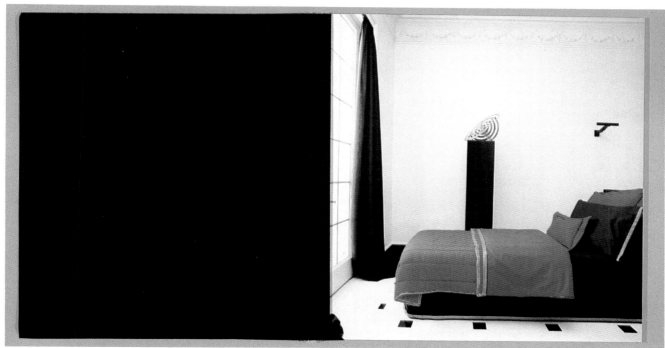

Catalogue:
Perry Ellis
Atelier Martex
Art Director:
James Sebastian
Designers:
James Sebastian
Jim Hinchee
Photographer:
Bruce Weber
Interior Designer:
Bill Walter/West
Point Pepperell
Design Firm:
Designframe, Inc.
New York, NY
Client:
Martex/West Point
Pepperell
Typographer:
M. J. Baumwell
Printer:
The Hennegan Co.

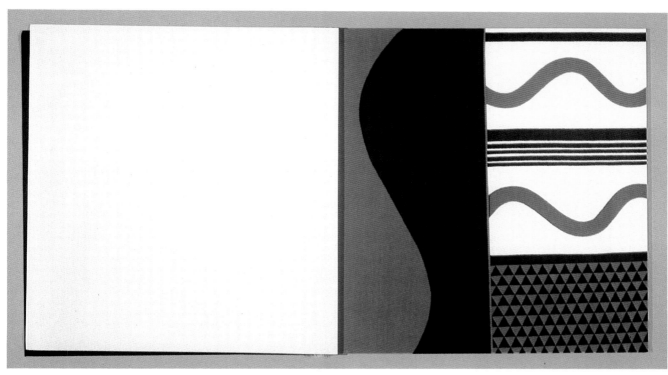

Brochure:
Paragon Center
Designer:
Scott Eggers
Photographer:
Jim Sims
Design Firm:
Richards Brock Miller
Mitchell & Assoc.
Dallas, TX
Client:
The Paragon Group
Typographer:
Chiles & Chiles
Printer:
Brodnax Printing

Booklet:
Boston Wharf
Art Director:
Lowell Williams
Designers:
Lowell Williams
Bill Carson
Photographers:
Ron Scott
Bob Haar
Design Firm:
Lowell Williams Design
Houston, TX
Client:
Rose Assoc., Inc.
Typographer:
Typeworks, Inc.
Printer:
Heritage Press

Promotional Folder:
Arcus
Designer:
Michael Vanderbyl
Photographer:
Stone & Steccati
Design Firm:
Vanderbyl Design
San Francisco, CA
Client:
Modern Mode, Inc.
Printer:
Lithosmith

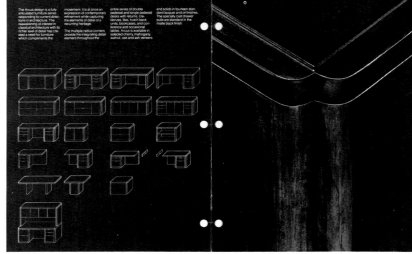

Promotional Folder:
Tek 3
Designer:
Michael Vanderbyl
Photographer:
Charlie Franklin
Design Firm:
Vanderbyl Design
San Francisco, CA
Client:
Modern Mode, Inc.
Printer:
Lithosmith

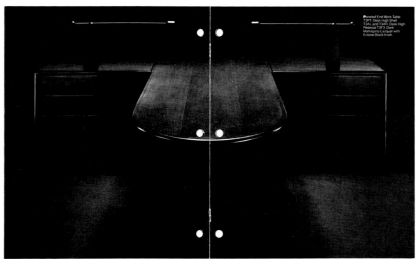

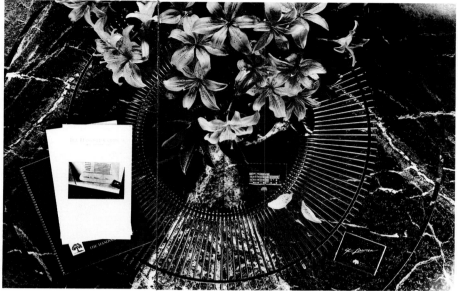

In following a strong marketing program, The Hanover Company reaches out into the community in many ways. Most importantly, we maintain dialog with other developers and are in communication with a selected network of professionals involved in commercial real estate financing and brokerage in Houston.

Through varied personal contacts and referrals, we are frequently in contact with investors. Moreover, investors seek out the Company when looking for investment opportunities attuned to specific personal goals.

Our reputation serves to bring us together with individuals who share our objective of participation in projects whose overall quality distinguishes them in the competitive marketplace.

66 A project is developed and managed to accomplish specific investment objectives, and these should match the objectives of all of the investors in that project. 99

Brochure:
The Hanover Company
Art Directors:
Richard Kilmer
Mark Geer
Designers:
Mark Geer
Richard Kilmer
Photographer:
Sims/Boynton
Photography
Design Firm:
Taylor, Inc.—
Kilmer/Geer Design
Client:
The Hanover Co.
Typographer:
Professional Typographers
Printer:
Grover Printing Co.

COPEN BLUE Windowpane, Waves, Nova, Dashes, Bath Rug

DRIFTWOOD Windowpane, Waves, Nova, Dashes, Bath Rug

Promotional Brochure:
Cannon Mills/Royal Family
Designer:
Lois Carlo
Photographer:
Lizzie Himmel
Design Firm:
Carlo Assoc.
New York, NY
Client:
Cannon Mills
Printer:
La Salle Litho Corp.

Calendar:
IBM Introduces
Jay Maisel 1985
Art Directors:
Linda Tom
Cindy Locaputo
Designer:
The Endicott, NY
IBM Design Center
Photographer:
Jay Maisel
Design Firm:
Janicelli-Pickall, Inc.
Client:
IBM Corporation
Typographer:
Eastern Graphics
Printer:
L. P. Thebault Co.

January

May

Calendar:
Calendar 1984
Designer:
Malcolm Waddell
Photographer:
Yuri Dojc
Design Firm:
Eskind Waddell
Toronto, CAN
Client:
Eskind Waddell
Typographer:
Cooper & Beatty
Printer:
Arthur Jones
Lithographing, Ltd.

Calendar:
American President
Lines
Art Director:
Kit Hinrichs
Designers:
Kit Hinrichs
Pam Shaver
Nancy Koc
Photographer:
Terry Heffernan/
Light Language
Design Firm:
Jonson Pedersen
Hinrichs & Shakery
San Francisco, CA
Client:
American President
Lines
Typographer:
Reardon & Krebs
Printer:
Dai Nippon Printing Co.,
Ltd.

With Daddy, at the piano.

Above, age six, at the Steinway.
Far right, newspaper article. Pianist Debbie is a sixth grader.
Right, three ribbons for soloing at the Van Katwijk club, a local music society.

Age two, studying already. Debbie's feet are propped on Daddy's trumpet case.

A junior high "letter" for the highest score in her class.

Debbie experiments with crystals at her junior high school Science Fair.

Marching band patch, freshman year in high school.

Official valedictorian medal, from Duncanville High School, 1980.

Unofficial valedictorian medal, from Lisa, Debbie's best friend.

Robert Stewart Hyer Society 1983–1984

Program cover, induction into an SMU honor society.

Both Debbie's parents are accomplished musicians, and she was taught piano from age 5. At 12, she was soloing with a symphony orchestra – and winning first prize in the Elementary Concerts Division of the Dallas Symphonic Festival. Music is a discipline that taught her the value of self-discipline. She learned that perfection is an ideal; day by day, what is needed is practice, patience, a bit of sacrifice, and a deep desire to be excellent; and she has made such qualities her own. In high school, when her fascination with science overtook her love for music, Debbie never missed a beat: she was valedictorian of her high school class, and went on to excel in the classroom and the laboratory at SMU.

"Switching to science in high school was a dramatic change for me. I was uncertain about it. My parents always said, 'Do your best, that'll be fine.' I felt the same at SMU: just do your best, and things will work out for you."

Brochure:
Southern Methodist University: The Decade Ahead
Art Director:
Jim Jacobs
Designer:
Danny Kamerath
Photographer:
Jim Olivera
Design Firm:
Jim Jacobs' Studio
Dallas, TX
Client:
Southern Methodist University
Printer:
Spruiell & Co.

Promotional Booklet:
Simpson Lithography
An Element of Magic
Art Director:
James Cross
Designer:
Steve Martin
Photographer:
Grant Mudford
Design Firm:
Cross Assoc.
Los Angeles, CA
Client:
Simpson Paper Co.
Typographer:
Central Typesetting Co.
Printer:
Anderson Lithography Co.

Appointment Calendar:
Images 85
Designer:
Jack Beveridge
Photographers:
Various
Design Firm:
Beveridge & Assoc., Inc.
Washington, DC
Client:
Stephenson, Inc.
Typographer:
Harlowe Typography, Inc.
Printer:
Stephenson, Inc.

Brochure:
Citicorp Venture Capital
Art Director:
Martin B. Pedersen
Designer:
Adrian Pulfer
Photographers:
Nathaniel Lieberman
Jon Ortner
April Johnson
Design Firm:
Jonson Pedersen
Hinrichs & Shakery
New York, NY
Client:
Citicorp Venture Capital
Typographer:
Boro Typographers
Printer:
Sanders Printing Corp.

tal purchased the largest share of preferred stock in a major private placement. This enabled the company to make acquisitions, start a $21 million producing properties program, and complete a Gulf Coast oil and gas study vital to its drilling endeavors. American uses sophisticated computer analysis in pursuit of exploration opportunities. The company's success and technical expertise have attracted co-investors to its drilling operations. An acquisition was consummated in late 1983 which rendered American a publicly owned company. A follow-on private financing was conducted in 1984. American's future remains promising.

HEALTH CARE
□ Citicorp Venture Capital has backed a number of medical companies in fields ranging from genetic engineering and laser surgical instruments to hospital management. The high cost of delivering medical services also has led to investment opportunities in innovative health care treatment.
□ In 1983, Houston-based *Ambulatory Hospitals of America (AHA)* was founded on the premise that minor surgery in acute care hospitals simply costs too much. Its alternative: a network of outpatient surgery centers that could save millions of dollars without diminution in the quality of medical care.
□ Joining forces with founder John Styles in 1983, Citicorp Venture Capital provided seed

financing to organize management, research potential locations and begin center development. After the first phase of development coalesced, Citicorp was joined by other venture capitalists in completing a $12 million second round in 1984.
□ Today, AHA has three centers in operation and several more under development. Significant cost savings to patients have been realized and doctors performing minor surgery have had fewer scheduling problems. The company now plans to develop a network of inpatient rehabilitation facilities. Built to treat postoperative stroke, heart attack and traumatic injury victims, these centers will provide the kind of intensive therapy that can save as much as $17 in disability insurance costs for every dollar spent.
□ *Amcare, Inc.* of Birmingham, Alabama, incorporated in early 1984, has concentrated on outpatient rehabilitation centers. Once again, Citicorp Venture Capital acted as founding investor, and helped to build both a board of directors and a talented management staff. Amcare's first two centers, in Little Rock and Birmingham, offer rehabilitative programs that build endurance, restore mobility and enable patients to normalize their lives.
□ Management has enhanced cashflow and reduced business risk by running rehabilitative departments in four acute care hospitals and opening a distributorship for home health care equipment. Growth is rapid and

Our approach to health care investment will remain aggressive as improvements in delivery services and medical techniques evolve.

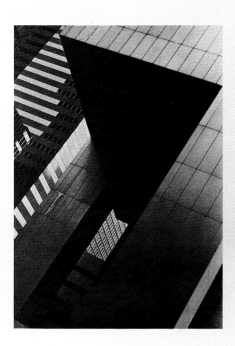

Slipcased Book:
Atlantic Center
Art Director:
Lowell Williams
Designers:
Lowell Williams
Bill Carson
Photographers:
Various
Design Firm:
Lowell Williams Design
Houston, TX
Client:
Cadillac Fairview
Typographers:
Typeworks, Inc.
Professional
Typographers
Printer:
Heritage Press

Momentum Place, Dallas

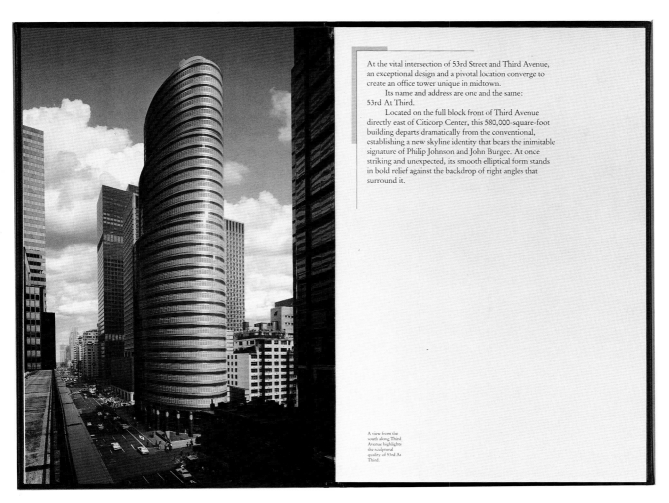

At the vital intersection of 53rd Street and Third Avenue, an exceptional design and a pivotal location converge to create an office tower unique in midtown.

Its name and address are one and the same: 53rd At Third.

Located on the full block front of Third Avenue directly east of Citicorp Center, this 580,000-square-foot building departs dramatically from the conventional, establishing a new skyline identity that bears the inimitable signature of Philip Johnson and John Burgee. At once striking and unexpected, its smooth elliptical form stands in bold relief against the backdrop of right angles that surround it.

A view from the south along Third Avenue highlights the sculptural quality of 53rd At Third.

Promotional Book:
53rd at Third
Designer:
Jerry Herring
Photographers:
Bob Haar
Steve Brady
Ron Scott
Richard Payne
Design Firm:
Herring Design
Houston, TX
Client:
Gerald D. Hines Interests
Typographer:
Professional
Typographers
Printer:
Grover Printing

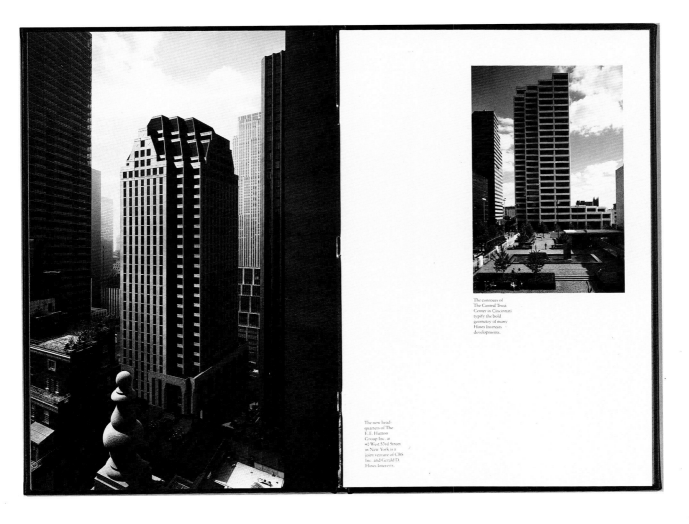

The new head-quarters of The E. F. Hutton Group Inc. at 42 West 53rd Street in New York is a joint venture of CBS Inc. and Gerald D. Hines Interests.

The contours of The Central Trust Center in Cincinnati typify the bold geometry of many Hines Interests developments.

Poster:
HBF-Hickory Business
Furniture
The New Tradition
Art Director/Designer:
Michael Vanderbyl
Artist:
Michael Vanderbyl
Design Firm:
Vanderbyl Design
San Francisco, CA
Client:
Hickory Business
Furniture
Printer:
Dimension 3

Magazine Ad:
Textiles,Textiles,Textiles
Art Director/Designer:
Bridget DeSocio
Photographer:
Bill White
Design Firm:
Bridget DeSocio Design
New York, NY
Client:
Stendig International
Typographer:
Nassau Type
Printer:
Sterling Roman Press

Catalogue:
SunarHauserman
Walls, Systems . . .
Art Director:
Wilburn Bonnell
Designers:
Wilburn Bonnell
Rick Biedel
Photographers:
Various
Design Firm:
Bonnell Design Assoc.
New York, NY
Client:
SunarHauserman, Inc.
Typographer:
Typogram
Printer:
Dai Nippon Printing
Co., Ltd.

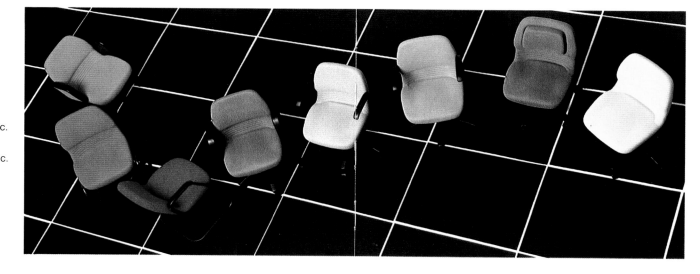

Catalogue:
Knoll
Art Directors:
Harold Matossian
Takaaki Matsumoto
Designers:
Leslee Ladds
Takaaki Matsumoto
Photographer:
Mikio Sieka
Design Firm:
Knoll Graphics
New York, NY
Publisher:
Knoll International
Typographer:
Susan Schechter
Printer:
Rapoport Printing Co.

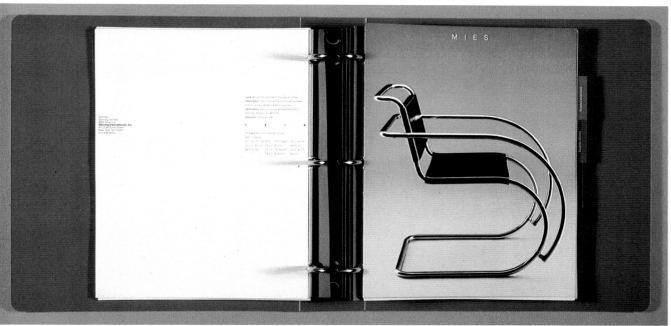

Trade Catalogue:
Stendig
Art Director/Designer
Bridget DeSocio
Photographer:
Bill White
Design Firm:
Bridget DeSocio Design
New York, NY
Client:
Stendig International
Typographer:
Nassau Type
Printer:
Sterling Roman Press

Promotional Portfolio:
580 California
Art Director/Designer:
Lowell Williams
Artist:
Tom McNeff
Design Firm:
Lowell Williams Design
Houston, TX
Client:
Gerald D. Hines Interests
Typographer:
Typeworks, Inc.
Printer:
Heritage Press

Environmental Graphics:
New York Public Library
Construction Fence
Art Director:
Rudolph de Harak
Designers:
Rudolph de Harak
Janice Bergen
Design Firm:
Rudolph de Harak &
Assoc.
New York, NY
Client:
New York Public Library

Brochure:
Action Office System
Designer:
Sara Giovanitti
Illustrator:
Steven Guarnaccia
Photographer:
Susan Wood
Design Firm:
Sara Giovanitti Design
Client:
Herman Miller, Inc.
Typographer:
Marvin Kommel
Productions
Printer:
Heritage Press

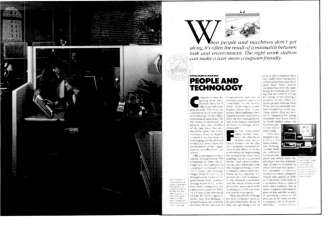

Promotional Magazine:
Leading Edge #5, 1984
Art Director:
Wilburn Bonnell
Designers:
Wilburn Bonnell
Rick Biedel
Cover Artist:
Rick Biedel
Photographers:
Various
Design Firm:
Bonnell Design Assoc.
New York, NY
Client:
SunarHauserman, Inc.
Typographer:
Typogram
Printer:
A. G. Brugora
L. S. Graphics, Inc.

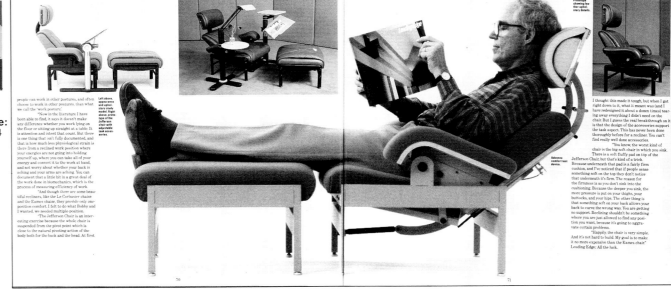

The Mayan Yoke, worn as a cere-
monial belt in ritual games, is a
marvel of technical and sculptural
perfection. Carved only out of the
most precious minerals, the Yoke
is exemplary of the consummate
mastery of design that infuses
Mayan art of the classic Toltec
period (725-1070 AD). The Yoke.
Translated now into a new form.

Brochure:
Yoke Chair
Art Directors:
Nancye Green
Michael Donovan
Designers:
Michael Donovan
Peter Galperin
Photographers:
Andy Unangst
Fred Schenk
Design Firm:
Donovan & Green
New York, NY
Client:
Brickel Assoc.
Printer:
Crafton Graphic Co., Inc.

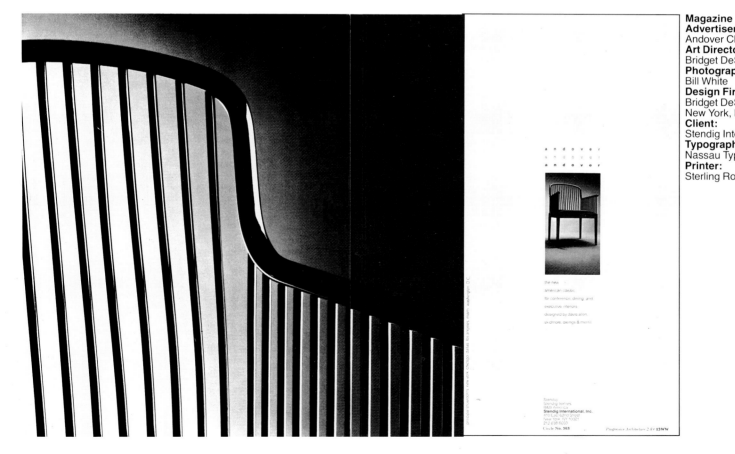

**Magazine
Advertisement:**
Andover Chair
Art Director/Designer:
Bridget DeSocio
Photographer:
Bill White
Design Firm:
Bridget DeSocio Design
New York, NY
Client:
Stendig International
Typographer:
Nassau Type
Printer:
Sterling Roman Press

The Book Show

When design is good, it suggests the presence of an individual with a strong point of view. That there are so many design points of view exhibited here indicates that, despite real constraints at publishing houses, design is healthier and designers are stronger than in previous years.

Call for Entry:
The Book Show
Designer:
Robert Anthony
Photographer:
Anthony Loew
Typographer:
Marvin Kommel Productions
Printer:
The Litho Concern, Inc.
Paper:
Hopper Papers
Separator:
Jalor Color
Binder:
A.E. Bindcraft, Inc.

Until the mid-twentieth century, "the art of the book" and the term "graphic design" were one and the same. In America, the book was the province of master printer/designers, such as Frederick Goudy, Bruce Rogers, D.B. Updike, and W.A. Dwiggins, early AIGA members, who practiced typography, illumination and decoration in atmospheres of respect. Though Dwiggins complained vociferously, yet wittily, about marketing department interference in his treatise "The Physical Properties of Books" as early as 1930, it was nevertheless a time when the savvy trade publishers commissioned "fine bookmen" to design their wares. It was also a period when the AIGA focused much of its attention on bookmaking and design; the prestigious "Fifty Books" show was one of the most definitive professional assessments. The field, however, has markedly changed since then and so has this exhibition.

Some years ago, the number "fifty" was abandoned in favor of a more catholic system. The criteria of the Book Show were expanded to include a greater variety of books, and so reflect the profligate and growing industry. Though some have criticized this change, stating that the judging standards were lowered to conform to the inferior production of today's books, a counter argument states that this methodology has attempted to raise the overall standards of an industry hard hit by the heavy bottom line. More important, while manufacturing details are still an issue, the major emphasis of this show is now on design. That over 80 books out of 750 entries were accepted this year suggests that, despite marketing interference and production problems, good design is still practiced and taken seriously.

Of course, the nature of book publishing has markedly changed, resulting in a paucity of well-produced volumes of fiction and other books that are primarily text. Few classical design solutions are now in evidence, and would probably seem dated if they were. Yet, according to Frank Metz, vice president and art director of Simon & Schuster, and chairman of the Book Show, the analytical criteria remain somewhat consistent with the past: "I entered into this judging believing that trade fiction was not being given a fair shake in recent years. But, based on our entry requirements, which include scrutiny of all the details—good binding, legible stamping, attractive color balance, care about placement of folios, and running heads—not many trade books deserved inclusion." One reason for this is economic: high paper and manufacturing costs are inconsistent with the necessary low cover prices, and even skyrocketing authors' advances result in cutting corners elsewhere. Moreover, the major houses issue "product" at such fantastic speed that thoughtful design becomes secondary.

On the other hand, due to surges in the national economy, certain kinds of book publishing are faring very well. Visual books, which long ago transcended their pristine coffee-table status, are now publishing mainstays, and hence, are well represented here. Relatively inexpensive, high quality printing from Japan, Singapore and Czechoslovakia account for many of the trade picture books published in the

United States. Also adding to this abundance, and reducing publishing costs, is an influx of books originally *packaged* in Europe. A trend in unusually generous design budgets, particularly for trendy "lifestyle" books, such as those on cooking and home design, insures good, if not exemplary, graphic design. "While some opulent books are too garish, when opulence, caring and intelligence go hand-in-hand, the results are laudatory," says Metz. "With the *Richard Meier Architect* monograph, the money spent on the design and production was in direct proportion to the subject matter." The majority of picture books selected are not lavish, but rather those designed with respect for the subject matter. *Irving Penn*, for example, was chosen because its design *serves* the material rather than vice versa.

Once again, children's books had a good showing. Chris Van Allsburg's *The Mysteries of Harris Burdick* was singled out for its soothingly mysterious illustrations and pleasing design. Textbooks, admittedly the most difficult category to judge, did fairly well, particularly *Calculus*, a well-organized volume with a beguilingly witty "neo-constructivist" design format.

This year, experimentation was not judged as favorably as in the past. "Those books submitted of an experimental nature were primarily in the private press category," states Metz. "Many were so illegible as to be counterproductive." However, this evidence is not conclusive because some excellent limited editions were not submitted.

Mass market paperbacks were avoided once again because of ephemeral production and design properties, but "quality paperbacks" made an impact. "New York Access" and "Tokyo Access" stand out as fine examples of design serving function. The covers for both enliven the package, and the manufacturing transcends the ephemeral.

The perennial issue of how to judge jackets and covers, once again, reared its head. Last year they were not included in the Cover Show but were judged separately in conjunction with the Book Show. This year, that practice was stopped. "We gave the entrant the option of submitting the book with or without the cover," says Metz, "because trade book jackets are usually not designed by the interior designer. The jackets are imposed, and can lack empathy with the rest of the book. Where they were integral to the entire package, they were judged as such." Many picture book and children's book jackets were submitted as parts of the whole.

Though marketing practices of different publishing firms have varying effects on design and production, technology is the single most influential force. "It's amazing to see books here that 10 or 15 years ago would not have been possible," admits Metz. "Four-color printing is at its zenith. And though the process may get faster or cheaper, the quality will probably not get any better for some time."

About this show, Metz concludes: "There is no mystique here. This is clearly a compendium of what appeals to the judges. And, in this case, the judges agreed about most of the selections and rejections." While a few "significant" publishers did not submit, making a definitive statement inappropriate, based on the volume and variety of entries, a guarded generalization is in order. And this is that contemporary book design does not conform to one or two sets of rules, as in the early days of the AIGA shows, though eclecticism is not the defining principle either. When design is good, it suggests the presence of an individual with a strong point of view. That there are so many design points of view exhibited here indicates that despite real constraints at publishing houses, design is healthier and designers are stronger than in previous years.

Book Title:
Animal Alphabet
Author:
Bert Kitchen
Art Directors:
Hugh Tempest-Radford
Atha Tehon
Designers:
Bert Kitchen
Hugh Tempest-Radford
Atha Tehon
Illustrator:
Bert Kitchen
Publisher:
Dial Books for Young
Readers
New York, NY
Typographer:
W.S. Cowell, Ltd.
Printer:
Arnoldo Mondadori
Editore
Production Manager:
Hugh Tempest-Radford
Paper:
Jupiter Cartridge
140 gsm
Binder:
Arnoldo Mondadori
Editore
Jacket Designer:
Gerry Cinnamon
Atha Tehon
Jacket Illustrator:
Bert Kitchen

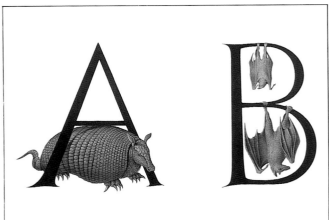

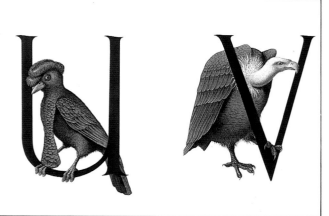
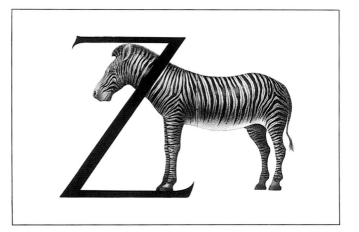

Book Title:
Integrated Principles
of Zoology
Authors:
Cleveland F. Hickman, Jr.
Larry S. Roberts
Frances M. Hickman
Art Director:
Kay M. Kramer
Designer:
William A. Seabright
Illustrator:
William C. Ober
Publisher:
Times Mirror/Mosby
College Publishing
St. Louis, MO
Typographer:
Typographic Sales, Inc.
Printer:
Von Hoffman Press, Inc.
Production Manager:
Jerry Wood
Paper:
Warren's Bookman
Matte
#50
Binder:
Von Hoffman Press, Inc.

Book Title:
The Other Bone
Author:
Ed Young
Art Director:
Al Cetta
Designers:
Ed Young
Al Cetta
Illustrator:
Ed Young
Publisher:
Harper & Row
Publishers, Inc.
New York
Typographer:
Cardinal Type Services,
Inc.
Printer:
Rae Publishing Co.
Production Manager:
Tom Consiglio
Paper:
P&S Regular Offset
Binder:
Rae Publishing Co.
Jacket Designer:
Ed Young
Jacket Illustrator:
Ed Young

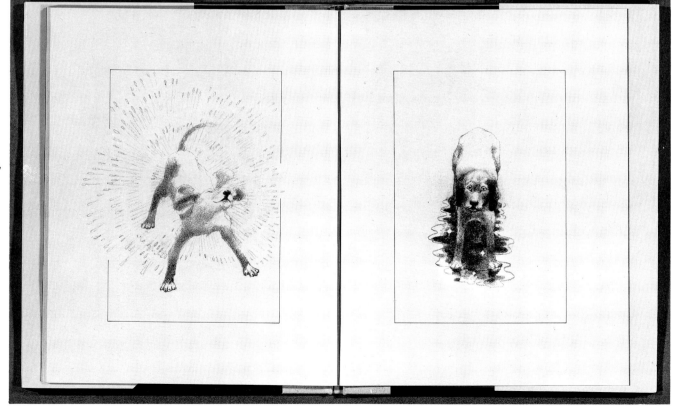

Monterey Cypress: PT. LOBOS

at whim of winds
my limbs are bent
to grotesque shape
by element
of ocean spray
and salty wind
and who may see
my bleached bole pinned
into the sand
shall
wonder
why
I
twist
while
others
die

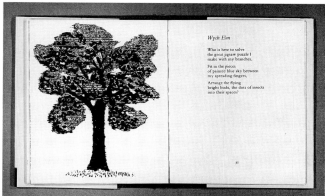

Wych Elm

Who is here to solve
the great jigsaw puzzle I
make with my branches,

Fit in the pieces
of painted blue sky between
my spreading fingers,

Arrange the flying
bright birds, the dots of insects
into their spaces?

Book Title:
Monkey Puzzle
and Other Poems
Author:
Myra Cohn Livingston
Art Director:
Christine Kettner
Designers:
Antonio Frasconi
Christine Kettner
Illustrator:
Antonio Frasconi
Publisher:
Margaret K. McElderry
Books
Atheneum Publishers
New York, NY
Typographer:
Dix Type, Inc.
Printer:
Connecticut Printers
Production Manager:
Jin Lau
Paper:
Mohawk #80
Binder:
Kingsport Press
Jacket Designer:
Antonio Frasconi
Jacket Illustrator:
Antonio Frasconi

FAR AWAY

THIS COULD BE THE WORLD

Book Title:
Moon
Author:
David Romtvedt
Designer:
Gerald Lange
Illustrator:
R. W. Scholes
Publisher:
The Bieler Press
St. Paul, MN
Typographer:
Gerald Lange
Printer:
Gerald Lange
Paper:
Nideggen
Binder:
The Campbell-Logan
Bindery

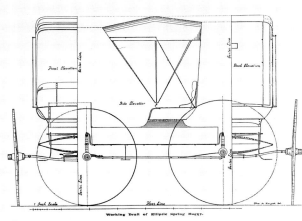

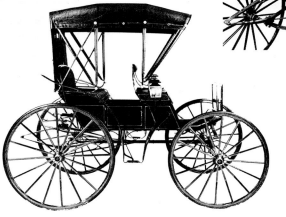

Working Draft of Elliptic Spring Buggy.

Book Title:
Buggy Town
Author:
Charles M. Snyder
Art Director:
Constance Timm
Photographer:
Terry Wild
Publisher:
Oral Traditions Project of
the Union County
Historical Society
Lewisburg, PA
Typographer:
Batsch Spectracomp
Printer:
Paulhamus Litho, Inc.
Production Manager:
Jeannette Lasansky
Paper:
Potlatch Vintage Velvet
#80
Binder:
Paulhamus Litho, Inc.
Jacket Designer:
Constance Timm
Jacket Photographer:
Terry Wild

Book Title:
1 2 3 Play With Me
Author:
Karen Gundersheimer
Art Director:
Harriett Barton
Designers:
Harriett Barton
Karen Gundersheimer
Illustrator:
Karen Gundersheimer
Publisher:
Harper & Row,
Publishers, Inc.
New York, NY
Typographer:
Cardinal Typographic
Services, Inc.
Printer:
Rae Publishing Co.
Production Manager:
John Vitale
Paper:
Moisturite Matte
Binder:
The Book Press, Inc.
Cover Illustrator:
Karen Gundersheimer

Book Title:
ABC Say With Me
Author:
Karen Gundersheimer
Art Director:
Harriett Barton
Designers:
Harriett Barton
Karen Gundersheimer
Illustrator:
Karen Gundersheimer
Publisher:
Harper & Row,
Publishers, Inc.
New York, NY
Typographer:
Cardinal Typographic
Service, Inc.
Printer:
Rae Publishing Co.
Production Manager:
John Vitale
Paper:
Moisturite Matte
Cover Illustrator:
Karen Gundersheimer

Book Title:
Hush Little Baby
Author:
Jeanette Winter
Art Director/Designer:
Denise Cronin
Illustrator:
Jeanette Winter
Publisher:
Pantheon Books
New York, NY
Typographer:
Haber Typographers
Printer:
Rae Publishing Co.
Production Manager:
Elaine Silber
Paper:
Rae Publishing Co.
Binder:
The Book Press
Jacket Designer:
Denise Cronin
Jacket Illustrator:
Jeanette Winter

Book Title:
The Look Again . . .
And Again, and
Again . . . Book
Author:
Beau Gardner
Art Directors:
Beau Gardner
Shelley Creech
Designer:
Beau Gardner
Illustrator:
Beau Gardner
Publisher:
Lothrop, Lee & Shepard
Books
New York, NY
Typographers:
Expertype, Inc.
Concept Typographic
Services, Inc.
Printer:
United Litho.
Production Manager:
Gene Sanchez
Paper:
Sterling Litho Matte #80
Binder:
The Book Press
Jacket Designer:
Beau Gardner
Jacket Illustrator:
Beau Gardner

The Tooth Fairy's teeth
fall out. She plants them
back in but they pop
loose. She can eat only
crackers and milk or
mashed potatoes. She
will pay for your teeth
in gold.

Book Title:
Imps, Demons,
Hobgoblins, Witches,
Fairies & Elves
Author:
Leonard Baskin
Art Director:
Denise Cronin
Designers:
Leonard Baskin
Denise Cronin
Illustrator:
Leonard Baskin
Publisher:
Pantheon Books
New York, NY
Typographer:
Centennial Graphics, Inc.
Haber Typographers
Printer:
Federated Litho, Inc.
Production Manager:
Steven Bloom
Paper:
Baldwin Paper
Binder:
The Book Press
Jacket Designers:
Leonard Baskin
Denise Cronin
Jacket Illustrator:
Leonard Baskin
Jacket Printer:
Longacre Press

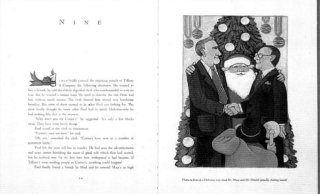

Book Title:
Miracle on 34th Street
Author:
Valentine Davies
Art Director:
Rubin Pfeffer
Designer:
Joy Chu
Illustrator:
Tomie de Paola
Publisher:
Harcourt Brace
Jovanovich
San Diego, CA
Typographers:
Maryland Linotype
Composition Co.
Haber Typographers, Inc.
Printer:
Holyoke Lithograph
Production Manager:
Warren Wallerstein
Paper:
Makers Matte #70
Binder:
The Book Press, Inc.
Jacket Designer:
Rubin Pfeffer
Jacket Illustrator:
Tomie de Paola

Book Title:
Universe
Author:
William J. Kaufmann III
Art Director:
Pat Cunningham
Designers:
Valerie Pettis
Sylvia Woodward
Publisher:
W.H. Freeman & Co.
New York, NY
Printer:
York Graphic Services
Production Manager:
Sarah Segal

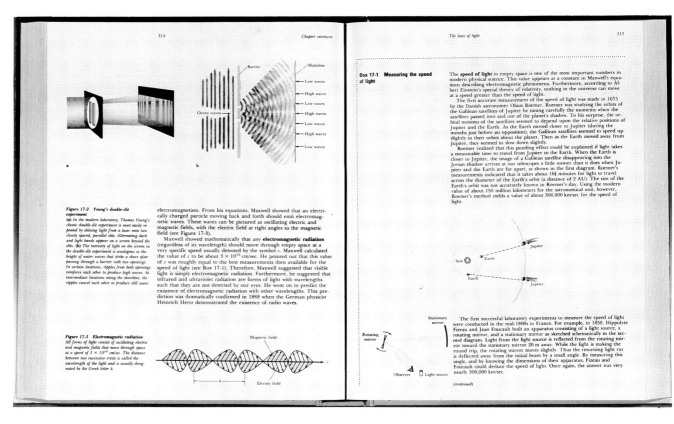

Book Title:
Calculus
Author:
Harley Flanders
Art Director:
Pat Cunningham
Designer:
Valerie Pettis Design
Publisher:
W.H. Freeman & Co.
New York, NY
Printer:
Kingsport Press
Production Manager:
Lynne Sheehan

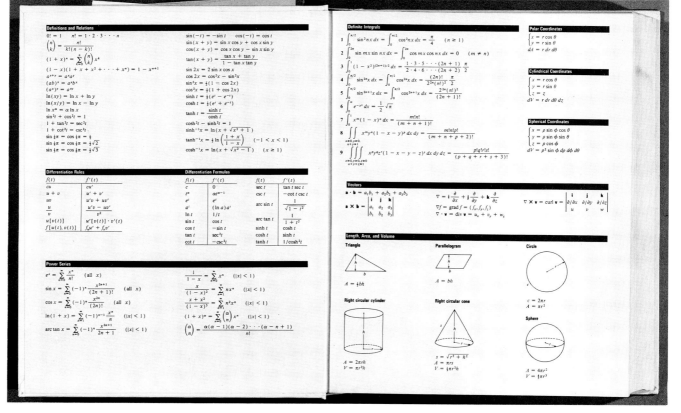

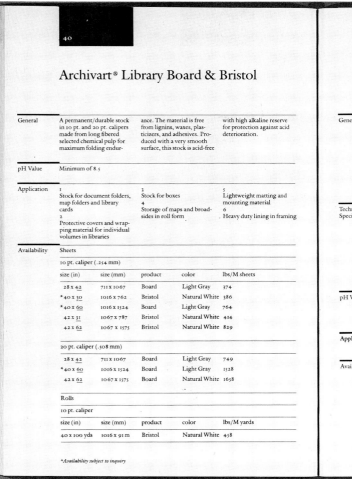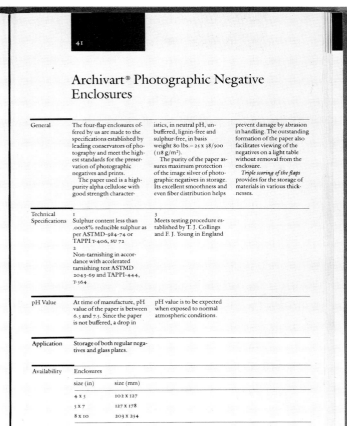

Book Title:
Archivart Products for
Conservation and
Restoration
Editors:
Ellen Meyer, Mill Roseman
Art Director/Designer:
Karen Salsgiver
Publisher:
Process Materials Corp.
A Lindenmeyr Co.
Rutherford, NJ
Typographer:
Finn Typographic Service
Printer:
Eastern Press, Inc.
Paper:
Warren Olde Style
Binder:
Eastern Press, Inc.
Jacket Designer:
Karen Salsgiver

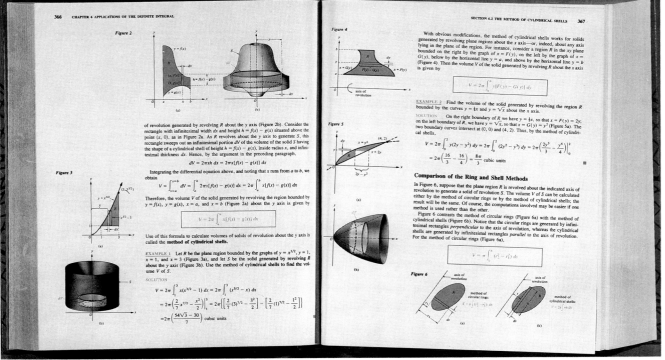

Book Title:
Calculus with Analytic
Geometry
Authors:
M. A. Munem
D. J. Foulis
Art Director:
Malcolm Grear
Designer:
Malcolm Grear Designers,
Inc.
Illustrator:
Mel Erikson Art Services
Publisher:
Worth Publishers, Inc.
New York, NY
Typographer:
York Graphic Services,
Inc.
Printer:
Kingsport Press
Production Managers:
George Touloumes
Pat Lawson
Paper:
Thorcote
Binder:
Kingsport Press
Jacket Designer:
Malcolm Grear Designers,
Inc.
Jacket Illustrators:
Tom Banchoff
David Laidlaw
David Margolis
Photo Researcher:
Elaine Bernstein

Book Title:
Rapunzel
Author:
The Brothers Grimm
Art Director:
Etienne Delessert
Designer:
Rita Marshall
Illustrator:
Michael Hague
Publisher:
Creative Education, Inc.
Minneapolis, MN
Typographer:
Libesatz
Printer:
Imprimeries Reunies,S.A.
Binder:
Imprimeries Reunies,S.A.
Cover Illustrator:
Michael Hague

Suddenly he heard a voice which seemed strangely familiar to him. He walked eagerly in the direction of the sound, and when he was quite close, Rapunzel recognized him and fell on his neck and wept. But two of her tears touched his eyes, and in a moment they became quite clear again, and he saw as well as he ever had. Then he led her to his kingdom, where they were received and welcomed with great joy, and they lived happily ever after.

Book Title:
Beauty and The Beast
Author:
Madame d'Aulnoy
Art Director:
Etienne Delessert
Designer:
Rita Marshall
Illustrator:
Etienne Delessert
Publisher:
Creative Education, Inc.
Minneapolis, MN
Typographer:
Libesatz
Printer:
Imprimeries Reunies, S.A.
Binder:
Imprimeries Reunies, S.A.
Cover Illustrator:
Etienne Delessert

"Mercy on us!" cried his father, "is that all you have learned? I will send you away again to another professor in a different town."

The youth was taken there, and remained with this professor for one more year. When he came back his father asked him again:

"Now, my son, what have you learned?"

He answered:

"I have learned the language of birds."

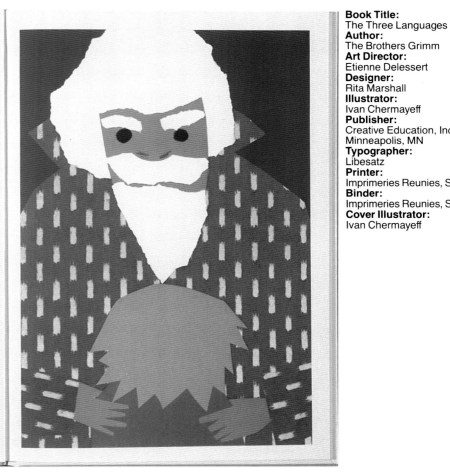

Book Title:
The Three Languages
Author:
The Brothers Grimm
Art Director:
Etienne Delessert
Designer:
Rita Marshall
Illustrator:
Ivan Chermayeff
Publisher:
Creative Education, Inc.
Minneapolis, MN
Typographer:
Libesatz
Printer:
Imprimeries Reunies, S.A.
Binder:
Imprimeries Reunies, S.A.
Cover Illustrator:
Ivan Chermayeff

Book Title:
Letters to a Young Poet
Author:
Rainer Maria Rilke
Art Director/Designer:
J. K. Lambert
Publisher:
Random House, Inc.
New York, NY
Typographer:
Maryland Linotype
Composition Co.
Printer:
The Haddon Craftsmen,
Inc.
Production Manager:
Carol Stiles
Paper:
S. D. Warren Sebago
Antique #55
Binder:
The Haddon Craftsmen
Jacket Designer:
J. K. Lambert
Jacket Illustrator:
J. K. Lambert

most life feels hemmed in by the form this pro-
fession imposes. I myself consider it a very diffi-
cult and very exacting one, since it is burdened
with enormous conventions and leaves very little
room for a personal interpretation of its duties.
But your solitude will be a support and a home
for you, even in the midst of very unfamiliar
circumstances, and from it you will find all your
paths. All my good wishes are ready to accom-
pany you, and my faith is with you.

Yours,
Rainer Maria Rilke

44

FIVE

Rome
October 29, 1903

Dear Sir,

I received your letter of August 29 in Flor-
ence, and it has taken me this long—two months
—to answer. Please forgive this tardiness—but I
don't like to write letters while I am traveling,
because for letter-writing I need more than the
most necessary tools: some silence and solitude
and a not too unfamiliar hour.

45

Book Title:
The Window Washer and
Other Work Poems
Author:
Dan Giancola
Art Director/Designer:
Walter Tisdale
Publisher:
The Landlocked Press
Madison, WI
Typographer:
Joe Napora
Printer:
Walter Tisdale
Papers:
Mohawk Superfine
Fabriano Ingres
Binder:
Walter Tisdale

LETTERING

A job for the old man working through retirement.
His art's inscribing racehorse names on yachts:
Lyn Jim V, Big Byte, Fat Cat, The Betty Boop.
Morning Star, Christine, Ryan's Girls, Past Due.
He arranges all his little jars of paint,
Lays out his line of brushes fine as lashes
And sets to mixing hues on a shred of cardboard box,
Creating tints to indulge the tastes of absent owners.
First, three horizontal lines are ruled across the transom
To keep letters evened-up from end to end
And then the blocked or scripted forms are penciled in.
Next, the ball of his mahl-stick pressed against
The hull for balance, palsied wrist bent
Over the shaft, bulging blue vein crimped
To steady wrinkled fingers, he applies
Strokes smooth as a woman does eyeliner, left hand
Raising and lowering the stick, doing the work
As the right, brush extended, rests.
But though a name's soon raised legible
From the flat, compounded gel-koat,
The job's not done until the darker lines
For depth are added, thick black or gray
Lines around lines that bring forth boldly
The shadows of vanity.

KNOTS

"Poetry is the little awl that unties knots."
—Gary Snyder

Befuddled on the dock by knots,
Unable to untie lines looped over pilings,
Boatowners wait to be freed from their slips
As I huff and puff, dig my fingers
In the lumpy, twisted handfuls of hemp
And only make them tighter.
Worse than a shoelace or drawstring snapped
In the morning, worse when wet.
The yardmanager clatters the planks
Of the dock in a hurry to help.

 "To untie these knots,
To comprehend these loopings,
You first must learn to tie 'em."
He pulled on an end and the knot fell loose like a robe.
 "This is a clove hitch,"
He instructed. "Make the first loop
Grasping the free end in one hand
And putting it under the hand
Holding the standing part,
Which is strained with the chore of holding
The boat. Slip the eye over the piling,
Take two new hand holds on the free end
And slide them under the new standing part
From the piling. See?"
I nodded, noting the syntax of this knot
As convoluted as the speech of Melville's sailors.
I've always had to read it twice.
 "Show me another."
He knotted a bowline and I practiced
Them both a few times, until I tied
And untied them fluidly. Then he left
Me with a cleat knot, saying,
 "When you break down
The engine, watch how the parts come apart,
Learn how it works, where it starts."

Composite: Philadelphia, 1964
66

Composite: Philadelphia, 1965
Composite: Philadelphia, 1966 (page 68)
Composites: Spruce Street Boogie, 1966 / 1981 (page 69; detail, pages 70–71)
67

Book Title:
Unknown Territory:
Photographs by Ray K.
Metzger
Author:
Anne Wilkes Tucker
Ray K. Metzker
Art Director:
Massimo Vignelli
Designers:
Massimo Vignelli
Sukey Bryan
Photographer:
Ray K. Metzker
Publishers:
The Houston Museum of
Fine Arts/Aperture
Millerton, NY
Typographer:
G & S Typesetters, Inc.
Printer:
Beck Offset Color Co.
Production Manager:
Charles Gershwin
Stevan Baron
Paper:
Quintessence Gloss
White Text #100
Binder:
Publishers Book Bindery
Jacket Designer:
Massimo Vignelli
Jacket Photographer:
Ray K. Metzker

Book Title:
White by Design
Author:
Bo Niles
Art Director:
Nai Chang
Designer:
Julio Vega
Publisher:
Stewart, Tabori & Chang
New York, NY
Typographer:
TGA Communications,
Inc.
Printer:
Toppan Printing Co., Ltd.
Production Manager:
Nan Jernigan
Paper:
Gloss-coated #100
Binder:
Toppan Printing Co., Ltd.
Jacket Designer:
Julio Vega
Jacket Photographers:
Keith Scott Morton
and others

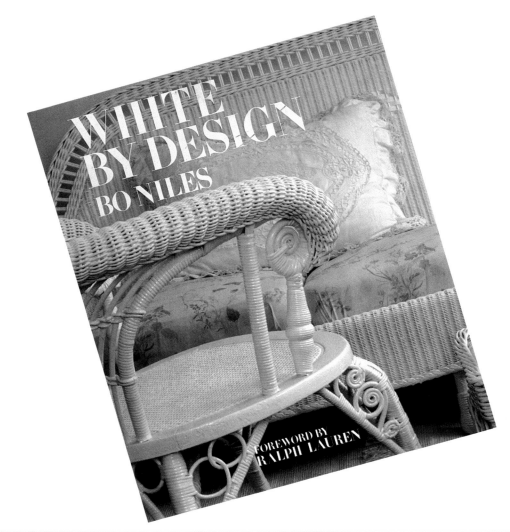

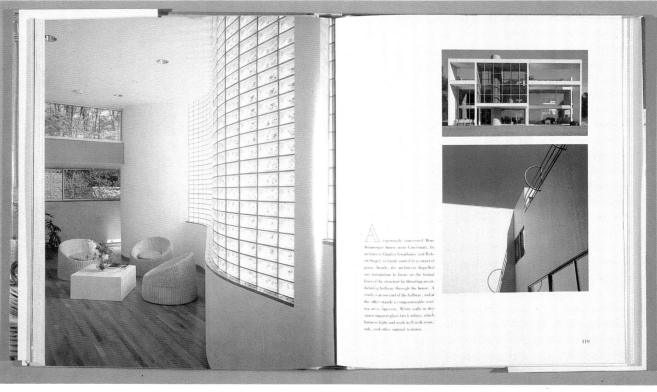

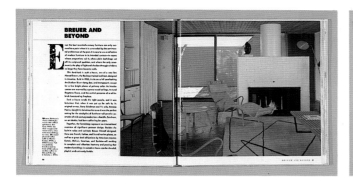

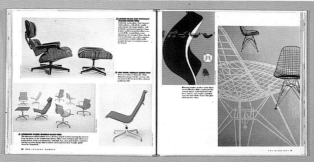

Book Title:
Mid-Century Modern
Author:
Cara Greenberg
Art Director:
Ken Sansone
Designer:
George Corsillo
Photographer:
Tim Street-Porter
and others
Publisher:
Harmony Books,
A Division of Crown
Publishers
New York, NY
Typographer:
Jackson Typesetting Co.
Printer:
Toppan Printing Co., Ltd.
Production Manager:
Murray Schwartz
Paper:
New OK Coated
Binder:
Toppan Printing Co., Ltd.
Jacket Designer:
George Corsillo
Jacket Photographer:
Tim Street-Porter

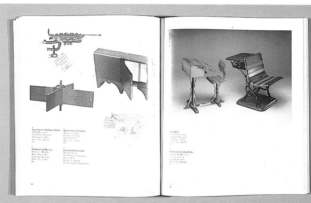

Book Title:
American Enterprise:
Nineteenth-Century Patent
Models
Editors:
Dorothy Twining Globus
Lucy Fellowes
Art Director/Designer:
Katy Homans
Photographers:
Kim Nielsen and
others
Publisher:
Cooper-Hewitt Museum
New York, NY
Typographer:
Trufont Typographers
Printer:
Mercantile Printing
Production Manager:
Katy Homans
Paper:
Lustro Dull
Binder:
Robert Burlen & Son
Jacket Designer:
Katy Homans

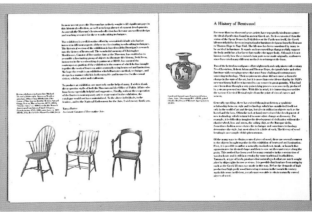

Book Title:
Bentwood
Authors:
Tanya Barter
John Dunnigan
Seth Stem
Art Director/Designer:
Joseph Gilbert
Gilbert Assoc.
Photographers:
Various
Publisher:
Museum of Art
Rhode Island School of
Design
Providence, RI
Typographer:
Gilbert Associates
Printer:
Eastern Press, Inc.
Papers:
Carnival Groove #70
Mohawk Superfine #100
Lustro Dull #100
Binder:
Mueller Trade Bindery
Cover Photographer:
Gary Gilbert

Book Title:
Half Moon Street
Author:
Paul Theroux
Designer:
Copenhaver Cumpston
Publisher:
Houghton Mifflin Co.
Boston, MA
Typographer:
Maryland Linotype
Composition Co.
Printer:
The Haddon Craftsmen,
Inc.
Production Manager:
Brenda Lewis
Papers:
Heritage Book #60
Warren Flo #80 Cover
Binder:
The Haddon Craftsmen,
Inc.
Jacket Designer:
Paul Bacon
Jacket Photographer:
Jerry Bauer
Jacket Printer:
New England Book
Components, Inc.

Book Title:
Sleeping With Soldiers
Author:
Rosemary Daniell
Design Director:
Amy Hill
Designer:
Susan Mitchell
Illustrator:
Susan Mitchell
Publisher:
Holt, Rinehart and
Winston
New York, NY
Typographer:
Adroit Graphic
Composition Inc.
Printer:
Fairfield Graphics Inc.
Production Manager:
Randy Lang
Paper:
Heritage Book Antique
#50
Binder:
Fairfield Graphics Inc.

Sean had managed to build into his life both his love of foot massage, and his predilection for gadgetry. "I just press this little bulb in my groin, it swells right up and stays that way. And ya-hoo! I can last forever! You tell Jack when you see 'im!"

A few weeks later, in Atlanta again, I was to drop by Sean's "for old times' sake," but it turned out to be the only night I could interview an outspoken and political local prostitute. "Carl's here —he'll be disappointed, 'n' so am I, hon," he said when I called to break our date. "I've got some long-stemmed yellow roses, a bottle of French champagne. But I'll just put it all on hold till you come back. . . ."

As I hung up, I was first flooded by what could have been that night—the roses, the champagne, the flicker of firelight, maybe even a foot massage, then by all that Sean had taught me—about friendship, true class, heroism. "It is in the extremities of evil circumstance that the possibilities of grace are -more clearly perceived," Flannery O'Connor wrote. "There is nothing that can cure the soul but the senses," Oscar Wilde said. And I had once written in a poem that "Only the sensual are innocent." But it had taken Sean to make me fully believe it, to disabuse me of the pie-in-the-sky, Bible Belt imprint that says the real baddies in life are best dealt with through self-denial rather than pleasure.

He and the Pirate had also contradicted my long held feminine notion that men never really supported or nurtured one another in times of duress, and the equally spurious idea that being a man has anything to do with having a functioning penis.

As a child, I had always sided with put-upon Mother, and rejected failed-macho Daddy as Bad Guy, the cause of all our troubles. With each of my three husbands, and many of my lovers along the way, I had confirmed my female chauvinistic values. But now—through my lark on the oil rig, my carelessly undertaken liaisons with the Pirate, Randy, Gary, Jay, Barry, Sean, and the rest—I had learned that while men—especially *some* men—were not perfect, they were not that imperfect, either.

And ironically—since I had picked these lovers for reasons of pleasure rather than shared values—I found myself in clear danger: that of liking and respecting the other sex for the first time in my life.

114

Book Title:
The Prints of
Samuel Chamberlain
Authors:
Narcissa Gellatly
Chamberlain
Jane Field Kingsland
Art Director/Designer:
Freeman Keith
Illustrator:
Samuel Chamberlain
Publisher:
Boston Public Library
Boston, MA
Typographer:
The Meriden-Stinehour
Press
Printer:
The Meriden-Stinehour
Press
Production Manager:
Freeman Keith
Paper:
Mohawk Superfine Text
Curtis Tweedweave Text
Binder:
The Meriden-Stinehour
Press
Jacket Designer:
Freeman Keith
Jacket Illustrator:
Samuel Chamberlain

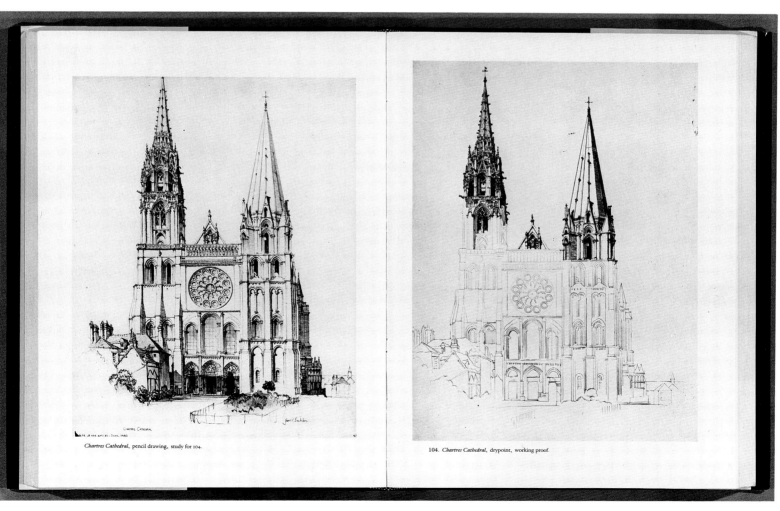

Chartres Cathedral, pencil drawing, study for 104.

104. *Chartres Cathedral*, drypoint, working proof.

Book Title:
American View
Author:
Raymond Waites, Bettye
Martin, Norma Skurka
Art Director/Designer:
Raymond Waites
Photographers:
Tom McCavera, Lilo
Raymond, Michael Skott
Publisher:
Harper & Row
Publishers, Inc.
New York, NY
Typographer:
LCR Graphics
Printer:
Princeton Polychrome
Press
Production Manager:
Mary E. Chadwick
Paper:
Warrens LOE Gloss #80
Binder:
The Haddon Craftsmen
Jacket Designer:
Raymond Waites
Jacket Photographer:
Raymond Waites

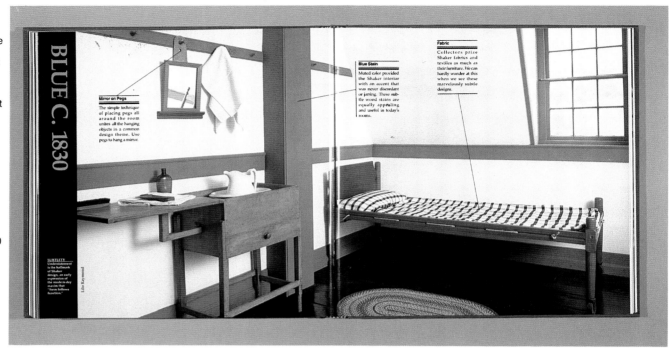

BLUE C. 1830

Mirror on Pegs
The simple technique of placing pegs all around the room unites all the hanging objects in a common design theme. Use pegs to hang a mirror.

SUBTLETY
Understatement is the hallmark of Shaker design, an early expression of the modern-day maxim that "form follows function."

Lilo Raymond

Blue Stain
Muted color provided the Shaker interior with an accent that was never discordant or jarring. These subtle wood stains are equally appealing and useful in today's rooms.

Fabric
Collectors prize Shaker fabrics and textiles as much as their furniture. We can hardly wonder at this when we see these marvelously subtle designs.

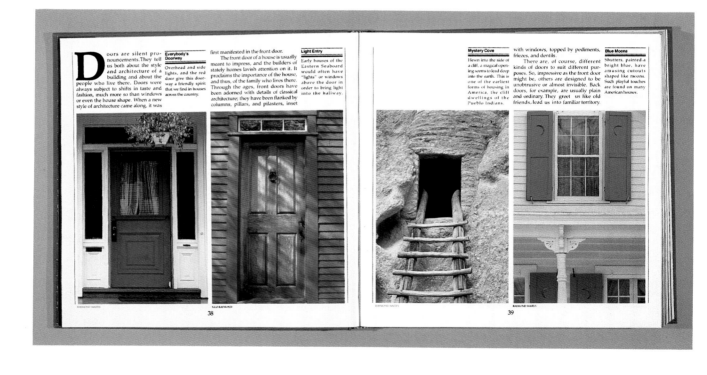

Doors are silent pronouncements. They tell us both about the style and architecture of a building and about the people who live there. Doors were always subject to shifts in taste and fashion, much more so than windows or even the house shape. When a new style of architecture came along, it was first manifested in the front door.

The front door of a house is usually meant to impress, and the builders of stately homes lavish attention on it. It proclaims the importance of the house, and thus, of the family who lives there. Through the ages, front doors have been adorned with details of classical architecture; they have been flanked by columns, pillars, and pilasters, inset with windows, topped by pediments, friezes, and dentils.

There are, of course, different kinds of doors to suit different purposes. So, impressive as the front door might be, others are designed to be unobtrusive or almost invisible. Back doors, for example, are usually plain and ordinary. They greet us like old friends, lead us into familiar territory.

Everybody's Doorway
Overhead and side lights, and the red door give this doorway a friendly spirit that we find in houses across the country.

Light Entry
Early houses of the Eastern Seaboard would often have "lights" or windows above the door in order to bring light into the hallway.

Mystery Cove
Hewn into the side of a cliff, a magical opening seems to lead deep into the earth. This is one of the earliest forms of housing in America, the cliff dwellings of the Pueblo Indians.

Blue Moons
Shutters, painted a bright blue, have amusing cutouts shaped like moons. Such playful touches are found on many American houses.

RAYMOND WAITES

LILO RAYMOND

RAYMOND WAITES

RAYMOND WAITES

38

39

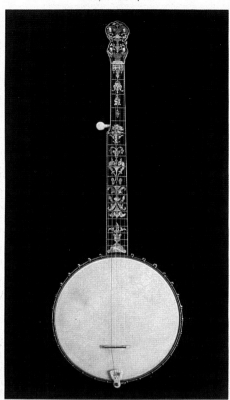

29
five-string banjo
The A. C. Fairbanks Co., Boston
"Electric," s/n 14913, ca. 1895
James F. Bollman Collection
Courtesy The Music Emporium

30
five-string banjo
The A. C. Fairbanks Co., Boston
"Electric," s/n 14913, ca. 1895
James F. Bollman Collection
Courtesy The Music Emporium

WALTER BURKE & WILLIAM GERKE—Providence, RI, ca. 1880; mostly inexpensive wooden-rim five-string banjos.

JOHN FABRIS—Hartford, CT, 1880s–1890s; reputedly made the first banjo-mandolin, ca. 1899.

GEORGE FLORENCE—ca. 1880; one fretless example known.

C. F. HANSON & CO.—Worcester, MA; late 1880s, one example known.

HOWARTH & KELLY—Providence, RI; ca. 1890s, made the popular tailpiece used by A. C. Fairbanks. No known examples exist of this firm's banjos.

C. W. HUTCHINS—Springfield, MA, ca. 1885; few examples known, but similar to low-grade Fairbanks & Cole banjos.

C. O. KIBBE—Hartford, CT, ca. 1890.

LIBBY BROS.—Gorham, ME, ca. 1890; one example known.

A. G. OATLEY—ca. 1875, one fretless banjo seen.

H. F. OATLEY—Putnam, CT, ca. 1898; no examples seen.

CALVERT PARKER—Keene, NH, ca. 1922; made a fair number of open-back tenor banjos, banjo-mandolins, and a few unusual mandolins.

PHILHARMONIC—Providence, RI, late 1920s; made tenor banjos with unusual metal rims; necks seem to have been made by Bacon.

E. P. SAUNDERS—Ludlow, VT, ca. 1910; violin-maker, one example, a copy of the Bacon FF Professional, seen.

G. S. W. TEEL—Springfield, MA, ca. 1890; one example seen.

WIKES—Holyoke, MA; none seen.

WOODS BANJO CO.—Falmouth, ME, ca. 1887; none seen.

Notes

[1] Christine Merrick Ayars, *Contributions to the Art of Music in America by the Musical Industries in Boston 1640 to 1936* (New York: H. W. Wilson Co., 1937), p. 275.

[2] Ayars, 276.

[3] Ditson's early roots in Boston are well established, as early as 1783. Oliver Ditson Company was formed in 1835, and incorporated in 1889. Oliver Ditson apparently supplied capital to launch the John Church Company in Cincinnati, in 1860; and Lyon & Healy in Chicago, in 1864. Lyon & Healy soon became an important manufacturer of banjos and other stringed instruments, and birthed the famous "Washburn" brand name before the turn of the 20th century.

[4] Ayars, 232.

[5] Ayars, 229.

Ring the Banjar!
Instruments from the Exhibition

1

four-string banjo
maker unknown
ca. 1800?
Stu Jamieson

Book Title:
Ring the Banjar
Author:
Robert Lloyd Webb
Designer:
David Ford
Photographers:
Old photographs
James Scherer
Publisher:
The MIT Museum
Cambridge, MA
Typographer:
DEKR Corp.
Printer:
Meridian Printing
Paper:
Warren's LOE #70
Binder:
Riverside Bindery

Book Title:
At Home in Manhattan
Author:
Karen Davies
Art Director/Designer:
Karen Salsgiver
Photographers:
Various
Publisher:
Yale University Art Gallery
New Haven, CT
Typographer:
Custom Typographic
Service, Inc.
Printer:
Rembrandt Press
Production:
Greer Allen
John Gambell
Yale University Printing
Service
Paper:
Lustro Dull
Binder:
Mueller Trade Bindery
Corp.
Jacket Designer:
Karen Salsgiver

27 Child's Victorian Luxembourg-pattern spoon, fork, and knife

Description
Knife, fork, and spoon all have upturned handle with flared rounded end; ornamented with foliate C-scrolls on front and back. Knife has straight blade with rounded end. Spoon has oval bowl. Fork has 4 tines. All engraved "JKR" in foliate script on front of handle.

Marks and Dimensions
Lion; anchor; "G"; and "STERLING" in raised letters on back of spoon and fork handles and knife blade. Spoon length: 6". Fork length: 5¾". Knife length: 7¼".

Maker, Locality, and Date
Gorham Company (1831–present), Providence. 1893–1900.

Comment
Many handle patterns for silver flatware were created during the late 19th century, with large manufacturers producing a vast array of them each year. Some patterns were short-lived, while others attained a popularity that lasted from generation to generation. This pattern was introduced in 1893; known as Luxembourg, it was meant to evoke the exotic aura and rich history of this European country.

Hints for Collectors
Children's eating utensils were popular gifts during the 19th century; many survive today and are readily available to collectors. Most desirable are those in sets, which have added appeal if they retain their original box. Unusual patterns that enjoyed short-lived popularity are of special interest and often of greater value because of their relative rarity.

28 Modern traveling knife, fork, and spoon

Description
Knife with flat, petal-shaped, curved blade; curved, flared handle, rectangular in section, with 2 narrow pockets to hold spoon and fork. Spoon with slender, curved, flared handle and shallow oval bowl. Fork with slender, curved, flared handle; shallow oval bowl with 3 short curved tines.

Marks and Dimensions
"STERLING" and "GRAHAM" stamped incuse on end of handle of each implement. Knife length: 8¼". Fork length: 7½". Spoon length: 7¼".

Maker, Locality, and Date
Anne Krohn Graham (b. 1942), Newark, Delaware. 1978.

Comment
Although the knife and spoon had become essential to eating long before the 16th century, the fork, introduced at about that time in Italy, was slow to be accepted. All 3 came to be fairly common by the late 18th century. Although these implements are simple in function, each has provided a challenging design problem over the centuries; this unusual and graceful traveling set is an outstanding response to that challenge.

Hints for Collectors
These 3 modern utensils function exactly like their centuries-old prototypes. Yet their maker has fashioned a visually stimulating and aesthetically pleasing group while retaining their conventional serviceability. Collectors should seek out innovative designs, such as the set shown here, that are fresh solutions to age-old questions. In many cases, contemporary examples are made in very limited quantities, so that an eager collector may wish to contact a particular maker to commission an object.

Book Title:
The Knopf Collectors' Guide to American Antiques: Silver & Pewter
Author:
Donald L. Fennimore
Art Director/Designer:
Massimo Vignelli
Photographer:
Rosmarie Hausherr
Publisher:
Alfred A. Knopf, Inc.
New York, NY
Prepared and produced:
Chanticleer Press
Typographer:
Dix Type, Inc.
Printer:
Dai Nippon Printing Co., Ltd.
Production Manager:
Helga Lose
Paper:
Kinfugi Art Dull 105 gram
Binder:
Dai Nippon Printing Co., Ltd.
Jacket Designer:
Massimo Vignelli
Jacket Photographer:
Rosmarie Hausherr

Illustrated Guide to American Makers and Marks

This table lists the American craftsmen and manufacturers whose work is featured in this book, along with their marks as they appear on the illustrated objects. The names are followed by birth and death dates, partnership dates, or operation dates, and by the primary location in which a maker worked. Makers of silver and silver plate are listed separately from pewterers.

Silver and Silver Plate

Silver and Silver Plate

Mark	Maker
ALLAN ADLER	**Allan Adler** b. 1916 Hollywood, CA
	Joseph Anthony 1762–1814 Philadelphia
	Thomas Arnold 1734–1828 Newport, RI
	Joseph T. Bailey & Andrew B. Kitchen 1833–46 Philadelphia
BAILEY & CO.	**Bailey & Company** 1846–78 Philadelphia
	Horace E. Baldwin & Company 1842–53 New Orleans
	Jabez Baldwin & John B. Jones c. 1813–19 Boston
W. BALL	**William Ball** 1763–1815 Baltimore
BALL, BLACK & CO.	**Ball, Black & Company** 1851–76 New York City

Mark	Maker
	Jurian Blanck, Jr. c. 1645–1714 New York City
	Jacob Boelen c. 1654–1729 New York City
	Charles Oliver Bruff 1735–85 New York City
	Cornelius van der Burch c. 1653–99 New York City
	Charles A. Burnett 1760–1849 Washington, DC
W. BURT	**William Burt** 1726–51 Boston
CARREL	**Daniel Carrel** dates unknown Philadelphia and Charleston, SC
	Simon Chaudron & Anthony Rasch 1809–12 Philadelphia
	Chicago Silver Company 1923–45 Chicago
	Hans Christensen 1924–83 Rochester, NY

Book Title:
Richard Meier
Compiler:
Richard Meier
Designer:
Massimo Vignelli
**Project Coordinator/
Editor:**
Joan Ockman
Photographers:
Various
Publisher:
Rizzoli International
Publications, Inc.
New York, NY
Typographer:
Roberts/Churcher
Printer:
Dai Nippon Printing Co.,
Ltd.
Design Coordinator:
Abigail Sturges
Paper:
U-Lite matte-coated #86
Binder:
Dai Nippon Printing Co.,
Ltd.
Jacket Designer:
Massimo Vignelli

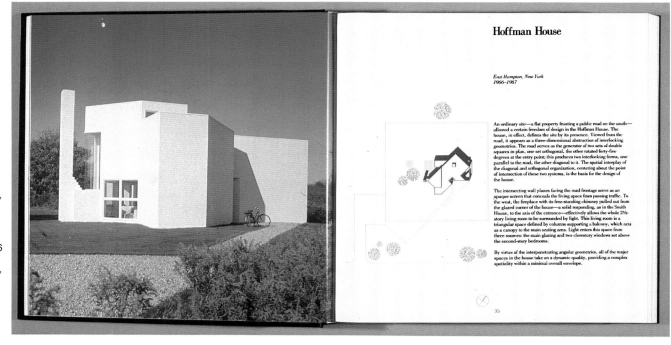

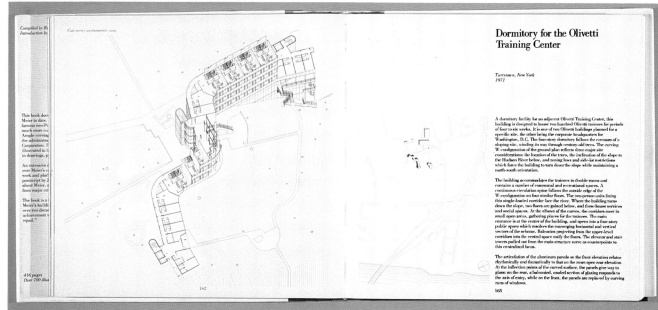

Book Title:
Perception
Author:
Irvin Rock
Art Director:
J. Malcolm Grear
Designer:
Malcolm Grear
Designers, Inc.
**Illustrators and
Photographers:**
Various
Publisher:
Scientific American
Books, Inc.
New York, NY
Typographer:
York Graphic Services
Printer:
Kingsport Press
Lehigh Press
Production Manager:
Lynne Sheehan
Paper:
Patina #70
Jacket Designer:
Malcolm Grear
Designers, Inc.
Jacket Artist:
Edouard Manet

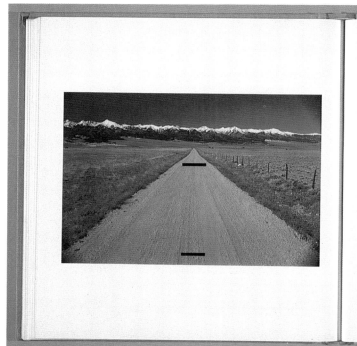

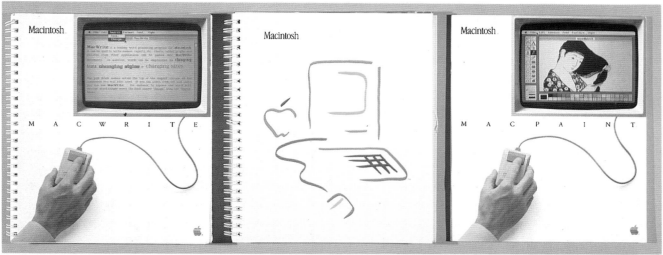

Book Title:
Macintosh MacWrite
Author:
Lynnea Johnson
Art Director:
Tom Hughes
Designer:
Ellen Romano
Illustrator:
Susan Kare
Photographers:
Various
Publisher:
Apple Computer Inc.,
Macintosh Div.
Cupertino, CA
Typographer:
George Graphics
Printer:
Thomson Lithograph
Production Manager:
Mimi Filizetti
Cindy Iwamura
Paper:
Quintessence Dull Cover
#100
Mountie Matte Text #70
Binder:
Thomson Lithograph

Book Title:
Macintosh Owner's Guide
Authors:
Carol Kaehler
Art Director:
Tom Hughes
Designer:
Ellen Romano
Illustrators:
Susan Kare
John Casado
Photographers:
Various
Publisher:
Apple Computer Inc.,
Macintosh Div.
Cupertino, CA
Typographer:
George Graphics
Printer:
ColorGraphics, Inc.
Production Managers:
Mimi Filizetti
Cindy Iwamura
Paper:
Quintessence Dull #100
Quintessence Dull #80
Binder:
Rodgers Bindery

Book Title:
Macintosh MacPaint
Author:
Carol Kaehler
Art Director/Designer:
Clement Mok
Illustrators:
Susan Kare
Clint Clemens
Publisher:
Apple Computer, Inc.,
Macintosh Div.
Cupertino, CA
Typographer:
Macintosh Personal
Computer,
Clement Mok
Printer:
Thomson Lithograph
Production Manager:
Mimi Filizetti
Cindy Iwamura
Paper:
Quintessence Dull #100
Mountie Matte #70
Binder:
Thomson Lithograph

Book Title:
Views and Viewmakers
of Urban America
Author:
John W. Reps
Designer:
Edward D. King
Lithographers:
Various
Publisher:
University of Missouri
Press
Columbia, MO
Typographer:
G & S Typesetters
Printer:
Thompson-Shore
Production Manager:
Natalia Nadraga
Papers:
Warren's Olde Style #60
Warren's LOE Dull #80
GSM Dia Paque 128
GSM Mitsubishi Real Art
157
Binder:
John Dekker & Sons
Jacket Printer:
Dai Nippon Printing Co.,
Ltd.
Jacket Designer:
Edward D. King

ISBN 0-8262-0416-3

Of Related Interest

The Forgotten Frontier
Urban Planning in the American West
Before 1890
John W. Reps. "A fascinating account, full of
knowledge and perception, of the complex
interplay of people, private citizens and pub-
lic officials, corporations, colonization so-
cieties and religious groups." —Planning
History Bulletin
ISBN 0-8262-0351-5 1982
184 pages $25.00 cloth
ISBN 0-8262-0352-3 $12.95 paper

Town Planning in Frontier America
John W. Reps. "This paperback book, first
published in paperback by Princeton Univer-
sity Press in 1969, is based closely on the au-
thor's longer study of city planning in the
United States, The Making of Urban Amer-
ica, published in 1965. . . . Reps has been
called America's foremost historian of urban
planning, and this book is an excellent exam-
ple of his work." —South Dakota History
ISBN 0-8262-0316-7 1980
320 pages $9.95 paper

An Artist in America,
Fourth Revised Edition
Thomas Hart Benton; Foreword and After-
word by Matthew Baigell. In this fiery and
provocative autobiography, Benton presents
an intriguing record of American art and
society during his lifetime. This new edition
includes seventy-nine drawings that add
much to his narrative, plus a foreword dis-
cussing Benton's place in American art and
an afterword covering his career after 1968.
1983 480 pages 79 illus.
$25.00 cloth $12.95 paper

View of Boston, Massachusetts, 1877,
courtesy the Geography and Map
Division, Library of Congress.

University of Missouri Press
P.O. Box 7088
Columbia, Missouri 65205-7088

Reps

Views and
Viewmakers of
Urban America

Missouri

Views and Viewmakers of Urban America
LITHOGRAPHS OF TOWNS AND CITIES IN THE UNITED STATES
AND CANADA, NOTES ON THE ARTISTS AND PUBLISHERS, AND
A UNION CATALOG OF THEIR WORK, 1825–1925

JOHN W. REPS

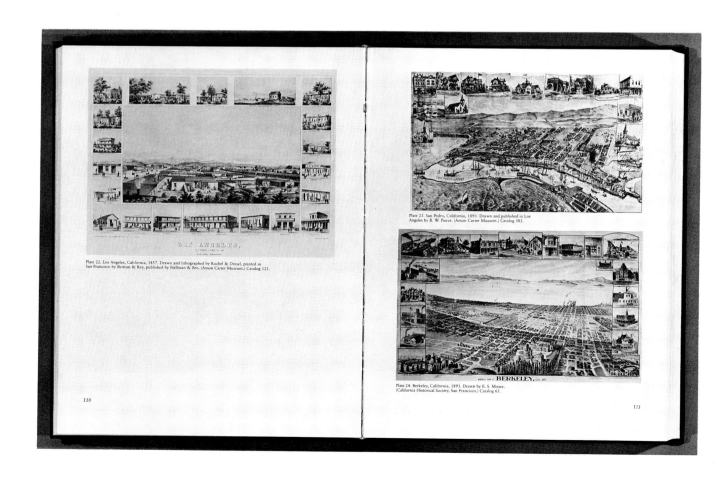

Plate 22. Los Angeles, California, 1857. Drawn and lithographed by Kuchel & Dresel, printed in
San Francisco by Britton & Rey, published by Hellman & Bro. (Amon Carter Museum.) Catalog 121.

Plate 23. San Pedro, California, 1893. Drawn and published in Los
Angeles by B. W. Pierce. (Amon Carter Musuem.) Catalog 383.

Plate 24. Berkeley, California, 1891. Drawn by E. S. Moore.
(California Historical Society, San Francisco.) Catalog 63.

110

111

Darting Guns, Darting-gun Harpoons, and Bombs

THE CONCEPT of fastening to and killing a whale simultaneously was important and the means for accomplishing this were pursued by many inventors. At the same time that the hand-darted explosive harpoons were being developed, unsuccessfully, a different implement, known as a darting gun, was perfected. The development of the darting gun began in 1865 and by 1872 it had replaced the hand-darted explosive harpoons. Originally developed for taking bowhead whales in the Arctic, darting guns were used in all whale fisheries.

Several types of darting guns were designed and all shared the same basic plan. The gun was mounted on a standard harpoon pole and was hand darted in the manner of ordinary harpoons. An explosive projectile, or bomb lance, was loaded into the gun barrel and a special harpoon, called the darting-gun iron, was mounted to the side of the gun. The harpoon was detachable and was mounted by wedging a tapered mounting tang tightly into mounting lugs on the side of the gun. The forged mounting tang replaced the socket on hand-darted harpoons. The trigger of the gun was a long plunger rod that extended beyond the muzzle to approximately mid-length of the mounted harpoon.

When the harpoon had penetrated a whale far enough, the plunger rod struck the side of the whale and was pushed back. This triggered the firing mechanism which discharged the bomb lance into the whale to kill it. The recoil disengaged the harpoon from the mounting lugs and the gun and pole were retrieved by means of a lanyard tied to the gun.

60

The whale line was tied to a ring or loop forged to the harpoon shank just forward of the mounting tang. This ring was served with marline to prevent chafing of the line.

Darting guns were highly successful, widely used, and afforded the added possibilities of use with the bomb lance only, with the harpoon only, or with harpoons specially designed to be fired from the barrel of the gun. Several variations were patented.

The first such gun to be patented was designed by Ebenezer Pierce, then of Hallowell, Maine, in 1865. It was a muzzle-loaded gun with a simple firing mechanism. A heavy block of metal that acted as a hammer pivoted at one end and was forced against a nipple by a strong leaf spring. This mechanism was positioned in a slot mortised through the breech-piece casting. When the hammer was rotated back against the spring it protruded slightly beyond the sides of the casting just prior to rotating the full distance back. A sliding rod was free to move back and forth in guides at the side of the gun. The butt end of the rod was bent in a J. The short leg of the J, which projected forward parallel to the main length of the rod, engaged the hammer when the hammer was fully rotated back, and retained it in the cocked position. When the rod struck the side of a whale, it moved back, disengaging the short leg from the hammer and allowing the hammer to discharge the gun.

E. Pierce darting gun, 1865

A hole at the end of the hammer allowed the use of a detachable lever for cocking the hammer against the strong spring. A sleeve of metal or leather was slid over the breech piece after cocking the gun to protect the mechanism against moisture. The mounting lugs for the harpoon were positioned at the side of the barrel near its forward end. The barrel screwed into the breech piece.

Pierce's original patent did not focus on the darting gun alone, but on fastening two irons to a whale simultaneously. One of the irons was a special bomb lance that acted as a harpoon after it exploded. Pierce's patent was reissued in 1880, however, and the reissue focused on the

61

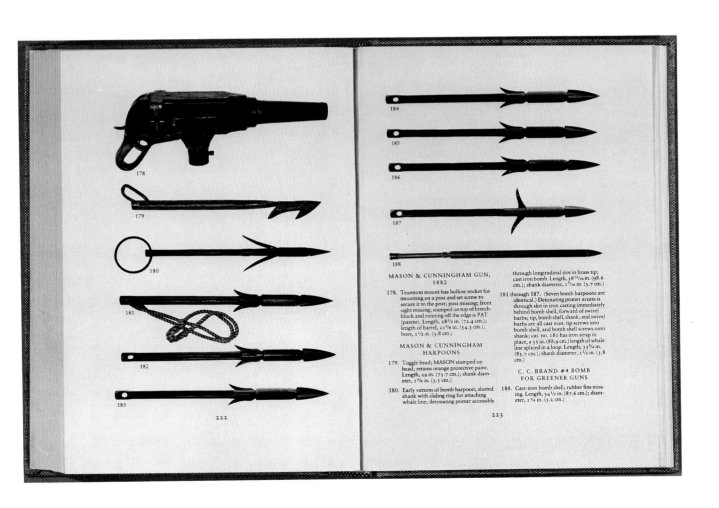

MASON & CUNNINGHAM GUN, 1882

178. Trunnion mount has hollow socket for mounting on a post and set screw to secure it to the post; post missing; front sight missing; stamped on top of breech-block and running off the edge is PAT (patent). Length, 28½ in. (72.4 cm.); length of barrel, 21³/₈ in. (54.3 cm.); bore, 1½ in. (3.8 cm.).

MASON & CUNNINGHAM HARPOONS

179. Toggle head; MASON stamped on head; retains orange protective paint. Length, 29 in. (73.7 cm.); shank diameter, 1³/₈ in. (3.5 cm.).

180. Early version of bomb harpoon; slotted shank with sliding ring for attaching whale line; detonating primer accessible

through longitudinal slot in brass tip; cast iron bomb. Length, 38¹³/₁₆ in. (98.6 cm.); shank diameter, 1⁷/₁₆ in. (3.7 cm.).

181 through 187. (Seven bomb harpoons are identical.) Detonating primer access is through slot in iron casting immediately behind bomb shell, forward of swivel barbs; tip, bomb shell, shank, and swivel barbs are all cast iron; tip screws into bomb shell; and bomb shell screws onto shank; cat. no. 181 has iron strap in place, a 35 in. (88.9 cm.) length of whale line spliced in a loop. Length, 33³/₄ in. (85.7 cm.); shank diameter, 1½ in. (3.8 cm.).

C. C. BRAND #4 BOMB FOR GREENER GUNS

188. Cast-iron bomb shell; rubber fins missing. Length, 34½ in. (87.6 cm.); diameter, 1¼ in. (3.2 cm.).

222

223

Book Title:
Harpoons and Other Whalecraft
Author:
Thomas G. Lytle
Art Director/Designer:
Freeman Keith
Illustrator:
Stephen Harvard
Publisher:
The Old Dartmouth Historical Society/Whaling Museum
New Bedford, MA
Typographer:
The Meriden-Stinehour Press
Printer:
The Meriden-Stinehour Press
Production Manager:
Freeman Keith
Paper:
Mohawk Superfine
Binder:
The Meriden-Stinehour Press

Book Title:
David Bowie's Serious
Moonlight
Author:
Chet Flippo
Art Director/Designer:
J. C. Suarès
Graphics:
Mick Haggerty
Photographer:
Denis O'Regan
Publisher:
A Dolphin Book
Doubleday & Co., Inc.
New York, NY
Typographer:
Leland & Penn, Inc.
Printer:
Leland & Penn, Inc.
Production:
Caroline Ginesi
Lawrence Vetu
Kathleen Gates
Coordinator:
Roy Finamore

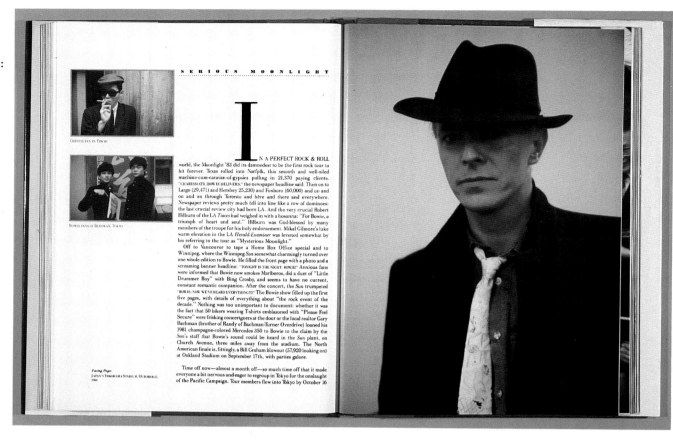

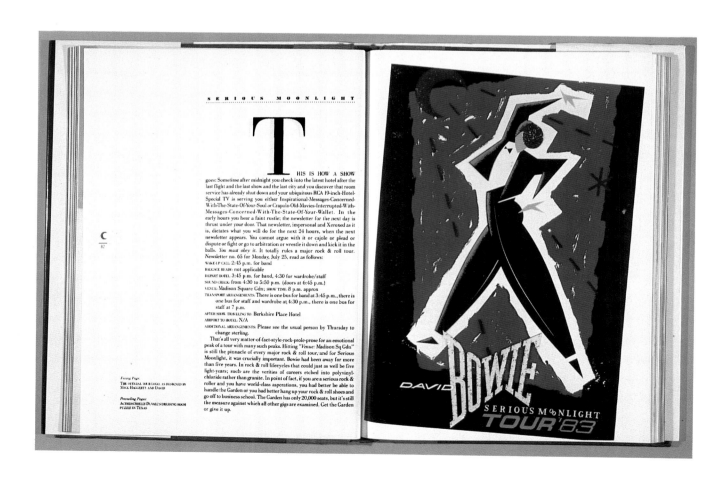

Book Title:
D.V.
Author:
Diana Vreeland
Art Director:
Betty Anderson
Designer:
Iris Weinstein
Publisher:
Alfred A. Knopf, Inc.
New York, NY
Typographer:
Maryland Linotype
Composition Co.
Printer:
Maple Press, Inc.
Production Manager:
Andrew Hughes
Paper:
P&S Vellum #60
Binder:
Maple Press, Inc.
Jacket Designer and Letterer:
Gun Larson
Front Jacket Illustrator:
William Acton
Back Jacket Photographer:
Horst

CHAPTER EIGHTEEN

I remember the night Reed and I arrived in Paris right after the war. Oh, how it had changed! Potato flour. To think that one was eating French bread, the great French triumph, made of potatoes! Everyone was in wooden shoes. *Clack clack clack.* You could tell the time of day from your hotel room by the sound of wooden soles on the pavement. If there was a great storm of them, it meant that it was lunch hour and people were leaving their offices for the restaurants. Then there'd be another great clatter when they returned to the office, et cetera et cetera. . . . The day we arrived it just happened to be Bastille Day, although we hadn't planned it that way. The fountains on the place de la Concorde were playing for the first time since the liberation. And we drove all over Paris. We went everywhere—Chaillot, St. Denis . . . I forget the names of the *quartiers* above Montmartre, but we went to all of them. Every little square had the most ghastly little band playing the same ghastly little tune.

Strangers were dancing with strangers. Girls were dancing with girls. Strange young men who looked haunted—as if they hadn't been out of a cellar in years—were dancing with fat old women. It was raining. No one was speaking. It was hideous—and marvelous.

At what must have been four o'clock in the morning, I

suddenly realized I was hungry. So we picked this little street above Montmartre, and on it was a restaurant that looked awfully nice, but the shutters were closed. So we banged and banged on the shutters until a man came out.

"We've had nothing to eat," I said. "We've just arrived from America and we've been spending this wonderful night in Paris, but we're so *hungry.*"

"*Mais entrez, madame et monsieur!*" the man said. "*Entrez! C'est une auberge!*"

I've never forgotten that, because, for me, France has always been an *auberge*—for feelings, for emotion, and for so many other things. Reed and I spoke of that experience for years after. The man opened up the door so wide that he could not have made a greater gesture if it had been the Hall of Mirrors!

Paris! I was so excited. But Paris had changed. The world had changed.

I realized this when I went for my fittings. You don't know what a part of life fittings once were. Remember I told you that before the war I used to have three fittings on a *nightgown*—and I'm not *that* deformed.

After the war you were no longer fitted for nightgowns.

Other things had changed. Couture before the war wasn't that expensive. It was hard to pay more than two hundred dollars for a dress. I had been what was known as a *mannequin du monde*—meaning "of the world"—because I was out every night in every nightclub, seen, seen, seen. . . . I was always given by the *maison de couture* for being a *mannequin du monde* what was known as a *prix jeune fille*—that is to say, they would give me the dress to wear and keep. The phrase no longer exists in the French vocabulary. The first thing I asked after the war was: "Does it still exist—as an expression?" I wasn't hinting around.

"Absolutely not!" I was told. "It's as dead as mud."

Before the war everybody in London and Paris was dressed by somebody. I remember Reed always used to say about plump old Elsa Maxwell, for instance, who never had a cent: "The great thing

Book Title:
One Writer's Beginnings
Author:
Eudora Welty
Art Director:
Marianne Perlak
Photographer:
Christian Webb Welty
Publisher:
Harvard University Press
Cambridge, MA
Typographer:
American-Stratford
Graphic Services, Inc.
Printer:
Halliday Lithograph Co.
Production Manager:
John Walsh
Paper:
Finch Opaque Book #70
Binder:
Halliday Lithograph Co.
Jacket Designer:
Marianne Perlak

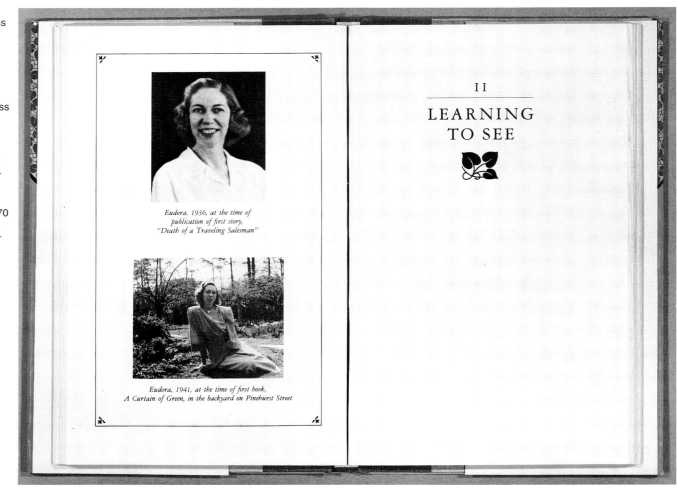

*Eudora, 1936, at the time of
publication of first story,
"Death of a Traveling Salesman"*

*Eudora, 1941, at the time of first book,
A Curtain of Green, in the backyard on Pinehurst Street*

II

LEARNING
TO SEE

Those had been early days. I tend to think that it had been Ned Andrews who saw himself in West Virginia as some original pioneer; he was the lone romantic in this story. He might have delighted in imagining the figure he'd cut to them back in Tidewater Virginia. (They *did* wonder at him: I grew to know the Virginia kin, his remarkable mother and his sisters who, when they knew, rallied around young Chessie and all Ned's family.)

His fine-grained wife lived on as a woman of unceasing courage and of considerable grace, with a great deal to make the best of. In the eyes of all their devoted children, and in every word I ever heard them say, it appeared that neither of their parents could ever have done conscious wrong or made an irretrievable mistake in their lives. When their mother died, the boys came down from the mountain. They married and made their own lives—except for John, who died of pneumonia after enlisting in the Army in 1918—in teaching, banking, civic or business affairs below. Carl became mayor of Charleston. They never let go of the home place. It was kept up as a family retreat, a camp for hunting and fishing. My mother and her brothers were able to visit each other, not only in times of trouble or crisis. It became comparatively easy, one day, after all.

IT SEEMS likely to me now that the very element in my character that took possession of me there on top of the mountain, the fierce independence that was suddenly mine, to remain inside me no matter how it scared me when I tumbled, was an inheritance. Indeed it was my chief inheritance from my mother, who was braver. Yet, while she knew that independent spirit so well, it was what she so agonizingly tried to protect me from, in effect to warn me against. It was what we shared, it made the strongest bond between us and the strongest tension. To grow up is to fight for it, to grow old is to lose it after having possessed it. For her, too, it was most deeply connected to the mountains.

When she was old, widowed, ill, and losing her sight, my mother one day announced to me she would be very glad to have the piano back in our house. It was the Steinway upright she had bought for me when I was nine, so far beyond her means, and had paid for herself out of the housekeeping money, which she added to by buying a Jersey cow, milking her, and selling part of the milk to the neighbors on our street, in quart bottles which I delivered on my bicycle. While I sat on the piano stool practicing my scales, I imagined my mother sitting on her stool in the cowshed, her fingers just as rhythmically pulling the teats of Daisy.

Two of her children had played this piano, I practicing my lessons and my brother Edward all along playing better by ear. When her grand-daughters came along, the piano was sent to their house to practice their lessons on. Now, all those years later, Mother wanted it under her roof again. **Right now!** It was brought and, the same day, tuned. She asked me to go directly to it and play for her "The West Virginia Hills."

I sat down and remembered how it went, and as I played I heard her singing it—singing it to herself, just as she used to while washing the dishes after supper:

*O the West Virginia hills!
How my heart with rapture thrills . . .
O the hills! Beautiful hills! . . .*

This one moment seemed to satisfy her. Once from her wheelchair, afterwards, she tried to pick it out herself, laying her finger slowly down on keys she couldn't really see. "A mountaineer," she announced to me proudly, as though she had never told me this before and now I had better remember it, "always will be *free.*"

"OH YES, we're in the North now," said my mother after we'd crossed the state line from West Virginia into Ohio. "The barns are all bigger than the houses. They care more about the horses and cows than they do about—" She forbore to say.

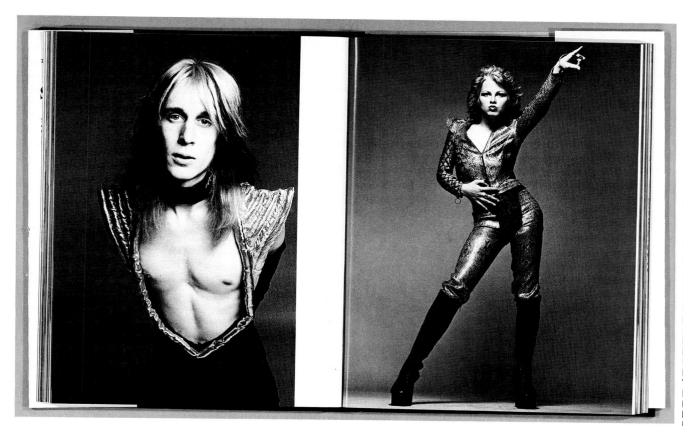

SCAVULLO
FRANCESCO SCAVULLO
PHOTOGRAPHS
1948–1984

PHOTOGRAPHY EDITOR
SEAN M. BYRNES

Book Title:
Scavullo
Author:
Francesco Scavullo
Photo Editor:
Sean M. Byrnes
Art Directors:
Rochelle Udell
Lydia Link
Designers:
Rochelle Udell
Doug Turshen
Photographer:
Francesco Scavullo
Publisher:
Harper & Row, Publishers,
Inc.
New York, NY
Typographer:
Fisher Composition, Inc.
Printer:
Meriden-Stinehour, Inc.
Production Manager:
Mary E. Chadwick
Paper:
Warren's LOE Dull #80
Binder:
A. Horowitz & Sons
Jacket Designers:
Rochelle Udell
Doug Turshen
Jacket Photographer:
Francesco Scavullo

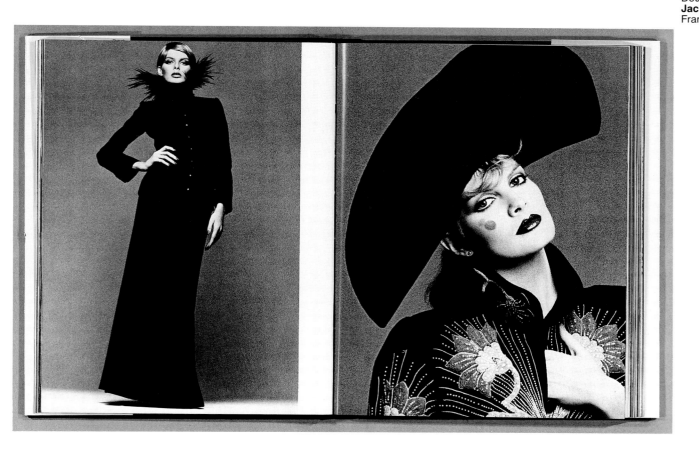

Book Title:
Irving Penn
Author:
John Szarkowski
Designer:
Christopher Holme
Photographer:
Irving Penn
Publisher:
Museum of Modern Art
New York, NY
Typographer:
M.J. Baumwell
Printers:
The Meriden Gravure
L.S. Graphics, Inc.
Production Manager:
Tim McDonough
Binder:
Sendor Bindery
Jacket Designer:
Christopher Holme
Jacket Photographer:
Irving Penn

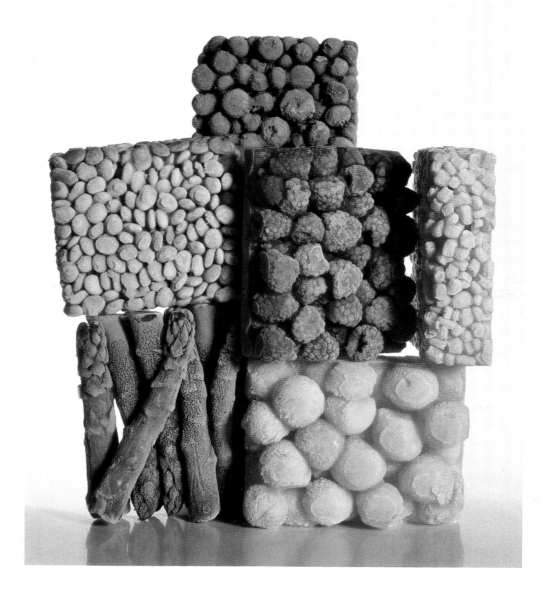

70. Frozen Foods, New York, 1977. Reproduced from Ektachrome transparency

71. Italian Still Life. New York, 1981. Reproduced from Ektachrome transparency

Book Title:
Man's Fate
Author:
André Malraux
Art Director:
Neal T. Jones
Designer:
Anthea Lingeman
Illustrator:
Madeline Sorel
Calligrapher:
Arlene Lee
Publisher:
Random House, Inc./
Book-of-the-Month Club
New York, NY
Typographer:
Maryland Linotype
Composition Co.
Printer:
The Murray Printing Co.
Production Manager:
Claire Friedland
Paper:
P&S Offset Laid Reg. #60
B-32
Binder:
The Murray Printing Co.
Jacket Designer:
Anthea Lingeman
Jacket Illustrator:
Madeleine Sorel
Jacket Calligrapher:
Arlene Lee

MAN'S
(LA CONDITION HUMAINE)
FATE

ANDRÉ MALRAUX

TRANSLATED BY HAAKON M. CHEVALIER
WITH A FOREWORD BY JOHN LEONARD
AND ILLUSTRATIONS BY MADELINE SOREL

RANDOM HOUSE, NEW YORK

verge both of laughter and anger; but she met his look. He had pushed the switch out of reach, and she realized that he expected his chief pleasure from the sensual transformation of her features. She knew that she was really dominated by her sexual feelings only at the beginning of an affair, or when she was taken by surprise: when she felt she could not find the switch, a familiar warmth seized her, mounted along her body to the tips of her breasts, to her lips, which she guessed by Ferral's look were imperceptibly swelling. She gave herself up to this warmth and, pressing him against her with her thighs and her arms, plunged with long pulsations far from a shore upon which she knew she would presently be thrown back, but bringing with her the resolve not to forgive him.

VALÉRIE was sleeping. Her regular breathing and the relaxation of sleep gently swelled her lips, and the wanton expression which pleasure gave to her features lingered like an afterglow. "A human being," thought Ferral, "an individual life, unique, isolated, like mine. . . ." He imagined himself as her, inhabiting her body, feeling in her place that enjoyment which he could experience only as a humiliation; he imagined himself—himself—humiliated by this passive voluptuousness, by this woman's sex. "It's idiotic: she feels herself in terms of her sex as I do in terms of mine, neither more nor less. She feels herself as a knot of desires, sadness, pride, as a destiny. . . . Obviously." But not at this moment: sleep and her lips gave her over to a perfect sensuality, as though she had agreed to be no longer a free and living being, but only the expression of gratitude for a physical conquest. The great silence of the Chinese

124

night, with its smell of camphor and leaves, it too asleep far out into the Pacific, covered her over, beyond the realm of time: not a ship called; not a gun fired. She did not trail with her in her sleep memories and hopes which he would never possess: she was nothing but the other pole of his own pleasure. Never had she lived: never had she been a little girl.

The cannon, once more: the armored train was again beginning to fire.

明天
下午四時

The next day,
four o'clock in the
afternoon

FROM a clock-maker's shop which had been transformed into a post, Kyo observed the armored train. Two hundred yards ahead of it and behind it the revolutionaries had blown up the rails, torn up the level crossing. Of the train which barred the street, motionless, dead, Kyo could see only two carriages, the one closed like a cattle-wagon, the other seemingly flattened out beneath its turret, from which a small-caliber gun projected. No men: neither the besieged hidden behind their blocked loop-holes nor the assailants, distributed in the houses overlooking the tracks. Behind Kyo, in the direction of the Russian church and the Commercial Printing House, the volleys did not let up. The soldiers who were ready

125

226

UNDER THE RUG

Two weeks passed and it happened again.

Book Title:
The Mysteries of
Harris Burdick
Author:
Chris Van Allsburg
Art Director:
Susan M. Sherman
Designers:
Susan Sherman
Chris Van Allsburg
Illustrator:
Chris Van Allsburg
Publisher:
Houghton Mifflin Co.
Boston, MA
Typographer:
Lithocomposition
Printer:
Thomas Todd
Production Manager:
Donna Baxter
Paper:
Sunray Opaque Vellum
#80
Binder:
A. Horowitz & Son
Jacket Designers:
Susan Sherman
Chris Van Allsburg
Jacket Illustrator:
Chris Van Allsburg

THE SEVEN CHAIRS

The fifth one ended up in France.

Book Title:
The Knopf Collectors'
Guides to American
Antiques:
Toys
Author:
Blair Witton
Art Director/Designer:
Massimo Vignelli
Photographer:
Schecter Me Sun Lee
Publisher:
A Chanticleer Press
Edition,
Alfred A. Knopf, Inc.
New York, NY
Prepared and produced:
Chanticleer Press
Typographer:
Dix Type, Inc.
Printer:
Dai Nippon Printing Co.,
Ltd.
Production Manager:
Helga Lose
Paper:
Kinfugi Art Dull 105 gram
Binder:
Dai Nippon Printing Co.,
Ltd.
Jacket Designer:
Massimo Vignelli
Jacket Photographer:
Schecter Me Sun Lee

Book Title:
Nutcracker
Author:
E.T.A. Hoffman
Art Director/Designer:
Ken Sansone
Illustrator:
Maurice Sendak
Publisher:
Crown Publishers, Inc.
New York, NY
Typographer:
B.P.E. Graphics, Inc.
Printer:
Toppan Printing Co., Ltd.
Production Managers:
Rusty Porter
Edward Otto
Paper:
NBK Nutcracker
Binder:
Toppan Printing Co., Inc.
Jacket Designers:
Ken Sansone
Maurice Sendak
Jacket Illustrator:
Maurice Sendak

Book Title:
A Writer
Author:
M. B. Goffstein
Designer:
Constance Fogler
Illustrator:
M. B. Goffstein
Publisher:
Harper & Row, Publishers
New York, NY
Typographer:
A. Colish, Inc.
Printer:
Eastern Press, Inc.
Color Separations:
Offset Separations Corp.
Production Manager:
Herman Riess
Paper:
Mohawk Vellum
Binder:
A. Horowitz & Sons
Jacket Designer:
Constance Fogler
Jacket Illustrator:
M. B. Goffstein

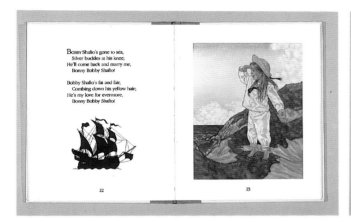

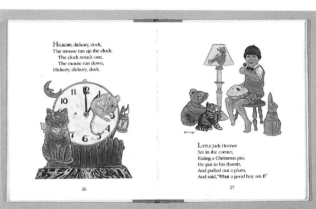

Book Title:
Mother Goose
Art Director/Designer:
Marc Cheshire
Illustrator:
Michael Hague
Publisher:
Holt, Rinehart and
Winston
New York, NY
Typographer:
Waldman Graphics, Inc.
Color Separations:
Offset Separations, Corp.
Printer:
W. A. Krueger Co.
Production Manager:
Karen Gillis
Paper:
Warren Patina #70
Binder:
W. A. Krueger Co.
Jacket Designer:
Marc Cheshire
Jacket Illustrator:
Michael Hague

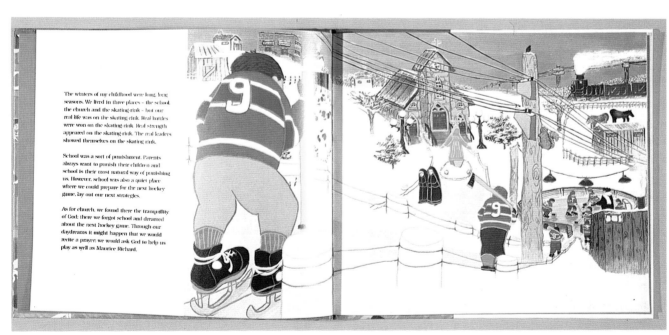

Book Title:
The Hockey Sweater
Author:
Roch Carrier
Translator:
Sheila Fischman
Art Director:
May Cutler
Designers:
Sheldon Cohen
May Cutler
Illustrator:
Sheldon Cohen
Publisher:
Tundra Books, Inc.
Montreal, CAN
Typographer:
Optima, Inc.
Printer:
Herzig Somerville, Inc.
Production Manager:
May Cutler
Paper:
Warrens Patina

Book Title:
Abraham Lincoln:
Mystic Chords of Memory
Editor:
Larry Shapiro
Art Director:
Neal T. Jones
Designer:
Joe Marc Freedman
Photographers:
Preston Butler
and others
Publisher:
Book-of-the-Month Club,
Inc.
New York, NY
Typographer:
Maryland Linotype
Composition Co.
Printer:
Semline, Inc.
Production Manager:
Claire Friedland
David Rivchin
Susan Horne
Paper:
SRT India #50
Binder:
Semline, Inc.

ABRAHAM LINCOLN

FAITH THAT RIGHT MAKES MIGHT, AND IN THAT FAITH, LET US, TO THE END, DARE TO DO OUR DUTY AS WE UNDERSTAND IT.

☆

LETTER TO MARY TODD LINCOLN, 1860

A note from the speaking tour that would help Lincoln win the Republican nomination at the convention in June.

[Exeter, N.H. March 4, 1860]

I have been unable to escape this toil. If I had foreseen it, I think I would not have come east at all. The speech at New York, being within my calculation before I started, went off passably well and gave me no trouble whatever. The difficulty was to make nine others, before reading audiences who had already seen all my ideas in print.

☆

☆ 34 ☆

☆ III ☆

"Essentially a
People's Contest"

ABRAHAM LINCOLN

LETTER TO GENERAL SHERMAN, 1864

Sherman's capture of Atlanta played a part in Lincoln's reelection in November, and now the general offered Savannah to Lincoln as "a Christmas gift."

Executive Mansion, Washington,
My dear General Sherman. Dec. 26, 1864.

Many, many, thanks for your Christmas-gift—the capture of Savannah.

When you were about leaving Atlanta for the Atlantic coast, I was *anxious*, if not fearful; but feeling that you were the better judge, and remembering that "nothing risked, nothing gained" I did not interfere. Now, the undertaking being a success, the honor is all yours; for I believe none of us went farther than to acquiesce. And, taking the work of Gen. Thomas into the count, as it should be taken, it is indeed a great success. Not only does it afford the obvious and immediate military advantages; but, in showing to the world that your army could be divided, putting the stronger part to an important new service, and yet leaving enough to vanquish the old opposing force of the whole—Hood's army—it brings those who sat in darkness, to see a great light. But what next? I suppose it will be safer if I leave Gen. Grant and yourself to decide.

Please make my grateful acknowledgments to your whole army, officers and men. Yours very truly A. LINCOLN.

☆

☆ 62 ☆

☆ V ☆

"The Fiery Trial
Through Which
We Pass"

Book Title:
Malik Verlag
Authors:
Steven Heller, Wieland
Herzfelde, George
Wyland, James Fraser,
Sibylle Fraser
Art Director/Designer:
Louis Fili
Photographers:
Various
Publisher:
Fairleigh Dickinson
University
Madison, NJ
Typographer:
National Photocomposition
Services
Printer:
Red Ink Productions
Production Manager:
Michael Josefowicz
Paper:
Patina #60
Binder:
Book Binders, Inc.
Jacket Designer:
Louise Fili
Jacket Illustrator:
John Heartfield

67. *Deutschland, Deutschland über alles,* Kurt Tucholsky and John Heartfield. Berlin: Neuer Deutscher Verlag, 1929. 231p. J:JH

The Heartfield cover of this single book collaboration of these two major satirists of the Weimar era is perhaps his most often reproduced photomontage in graphic anthologies in East and West.

Both men worked together in the fitting of the scores of photographs to the text, however, relatively few of Heartfield's photomontages are included.

That this book did raise a controversy in its time is understandable, although by contemporary standards of social satire it seems somewhat tame. We are accustomed to political leaders being referred to as animals. Ridicule of middle class foibles is commonplace. The ethnic slur is usually tolerated, at least when made by a member of the ethnic group disparaged. To measure the effect of this book at that time would be difficult if not impossible.

However, we do know its effect upon one graphic designer who fled Germany and came to America. Stefan Salter said in his *From Cover to Cover* (Englewood Cliffs, N.J., 1969):

I have seen many picture books in my life...But never before or since, such an impressive one as *Deutschland, Deutschland über alles...* What impressed me at once about the book were the photographs, the photomontages, and the way the text ran with the illustrations... It was a great textbook of our time, teaching important lessons which few people are willing to learn. It was like the handwriting on the wall, and it sent me away forever and in ample time.

Walter Laqueur, an exile like Salter and currently Director of the Institute for Contemporary History (London), put forth quite another point of view when writing on

Kurt Tucholsky

Tucholsky in *Encounter* (1969), stating that in *DDUA* was a caricature of Weimar Germany, some of it quite true, much of it distorted—all in questionable taste.

68. *Oktober; Ausgewählte Schriften,* Larissa Reissner. Edited with an intro. by Karl Radek. 2nd ed. Berlin: Neuer Deutscher Verlag, 1930. 521p. J:JH Enlarged reproduction of cover exhibited.

In the fall of 1924, Karl Radek (1885-1941), a major German Marxist theoretician and Comintern leader, brought his friend LR (1895-1926), a Soviet citizen, to Berlin to meet Willi Münzenberg, WM published her 1923 eyewitness account of the Hamburg revolution in 1924. That book was banned and the edition confiscated. Unfortunately it was not excerpted in this collection. Included are accounts of the Ullstein Verlag, the Krupp Corporation, reports from her travels in the Soviet Union immediately following the October Revolution and an extensive portion from her book on Afghanistan (where she lived for a time with her husband, a Soviet envoy to Kabul). The concluding text is a portion of her book on the Decembrists.

The cover photomontage by Heartfield suffers little by reproduction and enlargement. Indeed, **the exhibited piece demonstrates that Heartfield's work at its most direct can serve as book jacket, double as a poster, or stand alone as a book illustration.**

70 71

Im Schatten (December, 1921). Nine lithographs and title page. Editions A,B,C,D. Limited to 100 copies.

Edition A: #1-5; leaf size ranges from 48-49.4 cm×35.2-39.1 cm; Japan paper; each leaf signed.
Edition B: #6-20; leaf size ranges from 48-49.4 cm×35.2-39.1 cm; Heavy handmade Bütten; each leaf signed.
Edition C: #21-50; leaf size ranges from 48-49.4 cm×35.2-39.1 cm; Heavy handmade Bütten; each leaf signed.
Edition D: #51-100; leaf size ranges from 48-49.4 cm×35.2-39.1 cm; Light-weight handmade Bütten; each leaf signed.

An edition of several hundred copies (Organisationsausgabe) on drawing paper was done in 1922 for sale to members of various labor unions. The size of this 1922 edition is not recalled by WH or noted by Dückers.

10. *Vor den Fabriken* (In front of the Factories) (1920/1921). The second of nine leaves. 33.5 cm×25.4 cm.

Ecce Homo. 100 plates. 1923. Five editions. Edition size: 10,000 copies.

To summarize the seventeen pages of detail Dückers' has provided in the publishing history and dating of this work or the interpretation of its content by Hess' or Lewis' would serve little purpose here, for *Ecce Homo* remains the most widely-known of all of the Grosz collections of work and has been reprinted in book form a number of times over the past twenty years. We have limited therefore the selection of plates for exhibition to those which are not frequently shown or reproduced.

The intent of the artist and publisher was to show the debasement of the middle and upper classes of Germany of the period, and, in a wider sense, all capitalist society. As in any such work there is truth (not confined to German society) and there is exaggeration— sufficient for those in the bureaucracy concerned with such things to bring Grosz, Herzfelde and Jumpers into court once again. The motives in some of those individuals to suppress this work may have come about because they indeed saw themselves. There may also have been individuals in the bureaucracy who were dependable citizens with traditionally accepted moral values who saw themselves as doing their job by bringing some check on those publications which they suspected might have a corrosive effect upon the body social. But whatever the view held collectively or individually, the case and the trial focused yet more interest on the Malik-Verlag and its publisher. The judgment was against them and brought fines of 500 RM to Grosz and 1,000 RM each to Herzfelde and Gumperz as publishers. In addition, five of the watercolor illustrations and eighteen of the black and white illustrations were confiscated. **Ten thousand sets of sheets were printed by an offset process.**

Edition A: #1-L; 84 lithographs. 16 watercolors; approx. 35.8 cm×26.3 cm; wove paper; each leaf signed; 600 RM. Portfolio.
Edition B I: #1-100; 16 watercolors only; Bütten paper; each leaf signed; 200 RM. Portfolio.
Edition B II: 16 watercolors only; Bütten paper; unsigned; 32 RM. Portfolio.
Edition C: 84 lithographs. 16 watercolors; approx. 35.8 cm×26.3 cm; Bütten; unsigned; 45 RM. Bound.
Edition D: 84 lithographs only; poor quality paper; unsigned; 20 RM. Bound.

If one sets aside the 150 sets in the two special editions, one must rely on hearsay to determine the size of the other editions. It is believed that Edition C was between six and eight thousand copies. Assuming that the lower figure is correct that would leave around 1,925 copies for Edition B II and D each. It is also a matter of speculation as to the number of complete sets that remained after the confiscation. Later sets were advertised as containing 66 lithographs and 11 watercolors.

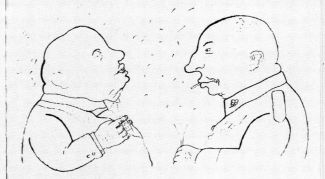

Ecce Homo Plates exhibited

11. "Hinterbliebene" (The Bereaved) 1921
Size: 20.5 cm×19.5 cm, B/W

12. "Die Verantwortlichen" (Those Responsible) 1920
Size: 17 cm×28.9 cm, B/W

13. "Ledebour," 1919 (Georg Ledebour, 1850-1947) 1919
Size: 22 cm×20.9 cm, B/W
Ledebour was a member of the Reichstag from 1900-1918. He played a leading role in the Spartakus Revolt in 1919 and published a periodical, *Klassenkampf*, from 1922 to 1923. He emigrated to Switzerland and died in Bern.

14. "Eheszene" (Domestic Scene) 1916
Size: 20.6 cm×20.5 cm, B/W

15. "Passanten" (Passers-by) 1921
Size: 26.4 cm×20 cm, Color

16. "Johannisnacht" (Midsummer Night) 1918
Size: 27.8 cm×16.4 cm, Color

30 31

Book Title:
Dreamer
Authors:
Mel Odom
Edmund White
Art Director/Designer:
Beth Tondreau
Illustrator:
Mel Odom
Publisher:
Penguin Books
New York, NY
Typographer:
Typographic Images
Printer:
Dai Nippon Printing Co.,
Ltd.
Production Managers:
Dolores Reilly
Anet Sirna-Bruder
Paper:
U-Lite Matte Coated #86
Binder:
Dai Nippon Printing Co.,
Ltd.
Cover Designer:
Neil Stuart
Cover Illustrator:
Mel Odom

"Smoke," 1978, 4" x 6".
48

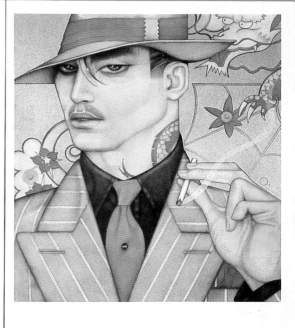

"The Yakuza," *Playboy*, 1984, unpublished, 10" x 13".
Reprinted by special permission from *Playboy* magazine; copyright © *Playboy*, 1984.
49

Almost all of the images in this book were first rendered as advertisements or as illustrations of magazine stories, and yet they resist their function, hold their secrets in reserve, refuse to comply. And almost all of Odom's images are of people, sex elusive, age unknown, race mestizo, who seem to be incestuously related not only to one another (the twins in Thomas Mann's—or Richard Wagner's—"Blood of the Volsungs") but also to certain flowers (orchids, lilies, tulips, chrysanthemums) and to animals of prey. Sometimes his people metamorphose into gorillas—or into angels.

To produce this kinship with the nonhuman, the faces have been deprived of creases, defects, hollows—in short, of character, psychology, and experience. As faces, they are the opposite of those twin aspects of Janus, since Odom's people have neither a future nor a past. They are lost in the eternal present of the dream.

Since they have no "soul," no innerness, they might just as well be dolls—and often are. Indeed, Odom has devised a series of Barbie Doll illustrations, the artistic counterpart to dressing up a real doll in deliciously different costumes. Paradoxically, these dolls are among Odom's most personal work. As he has remarked, "I grew up a sissy in a small town, and Barbie was forbidden, and very beautiful to me as a child. I finally convinced my parents to buy me a Barbie, but it was a dark secret and a hidden shame." For me the phrase "forbidden, and very beautiful" is a clue to Odom's aesthetic. The forbidden may be a secret (hence its erotic force) and shameful (whence its sadomasochistic splendor), but it is never deformed, ugly, dirty. No, the forbidden is "very beautiful."

Odom's faces are those of dolls, or they are masks, and it should not surprise us that he has made many real masks nor that his work has enjoyed a great vogue in Japan, the land of the Nō mask. Since the Nō actor wears a mask during the whole performance, he cannot vary his looks, although connoisseurs insist that they can find nuances of expression in the angle at which the mask is tipped, detect a dawning smile, say, in a mouth brought more fully up into the light. Exactly this sort of rejection of an overt "signifier" in favor of a covert "signified" is what Odom seems to be seeking; he gives us the latent, not the manifest, content of his dreams and dreamers.

In drawings, too, the face becomes a mask. In "Crack-up," the face is literally cracked into pieces. In fact, this literalization of a cliché ("I'm cracking up, I'm going to pieces") is one of Odom's most potent and poetic strategies. In his drawings, for example, eyebeams are actual beams of light.

In an illustration such as "Shirts," Odom runs through his full repertory of approaches to the human head. One lean, white-haired face is in Futurist motion, simultaneously in profile and full-face. Another head is just a shattered piece of polished green malachite sprouting pale weeds for hair. Two display-window mannequin torsoes are pinned into fashionable shirts, but one, amazingly, has "blown his top"; he has a head levitating in space and, still higher in the stratosphere, a free-floating brush-cut. A more normal, more convincingly human figure holds a shirt up—but with the socketed wooden arm of an artist's studio dummy. A man in an aubergine silk shirt occupies his own dimension, and his heart and head are transected by those mysterious beams of light I mentioned. Finally, a vigorous young exec blushes with pride—but keeps on blushing until he becomes a scarlet cockatoo before our very eyes! Man as motion, as statue, as dummy, as seer, as bird—the range and wit in a haberdashery illustration can be dazzling.

Since illustrations are exempted from the strictures of Real Art and the canons of Serious Painting, they need not submit to the exigencies of Art History. They do not constitute sites bombarded by meaning, cultural tradition, and aesthetic expectation. They are closer to dreams than stories. Illustrations do not participate in the dialectics of what is new, what is newly old, what constitutes an allusion instead of a dull repetition, what is merely "crude" instead of wonderfully "brut," etc. Nor must an illustrator's work "develop" or comment on itself. Erté, for instance, has retained the same vocabulary of images for nearly seventy years. To be sure, there are trends in illustration, but these trends simply demonstrate notions about what is "effective," "arresting," or "smart." No one ever praised an illustrator for

232

Book Title:
The Second Law
Author:
P. W. Atkins
Art Director:
J. Malcolm Grear
Designer:
Malcolm Grear Designers,
Inc.
Illustrator:
Gabor Kiss
Publisher:
Scientific American Books,
Inc.
New York, NY
Typographer:
York Graphic Services
Printers:
Kingsport Press
Lehigh Press
Production Manager:
Perry Bessas
Paper:
Patina #70
Jacket Designer:
Malcolm Grear Designers,
Inc.
Jacket Artist:
Henri Rousseau

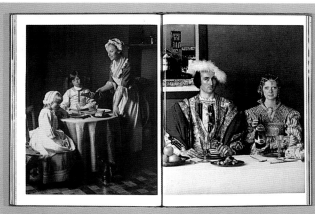

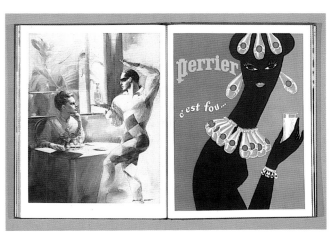

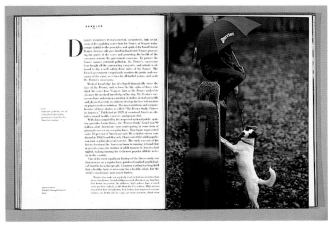

Book Title:
Perrier,
And Now The Book
Author:
Paul Chutkow
Art Director/Designer:
J.C. Suarès
Paintings:
Nina Duran
Photographers:
Matthew Klein
Dan Hamerman
Publisher:
Great Waters of France
Greenwich, CT
Typographers:
TGA Communications,
Inc.
TypoGabor
Printer:
Toppan Printing Co., Ltd.
Production Manager:
Caroline Ginesi

Book Title:
No Chariot Let Down
Editors:
Michael P. Johnson
James L. Roark
Designer:
Richard Hendel
Publisher:
The University of
North Carolina Press
Chapel Hill, NC
Typographer:
G & S Typesetters, Inc.
Printer:
Thomson-Shore, Inc.
Production Manager:
Richard Hendel
Paper:
Glatfelter Offset #55
Binder:
John Dekker & Sons
Jacket Designer:
Richard Hendel

234

Panama, New Granada,
South America
April 30/4/60

To My Esteemed Friends,[1]

It is now 17 years since I have left your little Borough.[2] *Would to God* I were there now. Had I of known as much as I know now I never should of left my *comfortable home.*

You are all aware of my Family's departing from our homes for the Island of Jamaica in May 1851, and perhaps this will be the [*first*] tidings that have ever reached you from us, although I wrote you all once from Jamaica and once from Aspinwall Navy Base N.G., of which I have never received any reply. But perhaps they never reached you. But as I have now a Favourable Opportunity, through the Politeness of Lieutenant Roberts of the U.S. Navy, I embrace the opportunity of writing once more. And should this reach you, Please give me all the news you can about the Family, [concerning] the prosperity of [*illegible word*] also how many Marriages & Deaths, of which I hope there is none of the latter. Also, how is Mr Natty[3] and Family and how many Children he has.

Now, as I have said, I wish I was back home. I have reason so to do, for you are aware that we were very comfortable there, and it seems as there has been a curse upon us every since we left home. I remained 2 years in Jamaica and then completely Failed. From thence my Father, Brother James, & myself came over here, leaving what little money we had with our Families. We were then employed by the Panama Rail Road Company as Overseers at $2.50 per day. My Poor Brother Died in 3 months after [he] was here and one month [*two illegible words*] I lost my then only Son, for you are aware that I lost one before I left home. I have now only one Daughter, near 10 years of age. My Poor unfortunate Father recieved an Injury whilst in the employ of the Said Company which has completely Disabled him for life. You you see the whole Burthen is thrown upon my Shoulders, and being in a country like this where every man is for himself, I find it *awfully hard* to get along. I see several ways that I could make money here, but not having anything like a capital, I can do nothing but Barbering and I can hardly pay my Rent and live out of it, having so many to feed and every thing is so very Dear here. As I have said, if I had a small Capital of $[200] make it [*illegible word*] in [*two illegible words*]. But I know of not a *Single Soul* in this world who would lend me the amount if I were to ask for it; so therefore I must be contented with my lot. Were it not

for the misfortune of my Father Being Crippled, I could live very comfortably.

Now I suppose you all would like to know what sort of a place Jamaica is. Well in the first place, if you like Negro Company, you may go [*page or pages missing*]

[*Jack Thomas*][4]

1. This letter was probably addressed to the Ellison family generally, but it was almost certainly designed to communicate with the elder William Ellison in particular.

2. A general reference to the Stateburg area.

3. While the census lists no one in Sumter District with the name Natty, it is possible that the writer was referring to Joseph M. Nettles or William Nettles, both older white planters with children. However, he may instead have been referring to a Sumter free man of color named Ignatius Miller. When Miller obtained a white guardian in December 1835, he noted

his name thus: "Ignatius Miller (Natty Miller)." 1850 Population Schedules, Sumter, dwellings 641, 863, SCDAH; Sumter County Guardians of Free Blacks, 1823–1842, Sumter County Historical Society, Sumter, South Carolina. We are indebted to Mr. Esmond Howell for access to this unique document.

4. That Jack Thomas is the author is known because of the reference in James M. Johnson's letter of May 30, 1860, below. Thomas was almost certainly a free man of color who, as Johnson indicates, was forced to leave Stateburg because of some sort of serious incident.

Christopher G. Memminger
From an original in the South Carolina Historical Society. Photograph by Harold H. Norvell.

Charleston, Decr 23d/59

Dear Henry,

I hope this will find you relieved from your cold. I am annoyed with one. The wedding came off in style. Nat Fuller[1] was the caterer. He had oysters served for E Ann[2] at 9 o'clock. We left soon after. We had two bottles of champagne broached before leaving & did not even eat a piece of cake. The crowd was a large & respectable one. Mr Gadsden[3] performed the ceremony, Dr Hanckel[4] being sick. There were 10 attending of each sex. Some of the bridesmaids left before we did for Savannah. Beard[5] went down with them but took care to get back before supper. The bride & groom are gone on a Tour in the country.

Matilda[6] was at Home today for the first time. She is well. Mrs Bonneau is quite feeble. R Kinloch[7] gets married shortly, also Miss Gourdin,[8] an apprentice of Mrs Lee.[9]

Do tender my congratulations to your Father on the adjournment of the Legislature. He ought to read Col Memminger's[10] speech against Moore's bill.[11] It is in the Courier of 16th. I prophesied from the onset that nothing would be done affecting our position.

We have sent some little nick nacks for the children, not having room for the grown folks. You must come down & follow the fashion. I heard a few days ago my cotton was sold, but did not learn the rates. I will be able to settle up with your Father for Bagging, Rope, &c. Do see that Sarah[12] behaves herself & salts the creatures regularly. We have not heard from Charley for some days. Father,[13] Mother, Gabriella, & E Ann unite with me in wishing you & all at Wisdom Hall a Merry Christmas. As ever, I am yrs truly

J M J

1. Nat Fuller was a free man of color whose catering business was well known in the city. In the recent mayoral election, when the activities of slaves and free persons of color had been the subject of heated discussion, a wedding at Zion Presbyterian Church similar to the one described in this letter prompted "A Slaveholder" to write the *Mercury*, "Well may we exclaim, 'where are we drifting to?' when in a slaveholding community the 'nuptials of *blacks*' are celebrated in a spacious temple of the Most High—where a bridal party of a score and ten in numbers are transported to the modern centre of fashion and false philanthropy in gay equipages— and where hundreds of others, robed in extravagant costumes, witness possibly with eyeglass in hand, this the dawn of a new

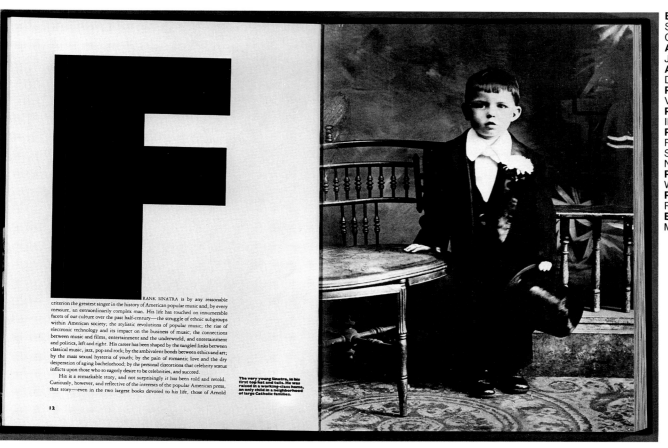

Book Title:
Sinatra, An American
Classic
Author:
John Rockwell
Art Director/Designer:
Derek Ungless
Photographers:
Various
Photo Editor:
Ilene Cherna
Publisher:
Random House/Rolling
Stone Press
New York, NY
Printer:
W. A. Krueger Co.
Production Manager:
Patrick Lee
Endpapers:
Michael Geiger

F

RANK SINATRA is by any reasonable criterion the greatest singer in the history of American popular music and, by every measure, an extraordinarily complex man. His life has touched on innumerable facets of our culture over the past half-century—the struggle of ethnic subgroups within American society; the stylistic revolutions of popular music; the rise of electronic technology and its impact on the business of music; the connections between music and films, entertainment and the underworld, and entertainment and politics, left and right. His career has been shaped by the tangled links between classical music, jazz, pop and rock; by the ambivalent bonds between ethics and art; by the mass sexual hysteria of youth; by the pain of romantic love and the dry desperation of aging bachelorhood; by the personal distortions that celebrity status inflicts upon those who so eagerly desire to be celebrities, and succeed.

His is a remarkable story, and not surprisingly it has been told and retold. Curiously, however, and reflective of the interests of the popular American press, that story—even in the two largest books devoted to his life, those of Arnold

The very young Sinatra, in his first top hat and tails. He was raised in a working-class home, an only child in a neighborhood of large Catholic families.

12

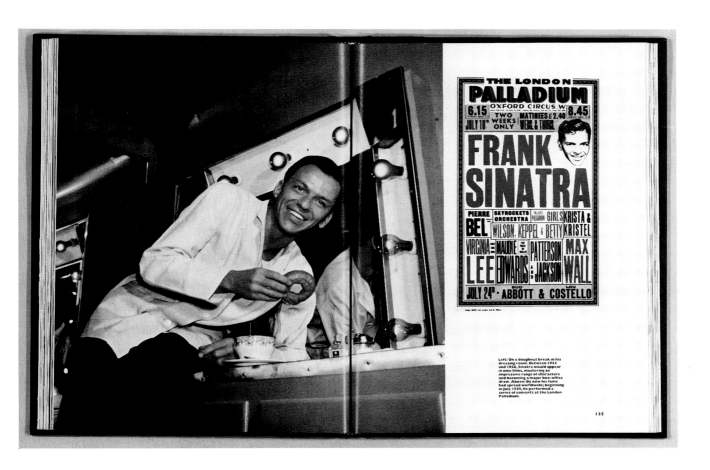

Left: On a doughnut break in his dressing room. Between 1953 and 1956, Sinatra would appear in nine films, mastering an impressive range of characters and becoming a major box-office draw. Above: By now his fame had spread worldwide; beginning in July 1950, he performed a series of concerts at the London Palladium.

135

Book Title:
Robert Natkin
Author:
Peter Fuller
Art Director:
J. Malcolm Grear
Designer:
Malcolm Grear
Designers, Inc.
Artist:
Robert Natkin
Photographers:
John Hill
Quesada/Burke
Publisher:
Robert Natkin
New York, NY
Typographer:
The Stinehour Press
Printer:
The Meriden Gravure Co.
Production Manager:
Malcolm Grear
Designers, Inc.
Paper:
Vintage Velvet
Jacket Designer:
Malcolm Grear
Designers, Inc.
Jacket Artist:
Robert Natkin

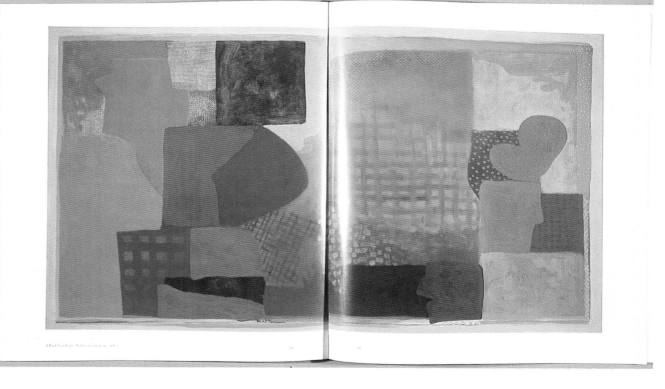

Book Title:
Jim Dine: Five Themes
Author:
Graham W. J. Beal
Art Director/Designer:
Robert Jensen
Illustrator:
Jim Dine
Publisher:
Abbeville Press
New York, NY
Typographer:
Julie Condecon
Printer:
Amilcare Pizzi s.p.a.
Production Manager:
Dana Cole
Paper:
Matte Coated #100
Binder:
Amilcare Pizzi s.p.a.
Jacket Designer:
Robert Jensen

As a zoological study, this watercolor of a female bullfrog made on August 8 at Bethlehem shows not only the artist's attention to detail but also his ability to represent his subject in a convincing, lifelike attitude.

With Dreidoppel, Maximilian spent much of August 13 through 16 exploring the heights above the Lehigh Valley; during this time he obtained several specimens of snakes, frogs, turtles, and toads. In his journal for August 17 he noted that "Mr. Bodmer made some very exact drawings of toads."

34. *A Female Bullfrog*, watercolor over pencil on paper, 6½ x 8

35. *A Toad*, watercolor on paper, 8 x 10

Book Title:
Karl Bodmer's America
Authors:
William H. Goetzmann, David C. Hunt, Marsha V. Gallagher, William J. Orr
Art Director/Designer:
Richard Eckersley
Artist:
Karl Bodmer
Photographer:
Malcolm Varon
Publisher:
Joslyn Art Museum
University of Nebraska Press
Lincoln, NE
Typographer:
G & S Typesetters
Printer:
Dai Nippon Printing Co., Ltd.
Production Manager:
Debra Turner
Alison Rold
Paper:
Sum fuger #86
Binder:
Dai Nippon Printing Co., Ltd.
Jacket Designer:
Richard Eckersley
Jacket Artist:
Karl Bodmer
Jacket Photographer:
Malcolm Varon

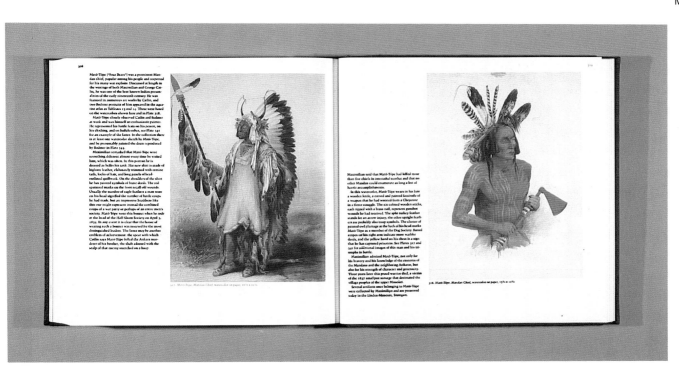

Book Title:
A Guided Tour of
The Living Cell
Author:
Christian de Duve
Art Director:
J. Malcolm Grear
Designer:
Malcolm Grear
Designers, Inc.
Illustrator:
Neil O. Hardy
Publisher:
Scientific American
Books, Inc.
New York, NY
Typographer:
York Graphic Services,
Inc.
Printers:
Kingsport Press
Lehigh Press
Production Manager:
Sarah Segal
Paper:
Patina #70
Jacket Designer:
Malcolm Grear
Designers, Inc.
Jacket Photographer:
Helen Shio

Book Title:
Knock Wood
Author:
Candice Bergen
Art Director:
Eve Metz
Designer:
Karolina Harris
Photographers:
Various
Publisher:
Simon & Schuster
New York, NY
Typographer:
Dix Type, Inc.
Printer:
Kingsport Press
Production Manager:
Jeanne Palmer
Paper:
Finch Opaque Cream #60
Binder:
Kingsport Press
Jacket Designer:
Fred Marcellino
Jacket Photographer:
Mary Ellen Mark

Book Title:
Voyage into Substance
Author:
Barbara Maria Stafford
Designer:
Celia Wilson
Illustrators:
Various
Publisher:
The Massachusetts
Institute
of Technology
Cambridge, MA
Typographer:
The MIT Press
Computergraphics Dept.
Printer:
Halliday Lithograph Co.
Production Manager:
Dick Woelflein
Paper:
LOE Dull #70
Binder:
Halliday Lithograph Co.
Jacket Designer:
Celia Wilson

Book Title:
Olympic Access
Authors:
Richard Saul Wurman
Al Stump
Art Director:
Richard Saul Wurman
Designers:
Michael Everitt
Richard Saul Wurman
Illustrator:
Michael Everitt
Publisher:
Access Press Ltd.
Los Angeles, CA
Typographer:
Sara Reeder Ortiz
Printer:
Craftsman Press
Production Manager:
Wendie Ahrensdorf
Papers:
Litho Bright
Litho Blade
Binder:
Craftsman Press

Book Title:
Washington DC Access
Author:
Richard Saul Wurman
Art Director:
Richard Saul Wurman
Designers:
Richard Saul Wurman
Michael Everitt
Allison Goodman
Illustrators:
Various
Publisher:
Access Press Ltd.
Los Angeles, CA
Typographer:
Linda Lenhoff
Printer:
Craftsman Press
Production Manager:
Cathy Gurvis
Paper:
Access Offset
Hammermill
Binder:
Craftsman Press
Cover Designer:
Richard Saul Wurman
Cover Photographer:
Joel Katz

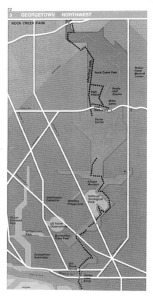

second edition

The guidebook to New York City & North New Jersey $11.95

NYC ACCESS®

Richard Saul Wurman

Book Title:
NYC Access
Author:
Richard Saul Wurman
Art Director:
Richard Saul Wurman
Designers:
Richard Saul Wurman
Michael Everitt
Allison Goodman
Illustrators:
Various
Publisher:
Access Press Ltd.
Los Angeles, CA
Typographer:
Sara Reeder Ortiz
Printer:
Craftsman Press
Production Manager:
Allison Goodman
Paper:
Access Offset
Hammermill
Binder:
Craftsman Press
Cover Designer:
Richard Saul Wurman
Cover Illustrator:
Robert M. Kulicke

Richard Saul Wurman $4.95

BASEBALL ACCESS®

Book Title:
Baseball Access
Authors:
Richard Saul Wurman
Al Stump
Art Directors:
Richard Saul Wurman
Designers:
Richard Saul Wurman
Michael Everitt
Lee Buckley
Illustrator:
Lee Buckley
Publisher:
Access Press Ltd.
Los Angeles, CA
Typographers:
Sara Reeder Ortiz
Linda Lenhoff
Printer:
Craftsman Press
Production Manager:
Allison Goodman
Paper:
Access Offset
Hammermill
Binder:
Craftsman Press
Cover Designer:
Richard Saul Wurman
Cover Photographer:
Reven T. C. Wurman

Book Title:
California Sculpture
Show
Art Director/Designer:
Nancy Zaslavsky,
Ultragraphics
Photographers:
Mimi Jacobs
Thomas P. Vinetz
Publisher:
California/International
Arts Foundation
Los Angeles, CA
Typographer:
Barbara McAlpine
Typography
Printers:
Lithographix, Inc.
Crown Sojourn
Papers:
Condat Dull #80
Grandee Cover #80
Color Separations:
Heinz Weber, Inc.
Cover Letterer:
Morris Zaslavsky

Von der Nachrichtenpresse The Oakland Museum:
«Jeder Künstler arbeitet innerhalb gewisser Grenzen,» sagt Benton. «Ich muß die sind meine. Ich muß in Formen schneiden, mit ihnen arbeiten—und ein Bogen ist immer da oder eine gradlinige Kante. Ich finde jene Herausforderungen aufregend. . . . Es wäre für mich einfach, keine Grenzen zu haben und einfach Metallstücke zusammenzustecken, aber das ist nicht etwas, woran ich interessiert bin . . .»

Aus Peter Selz, Fletcher Benton (La Jolla Museum of Contemporary Art, 1972):
Seine beweglichen Gegenstände sind irgendwo in jenem Grenzland zwischen Malerei und Bildhauerei geblieben, falls in der Tat diese traditionellen Klassifizierungen in einer Kunst, welche Zeiten durchfließt, viel Bedeutung haben. Ob er mit Scheiben arbeitet, die sich drehen, um wechselnde geometrische Entwürfe zu schaffen (wie in seinen frühen Stücken), oder mit Flammenmustern, die er als visuelles Equivalent zum Doppler-Effekt ansieht, oder mit durchsichtigen Folien arbeitet, bleibt Fletcher Benton im wesentlichen auf der Ebene, wenn auch der Rahmen seiner kristallinen Stücke ständig skulpturhafter geworden ist.
In vielen seiner Werke benutzt er durchsichtige Plexiglas-Farbplatten, die aneinander vorbeigleiten und sich überlappen und dabei ständig wechselnde und gänzlich unerwartete Farbmischungen produzieren. Indem er hochentwickelte Technologie benutzt und tatsächlich die technischen Aspekte in der Erscheinung seiner glänzenden rostfreien Stahlstücke hervorhebt, verschmilzt Fletcher Benton Farbe und Bewegung in einzigartige Fenster von Freude und Vergügen.

Aus Diane Ghirardo Burke, Fletcher Benton, Selected Works 1964–74 (Santa Clara: deSaisset Art Gallery and Museum, 1974):
In der Tat kann Benton als der Farbkünstler der Kinetischen Bewegung angesehen werden. Seine frühen Farbwerke . . . sind den Arbeiten der Farbkünstler Morris Louis, Gene Davis und Kenneth Noland auffallend ähnlich, nur mit dem wesentlichen Unterschied, daß in Bentons Werken die Farbänderung nicht eigentlich, sondern tatsächlich ist. Benton deutet an, daß er auch von den Farbstudien von Josef Albers und von dem Werk Malevichs beeinflußt wurde. Der Einfluß des letzteren ist vielleicht am deutlichsten in Bentons neuen Gemälden, die hier zum erstenmal gezeigt werden und die Malevichs konstruktivistischen Gebrauch des Raumes mit Bentons eigenen konstruktivistischen Neigungen verbinden. . . . Trotz der offensichtlichen Dreidimensionalität des Skulpturkörpers in den frühen transparenten Werken, hält Benton sie eher für ein Gemälde als eine Skulptur, weil sie im wesentlichen nur aus einer Perspektive betrachtet werden.

Von Jan Butterfield in Art International:
1978 «entdeckte» Benton rostfreien Stahl—ein interessantes Phänomen in sich selbst, da er ihn schon andauernd als Gußstück für seine kinetischen Arbeiten benutzt hatte, wo er rein und bearbeitet als Rahmen für seine technologischen Kunst diente. Nun, indem er das Material mit neuen Augen betrachtete, begann Benton den Stahl in Angriff zu nehmen, zu schneiden, auszuhöhlen und zu polieren, damit rauh und direkt umzugehen, nicht mit Glacéhandschuhen, wie er es vorher mit der Bronze getan hatte. Das Ergebnis sind die Folded Square oder die Alphabet Series Skulpturen, die einen großen Durchbruch darstellen.
Kühn, stark haben die neuen Werke einen unfehlbaren Sinn für Gleichgewicht und Schwerkraft. Ihre geometrischen,

linearen und krummlinigen Elemente reichen aus, falten sich in und legen sich im Zick-Zack auf, verleihen einigen ihrer Winkel eine zarte, zeichnungsähnliche Eigenschaft, welche die Harmonie für deren volle Orchestrierung zu Verfügung stellt. [No. 3-4, November-Dezember 1980/126-128]

Von Allan Temko im San Francisco Sunday Examiner & Chronicle:
Die Oakland Museum Ausstellung der «gefalteten Kreise» und «gefalteten Vierecke» (die Vierecke sind keine bloßen Abstraktionen, sondern alphabetische Buchstaben aus der Geometrie) stellen Benton als einen hervorragenden Metallschmied wie auch einen ausgezeichneten Polierer, Schleifer und Maler metallener Oberflächen heraus. . . . Nichts in diesem Teil der Welt übertrifft den bearbeiteten Glanz dieser Objekte. . . . Aber platonische Vollendung dieser Größenordnung ist nicht die Absicht von Bentons Kunst. Er ist interessiert an der Natur der Formen ihrer selbst wegen und an den entzückenden Überraschungen—buchstäblich unerwartete räumliche Schätze—, die er den zerschnittenen Metallbögen entziehen kann. [30. März 1980/36]

Folded Circle, Two Squares, 1982. Cor-ten steel.
96 x 96", 244 x 244 cm

74

Book Title:
Frankenstein: or, the
Modern Prometheus
Author:
Mary Wollstonecraft
Shelley
Art Director:
Steve Renick
Designer:
Barry Moser
Illustrator:
Barry Moser
Publisher:
University of California
Press
Berkeley, CA
Typographer:
Michael & Winifred Bixler
Printer:
Lehigh Press
Production Manager:
Czeslaw Jan Grycz
Paper:
80 lb. Enamel
Binder:
Kingsport Press
Jacket Designer:
Steve Renick
Jacket Illustrator:
Barry Moser
Letterer:
Yvette Rutledge

Book Title:
Edward Weston's
California Landscapes
Author:
James L. Enyeart
Designer:
Katy Homans
Photographer:
Edward Weston
Publisher:
New York Graphic Society
Books
Little Brown and Co.
Boston, MA
Typographer:
The Stinehour Press
Printer:
The Meriden Gravure Co.
Production Manager:
Nancy Robins
Paper:
LOE Dull #100
Book Binder:
A. Horowitz & Sons
Slipcase:
Brick & Ballerstein
**Slipcase and Binding
Designer:**
Katy Homans
Slipcase Photographer:
Edward Weston

An artist's work is influenced by his surroundings – his material at hand. But perchance my walls are bare and Whistler-like – my work therefore possessing sometimes a suggestion of his qualities. The critics 'those cut-throat bandits on the road to fame' will say, 'Oh – he is influenced by Whistler or Japanese prints or whatnot.' Now I do not protest against any intimated influence, but I do say that mostly the artist takes the customs and types of the day – ugly or fine – and recreates them in his fancy. – The architecture of the age, good or bad – showing it in new and fascinating aspects. – It would seem as though the greatest work from those who paint, etch or photograph must come from ugly or sordid surroundings – or at least from surroundings not too near a completion of grandeur – for one feels the artist's greater achievement when a New York slum – in all its sordidness – is raised to a glorification of reality – while the most serious interpretation of, for instance, the 'Taj Mahal' would not be likely to stir one intellectually nor emotionally – for one has the realization that the building is already an end in itself – not to be used as a basis for further interpretations."[1]

So wrote the young artist Edward Weston in 1922. Living in California since 1906, he had by this time, at age thirty-six, already achieved a substantial reputation for his contribution to pictorial photography in America. But as he recognized and admitted in the passage quoted, his work was not merely influenced by the tide of environmental and artistic directions of the day, it was dominated by them. Romanticized and sentimental allegories of street urchins, peacocks and maidens, and a soft veil of visual oriental embroidery had invaded the work of most photographers during the first two decades in America. Even under such heavily perfumed influences, however, Weston had brought original concepts of art to photography. He recognized the interlocking relationship between what an artist creates and the environment he chooses to work in. Although his fine photographs (figures 1, 2, 3), at age seventeen, were landscapes, the

subjects of the majority of his work between 1910 and 1923 were portraits, nudes, and studies in geometric form. His chosen environment was his studio, where he made portraits for a living. The shapes and forms of torsos, faces, shadows, and the sculptural play of light on the walls of the studio itself were his "material at hand." (figure 3)

These early works were later disdained by Weston for their pictorial style. Nevertheless, they contained the seeds of the aesthetic context that Weston proceeded to develop and refine for the remainder of his life. The work was what he termed "pure" photography, executed without resort to "painterly" manipulation of the medium so typical of the Salons of the time. Weston's early fascination with form for its own sake developed into one of the most innovative philosophies of creative photography in the twentieth century. It began with honoring the integrity of the medium as the basis for aesthetic experiments and culminated in a vision in which form was more than form; in which an object recorded by the camera could represent more than the tangible reality it mirrored. These later photographs are not visual metaphors or symbols in the conventional sense. They are what Weston called "significant representation," meaning the essence of the object, both physically and metaphysically.

The years 1922 and 1923 were turning points in both Weston's life and his work. Following a trip east in 1922 to Ohio and to New York City, where he met three of America's leading photography modernists, Alfred Stieglitz, Paul Strand, and Charles Sheeler, Weston returned to California confident of the direction of his "straight" photography. His published *Daybooks* recount with unrestrained emotion the importance of this trip as a reinforcement of the new vision that was replacing the past he was shedding. His daybooks for the years 1922 through 1944 are invaluable both as personal diaries and as a unique record of an ever-changing manifesto of his ideas.

In 1923 Weston left home, family, and livelihood to live

2 Tomato Field, South Coast, 1937

7

Book Title:
Park City
Author:
Katherine Reynolds
Art Director/Designer:
Don Weller
Illustrator:
Don Weller
Photographers:
Pat McDowell, Nick Nass,
Neil Rossmiller,
Tom Shaner, Don Weller
Publisher:
The Weller Institute
For the Cure of Design,
Inc.
Los Angeles, CA
Typographer:
Alpha Graphix, Inc.
Printer:
Dai Nippon Printing Co.,
Ltd.
Production Managers:
Don Weller
Chikako Matsubayashi
Paper:
Mitsubishi Gloss
ST Cover
Binder:
Dai Nippon Printing Co.,
Ltd.
Jacket Designer:
Don Weller
Jacket Photographer:
Pat McDowell

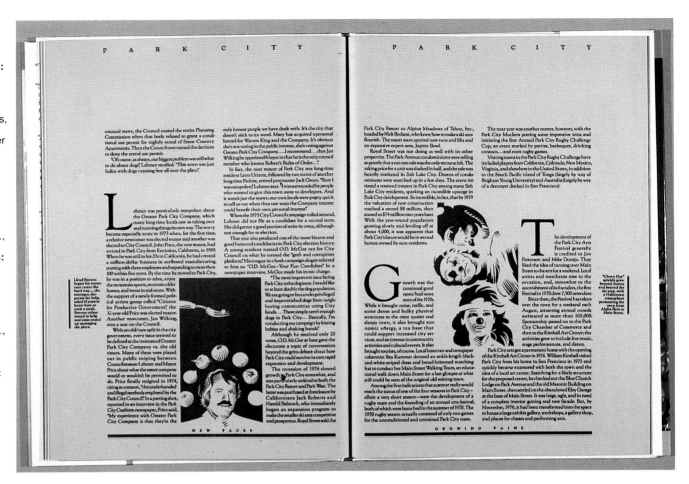

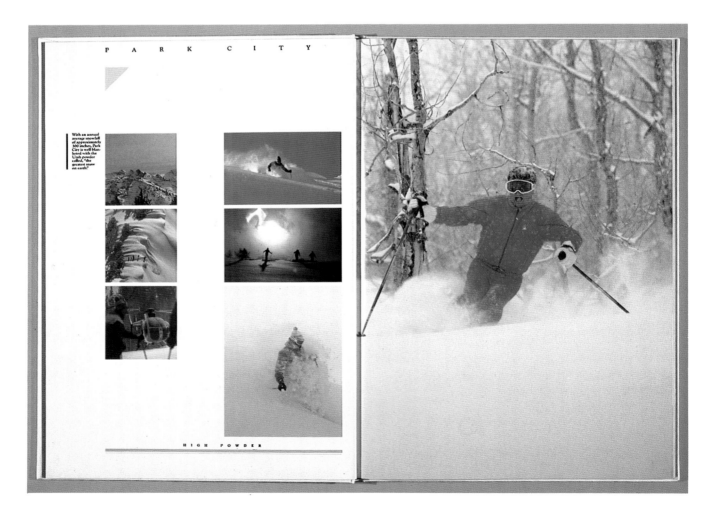

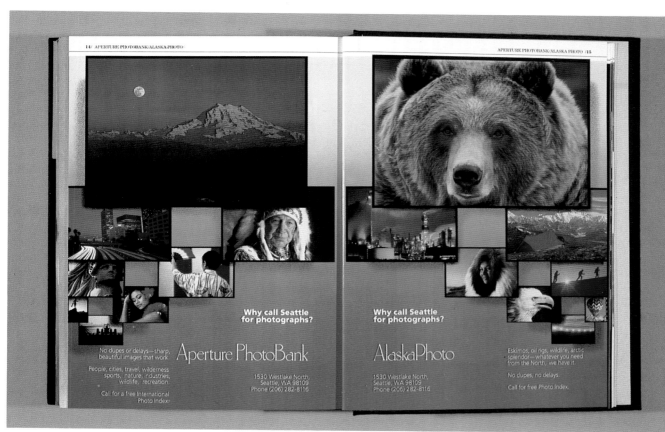

Book Title:
ASMP Book 3
Art Director:
Warren Rogers
Designer:
Robert Anthony, Inc.
Photographers:
Various
Publisher:
Annuals Publishing Co.
New York, NY
Typographer:
True To Type
Printer:
Dai Nippon Printing Co.,
Ltd.
Production Manager:
Cathy Citarella
Binder:
Dai Nippon Printing Co.,
Ltd.
Jacket Designer:
Robert Anthony, Inc.
Photographers:
Carl Flatow
Baron Wolman

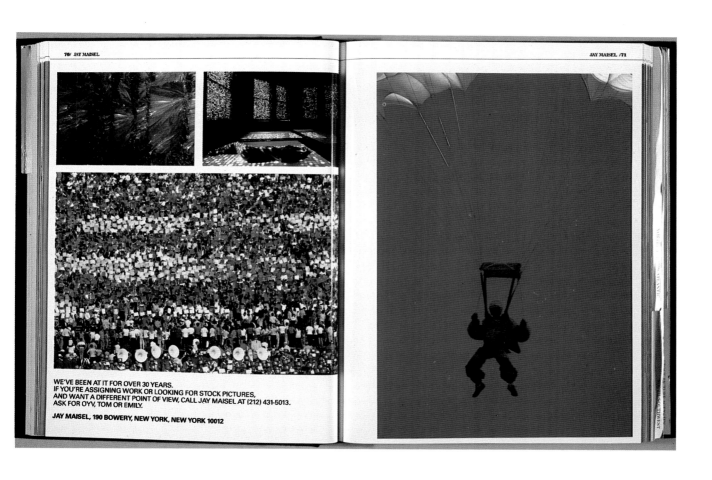

Book Title:
Strange Gravity
Author:
Paul Petrie
Art Director:
Charles E. Wadsworth
Designers:
Charles E. Wadsworth
Freeman Keith
Illustrator:
Charles E. Wadsworth
Publisher:
The Tidal Press
Portsmouth, NH
Printers:
The Stinehour Press
Meriden Gravure
Production Manager:
Charles E. Wadsworth
Freeman Keith
Paper:
Mohawk Superfine Text
Binder:
The Stinehour Press
Jacket Designers:
Charles E. Wadsworth
Freeman Keith
Jacket Illustrator:
Charles E. Wadsworth

STRANGE GRAVITY

Songs Physical and Metaphysical
by
PAUL PETRIE

Drawings by
CHARLES E. WADSWORTH

THE TIDAL PRESS
1984

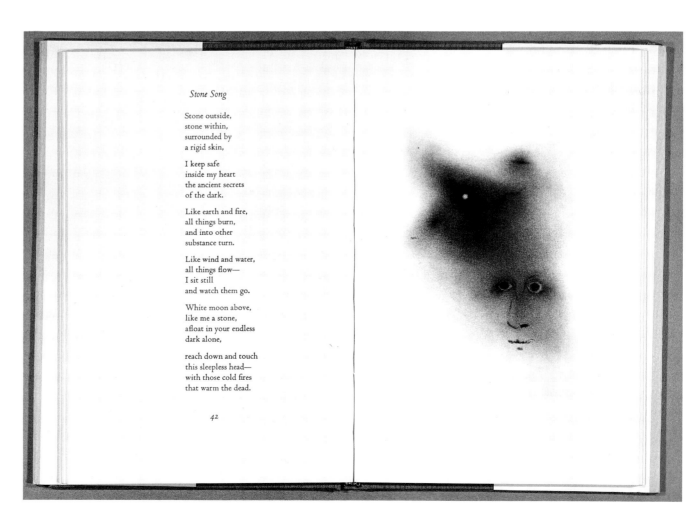

Stone Song

Stone outside,
stone within,
surrounded by
a rigid skin,

I keep safe
inside my heart
the ancient secrets
of the dark.

Like earth and fire,
all things burn,
and into other
substance turn.

Like wind and water,
all things flow—
I sit still
and watch them go.

White moon above,
like me a stone,
afloat in your endless
dark alone,

reach down and touch
this sleepless head—
with those cold fires
that warm the dead.

42

246

Book Title:
The Connoisseurs'
Handbook of California
Wines
Authors:
Charles Olken
Earl Singer, Norman Roby
Art Director:
Betty Anderson
Designers:
Lazin & Katalan
Betty Anderson
Maps:
Jean-Paul Tremblay
Charts:
James Paul Faris
Publisher:
Alfred A. Knopf, Inc.
New York, NY
Typographer:
The Haddon Craftsmen,
Inc.
Printer:
Kingsport Press, Inc.
Production Manager:
Andrew Hughes
Paper:
Lockhaven Machine #50
Binder:
Kingsport Press, Inc.
Jacket Designer:
Robert Anthony

California Vintages

This vintage chart summarizes information presented and discussed in more detail on pages 25 through 34. The five wines covered are those whose aging characteristics and general quality levels vary the most according by vintage in California.

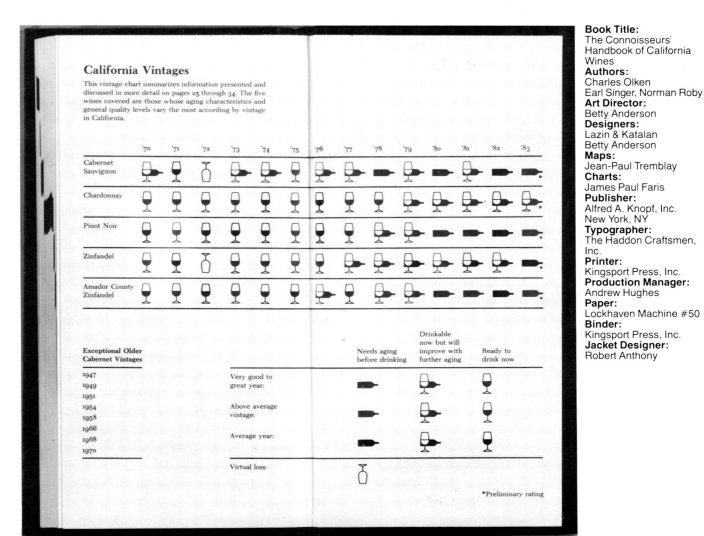

		Needs aging before drinking	Drinkable now but will improve with further aging	Ready to drink now
Exceptional Older Cabernet Vintages				
1947	Very good to great year:			
1949				
1951				
1954	Above average vintage:			
1958				
1966				
1968	Average year:			
1970				
	Virtual loss:			

*Preliminary rating

Wineries and Wines
in California

Location by county and date established are indicated in italics within each winery entry.

ACACIA WINERY *Napa 1979* Primarily using Los Carneros-grown grapes, the winery is concentrating on Chardonnay and elegant, rich Pinot Noir (all with vineyard designations). First wines, about 13,000 cases, were immediate successes and have placed Acacia among the leaders for both varieties.

Chardonnay (Winery Lake): *Intense, oaky, fruity, rich, complex, powerful* 🟊🟊
Chardonnay (other bottlings): *Fruity, toasty, balanced, well-focused wines identified as Napa Valley and Los Carneros have been best; others less interesting* 🟊/🟊🟊🟊
Pinot Noir: *Toasty, elegant, somewhat restrained sense of proportion, good varietal fruit* 🟊/🟊🟊

ADELAIDA CELLARS *San Luis Obispo 1983* Chardonnay and Cabernet Sauvignon from Paso Robles are the primary wines from this 4,000-case winery.

ADLER FELS *Sonoma 1980* Situated on the Sonoma Valley side of the Mayacamas Mountains, this compact winery produces 5,000 cases annually. Its name derives from the German for Eagle Rock, a local landmark—which perhaps explains the ominous, Teutonic-looking eagle on the label. The three main varietals, Johannisberg Riesling, Gewurztraminer, and Cabernet, are made from purchased grapes.

ADOBE CELLARS Negociant label primarily focused on purchasing North Coast lots of Cabernet, Chardonnay, and Zinfandel. Quality has been modest.

Alexander Valley Vineyards

AHERN WINERY *Los Angeles 1978* Using grapes from Santa Barbara and Amador counties, this 3,500-case winery has done a creditable job with its varietals. While its barrel-aged Sauvignon Blanc and Zinfandels have tended to be high in alcohol, the Chardonnay has been well balanced and quite appealing.

Chardonnay: *Toasty, ripe, full-bodied* 🟊

AHLGREN VINEYARDS *Santa Cruz 1976* A 1,200-case winery offering several varietals made from purchased grapes. Quantity of each varies from 40 to 400 cases. Its red wines

Zinfandel: *Blackberry jam aroma, intense* 🟊

ALATERA VINEYARDS *Napa 1977* First wines appeared in 1979. Winery specialized in Pinot Noir, Cabernet Sauvignon, and Gewurztraminer from grapes grown in partner's vineyards (70 acres) near Yountville. Efforts were most unexciting save for an exceptional, intense, honeylike late harvest Johannisberg Riesling. The brand is now defunct after the partnership was dissolved.

ALDERBROOK VINEYARDS *Sonoma 1982* A new venture specializing in Sauvignon Blanc and Chardonnay—with emphasis on the former, the winery's initial success story. With a small quantity of Semillon included, current production has reached 8,000 cases. Through the 1984 harvest, all wines were made from purchased grapes. The winery owns 60 acres of young vines (planted in 1982) and plans to double production after its vineyards come into full bearing.

ALEXANDER VALLEY VINEYARDS *Sonoma 1975* Family-run 120-acre vineyard is among the best in the Alexander Valley region. The winery has approached maximum output of 20,000 cases, mostly of white varietals. Cabernet blended with Merlot and Pinot Noir are the only reds. Enjoys a good reputation for the whites, with Chardonnay being the most consistent. All wines are made from its own vineyards. Reasonably priced.

Cabernet Sauvignon: *Herbaceous, soft, some oak* 🟊
Chardonnay: *Ripe, moderate oak, balanced* 🟊/🟊
Johannisberg Riesling: *Flowery, delicate flavors, slightly sweet* 🟊/🟊
Pinot Noir: *Varietal fruit, slightly earthy, balanced, light oak* 🟊/🟊

Book Title:
Al Held
Author:
Irving Sandler
Art Director:
Paul Anbinder
Designer:
James Wageman
Artist:
Al Held
Publisher:
Hudson Hills Press, Inc.
New York, NY
Typographer:
U.S. Lithograph Inc.
Printer:
Toppan Printing Co.
Production Manager:
Paul Anbinder
Paper:
New Age #105
Binder:
Toppan Printing Co.
Jacket Designer:
James Wageman
Artist:
Al Held

Book Title:
The Advertising World of
Norman Rockwell
Authors:
Dr. Donald Stoltz
Marshall Stoltz
William F. Earle
Designer:
Robert Anthony, Inc.
Illustrator:
Norman Rockwell
Publisher:
Madison Square Press
New York, NY
Typographer:
True To Type
Printer:
Dai Nippon Printing Co.,
Ltd.
Production Manager:
Arpi Ermoyan
Binder:
Dai Nippon Printing Co.,
Ltd.
Jacket Designer:
Robert Anthony, Inc.
Jacket Illustrator:
Norman Rockwell

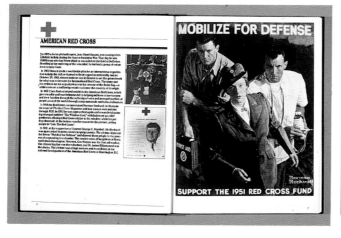
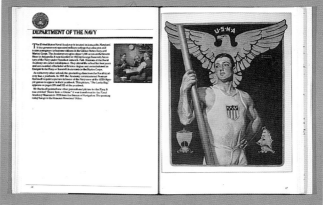

Book Title:
Tokyo Access
Author:
Richard Saul Wurman
Art Director:
Richard Saul Wurman
Designers:
Richard Saul Wurman
Michael Everitt
Julie Jacobson
Makoto Araya
Illustrators:
Various
Publishers:
Access Press Ltd.
C. Itoh Fashion System
Co., Ltd.
Los Angeles, CA
Typographer:
Linda Lenhoff
Dai Nippon Printing Co.,
Ltd.
Printer:
Craftsman Press
Production Manager:
Allison Goodman
Paper:
Access Offset Hammermill
Binder:
Craftsman Press
Cover Designer:
Richard Saul Wurman
Cover Photographer:
Reven T. C. Wurman

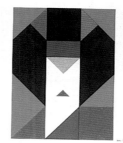

Book Title:
In One Day
Author:
Tom Parker
Designers:
Tom Parker, Kat Dalton
Illustrator:
Tom Parker
Publisher:
Houghton Mifflin Co.
Boston, MA
Typographer:
Partner's Composition, Inc.
Printer:
Federated Lithographers
Production Manager:
Brenda Lewis
Papers:
Patina Matte #70
CIS Coverstock 12 pt.
Binder:
A. Horowitz & Sons
Jacket Designers:
Tom Parker
Kat Dalton
Jacket Illustrators:
Tom Parker
Kat Dalton
Jacket Printer:
Dynagraf, Inc.

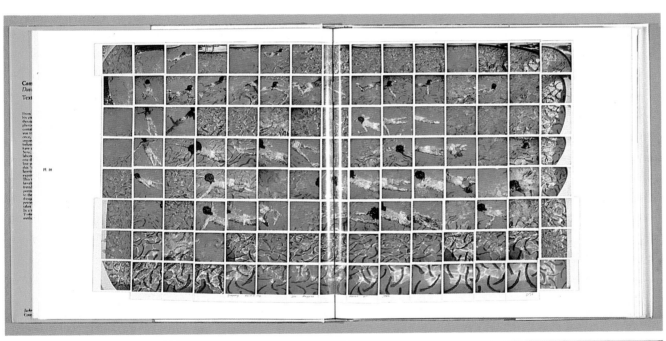

Book Title:
Cameraworks:
David Hockney
Author:
Lawrence Weschler
Art Director/Designer:
Peter Arnell
Arnell/Bickford Assoc.
Photographer:
David Hockney
Publisher:
Alfred A. Knopf, Inc.
New York, NY
Typographer:
Circle Graphics, Inc.
Printer:
Amilcare Pizzi, s.p.a.
Production Manager:
Grant Rector
Jacket Designer:
Peter Arnell
Jacket Photographer:
David Hockney

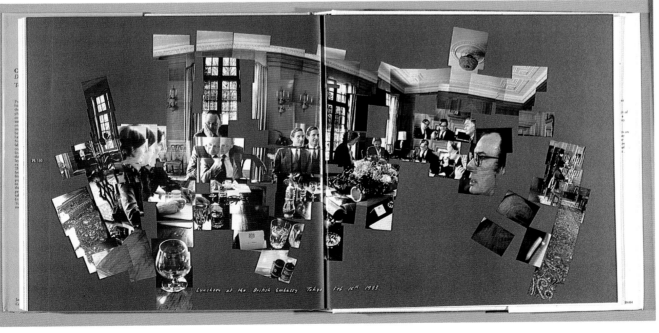

Book Title:
Maybe I'm It,
Maybe I'm Not
Author:
Gary Powell
Art Director:
Steve Freeman
Designer:
Steve Freeman
Illustrator:
Nelson Shipman
Publisher:
PSP Records
Austin, TX
Typographer:
G & S Typesetters
Printer:
Tracor, Inc.
Paper:
Mohawk Superfine
Binder:
Custom Bookbinders
Jacket Designer:
Steve Freeman

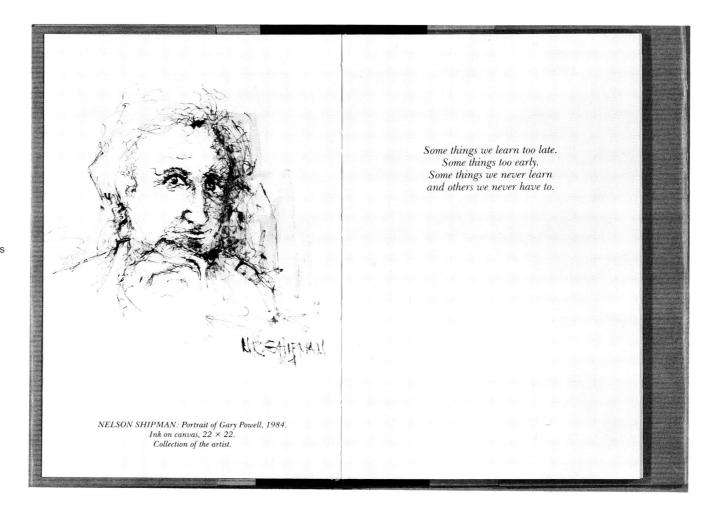

Some things we learn too late.
Some things too early.
Some things we never learn
and others we never have to.

NELSON SHIPMAN: Portrait of Gary Powell, 1984.
Ink on canvas, 22 × 22.
Collection of the artist.

PABLO PICASSO

original lithograph, image 15 × 12½, edition 10.
© 1984 Jesmax Music, BMI

14

SCHOOL FOR THE BLIND

While teaching choir and voice at the Texas State School for the Blind, I learned to watch faces. After watching these handicapped kids, I found they acted just like any other teenagers you've ever known. They had boyfriend and girlfriend troubles, they had best friends, and they gossiped. They yelled and fought with each other, just like the kids do in public school. It serves me well to remember their faces from time to time, for out of their disability was born a truer understanding of stewardship, serving and caring for one another, which was evident in their everyday encounters.

It was a big day when the students' school pictures were delivered. They came packaged just like they used to, in a little brown envelope with a cellophane window cut out in one side. Two blind girls were in the office between classes, showing me their pictures, when one girl asked for the other's brown envelope, held the wrong side of the package right to her face and complimented her

15

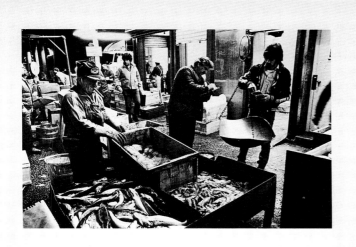

NIGHT MARKETS

Bringing Food to a City by Joshua Horwitz

Thomas Y. Crowell New York

Before dawn the florists arrive and examine the day's offerings. They are careful to choose the flowers with the tightest buds and greenest stems. Like the greengrocers, they can't afford to be stuck with spoiled goods.

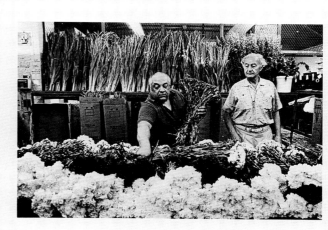

Book Title:
Night Markets
Author:
Joshua Horowitz
Art Director/Designer:
Al Cetta
Photographer:
Joshua Horowitz
Publisher:
Thomas Y. Crowell
New York, NY
Typographer:
Linoprint Composition
Printer:
Rae Publishing Co., Inc.
Production Manager:
Herman Riess
Paper:
Moisturite Matte
Binder:
The Book Press, Inc.
Jacket Designer:
Al Cetta
Jacket Photographer:
Joshua Horowitz

Book Title:
Herbert Bayer
Author:
Arthur A. Cohen
Designer:
Herbert Bayer
Assisting Designer:
Sylvia Steiner
Illustrations:
Herbert Bayer
Publisher:
The MIT Press
Cambridge, MA
Typographer:
Typographic House
Printer:
Daniels Printing Co.
Production Manager:
Dick Woelflein
Paper:
LOE Dull #80
Binder:
Publisher's Book Bindery
Jacket Designer:
Herbert Bayer
Jacket Photographer:
Herbert Bayer

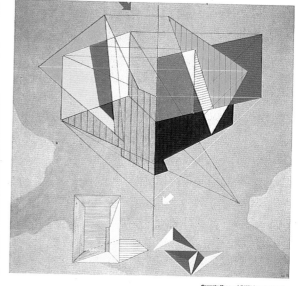

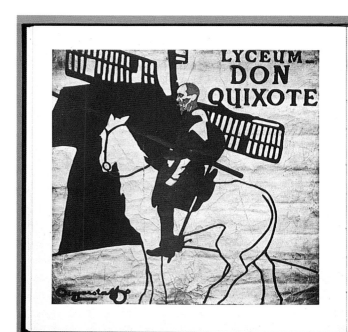

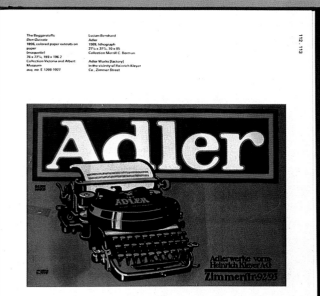

Book Title:
Posters: The 20th-Century Poster
Author:
Dawn Ades
Editor:
Mildred Friedman
Art Director:
Robert Jensen
Designer:
Don Bergh
Illustrators:
Various
Publisher:
Abbeville Press
New York, NY
Typographer:
Julie Condecon
Printer:
Toppan Printing Co., Ltd.
Production Manager:
Dana Cole
Paper:
Matte Coated #100
Binder:
Toppan Printing Co., Ltd.
Jacket Designers:
Robert Jensen
Donald Bergh

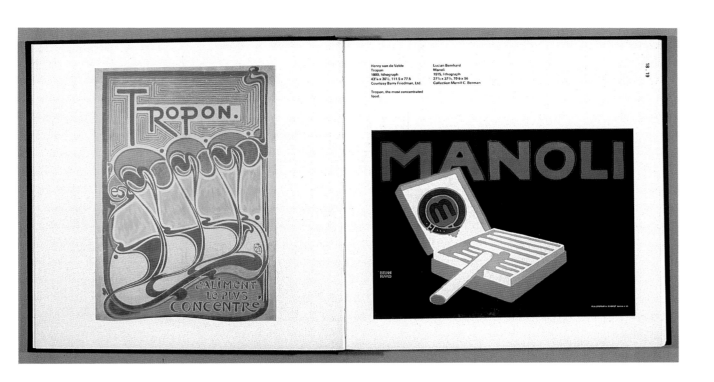

Book Title:
The Phenomenon
of Change
Authors:
Various
Editor:
Lisa Taylor
Art Director/Designer:
Heidi Humphrey/H+
Illustrators:
Various
Publisher:
The Cooper Hewitt
Museum
New York, NY
Typographer:
Trufont Typographers, Inc.
Printer:
Eastern Press, Inc.
Production Manager:
Nancy Akre
Paper:
Williamsburg Offset
Binder:
Eastern Press, Inc.
Jacket Designer:
Heidi Humphrey

The Phenomenon of CHANGE

Unprecedented social, political, and technological changes have occurred during this century. More profound changes lie ahead. To make the decisions that will be required, we must understand the nature of change itself—its causes and effects—its dangers and possibilities. How to create a more desirable and humane future is of urgent and vital concern.

The Totalitarian State

It is a twentieth-century innovation in politics.

By Joseph LaPalombara

Gerhard Marcks, Dies Irae (The Day of Wrath), 1946 (detail).

The advent of the totalitarian state is, without doubt, the most significant political change of the twentieth century. Previous history is strewn with other momentous political developments, some of them beneficial, some of them cataclysmic for mankind. On the plus side, one quickly recalls the golden ages of the Greek and Roman city-states, the rediscovery in the early Middle Ages of the classical political writings of the Greeks, the later development of humanistic writing and the Enlightenment, followed by the American and French revolutions, the abolition of serfdom and slavery, and the birth of representative forms of democracy in the nineteenth century.

[body text continues in multiple columns]

Joseph LaPalombara is chairman of the Political Science Department at Yale University.

The Third World

Ironies have developed.

By Janet Abu-Lughod

Fibre Bag Manufacturing Corporation plant in Kumasi, Ghana, 1966.

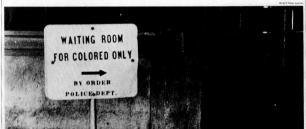

Quiapo Marketplace in Manila, Philippines, December 1982.

Decolonization

The Internationalization of the Economy

Westernization

The Results

Janet Abu-Lughod is a Professor of Sociology, Geography, and Urban Affairs at Northwestern University and has published widely on Third World issues.

The Fight for Social Justice

Progress has been made.

By Wilcomb E. Washburn

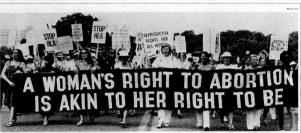

WAITING ROOM FOR COLORED ONLY →
BY ORDER POLICE DEPT.

Black Americans

The American Indian

Women's Rights

Sexual Deviates

Social Justice (cont'd.)

A WOMAN'S RIGHT TO ABORTION IS AKIN TO HER RIGHT TO BE

Pro-choice rally at Cherry Hill, New Jersey, 1982.

Religious Freedom

Rights For Children

Foreign Policy

The Elderly

The Handicapped

Wheelchair access to New York City bus.

Wilcomb E. Washburn is Director of the Office of American Studies of the Smithsonian Institution and a past president of the American Studies Association and of the American Society for Ethnohistory.

Portraits II

MENTAL PICTURE VII

**Portraits II/
Mental Picture VII:
A Seven-Year Retrospective**

**A significant factor of selection was how much
of the artist's personality comes to the fore in
the portrait, and how much of that personality is
point of view and how much is style. The marriage
of the two equals success.**

Call for Entry:
Portraits II/
Mental Picture VII
Designer:
Rudy Hoglund
Illustrator:
Mario Donizetti
Captions:
Roger Rosenblatt
Lettering Design:
Tim Girvin
Typographer:
Suzi Romanik
Printer/Color Separator:
Liberty Engraving
Paper:
Westvaco

Drawn or painted portraits are as ubiquitous in the "civilized" world as tribal masks are in primitive cultures. Though their reasons for being may be overtly different, both deal ritualistically with the issue of immortality. Caricature, known as the "charged portrait," is also an ancient form, though less venerable. When practiced by its early masters, Annabale Carraci and Leonardo da Vinci, it was considered the nasty stepchild of art, because the skewed or exaggerated portrait took liberties with the accepted definitions of beauty. As a tool of graphic satire, it was eventually accepted, but only as an artless convention. Today, the academic strictures applied to art are virtually nonexistent; hence, the expressionistic portrait might be described as a caricature, and the caricature might serve to enhance, rather than ravage, human physiognomy. Portraiture as illustration is another matter, a blend of commercial requisites and personal ecclecticism which results in variations ranging from credible to incredible. While the intent of the illustration-portrait is to portray a face and convey an idea, all too often this marriage is doomed from the outset because the proper balance is not achieved. Yet, when the process succeeds, it results in the quintessential portrait.

The concept for the Portraits Show began seven years ago under the umbrella of "The Mental Picture," ostensibly to emphasize the illustrator's interpretive contribution to the subject at hand. Therefore, criteria for inclusion are strict. For the most part, the exhibition includes those pictures that depict a visible representation or likeness of a *known* individual. Symbolic or "generic" portraits (i.e., the ubiquitous everyperson) and portrayals of family members (even when used as models for some concept) are rarely included. The show, however, is not limited to human portraits. Famous and recognizable creatures, both in fact and fiction, sometimes slip through the net. And curiously, some mythical or fictional characters, when credibly portrayed, are also sanctioned. Ultimately, what are being judged are solutions to the broad problem of depiction—accuracy, style, expression and imagination being measures of success.

Unlike some other illustration competitions of the past few years that have shown distinct stylistic changes, Portraits II differs slightly from the previous survey, seven years ago. Some of the same faces are rendered by some of the same artists. While a few veterans have been replaced by some newcomers, the method of portraiture has not taken a quantum leap into any new dimensions. "This is generally a period of consolidation and conservatism in illustration," says Rudy Hoglund, chairman of Portraits II and art director of *Time* magazine, where the portrait tradition is time-honored, "and portraiture is essentially more conservative anyway. Very little experimentation goes on since those few clients who commission portraits are not looking for ambiguity."

To what extent, then, can a portrait be abstracted and distorted and still remain credible? "The best portrait shows the person and conveys an idea," continues Hoglund. "If artists want to take liberties with the traditional portrait approach, they're going to have to be pretty damn clever." In this regard, Philip Burke and Robert Risko were singled out in discussion among the jurors, Burke for coarse, painterly expressionism which enhances an otherwise grotesque distortion of the human form (in this case, Ronald Reagan), and Risko for colorful deco revivalism. Both signal interesting turns in the continuum of caricature. While those two were chosen for reasons of novelty, Brad Holland and Edward Sorel chalk up the most inclusions in the show because of their qualitative consistency. "Sorel gets better and better," says Paul Davis, a jury member and portraitist, "and makes it look easier and easier."

Indeed, the appearance of effortlessness indicates self-assuredness and authority. Therefore, a significant factor of selection was how much of that personality is point of view and how much is style. The marriage of the two equals success—Milton Glaser's exquisite Monet drawing is a case in point. On the other hand, having only one of these attributes is not grounds for exclusion—Mick Haggerty's portrait of Norman Mailer is an example where style dominates. Many, but not all, of the works chosen

suggest that the artists were having fun—this, too, creates a powerful result.

When discussing personality in portraiture, a nagging question arises: When is it valid to replicate a recognizable or famous photograph? Due to deadline constraints, the photograph is the accepted reference material of the illustrator. A few of the pieces in this show derive from well-known images. Where is the line drawn between reference and copying? "Obviously, drawing from life gives the best results, but it is not always possible," says Hoglund. "Some artists are shackled to the photograph, and so all too often the best photo scrap equals the best portrait. However, direct copying is unquestionably wrong. Use of a famous photograph is acceptable only when the artist is clearly not trying to fool anybody, but is simply making another editorial statement." Logical as this viewpoint may be, the déjà-vu quality of those portraits based on photographs is disconcerting and tends to lessen the effectiveness of the art.

The photograph has encouraged candid portraiture. In contrast to the stiff, formal portraits of the past, the face has become somewhat more desanctified in illustration and photos taken by the artist are the reason. In this show, there are few boring head-on confrontations, sentimentalism is at a minimum, and saccharine contrivances are eschewed. Moreover, this selection of portraits is very entertaining.

About contemporary illustration, Portraits II reflects its variety. About the portrait, one very interesting statement is made through the show: Not every illustrator can do portraiture well, and even fewer can do caricature intelligently.

Portrait:
David Bowie
Illustrator:
Mick Haggerty
Hollywood, CA
Art Directors:
Rudy Hoglund
Nigel Holmes
Publication:
Time

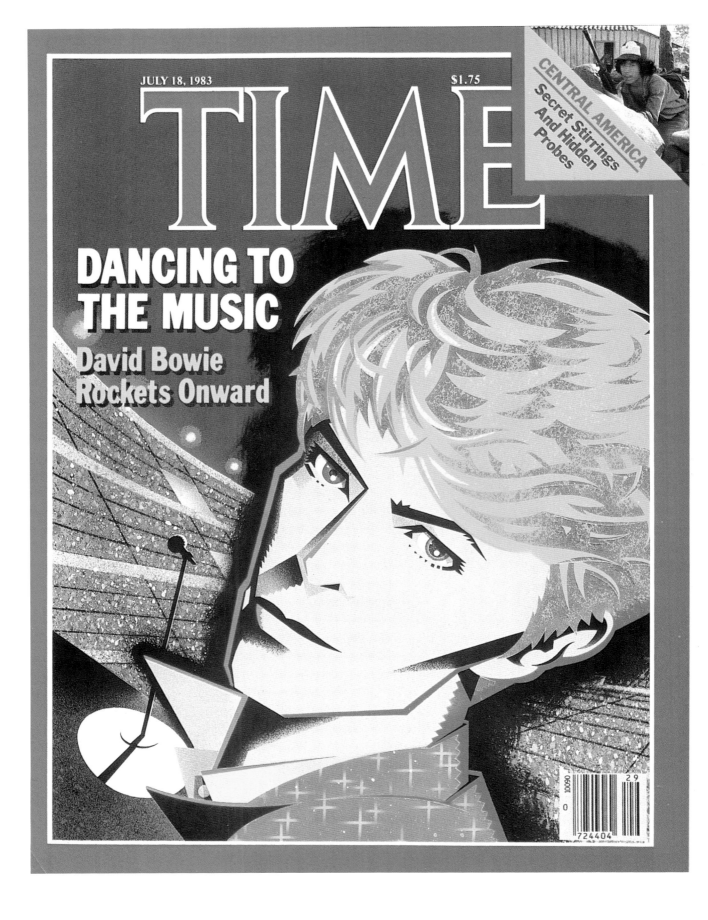

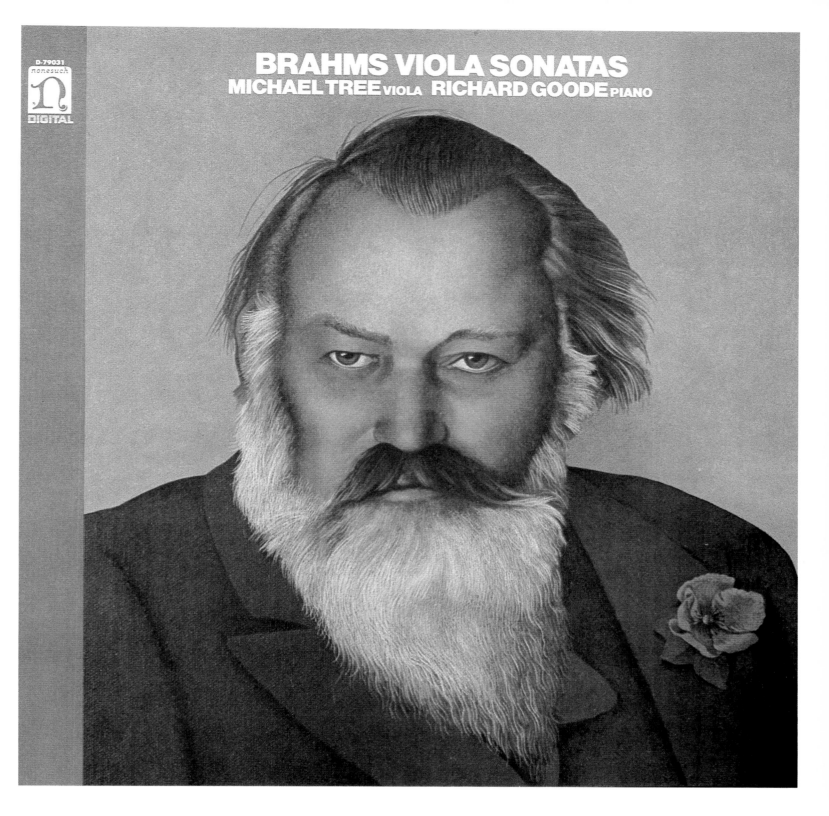

Portrait:
Johannes Brahms
Illustrator:
Richard Mantel
New York, NY
Art Director:
Ron Coro
Design Firm:
Mantel, Koppel & Scher
Publisher:
Nonesuch Records

Portrait:
Giacomo Rossini
Illustrator:
David Levine
New York, NY
Art Director:
Henrietta Condak
Publisher:
CBS Records

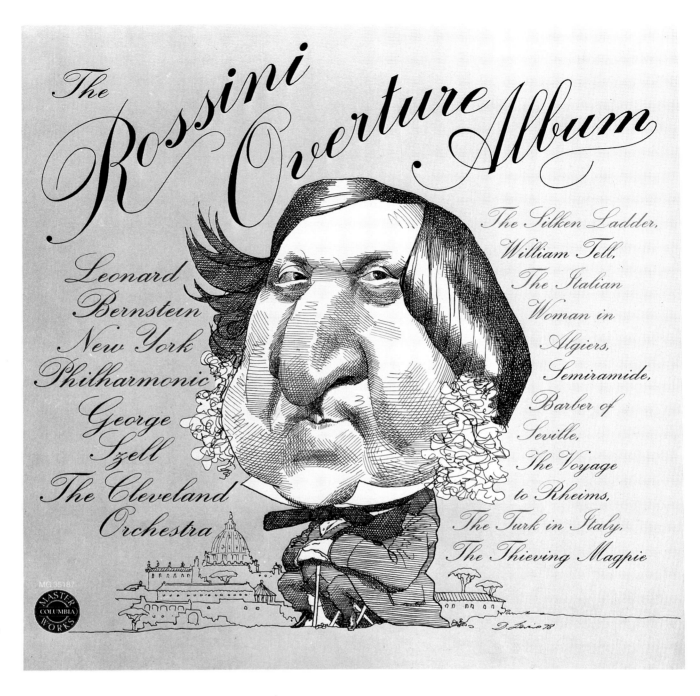

The Rossini Overture Album

Leonard Bernstein New York Philharmonic George Szell The Cleveland Orchestra

The Silken Ladder, William Tell, The Italian Woman in Algiers, Semiramide, Barber of Seville, The Voyage to Rheims, The Turk in Italy, The Thieving Magpie

Portrait:
Igor Stravinsky
Illustrator:
Alan E. Cober
Ossining, NY
Art Director:
Judy Garlan
Publication:
The Atlantic Monthly

262

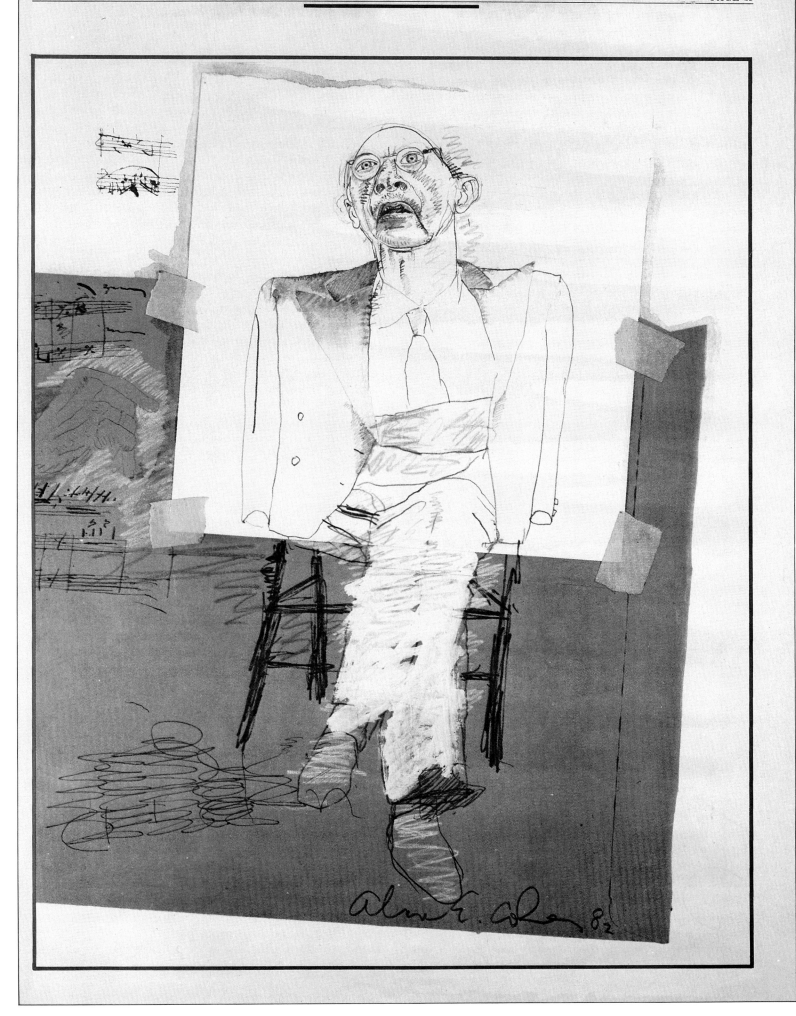

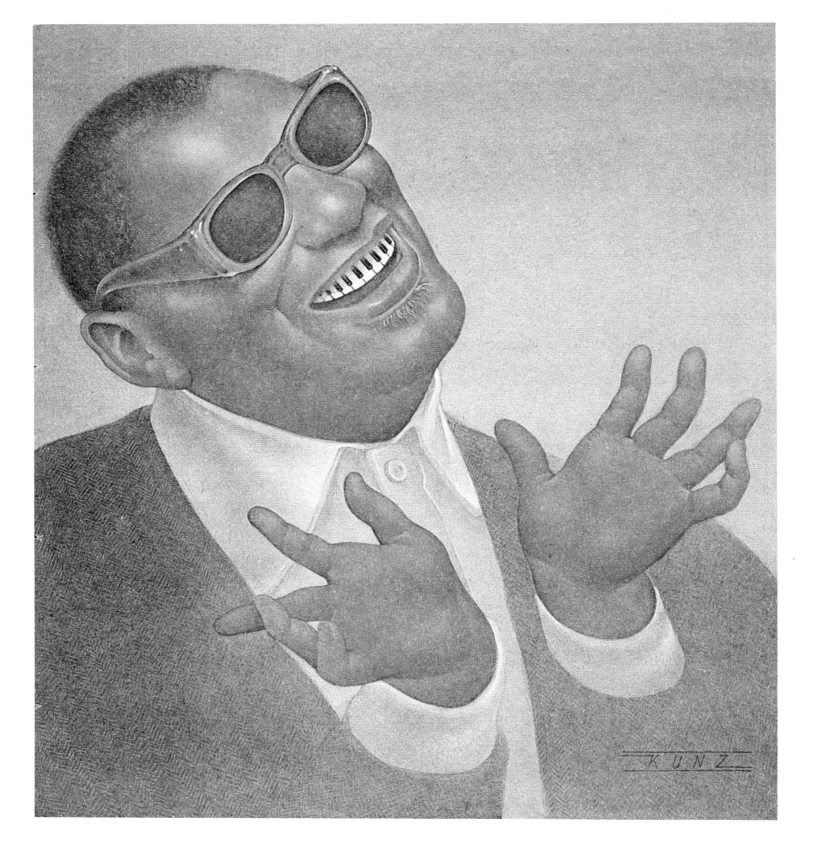

Portrait:
Ray Charles
Illustrator:
Anita Kunz
Toronto, CAN
Art Director:
Fred Woodward
Publication:
Westward Magazine
Publisher:
The Dallas Times
Herald

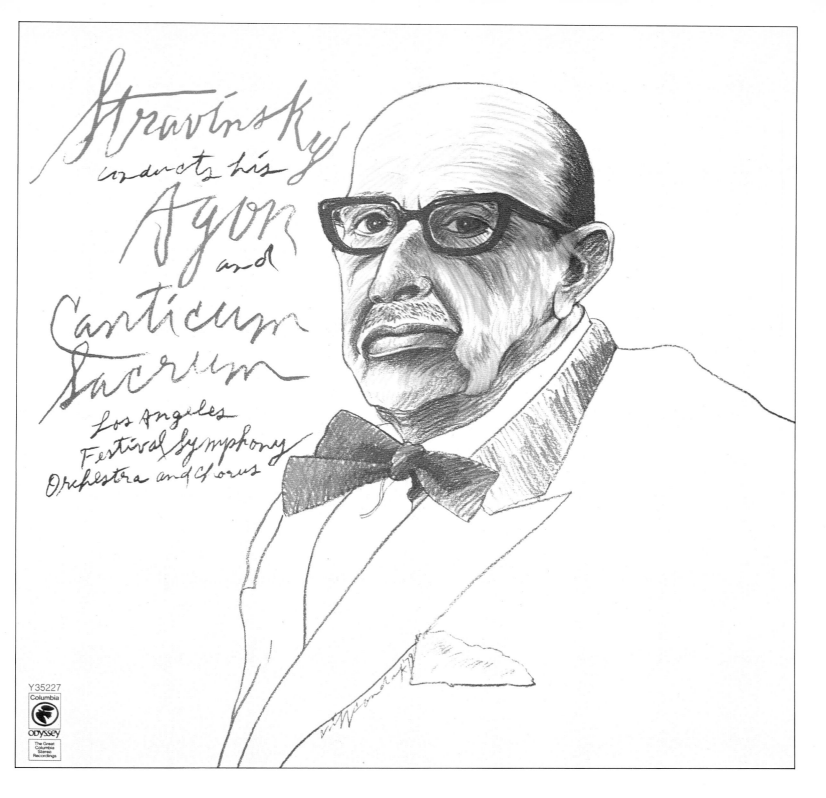

Stravinsky
conducts his
Agon
and
Canticum
Sacrum

Los Angeles
Festival Symphony
Orchestra and Chorus

Y35227

Columbia
ODYSSEY

The Great
Columbia
Stereo
Recordings

Portrait:
Stravinsky
Illustrator:
Cliff Condak
Cold Spring, NY
Art Director:
Henrietta Condak
Publisher:
CBS Records

Portrait:
Muddy Waters
Illustrator:
Philip Hays
Los Angeles, CA
Art Director:
Paula Scher
Publisher:
CBS Records

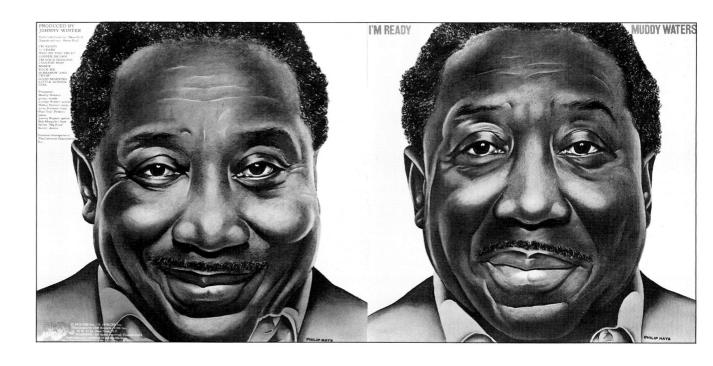

Portrait:
Liberace
Illustrator:
Ann Meisel
New York, NY
Art Director:
Caren Martineau
Agency:
Ashe LeDonne
Publisher:
Radio City Music Hall

Portrait:
Elvis
Illustrator:
Milton Glaser
New York, NY
Design Firm:
Milton Glaser, Inc.
Publisher:
Kevin Eggers
Client:
McGraw-Hill Book Co.

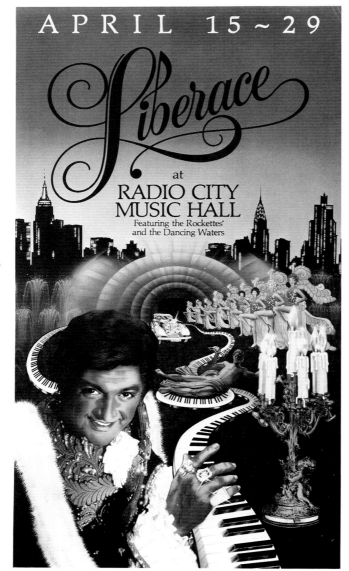

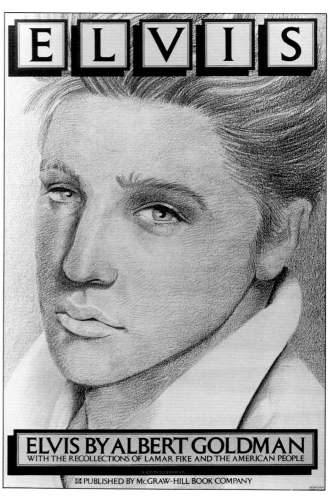

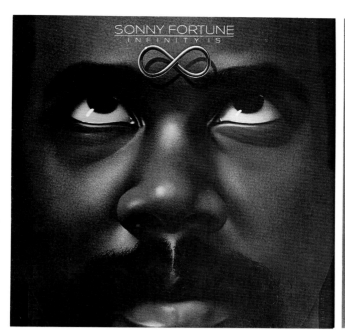

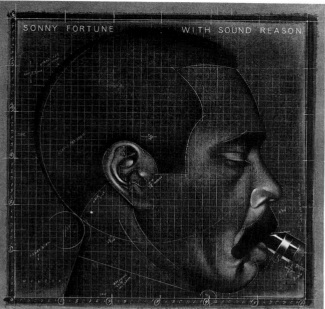

Portrait:
Sonny Fortune
Illustrator:
Bob Giusti
New York, NY
Art Director:
Lynn Dreese Breslin
Design Firm:
Atlantic Records
Client:
Sonny Fortune

Portrait:
Sonny Fortune
Illustrator:
David Wilcox
Califon, NJ
Art Director:
Lynn Dreese Breslin
Design Firm:
Atlantic Records
Client:
Sonny Fortune

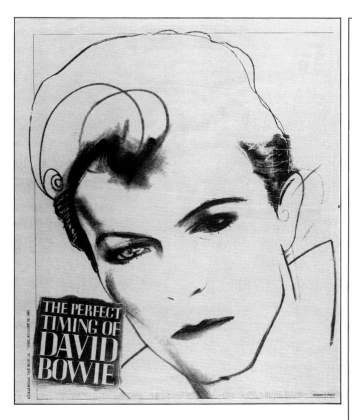

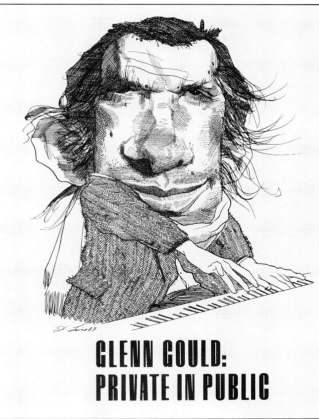

Portrait:
David Bowie
Illustrator:
Vivienne Flesher
New York, NY
Art Director:
Lynn Staley
Publication:
The Boston Globe

Portrait:
Glenn Gould
Illustrator:
David Levine
New York, NY
Art Director:
Lloyd Ziff
Publication:
Vanity Fair
Publisher:
The Conde Nast
Publications, Inc.

Portrait:
Jelly Roll Morton
Illustrator:
Brad Holland
New York, NY
Art Director:
Chris Peterson
Publication:
Book of the Month
Club News

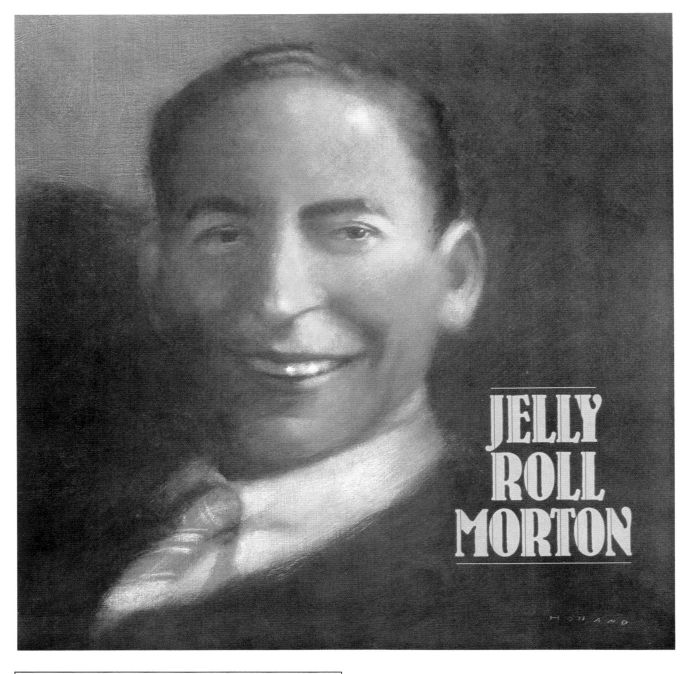

Portrait:
Mick Jagger
Illustrator:
Ian Pollack
London, England
Art Director:
Derek W. Ungless
Publication:
Rolling Stone

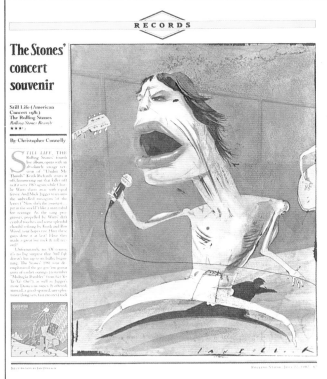

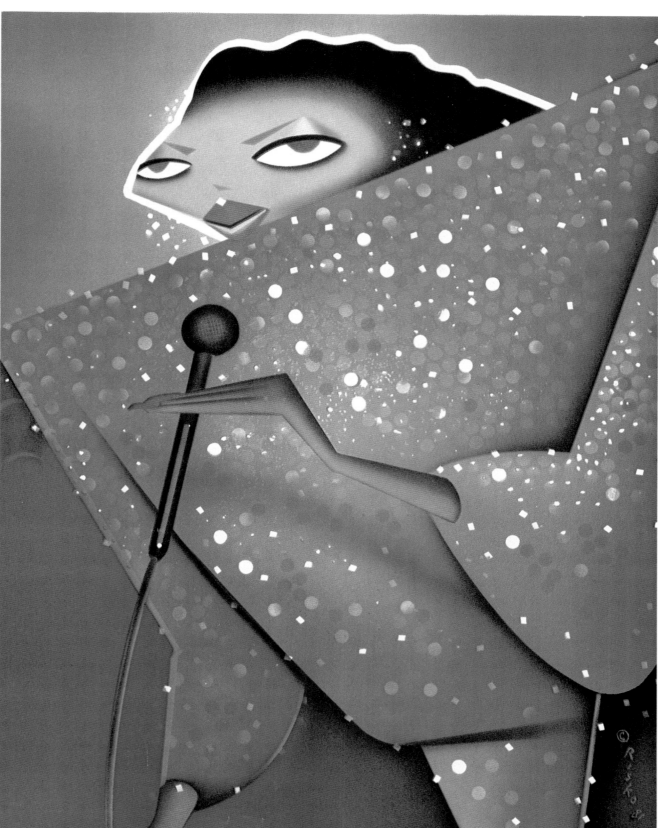

Portrait:
Diana Ross
Illustrator:
Robert Risko
New York, NY
Art Director:
Lloyd Ziff
Publication:
Vanity Fair
Publisher:
The Conde Nast
Publications, Inc.

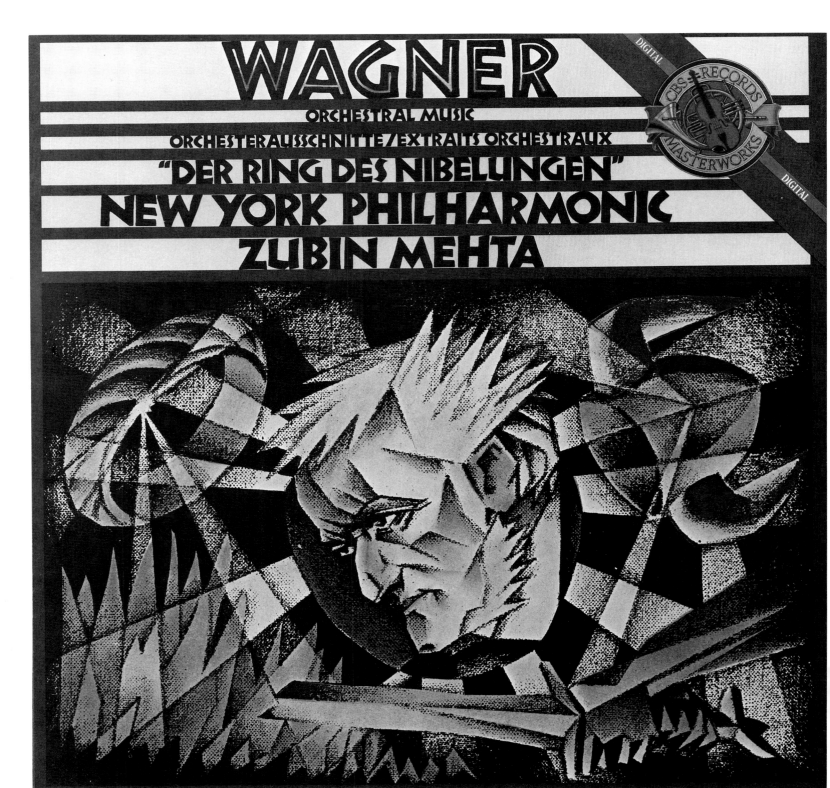

Portrait:
Richard Wagner
Illustrator:
Robert Van Nutt
New York, NY
Art Director:
Henrietta Condak
Publisher:
CBS Records

ALBERT KING MASTERWORKS

(or, The Velvet Bulldozer)

When Albert King hooked up with Memphis, Tennessee's super-hot Stax label in 1966 and began making singles with backing by Booker T. and the MG's and the Memphis Horns, fortune began to smile on him. He was not a youngster. He was born near Indianola, Mississippi, which is the heart of the Delta, blues country, in either 1923 or 1924, and he made his first records in Chicago in 1953, thirteen years before the beginning of his fortuitous association with Stax. But it was at Stax that his mature playing and singing and the definitive soul rhythm section of the sixties clicked together to produce music that would fundamentally alter the mainstream of white rock as well as the sound of commercial blues within a few years' time. In 1968, Stax collected King's best singles of the preceding two years on an album, *Born Under A Bad Sign*. It was the most influential blues album of its era. Within months, Eric Clapton and Cream were regurgitating chunks of it whole (e.g. "Strange Brew" and their own "Born Under A Bad Sign") and rockers everywhere were scurrying into their woodsheds to learn King's songs and his signature guitar licks.

Seven selections from the *Born Under A Bad Sign* album are reissued in this collection: "Personal Manager," "The Very Thought of You," "Born Under A Bad Sign" itself, "Laundromat Blues," "Kansas City," "Crosscut Saw," and "As The Years Go Passing By." Since *Born Under A Bad Sign* hasn't been available in this country for a number of years, these tracks, the backbone of any good modern blues collection, are worth the price of admission all by themselves. But there is more here, lots more— Albert King with the great Allen Toussaint's New Orleans band ("Angel of Mercy" and Toussaint's "We All Wanna Boogie,") King with several other groupings of musicians, updating his backdrops, as he always has, while playing the natural blues.

The development of King Albert's music, and especially of his recordings, is the ultimate case study in the continuing relevance of the blues, which keeps hanging in there with an almost uncanny tenacity as changing fashions swirl around it. To begin with,

(Continued on inside)

Portrait:
Albert King
Illustrator:
Milton Glaser
New York, NY
Art Director:
Milton Glaser
Design Firm:
Milton Glaser, Inc.
Publisher:
Kevin Eggers
Client:
Atlantic/DeLuxe

Portrait:
The Who
Illustrator:
Gary Panter
London, England
Art Director:
Walter Bernard
Publication:
Time

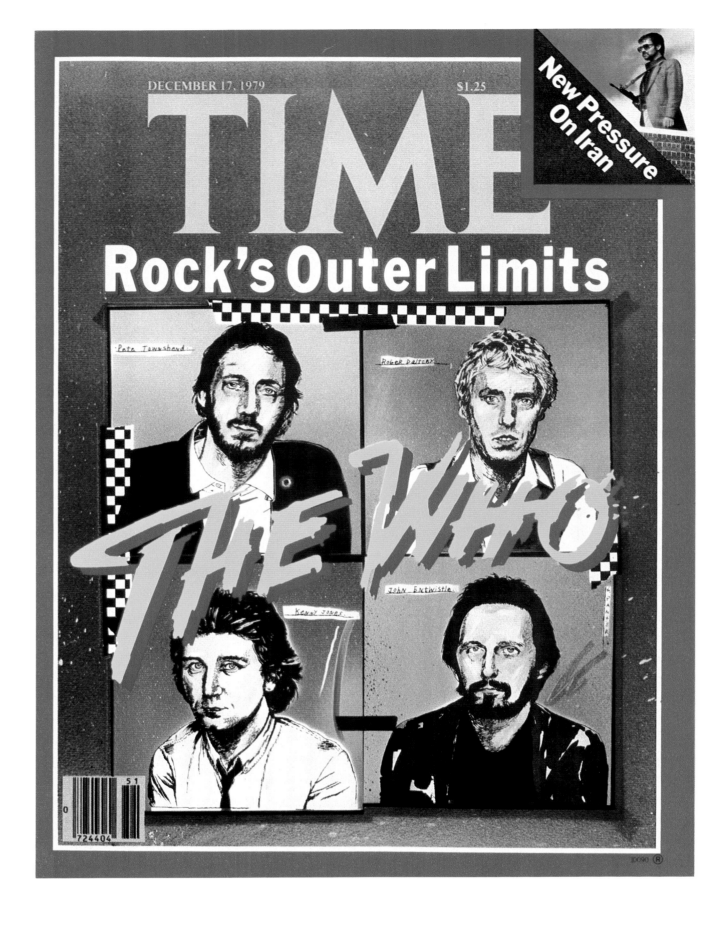

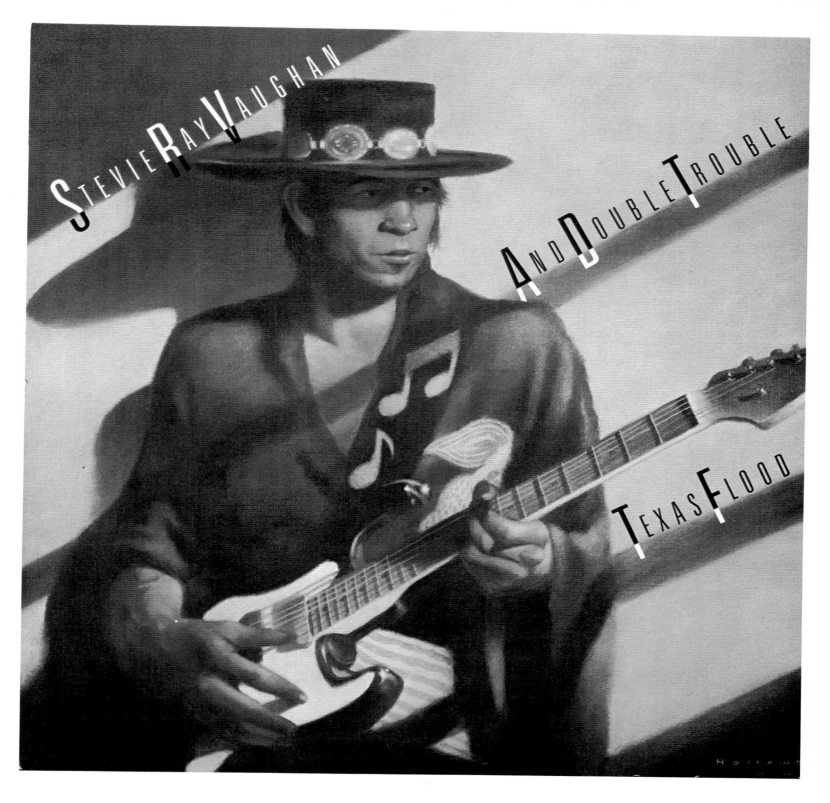

STEVIE RAY VAUGHAN
AND DOUBLE TROUBLE
TEXAS FLOOD

Portrait:
Stevie Ray Vaughan
Illustrator:
Brad Holland
New York, NY
Art Directors:
John Berg
Allen Weinberg
Publisher:
CBS Records

Portrait:
Prince
Illustrator:
Blair Drawson
Toronto, CAN
Art Director:
Derek W. Ungless
Publication:
Rolling Stone

Prince ponders the future of the planet

1999
Prince
Warner Bros.
★★★★

By Michael Hill

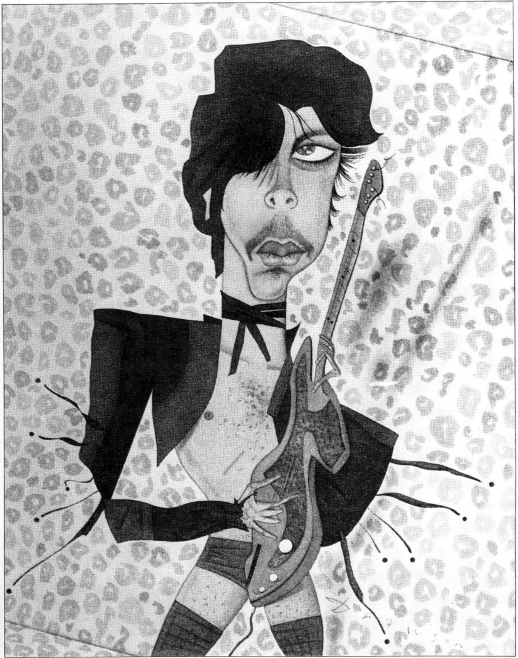

AFTER THE CRITI-cal success of his *Dirty Mind* LP in 1980 and the subsequent notoriety of last year's *Controversy*, Prince, at the tender age of twenty-two, has become the inspiration for a growing renegade school of Sex & Funk & Rock & Roll that includes his fellow Minneapolis hipsters Andre Cymone, the Time and Vanity 6. Yet regardless of the jive that he hath wrought, Prince himself does more than merely get down and talk dirty. Beneath all his kinky propositions resides a tantalizing utopian philosophy of humanism through hedonism that suggests once you've broken all the rules, you'll find some real values. All you've got to do is act naturally.

Prince's quasi-religious faith in this vision of social freedom through sensual anarchy makes even his most preposterous utterances sound earnest. On the title track of *1999*, which opens this two-LP set of artfully arranged synthesizer pop, Prince ponders no less than the future of the entire planet, shaking his booty disapprovingly at the threat of nuclear

ILLUSTRATION BY BLAIR DRAWSON

Portrait:
Linda Ronstadt
Illustrator:
Anita Kunz
Toronto, CAN
Art Directors:
Stephen Doyle
Derek Ungless
Publication:
Rolling Stone

Linda Ronstadt's spunky slap in the ears

Get Closer
Linda Ronstadt
Asylum
★★★★

By Ken Tucker

L INDA RONSTADT'S voice has never sounded better than it does on *Get Closer.* It's an uneven album, to be sure, but its spirit is unassailable. Ronstadt's ringing soprano vibrates with clarity and authority on the record's best songs, and sometimes she uses her voice like a daring rock & roller: she yells until it hurts your ears. Her tone has lost its mewling self-pity, and her phrasing is both sensible and sly.

Ronstadt spent time last year testing her vocal cords against a zippy production of Gilbert and Sullivan's *The Pirates of Penzance,* and it proved to be an ideal role for her. As Mabel, Ronstadt was allowed to act innocent and dreamy, yet strong-willed and passionate. The part seems to have filled her with confidence and energy, and although *Get Closer* glistens with the rippling musculature of her now formally exercised voice, her new strength hasn't made her self-conscious. Just the opposite, in fact: Linda Ronstadt is no longer a prisoner of technique.

"Want love? Get closer," snaps Ronstadt in the opening words of

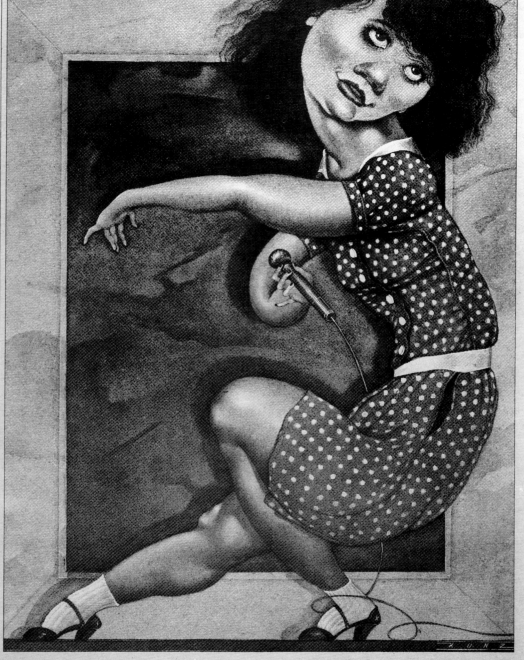

ILLUSTRATION BY ANITA KUNZ

ROLLING STONE, November 11, 1982 : 55

Design: Henrietta Condak / Cover art: Robert Weaver / © 1977 CBS Inc. / Manufactured by Columbia Records / CBS Inc. / 51 West 52 Street, New York, N.Y. / ® "Columbia." ℗ "Odyssey." Marcas Reg.
Warning: All rights reserved. Unauthorized duplication is a violation of applicable laws.

Portrait:
Bruno Walter
Eugene Istomin
Eugene Ormandy
Illustrator:
Robert Weaver
New York, NY
Art Director:
Henrietta Condak
Publisher:
CBS Records

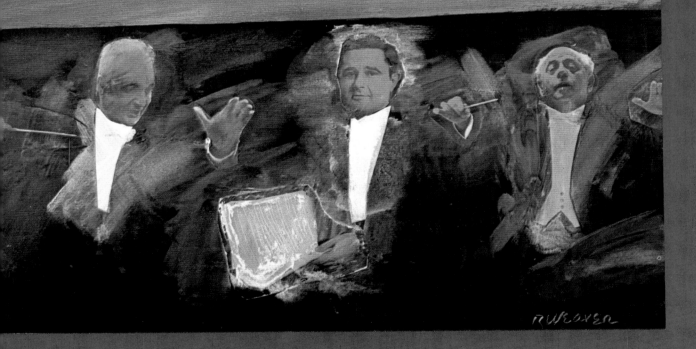

SCHUMANN
PIANO CONCERTO
WALTER
THE COLUMBIA SYMPHONY

EUGENE
ISTOMIN

CHOPIN
PIANO CONCERTO NO. 2
ORMANDY
THE PHILADELPHIA ORCHESTRA

Portrait:
George Orwell
Illustrator:
Paul Davis
New York, NY
Art Director:
Jan Drews
Design Firm:
Paul Davis Studio
Publication:
Harper's

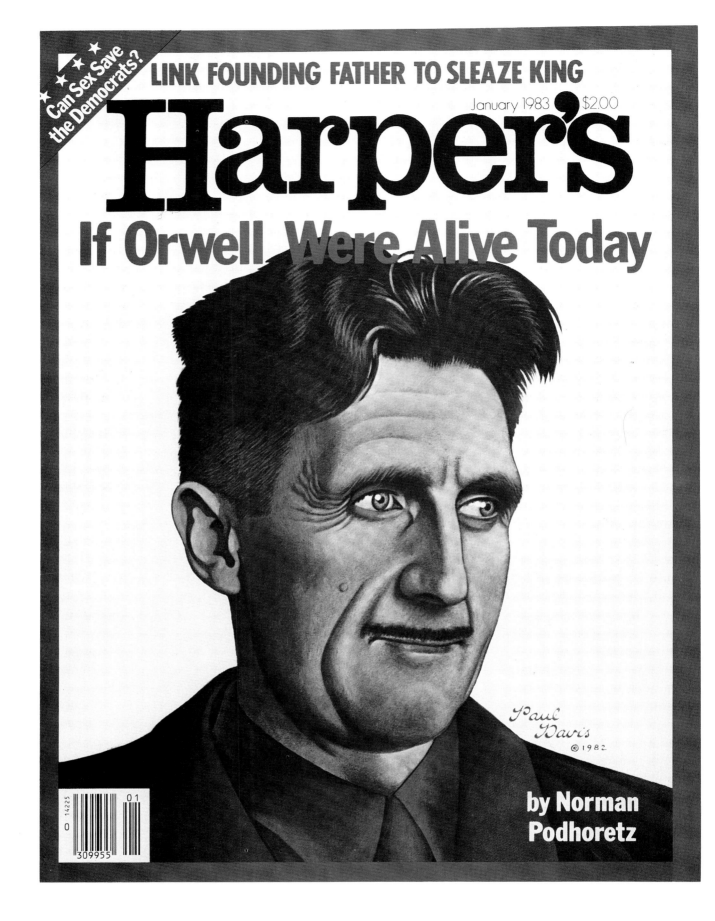

Can Sex Save the Democrats?

LINK FOUNDING FATHER TO SLEAZE KING

January 1983 $2.00

Harper's

If Orwell Were Alive Today

Paul Davis
© 1982

by Norman Podhoretz

NOVEMBER 28, 1983 $1.75

TIME

1984
Big Brother's Father

Author
George Orwell

Portrait:
George Orwell
Illustrator:
R. B. Kitaj
London, England
Art Director:
Rudy Hoglund
Publication:
Time

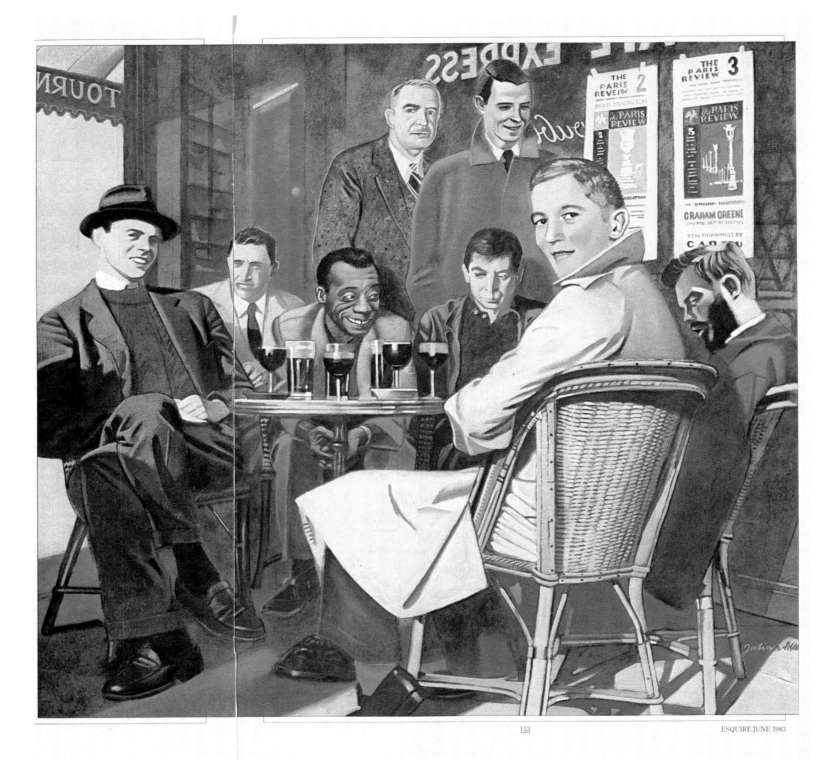

Portrait:
Members of the
Paris Review
Illustrator:
Julian Allen
New York, NY
Art Director:
April Silver
Publication:
Esquire

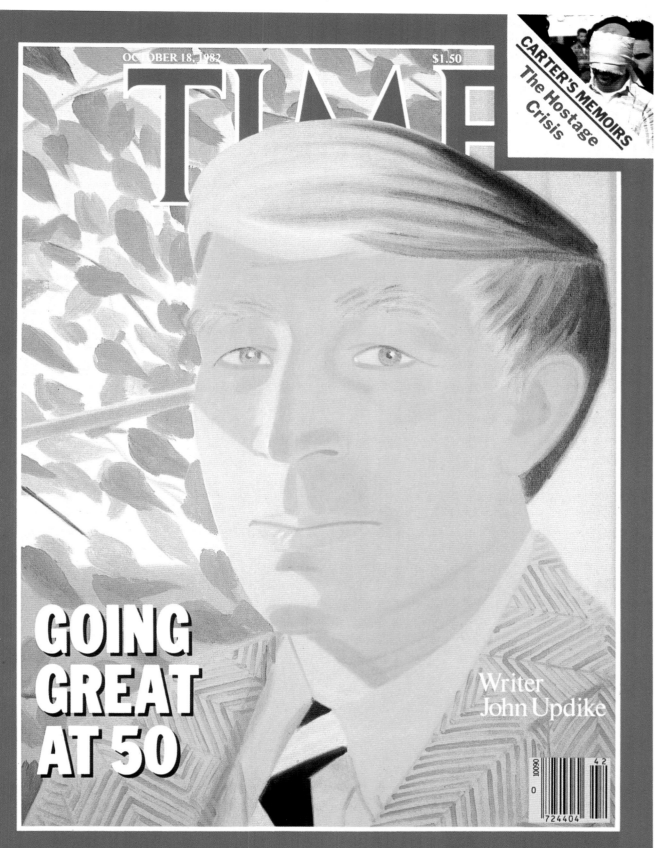

Portrait:
John Updike
Illustrator:
Alex Katz
New York, NY
Art Directors:
Rudy Hoglund
Nigel Holmes
Publication:
Time

OCTOBER 18, 1982 $1.50

TIME

CARTER'S MEMOIRS
The Hostage
Crisis

GOING
GREAT
AT 50

Writer
John Updike

VOLUME IX, NUMBER 3 SUNDAY, AUGUST 26, 1979 PAGE 1

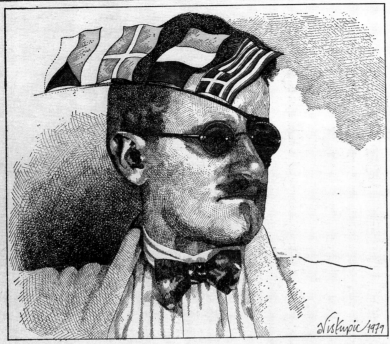

ILLUSTRATION BY GARY VISKUPIC FOR THE WASHINGTON POST

Joyce to the World

PORTRAITS OF THE ARTIST IN EXILE: Recollections of James Joyce by Europeans. Edited by Willard Potts. University of Washington. 304 pp. $12.95

By ANTHONY BURGESS

THE BEST JOYCE SCHOLARSHIP comes from America. Richard Ellmann's life of Joyce is a masterpiece of American industry, empathy and humor, and is probably the best biography of the century so far. If Joyce is now assumed to be an American property, there is a sense in which that terribly direct and profoundly enigmatic Irishman can never really be exported from Europe. He was fascinated by the idea of a New World, and *Finnegans Wake* is full of Mark Twain and a letter from Boston, but he never felt a desire to visit that other Georgian Dublin on the stream Oconee. Nor did he open his heart to the American expatriates in Paris as he did to the Triestines, Danes and Greeks. And yet to learn, as in this book, how fundamentally European Joyce was, and how shrewdly and lovingly other Europeans were able to draw him in and draw him out, we have to go to an American. Pro-

fessor Potts, of Corvallis in Oregon, has made an admirable compilation, meticulously annotated, and I am happy to be early with a gush of gratitude, grash of guttitude.

Indispensable as Ellmann's biography is, it is already 20 years old and could not make use of the delayed reminiscences that we slow Europeans are costive to deliver. I am always urging Georges Belmont in Paris to hurry with his memoirs (he translated Joyce's poems and helped with the French *Finnegan;* now down in the world, he merely translates me). He has a lot to tell about Joyce the man, and he is not alone. The Joyceana of the Potts book are fine, but we shall always be ready for more.

Not that we are likely ever to get anything so hilarious as the saga of Joyce at the Berlitz Institute in Pola, as recounted by his old colleague Alessandro Francini Bruni. The future master of most of the Italian dialects talked at that time "a crippled Italian full of ulcers"—a bookish porridge of archaisms. Asked how he liked Italy, he could only find a reply out of Canto III of the *Inferno.* "A bunch of rags tumbling out of a third class car— too bad that in Austria there were no fourth class cars as in Germany—like two sacks of spoiled beans," Joyce and his wife Nora were sad clowns

CONTINUED ON PAGE 6

ANTHONY BURGESS, author of *A Clockwork Orange* and *Man of Nazareth,* has also written *Re Joyce, Joysprick,* and *A Shorter Finnegans Wake.*

Nadine Gordimer And the Fine Art Of Fiction

BURGER'S DAUGHTER. By Nadine Gordimer. Viking. 361 pp. $10.95

By ERIC REDMAN

THREE YEARS AGO, in reviewing her *Selected Stories,* I insisted that Nadine Gordimer "writes as well as anyone alive today." Those words embarrass me now, not because *Harper's* and *The Atlantic* have chastised reviewers who engage in hyperbolic praise, but because in this instance the praise was understated, almost churlish. I should have said— admitted, really— that I don't know a living writer who's even in a class with this enchanting and adroit South African.

Many small delights distinguish Gordimer's fiction. Her prose is meticulous yet earthily sensual, a blend of metaphor and minute detail. ("He made love to me with the dragon Hoover breathing in the corridor outside and he does not know that the essence on his tongue in the bitter wax of my ear chamber, the brines of mouth or vagina were not my secret.") She has an unerring sense of scene, an ability to build force as if each chapter were one of her luminous short stories. And while her writing is often oblique, it is never obscure.

The technical mastery of Gordimer's craft is subordinate, however, to her literary purpose: to capture the many nuances of desire and perception without losing their emotional intensity. This is no small task; contemporary writing often achieves intensity only through the clash of bloodless stereotypes, or else sacrifices intensity in order to explore every nook and cranny of the human psyche. Gordimer's gift is to combine power with intricacy.

Her novels share South African settings, but otherwise each is distinct. *The Conservationist* (1975) was a tale of realization: a complacent industrialist gradually discovers that the decay of his prized weekend farm reflects the decay of his entire land. *Burger's Daughter,* by contrast, is a story about choice. And the choices involved are by no means uniquely South African.

CONTINUED ON PAGE 2

ERIC REDMAN is the author of *The Dance of Legislation.*

IN THIS ISSUE:

FROM "THE SENSE OF ORDER"

E. H. Gombrich on what makes the decorative arts decorative. Page 9

The Pooh complex—the later life of Christopher Robin. Page 3

Practical guides to planning for old age. Page 11

RADIO GUIDE

THE GENIUS OF JOYCE

ANTHOLOGY celebrates
the Irish author's 100th birthday
on January 30 and February 6

PROGRAMS FOR JANUARY 30–FEBRUARY 12

THE GUIDE TO CBC RADIO AND CBC STEREO

Portrait:
Mario Puzo
Illustrator:
Braldt Bralds
New York, NY
Art Director:
Walter Bernard
Publication:
Time

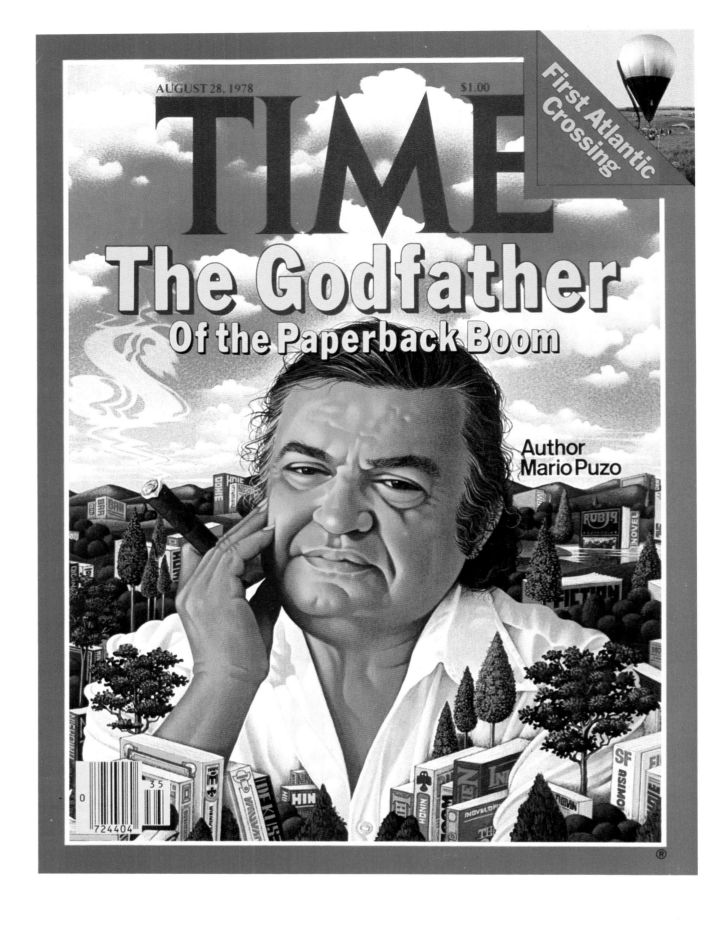

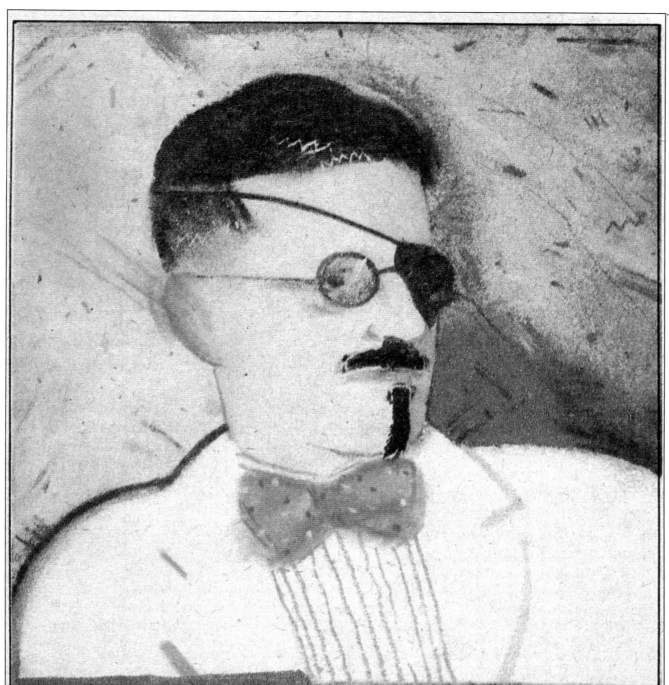

Portrait:
James Joyce
Illustrator:
Vivienne Flesher
New York, NY
Art Director:
Katie Aldrich
Publication:
The Boston Globe

AND YES I SAID YES...

For James Joyce fans, June 16 is a mythic literary holiday called Bloomsday. To celebrate, John Crelan has put together another evening of music, poetry, and dramatic readings culled from and elaborating on Joyce's works. The spirit of Joyce — his lyricism, his bitter bite, his public and private lives — will be evoked in a variety of modes including part of the long stream-of-consciousness soliloquy from *Ulysses* as well as letters from Nora Joyce to her husband. There will be a composition by Mar̶̶ ̶ ̶ ̶ ̶derived fror̶ ̶ ̶ *Ar̶* Pulitzer Prize-winning composer Donald Martino from *Pomes Penyeach*. Tenor Karl Dan Sorenson, and many others, will be on the program.

You can buy tickets at Jordan Hall before the performance, which starts at 8 p.m.

BLOOMSDAY, JUNE 16
JORDAN HALL
30 GAINSBOROUGH STREET
BOSTON 02115

Portrait:
Henry Miller
Illustrator:
Stephen Alcorn
Lyme, CT
Art Director:
R. D. Scudellari
Bookjacket:
Tropic of Cancer
Publisher:
Modern Library

Portrait:
Norman Mailer
Illustrator:
Mick Haggerty
Hollywood, CA
Art Director:
Lloyd Ziff
Publication:
Vanity Fair
Publisher:
The Conde Nast
Publications, Inc.

Portraits:
Sean O'Casey, W. B.
Yeats, James Joyce, J.M.
Synge, Oliver St. John
Gogarty, Lady Gregory
and Samuel Beckett
Illustrator:
Edward Sorel
New York, NY
Art Director:
Lidia Ferrara
Bookjacket:
A Colder Eye
Publisher:
Alfred A. Knopf,
Publisher

Portrait:
Norman Mailer
Illustrator:
Brad Holland
New York, NY
Art Director:
Bob Ciano
Publication:
Life

Portrait:
Emigres
Illustrator:
Julian Allen
New York, NY
Art Director:
April Silver
Publication:
Esquire

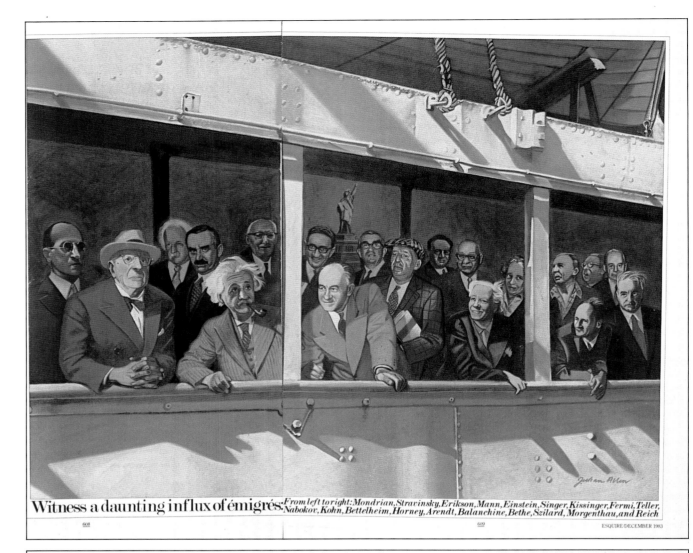

Witness a daunting influx of émigrés. *From left to right: Mondrian, Stravinsky, Erikson, Mann, Einstein, Singer, Kissinger, Fermi, Teller, Nabokov, Kohn, Bettelheim, Horney, Arendt, Balanchine, Bethe, Szilard, Morgenthau, and Reich*

608 609 ESQUIRE/DECEMBER 1983

Portraits:
Humphrey Bogart, George
Raft, Eduardo Giannelli,
Jack L. Warner, Barton
MacLane, John Garfield,
Edward Robinson and
James Cagney
Illustrator:
Edward Sorel
New York, NY
Art Director:
Walter Bernard
Publication:
New York Film Review

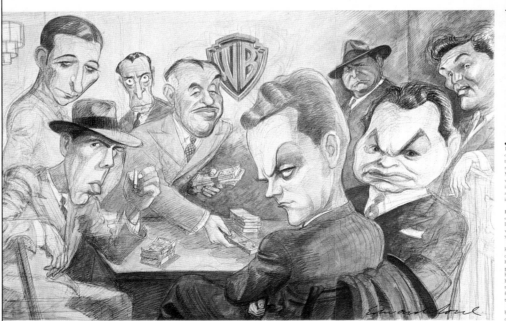

The Mob by Sorel. Clockwise from lower left: Humphrey Bogart, George Raft, Eduardo Ciannelli, Jack Warner, Barton MacLane, John Garfield, Edward G. Robinson, James Cagney

32 33

The Warner Mob

by Neil Hickey and Edward Sorel

With the Depression pushing the studio toward bankruptcy, Warner Brothers had to resort to crime—and crime paid so well that the company was able to recruit the toughest guys that ever shot up a sound stage.

JACK WARNER RAN HIS organization the same way Al Capone ran his ruthlessly. The problem was that, unlike Capone, he couldn't simply wipe out the competition. In 1930 Jack and his two older brothers, Sam and Harry, owned one-quarter of all the movie houses in the United States, plus the Warner Brothers studio and fifty-one subsidiary companies. But their theaters were now frighteningly empty. Millions were out of work, and the novelty of talking pictures, which had started with Warner's Vitaphone process, had lost its drawing power. Warner's profits came crashing down along with the stock market—$14 million in 1929, $7 million in 1930, and losses of $8 million anticipated for 1931.

Jack could not be consoled by the knowledge that other Hollywood studios were in trouble too. MGM was the exception, but MGM's movies had opulent sets, high-key lighting, lush scores, large casts. The Warner assembly line was not equipped to turn out that sort of luxury product. Something else was called for, something fast—and cheap.

The man who would supply it was Darryl F. Zanuck. He had come to Warner's in 1924 to write screenplays for the canine star Rin Tin Tin (the only actor for whom Jack Warner had a good word); but soon graduated to more ambitious projects. In his first six years he turned out so many scripts that he had to adopt various pseudonyms. By 1930 Zanuck was head of production for the entire studio. He was then twenty-eight years old and convinced he knew the formula for bringing Depression audiences back into the movie theater: crime.

There was nothing new about gangster films. They had been around ever since D. W. Griffith made *The Musketeers of Pig Alley* in 1912, but few in recent years had shown strength at the box office. Jack Warner was not enthusiastic

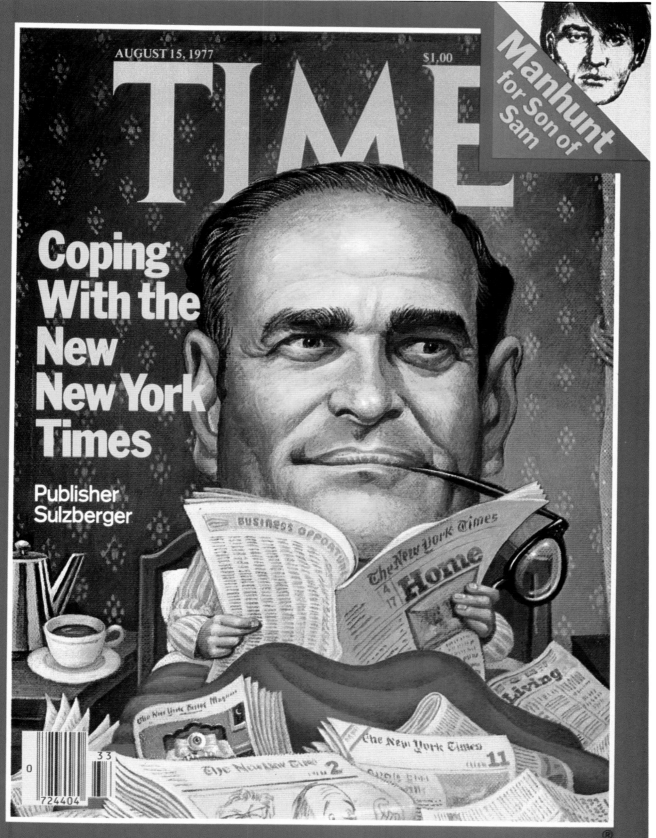

Portrait:
Arthur H. Sulzberger
Illustrator:
Richard Hess
Roxbury, CT
Art Director:
Walter Bernard
Publication:
Time

Portrait:
A Portrait of
Gertrude Steinbrenner
Illustrator:
Ron Barrett
New York, NY
Art Directors:
Michael Grossman,
Arlene Lappen
Publication:
National Lampoon

Portrait:
William Shakespeare
Illustrator:
Heather Cooper
Toronto, CAN
Art Director:
Heather Cooper
Publisher:
Stratford Festival,
Canada

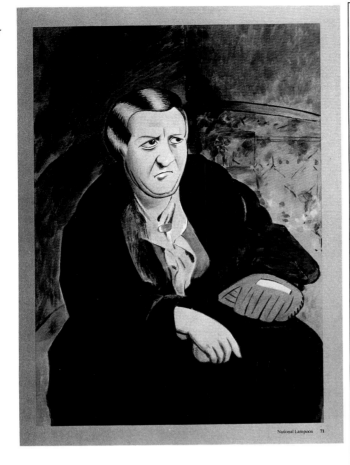

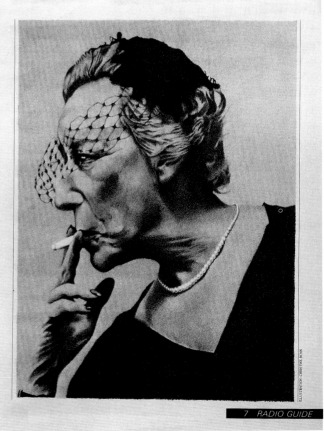

STRATFORD FESTIVAL

1982 SEASON
STRATFORD ONTARIO CANADA

Portrait:
Jack Kerouac
Illustrator:
Ralle
Scarborough, CAN
Art Director:
April Silver
Publication:
Esquire

Portrait:
Lillian Hellman
Illustrator:
Christine Bunn
Toronto, CAN
Art Director:
B. J. Galbraith
Publication:
C.B.C. Radio Guide

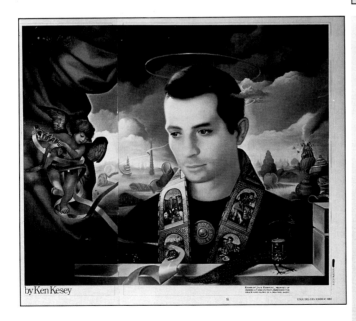

by Ken Kesey

7 RADIO GUIDE

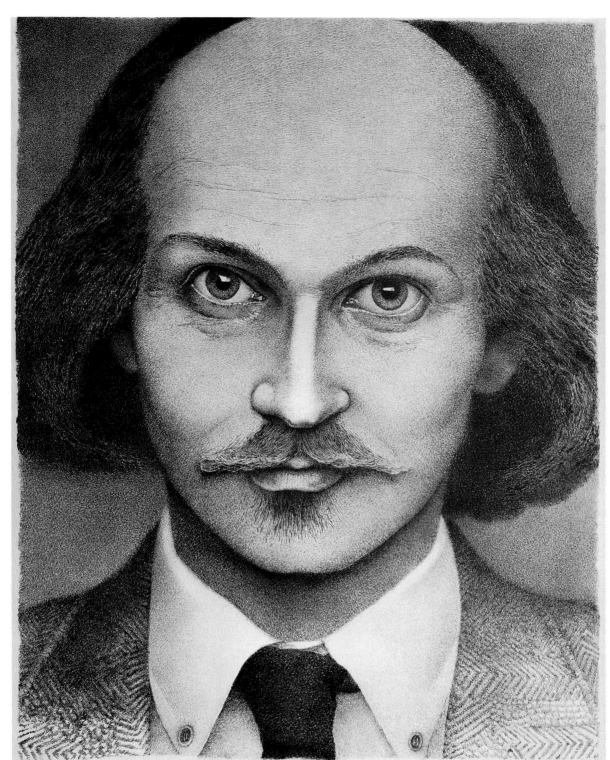

Portrait:
William Shakespeare
Illustrator:
Jim Jacobs
Dallas, TX
Design Firm:
Jim Jacobs' Studio
Publisher:
Dallas Public Library

UNCOMMON SHAKESPEARE

NONTRADITIONAL PRODUCTIONS OF CLASSIC PLAYS
NOVEMBER 17, 1980 - JANUARY 4, 1981, DALLAS PUBLIC LIBRARY,
1954 COMMERCE, TERRACE ROOM, FOURTH LEVEL

THE FOLLOWING GROUPS CONTRIBUTED TO THIS EXHIBITION: AMERICAN SHAKESPEARE THEATRE
STRATFORD, CONNECTICUT ❧ DALLAS CIVIC BALLET ❧ DALLAS CIVIC OPERA ❧ DALLAS THEATER
CENTER ❧ GLOBE OF THE GREAT SOUTHWEST, ODESSA, TEXAS ❧ GREAT LAKES SHAKESPEARE FESTIVAL,
LAKEWOOD, OHIO ❧ NATIONAL SHAKESPEARE COMPANY, NEW YORK, NEW YORK ❧ OREGON
SHAKESPEAREAN FESTIVAL ASSOCIATION, ASHLAND, OREGON ❧ SHAKESPEARE FESTIVAL OF DALLAS
STRATFORD FESTIVAL, ONTARIO, CANADA ❧ ❧ ❧ FUNDED IN PART BY THE FRIENDS OF THE
DALLAS PUBLIC LIBRARY AND THE NEH LEARNING LIBRARY PROGRAM ❧ ❧ ❧

Portrait:
Bo Derek and
Ayatollah Khomeini
Illustrator:
Blair Drawson
Toronto, CAN
Art Director:
Lloyd Ziff
Publication:
Vanity Fair
Publisher:
The Conde Nast
Publications, Inc.

Portrait:
Groucho Marx
Illustrator:
Blair Drawson
Toronto, CAN
Art Director:
April Silver
Publication:
Esquire

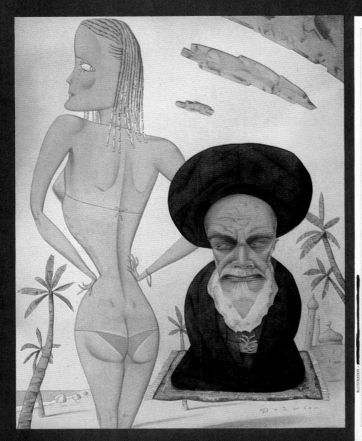

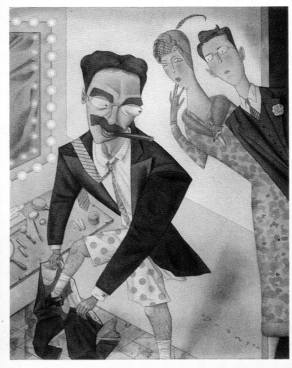

HASTENING BACKSTAGE, THEY FOUND GROUCHO, FRESH FROM A PERFORMANCE
of *Animal Crackers*, clad casually in his shorts. The encounter was fateful.

ESQUIRE/SEPTEMBER 1981

Portrait:
Alan E. Cober
Illustrator:
Alan E. Cober
Ossining, NY
Art Director:
Dick Henderson
Client:
Fox Valley
Advertising Club

Portrait:
Wally Cleaver
Illustrator:
Regan Dunnick
Houston, TX
Art Directors:
Chris Hill
Regan Dunnick
Design Firm:
The Hill Group
Publisher:
Dunnick/Hill

IS ALAN E. COBER LYING
ABOUT DRAWING?

Not anymore. He's on his way to Appleton to tell the truth about his illustrative reportage for major national
magazines, his mural for the Smithsonian, and this provocative series of self-portraits.
And to conduct a day long Hands-On-Workshop.

COBER TELLS THE TRUTH
April 13, 1983
Advertising Association of the Fox River Valley
Paper Valley Hotel
Cocktails 5:30. Dinner 6:00. Program follows.
Guests are welcome. No charge to AA-FRV members.
Others, $15.

ALAN E. COBER WORKSHOP
April 14, 1983
Lawrence University Art Center
8:30 a.m. to 2:00 p.m.
Informal lecture. Group discussions. Live model.
Bring drawing materials & your best work for portfolio review.
Lunch provided. Enrollment limited to 25 persons.
Non-refundable fee. $45.
CALL 414-734-4822 FOR INFORMATION AND TO
MAKE RESERVATIONS.

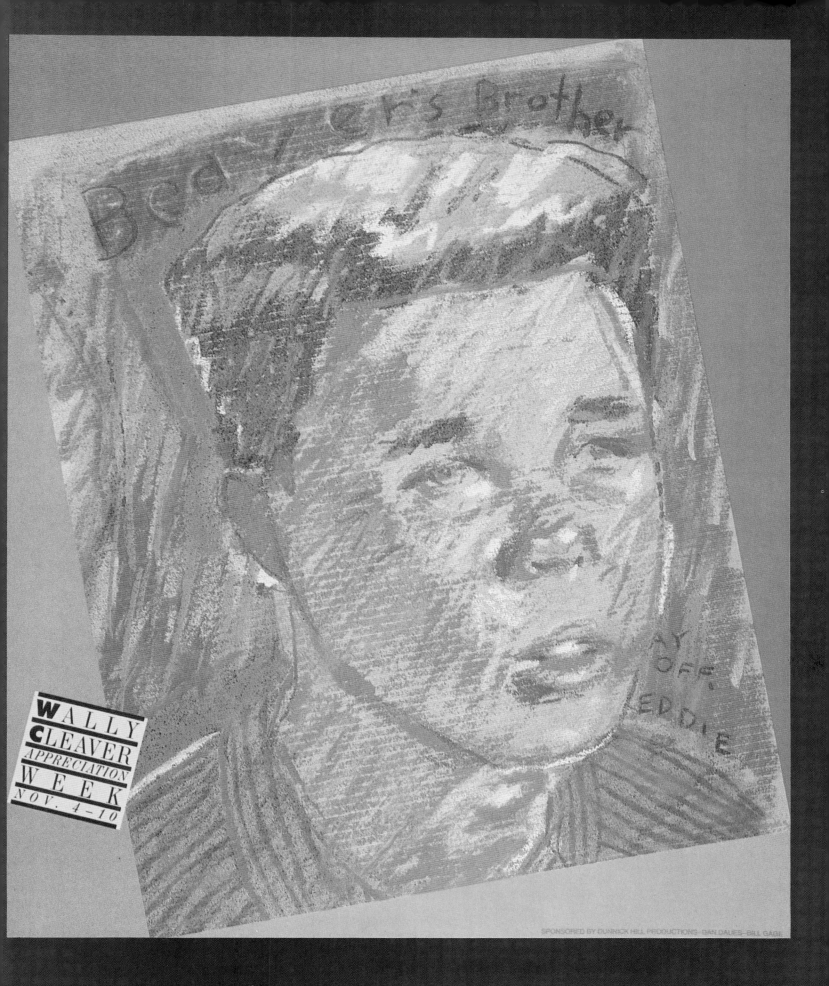

Portrait:
Jesse Helms
Illustrator:
Alfred Leslie
Amherst, MA
Art Director:
Rudy Hoglund
Publication:
Time

Portrait:
Gösta Bohman
Illustrator:
Alan Reingold
New York, NY
Art Director:
John Peters
Publication:
Veckans Affarer

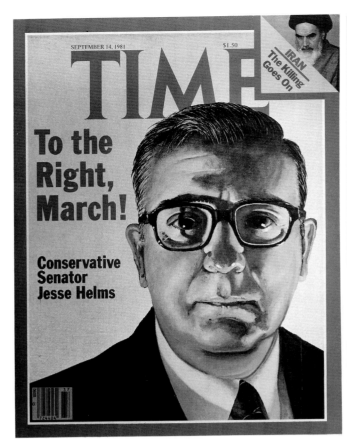

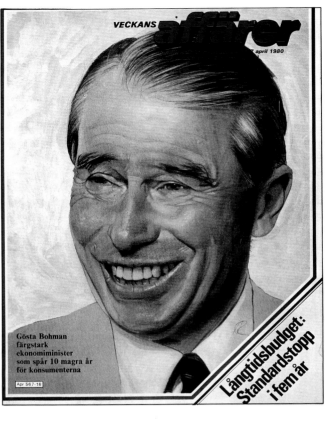

Portrait:
Jimmy Carter
Illustrator:
Edward Sorel
New York, NY
Art Director:
Walter Bernard
Publication:
Time

Portrait:
Jimmy Carter
Illustrator:
Edward Sorel
New York, NY
Art Director:
Walter Bernard
Publication:
Time

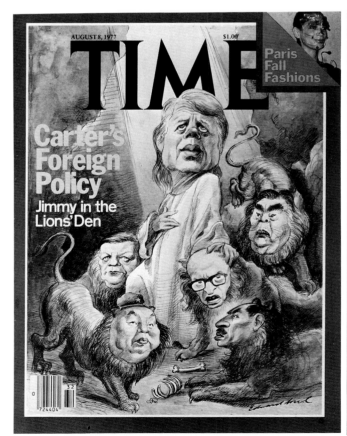

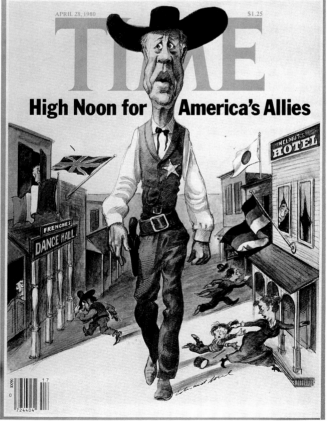

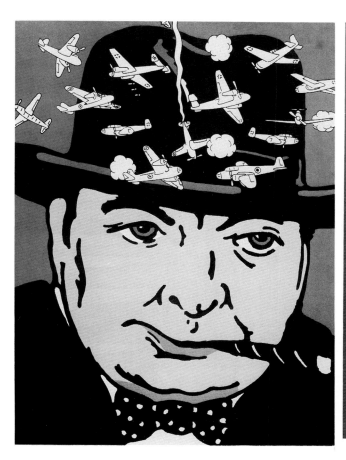

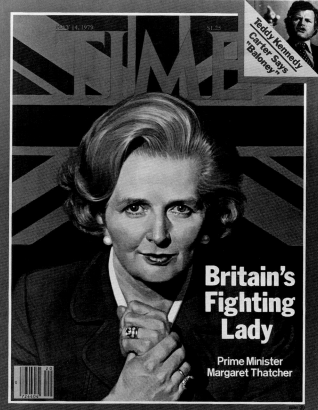

Portrait:
Winston Churchill
Illustrator:
Seymour Chwast
New York, NY
Designer:
Pushpin Studios
Publisher:
Pushpin Graphic

Portrait:
Margaret Thatcher
Illustrator:
Michael Leonard
London, England
Art Director:
Walter Bernard
Publication:
Time

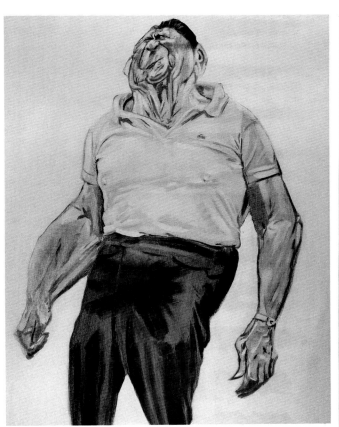

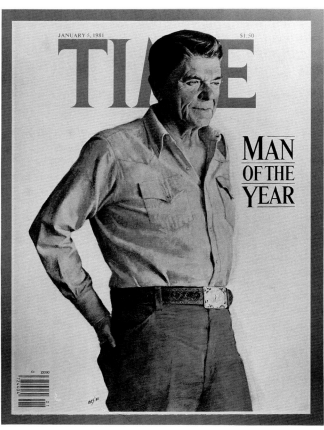

Portrait:
Ronald Reagan
Illustrator:
Phil Burke
New York, NY
Art Director:
Lloyd Ziff
Publication:
Vanity Fair
Publisher:
The Conde Nast
Publications, Inc.

Portrait:
Ronald Reagan
Illustrator:
Aaron Shikler
New York, NY
Art Director:
Rudy Hoglund
Publication:
Time

Portrait:
Teng Hsiao-ping
Art Director:
Richard Hess
Roxbury, CT
Art Director:
Walter Bernard
Publication:
Time

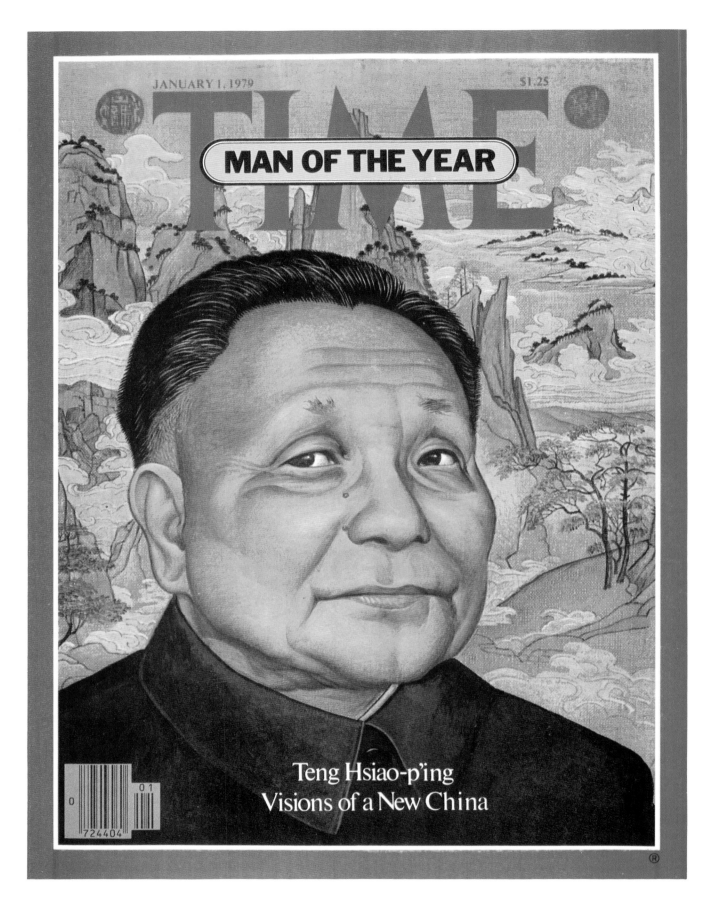

JANUARY 1, 1979

TIME

$1.25

MAN OF THE YEAR

Teng Hsiao-p'ing
Visions of a New China

0 724404 01

Portraits:
Reagan
Mondale
Illustrator:
Robert Grossman
New York, NY
Publication:
WEST
Publisher:
San Jose Mercury News

Portrait:
Tip O'Neill
Illustrator:
Don Ivan Punchatz
Arlington, TX
Art Director:
Bob Post
Publication:
Playboy
Publisher:
Playboy Enterprises, Inc.
February 1982

Portrait:
Richard Nixon
Illustrator:
Julian Allen
New York, NY
Art Director:
Ruth Ansel
Publication:
Vanity Fair
Publisher:
The Conde Nast
Publications, Inc.

Portrait:
Jimmy Carter
Ronald Reagan
Illustrator:
Robert Grossman
New York, NY
Art Director:
John Berg
Publisher:
CBS Records

KISSINGER
trium-
phant

BY GARRY WILLS

He won the Nobel Peace Prize
for a war that never ended.
Watergate left him unscathed.
The sovereign schemer somehow
manages to turn each defeat into
a personal victory. But, we ask
you, is this diplomacy?

How does Henry Kissinger do it? He strolls from scene to scene, tinkering with structures that collapse behind him; he is sniped at from the left and from the right; he wiretaps his friends and accumulates enemies—yet all the while he is moving from strength to strength. An Al Capp character used to travel under his own private rain cloud of attendant trouble; Kissinger seems to walk through storms, through earthquakes, through apocalypses, in a protective spotlight of sunshiny luck.

He is one of the few men who palled around with the tar baby of Watergate yet did not get stuck to it. He picked up a Nobel Peace Prize for a war that never ended. He mocked Third World concerns and is now asked to preside over them. Others talk of success just barely eluding them. He manages to have failure skitter endlessly out of his grasp.

This mysterious not-quite-success story is explained hyperbolically by both friend and foe. To his supporters he remains Super-K, history's Mister Fix-It. To critics like Seymour Hersh, he is diabolical, a colossal liar and schemer, a vindictive egomaniac.

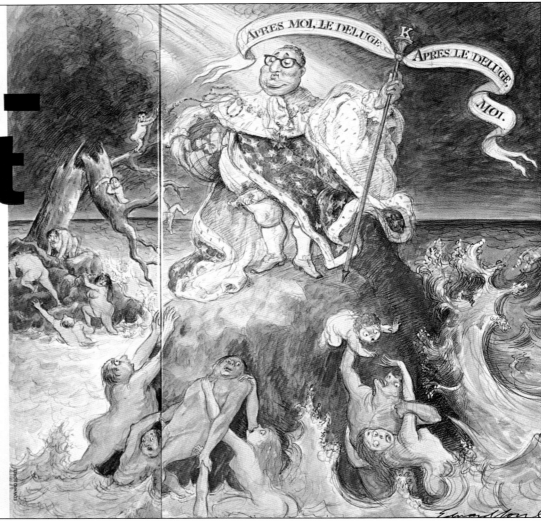

APRES MOI, LE DELUGE. K APRES LE DELUGE, MOI.

Portrait:
Henry Kissinger
Illustrator:
Edward Sorel
New York, NY
Art Director:
Rochelle Udell
Publication:
GQ Magazine
Publisher:
The Conde Nast
Publications, Inc.

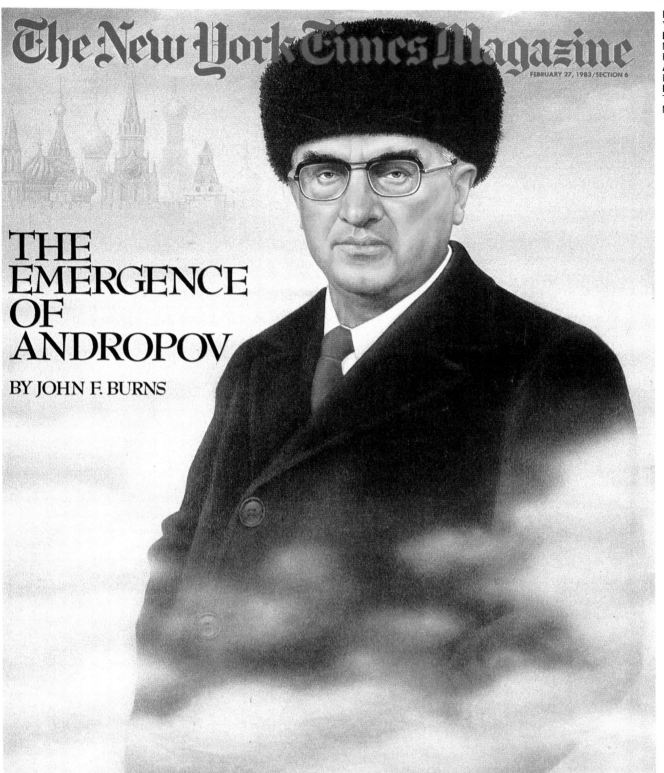

The New York Times Magazine

FEBRUARY 27, 1983/SECTION 6

THE EMERGENCE OF ANDROPOV

BY JOHN F. BURNS

Portrait:
Yuri Andropov
Illustrator:
Mark Hess
Katonah, NY
Art Director:
Roger Black
Publication:
The New York Times
Magazine

Portrait:
William Buckley
Illustrator:
Julian Allen
New York, NY
Art Director:
Caroline Bowyer
Publication:
Book Digest

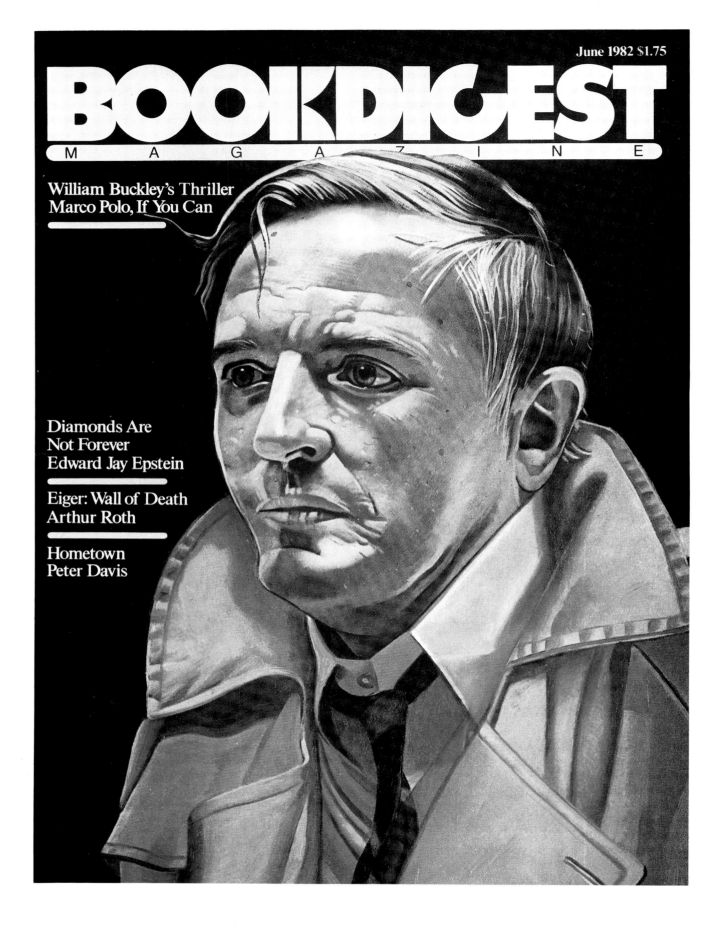

June 1982 $1.75

BOOKDIGEST
MAGAZINE

William Buckley's Thriller
Marco Polo, If You Can

Diamonds Are
Not Forever
Edward Jay Epstein

Eiger: Wall of Death
Arthur Roth

Hometown
Peter Davis

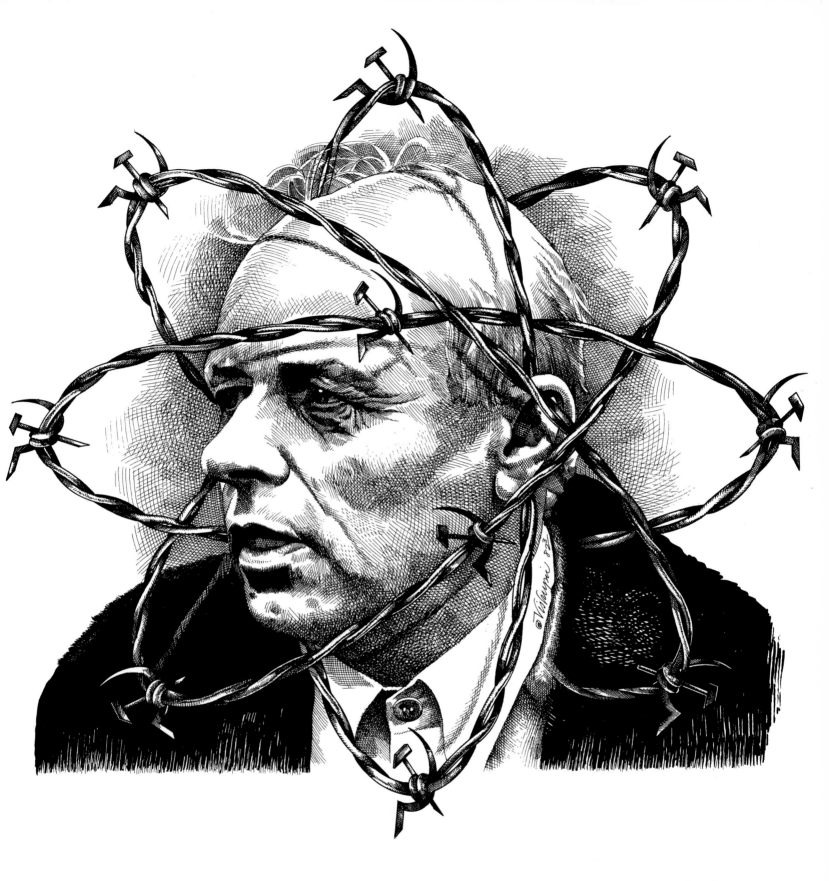

Portrait:
Andrei Sakharov
Illustrator:
Gary Viskupic
Centerport, NY
Art Director:
Frances Tanabe
Design Firm:
Pen & Inc.
Publication:
The Washington Post
Book World

Portrait:
Deng Xiaoping
Illustrator:
Kinuko Craft
Norfolk, CT
Art Directors:
Rudy Hoglund
Irene Ramp
Publication:
Time

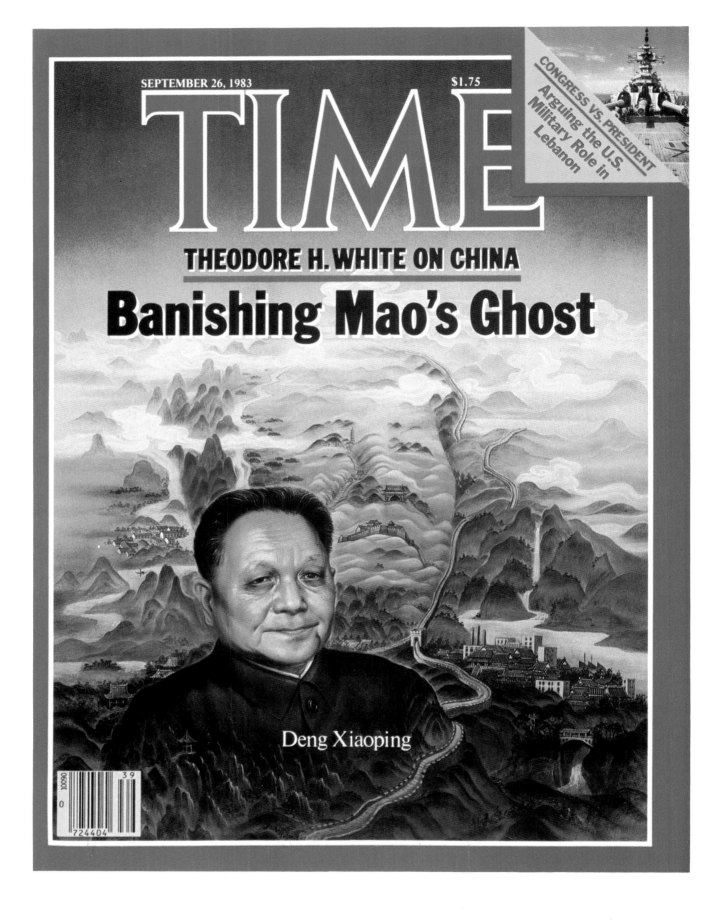

SEPTEMBER 26, 1983 $1.75

TIME

THEODORE H. WHITE ON CHINA

Banishing Mao's Ghost

Deng Xiaoping

CONGRESS VS. PRESIDENT
Arguing the U.S.
Military Role in
Lebanon

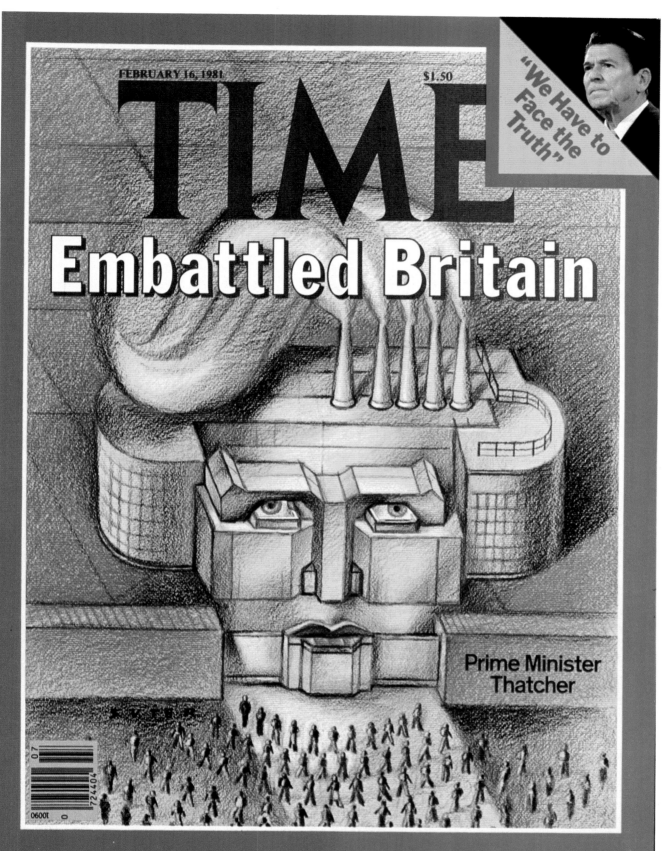

FEBRUARY 16, 1981

$1.50

TIME
Embattled Britain

Prime Minister
Thatcher

Portrait:
Margaret Thatcher
Illustrator:
David Suter
New York, NY
Art Directors:
Rudy Hoglund
Nigel Holmes
Publication:
Time

"We Have to Face the Truth"

Portraits:
Ronald Reagan
Margaret Thatcher
Illustrator:
Julian Allen
New York, NY
Art Director:
April Silver
Publication:
Esquire

Portrait:
Lee Harvey Oswald
Illustrator:
Vivienne Flesher
New York, NY
Art Director:
Fred Woodward
Publication:
Texas Monthly

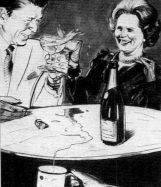

UNCONVENTIONAL WISDOM
BY ADAM SMITH

THE LESSONS OF MRS. T.
For better or worse, we can learn from Britain's Iron Lady

"MRS. T." is what the prime minister is called in London. "We are thinking of doing a TV show," said the managing director of *The Economist*, "and one of our editors, Sarah here, does a very good Mrs. T." The BBC and the Treasury still call her "prime minister." Labour hecklers in Parliament call her "a vandal" and "stupid woman"; placards of demonstrators call her "bitch." Everybody else just says "Mrs. T."

I was in London to ask a question: What can we learn from Mrs. T.?

When she came to power, she seemed like the point man (or point woman) of the platoon, someone who goes first and draws the fire. Like the Reagan administration, she was determined to cut down the government's role in the economy. She has, of course, faced more trouble than the President; unemployment is at a postwar high, and so are the numbers of demonstrators in Trafalgar Square. Riots have swept the racially mixed areas of Liverpool, Manchester, Birmingham, and Newcastle. Some pundits thought those riots would finish her tenure. Her stern Iron Lady policies of tight money and retrenchment, it was said, created the unemployment that produced the riots. That is dismissing Mrs. T. too quickly.

She came to power with two main programs: cutting down the rate of inflation, which was in the mid-twenties, and revitalizing British industry, which had fallen far behind the leading industrial countries of Europe. "Made in England" once stood for quality. Britain was the first industrialized country, and "made in England" made London rich when Germany was a string of petty principalities and the Japanese were still cut off from the world. Rich London can be deceiving. It always looks so serene with its houses around handsome squares and its parks with centuries-old trees. Limousines purr at the curbsides, and the restaurants are expensive and full. Construction signs are everywhere as the pleasant town houses of nineteenth-century barristers and stockbrokers are converted into $300,000 apartments. (The barristers never owned the land under the houses; great dukes always kept the land, and leased it for ninety-nine years.) Manchester and Birmingham could be in another country.

If a whiff of depression is what the economy needs to restore it, said Mrs. T.'s men, then down it goes like cod-liver oil: it may make you shudder, but it's good for you and it gets the job done and you'll be glad later. Do the armed forces protest that Mrs. T. is cutting their budgets, that the once-great British navy is reduced to bathtub proportions? Perhaps the armed forces lobby too effectively: Mrs. T. abolishes the posts of the secretaries of army, navy, and air force so they cannot lobby so well. Mrs. T.'s cabinet feels it is working against time; it must get the job done before 1984, the date of the next election, and it must utilize the economic breathing space granted by North Sea oil, which will begin to run out in the next decade.

This summer, Mrs. T.'s critics, who sprang to life in the wake of the riots, all ganged up on the issue of unemployment. The television films of besieged bobbies made it seem not only that Mrs. T.'s days were numbered but that unemployment was the reason for the violence.

But other critics chose another tack: not that she had cut too much but that she had not cut enough. She had, indeed, by a whiff of depression, made private industry leaner and fitter. Productivity had actually increased, turning around a sad slide. (From 1973 to 1980, for example, output per person went up one percent, but hourly wages went up more than 213 percent.) But her critics charged she had not cut the public sector nor tamed the unions. A million jobs disappeared from the private sector, but the civil service and the nationalized industries were so strong that they successfully resisted the cuts. "She should have gone in with a bloody great ax," said Norman Macrae, deputy editor of *The Economist*, "and instead she used a scalpel."

Mrs. T. would probably have liked to use an ax. "Thatcherism" is more than a hard-money, pull-up-your-socks policy; it is an economic program with moral overtones. Mrs. T. deplores the image of the state as parent; she decries "a pocket money society, in which the fruits of our work belong mainly to the state, and where we are handed back a little each week for our personal use."

I TOOK a taxi to Parliament Square, to the Treasury.

"We realized," said my Treasury host, "that what we had to do was to change the national perception on a very deep level. *The government cannot be responsible for the national happiness.* Now that goes

13 ESQUIRE/OCTOBER 1981

146 TEXAS MONTHLY/NOVEMBER 1983 Illustration by Vivienne Flesher

Portrait:
Rupert Murdoch
Illustrator:
Julian Allen
New York, NY
Art Director:
Ruth Ansel
Publication:
Vanity Fair
Publisher:
The Conde Nast
Publications, Inc.

Portrait:
Lee Harvey Oswald
Illustrator:
Julian Allen
New York, NY
Art Director:
Derek W. Ungless
Publication:
Rolling Stone

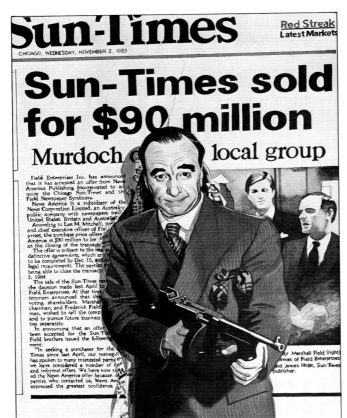

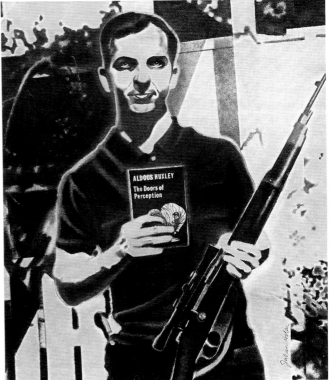

21ST CENTURY FACES

What will the most famous faces in the world look like in the year 2000? Will time (and age) be kind to their familiar features? For the fun of it, *Sunday Woman* invited artist Alan Reingold to project his imagination two decades into the future. Here, he paints his impressions of four well-known women at the dawn of the 21st century. Can you guess who's who? Check your answers against the photos in the upside-down panel at the bottom of the page. Can you score four out of four? It's harder than you think!

Portraits:
Anita Bryant, Jaclyn Smith, Amy Carter, Jackie Onassis
Illustrator:
Alan Reingold
New York, NY
Art Director:
Estelle Walpin
Publication:
Sunday Woman

1. 2.

3. 4.

1. ANITA BRYANT **2. JACLYN SMITH** **3. AMY CARTER** **4. JACKIE ONASSIS**

Portrait:
Cocaine Addict
Illustrator:
Brad Holland
New York, NY
Art Directors:
Tom Staebler
Kerig Pope
Publication:
Playboy
Publisher:
Playboy Enterprises, Inc.
June 1980

Portrait:
Dorothy Day
Illustrator:
Sue Coe
New York, NY
Art Director:
April Silver
Publication:
Esquire

Portrait:
Woman in a Chinese
Coat
Illustrator:
Anita Kunz
Toronto, CAN
Art Director:
Louis Fishauf
Publication:
Saturday Night

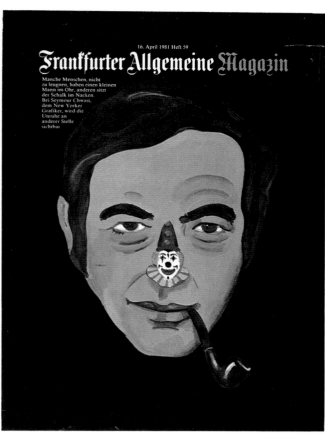

Portrait:
Walter Gropius
Illustrator:
Wilson McLean
New York, NY
Art Director:
Steve Miller
Agency:
Garrison Jasper Rose & Co.
Publisher:
Kawneer Architectural Products

Portrait:
Seymour Chwast
Illustrator:
Seymour Chwast
New York, NY
Art Director:
Hans Georg Pospischil
Design Firm:
Pushpin Lubalin Peckolick
Publisher:
Frankfurter Allgemeine Magazine

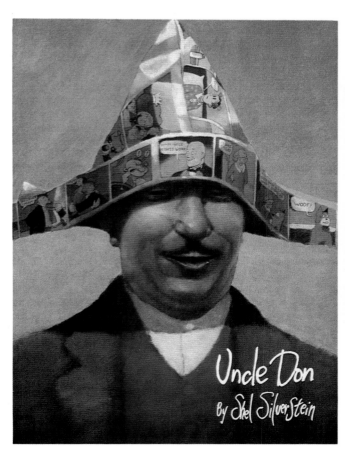

Portrait:
Uncle Don
Illustrator:
Brad Holland
New York, NY
Art Directors:
Arthur Paul
Kerig Pope
Publication:
Playboy
Publisher:
Playboy Enterprises, Inc.
March 1980

Portrait:
Muhammed Ali
Illustrator:
Brad Holland
New York, NY
Art Directors:
Tom Staebler
Kerig Pope
Publication:
Playboy
Publisher:
Playboy Enterprises, Inc.
January 1984

Portrait:
Rupert Murdoch
Illustrator:
Edward Sorel
New York, NY
Art Director:
Christian Von Rosenvinge
Publication:
Columbia Journalism
Review

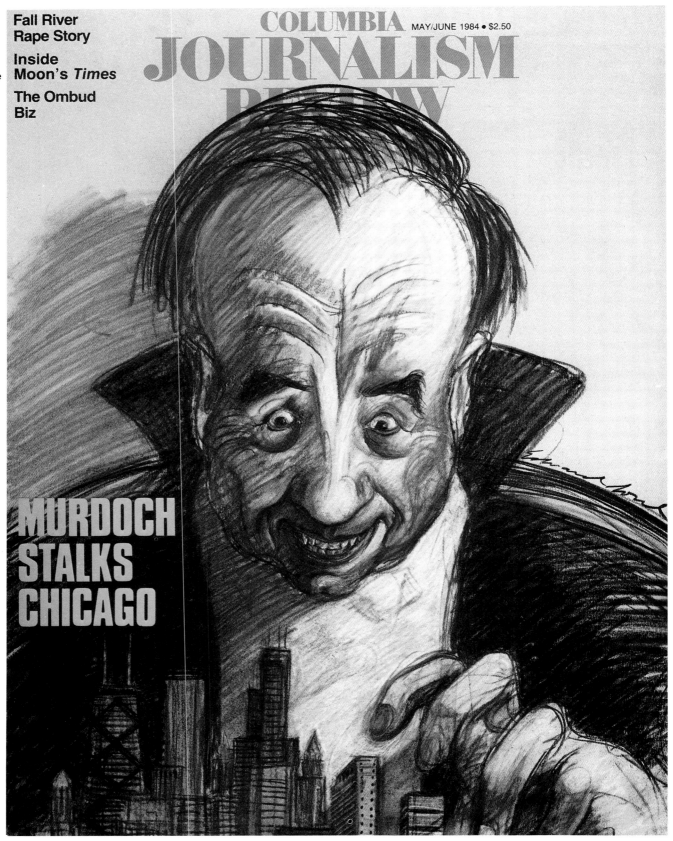

**Fall River
Rape Story**

**Inside
Moon's** *Times*

**The Ombud
Biz**

COLUMBIA
JOURNALISM
REVIEW

MAY/JUNE 1984 ● $2.50

MURDOCH
STALKS
CHICAGO

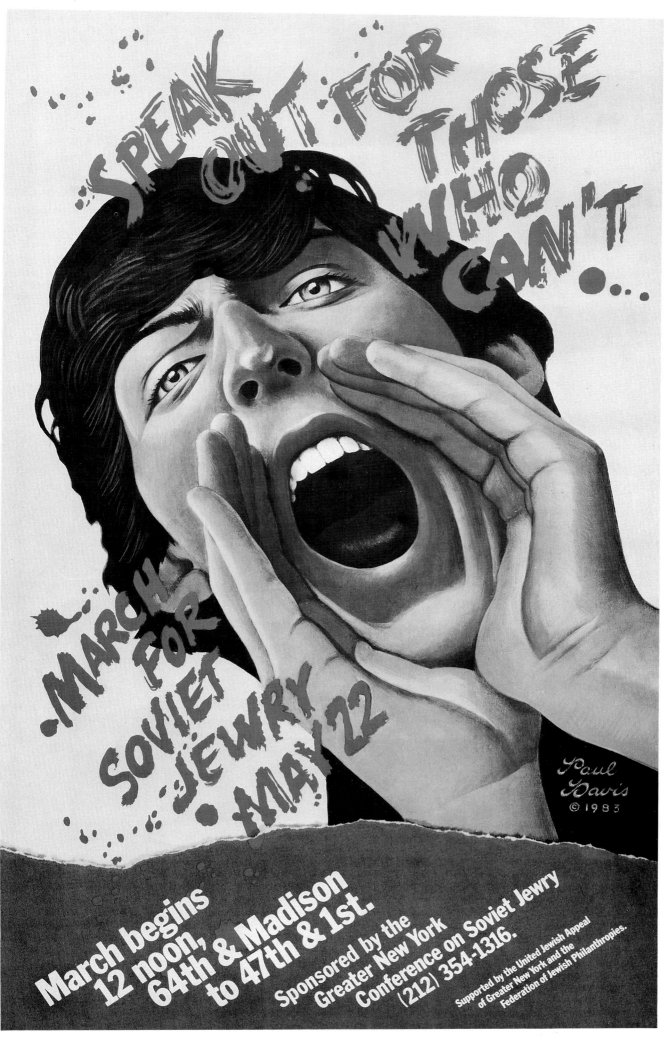

Portrait:
Matthew Davis
Illustrator:
Paul Davis
New York, NY
Design Firm:
Paul Davis Studio
Publisher:
Greater New York
Conference on
Soviet Jewry

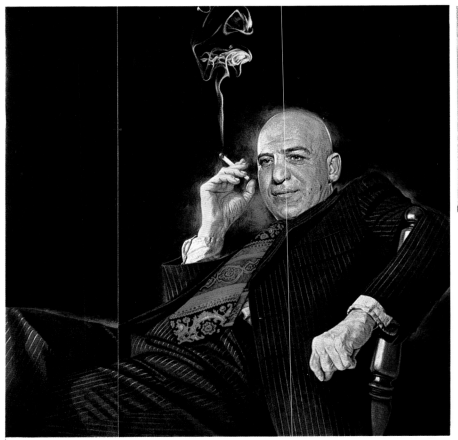

FIDELITY PRINTS JULY

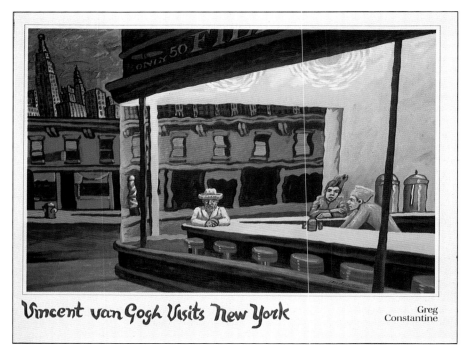

Vincent van Gogh Visits New York

Greg
Constantine

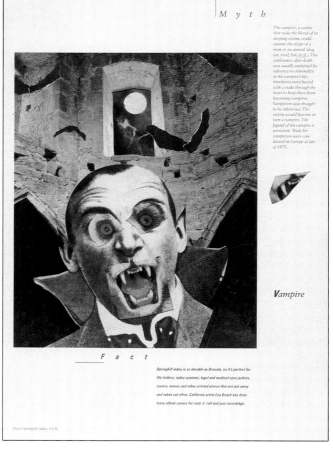

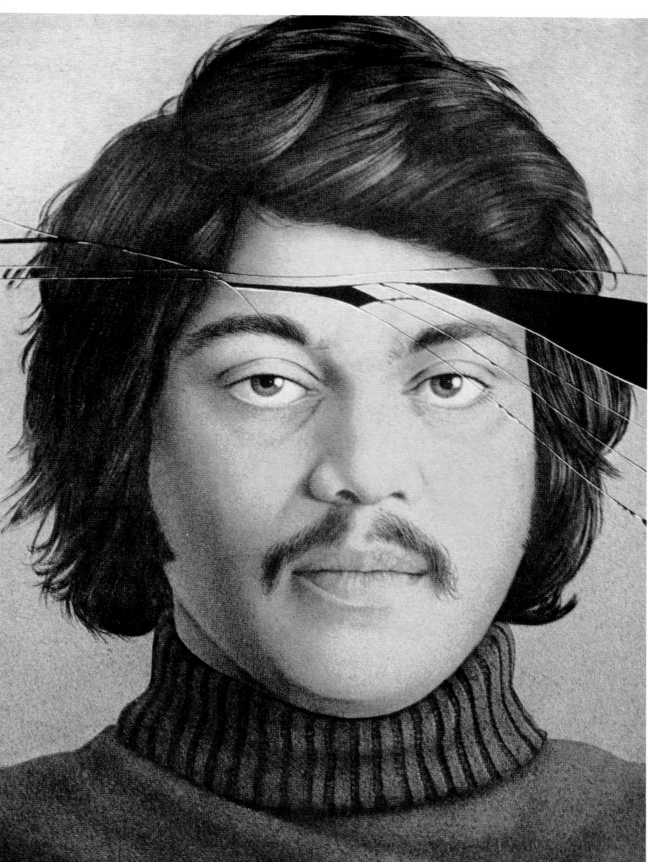

Portrait:
Freddy Prinze
Illustrator:
Allen Magee
Camden, ME
Art Director:
Tom Staebler
Publication:
Playboy
Publisher:
Playboy Enterprises, Inc.
June 1977

Portrait:
Telly Savalas
Illustrator:
Herb Davidson
Chicago, IL
Art Director:
Tom Staebler
Publication:
Playboy
Publisher:
Playboy Enterprises, Inc.
June 1978

Portrait:
Ted & Stan
Illustrator:
Regan Dunnick
Houston, TX
Art Director:
Steven Sessions
Design Firm:
Steven Sessions Design
Publisher:
Fidelity Prints July

Portrait:
Vincent Van Gogh
Illustrator:
Greg Constantine
Berrien Springs, MI
Art Director:
R. D. Scudellari
Bookjacket:
Vincent Van Gogh Visits
New York
Publisher:
Alfred A. Knopf,
Publisher

Portrait:
Vampire
Illustrator:
Lou Beach
Los Angeles, CA
Art Director:
Lucille Tenazas
Design Firm:
Harmon Kemp
Client:
International Paper Co.

Portrait:
Christopher Plummer
Illustrator:
Paul Davis
New York, NY
Design Firm:
Paul Davis Studio
Client:
New York
Shakespeare Festival

Portrait:
Darth Vader
Illustrator:
Marshall Arisman
New York, NY
Art Director:
Walter Bernard
Publication:
Time

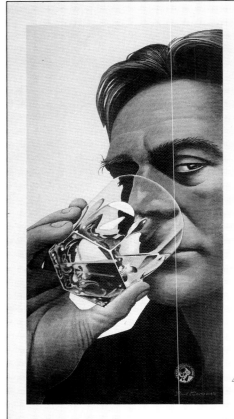

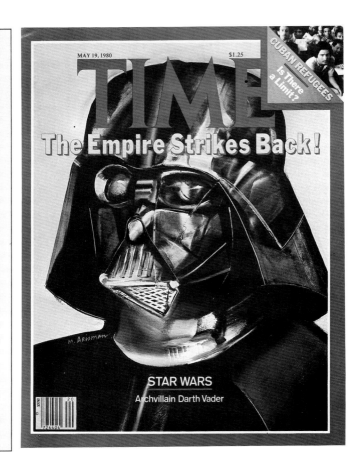

Portrait:
Sacco & Vanzetti
Illustrator:
Julian Allen
New York, NY
Art Director:
Patrick JB Flynn
Publication:
The Progressive

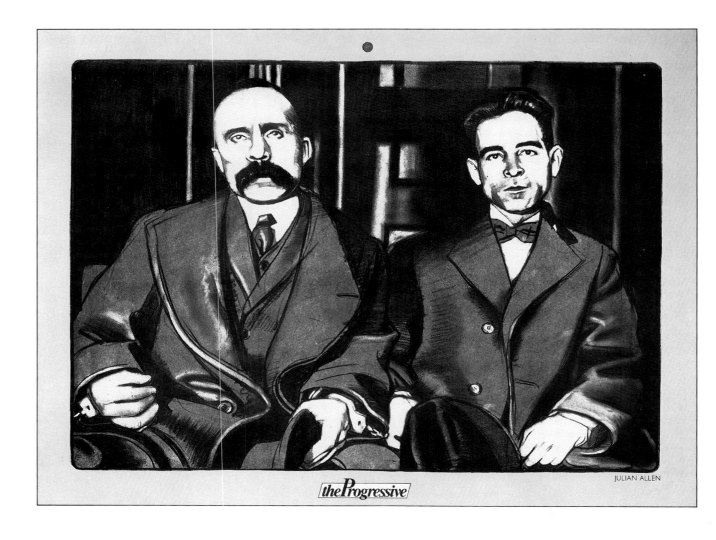

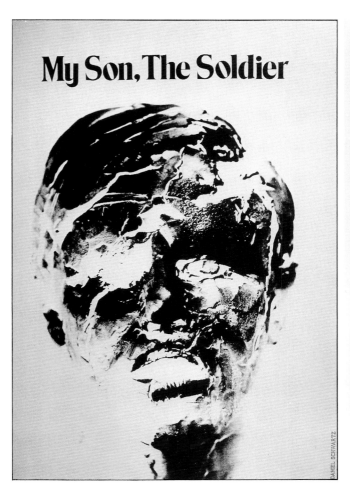

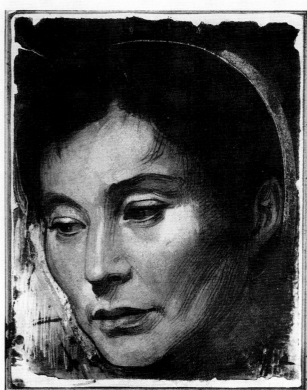

Portrait:
A Soldier
Illustrator:
Daniel Schwartz
New York, NY
Client:
Daniel Schwartz

Portrait:
Yoko Ono
Illustrator:
Daniel Maffia
Englewood, NJ
Art Director:
Robert Best
Publication:
New York

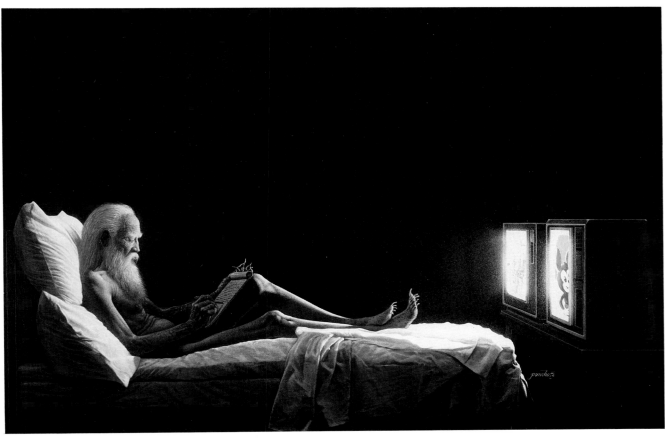

Portrait:
Howard Hughes
Illustrator:
Don Ivan Punchatz
Arlington, TX
Art Director:
Theo Kouvatsos
Publication:
Playboy
Publisher:
Playboy Enterprises, Inc.
November 1984

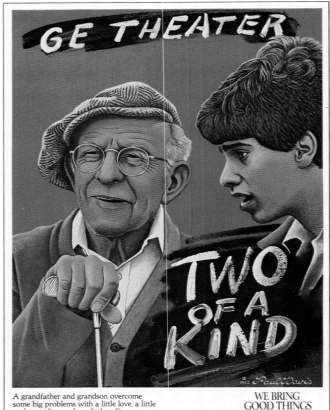

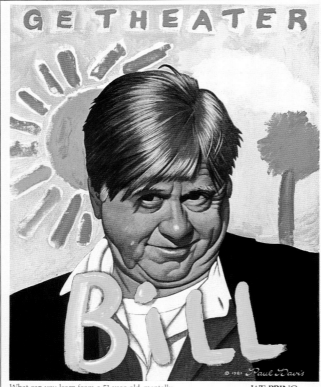

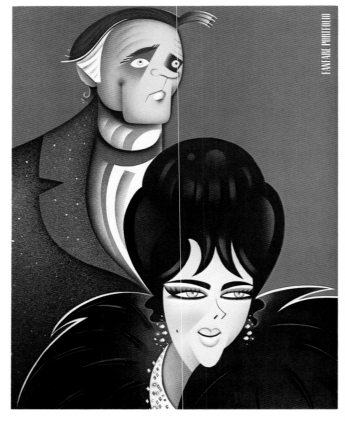

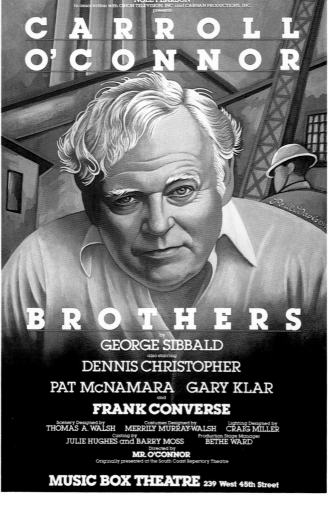

Portrait:
Warren Beatty
Illustrator:
Mike Haggerty
Hollywood, CA
Art Director:
Lloyd Ziff
Publication:
Vanity Fair
Publisher:
The Conde Nast
Publications, Inc.

Portraits:
Robert De Niro
Meryl Streep
Illustrator:
Mick Haggerty
Hollywood, CA
Art Director:
Lloyd Ziff
Publication:
Vanity Fair
Publisher:
The Conde Nast
Publications, Inc.

Portrait:
John Belushi
Illustrator:
Gottfried Helnwein
Vienna, Austria
Art Director:
Derek W. Ungless
Publication:
Rolling Stone

Portrait:
Russian Woman
Illustrator:
Paul Davis
New York, NY
Design Firm:
Paul Davis Studio
Publisher:
Greater New York
Conference on
Soviet Jewry

Portrait:
Don King
Illustrator:
Mark Hess
Katonah, NY
Art Director:
Jim Kiehle
Publication:
Oui

Portrait:
Rumpole of the
Bailey
Illustrator:
Seymour Chwast
New York, NY
Design Firm:
Pushpin Lubalin
Peckolick
Publisher:
Mobil Oil Corp.

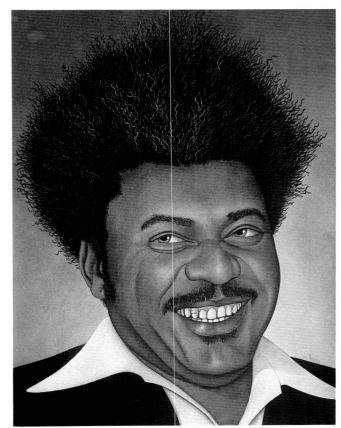
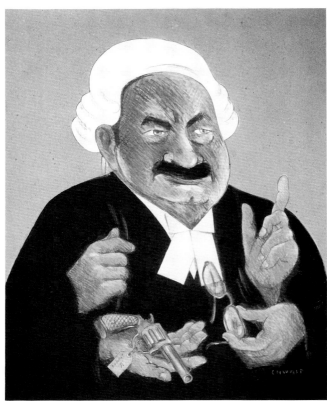

Portrait:
Van Gogh
Illustrator:
Dick Mitchell
Dallas, TX
Design Firm:
Richards Brock Miller
Mitchell & Assoc.
Publisher:
Dallas Society of
Visual Communications

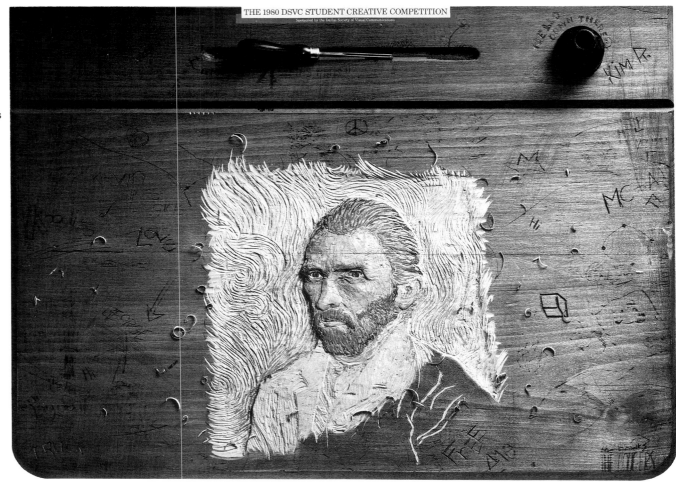

318

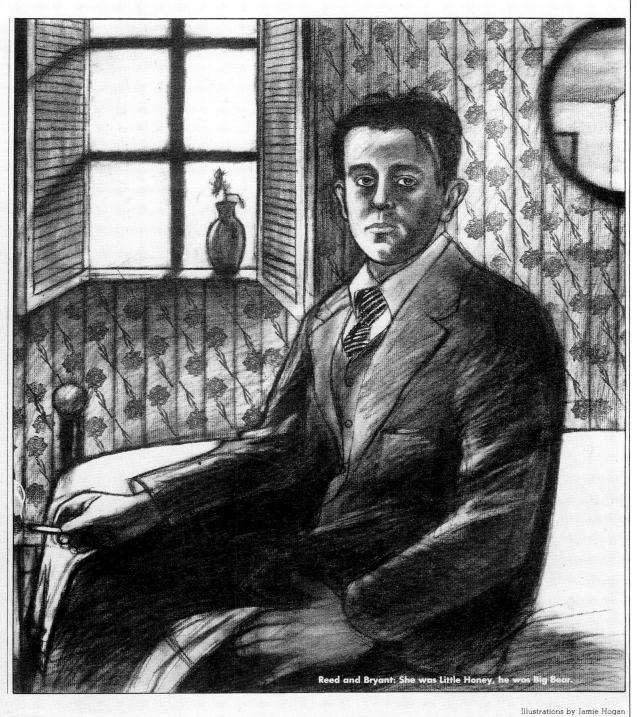

Reed and Bryant: She was Little Honey, he was Big Bear.

Portrait:
John Reed
Illustrator:
Jamie Hogan
Jamaica Plains, MA
Art Director:
Ron Campisi
Publication:
The Boston Globe
Magazine

12

Illustrations by Jamie Hogan

Portrait:
Leonard Crowdog
Illustrator:
Paul Davis
New York, NY
Design Firm:
Paul Davis Studio
Client:
Leonard Crowdog

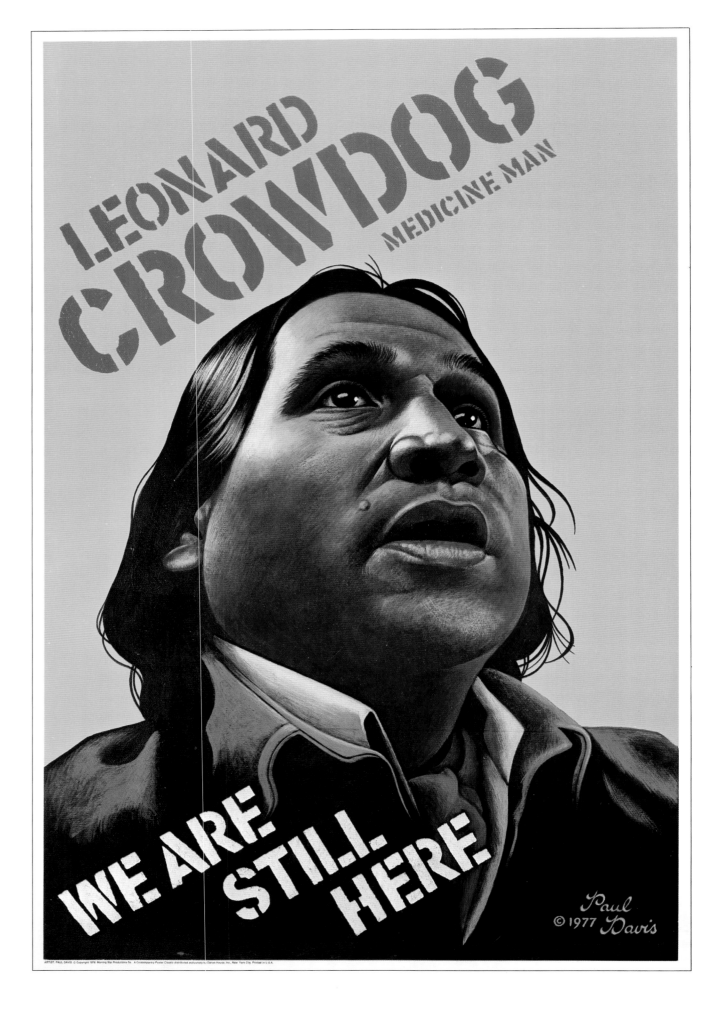

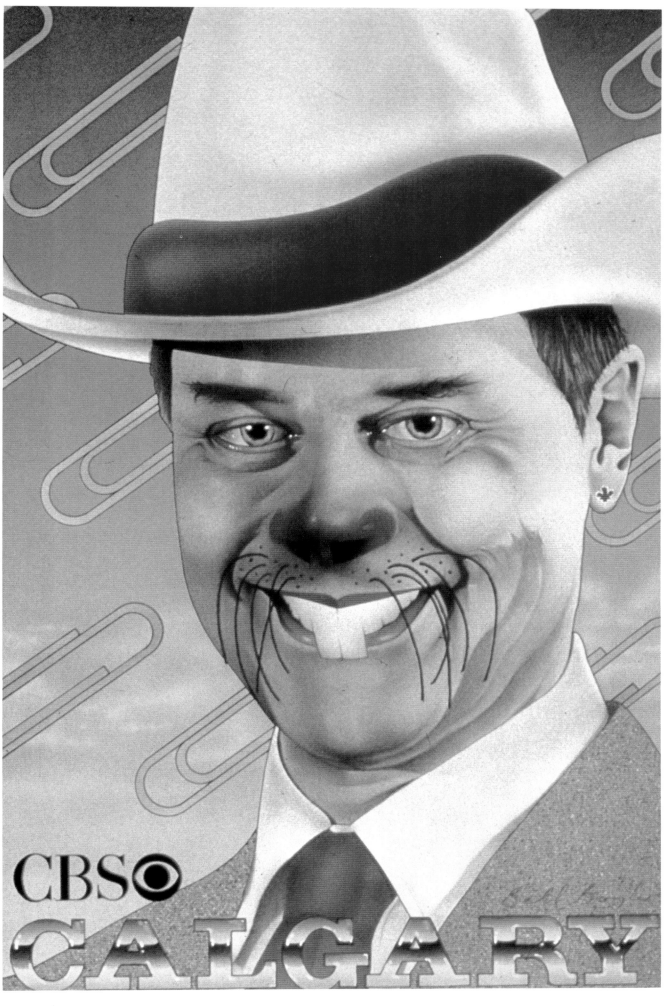

Portrait:
J. R. Beaver
Illustrator:
Bill Boyko
Toronto, CAN
Publication:
Star Week Magazine

COLUMBIA PICTURES PRESENTS A MARTIN RITT-JACK ROLLINS-CHARLES H. JOFFE PRODUCTION
WOODY ALLEN AS **"THE FRONT"** WITH **ZERO MOSTEL**
CO-STARRING HERSCHEL BERNARDI MICHAEL MURPHY WRITTEN BY WALTER BERNSTEIN PRODUCED & DIRECTED BY MARTIN RITT.
EXECUTIVE PRODUCER CHARLES H. JOFFE

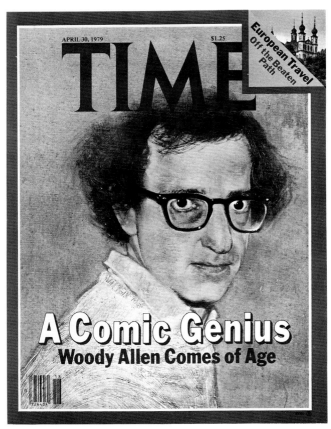

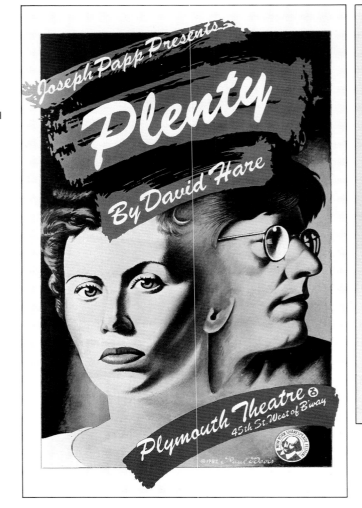

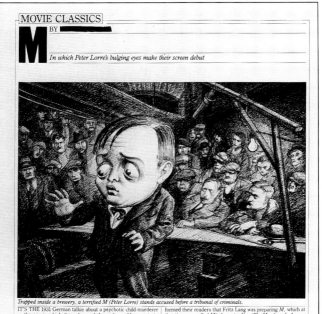

Trapped inside a brewery, a terrified M (Peter Lorre) stands accused before a tribunal of criminals.

IT'S THE 1931 German talkie about a psychotic child-murderer ... the one in which the police and the underworld compete to capture the madman. It's the movie with the ominous camera angles: the camera seems obsessed with geometric patterns and overhead shots, all carefully planned to heighten the sense of impending entrapment. It's the movie that used sound more creatively than ever before ... the movie in which Peter Lorre's bulging eyes made their screen debut ... the movie that remains unsurpassed in its intercutting of scenes. (In one scene, the murderer's use of a broken pocketknife to escape capture is juxtaposed with his pursuers' use of a massive electric drill to enter a building.) It's the movie in which a balloon caught in telephone wires serves as a symbol for the murder of a child ... the movie with the famous bouncing-ball sequence ... the movie in which director Fritz Lang gave full expression to a theme he would return to again and again: the agony of a helplessly trapped victim.

An understandable error: In 1930, Berlin newspapers in-

formed their readers that Fritz Lang was preparing M, which at that time was called Mörder unter Uns (The Murderer Is Among Us). With a screenplay by Thea von Harbou (Lang's wife), it was Lang's first sound film. As soon as this item appeared, Lang began receiving anonymous threats. Undaunted, he went to the Staaken Zeppelinhalle, where the film was to be made, only to be refused admittance. Suddenly he had become the victim in one of his own pictures—persecuted by some mysterious force for no known reason. Bewildered, he confronted the studio's top executive and demanded to know why he was being prevented from making a film based on the crimes of Peter Kürten. (Kürten, a child-murderer known as The Vampire of Düsseldorf, had terrorized that city in the mid-Twenties.) Upon learning what the movie was to be about, the executive smiled and nonchalantly handed Lang the keys to the studio. Lang, noticing the Nazi party insignia on the man's lapel, immediately realized what had happened. The Nazis had assumed from the movie's title that the picture was going to be about them.

ESQUIRE/AUGUST 1980

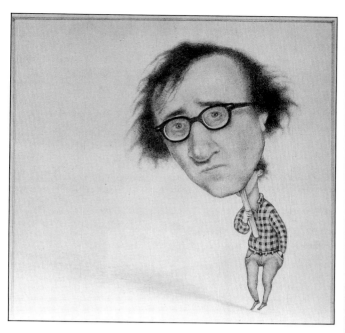

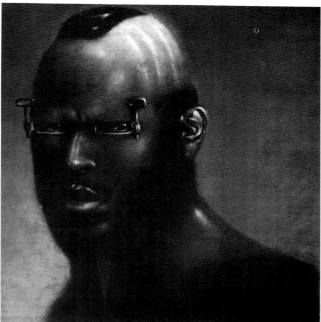

Portrait:
Woody Allen
Illustrator:
Anita Kunz
Toronto, CAN
Art Director:
Louis Fishauf
Publication:
Saturday Night

Portrait:
Mr. T.
Illustrator:
Brad Holland
New York, NY
Art Director:
Tom Staebler
Publication:
Playboy
Publisher:
Playboy Enterprises, Inc.
September 1983

". . . A week after having his life kicked apart, Clay awoke on a Caribbean island with a shudder. 'I realize how fragile my life is' . . ."

Portrait:
Pat Paulsen
Illustrator:
John O'Leary
Philadelphia, PA
Art Director:
Bob Warkulwiz
Design Firm:
Carlyle & Warkulwiz
Client:
INA

Portrait:
Clay Felker
Illustrator:
Julian Allen
New York, NY
Art Director:
Roger Black
Publication:
Rolling Stone

MONET

1840-1926 GIVERNY

324

MOBIL PRESENTS
LAURENCE OLIVIER'S

KING LEAR
STARRING LAURENCE OLIVIER

Colin Blakely Anna Calder-Marshall John Hurt Jeremy Kemp Robert Lang
Robert Lindsay Leo McKern Diana Rigg David Threlfall Dorothy Tutin

Host: Peter Ustinov
Wednesday, January 25
8:00-11:00 PM WNEW-TV Channel 5

**Mobil
Showcase
Network**

Available in paperback from Penguin Books ⓟ Recommended by the National Education Association Closed captioned for the hearing impaired

Portrait:
Donald Duck
Illustrator:
Gottfried Helnwein
Vienna, Austria
Art Director:
Derek W. Ungless
Publication:
Rolling Stone

Happy 50th Birthday, Donald

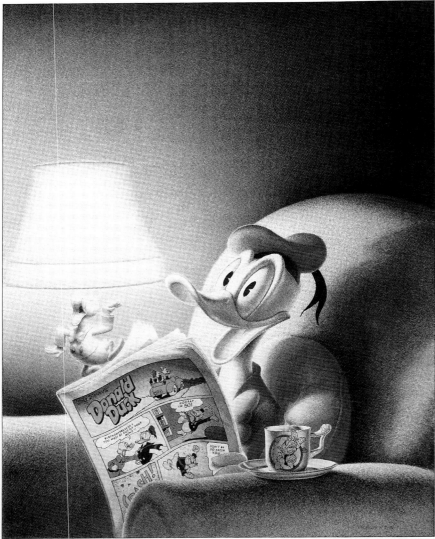

PAINTING BY GOTTFRIED HELNWEIN

'People could really relate to Donald. He was much more emotional than Mickey or Pluto. He would lose his temper, fly off the handle. Everybody, at some time or another, would like to release their emotions like Donald did.'

– BILL JUSTICE, *one of Donald Duck's main illustrators since 1937*

SUMMER '84

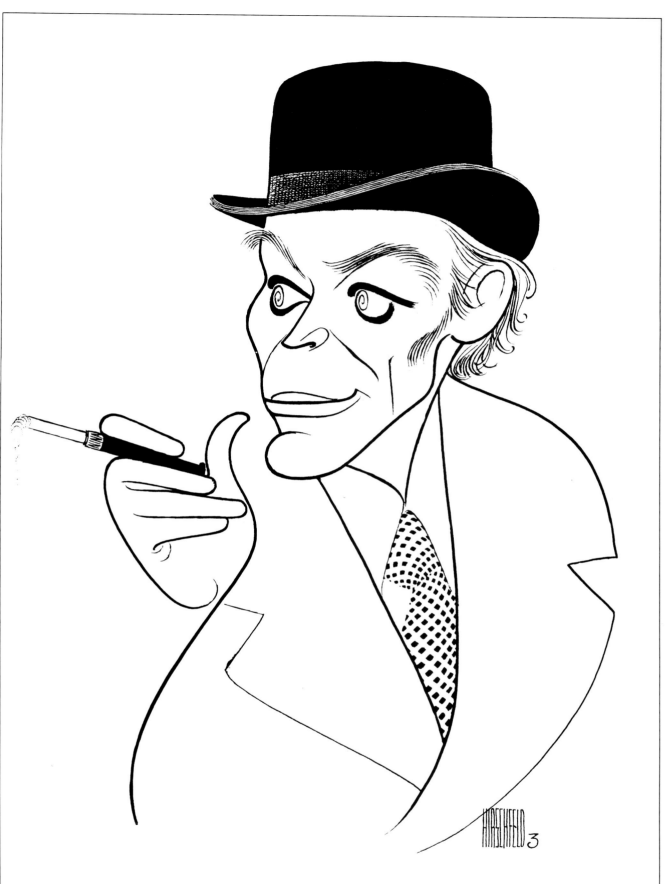

Portrait:
Peter O'Toole
Illustrator:
Al Hirschfeld
New York, NY
Art Directors:
Tom Staebler
Kerig Pope
Publication:
Playboy
Publisher:
Playboy Enterprises, Inc.
August 1982

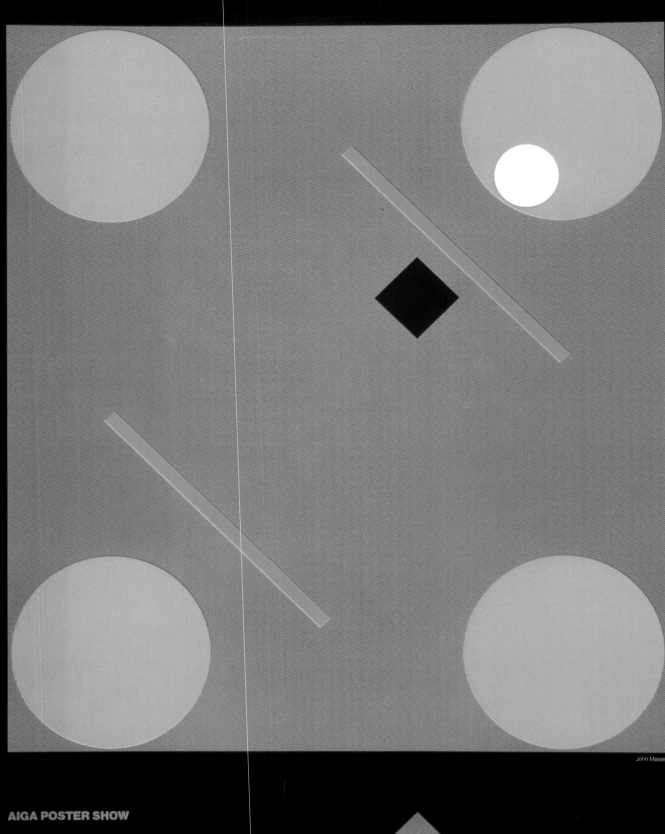

AIGA POSTER SHOW

John Massey

CALL FOR ENTRIES

The Poster Show:
A Five-Year Retrospective

Today, it is injudicious to compare the contemporary poster in relation to the past. Although the function remains constant, the prerequisites are quite different—as are the outlets. The technology has changed, the viewer's perceptions have been altered, and the poster has been adapted to the Eighties.

Call for Entry:
The Poster Show
Designer:
John Massey
Typographer:
RyderTypes
Printer:
Rohner Printing Co.
Paper:
Mead Paper Co.
Binder:
Advertisers Bindery
Production:
Goldsmith Yamasaki
Specht, Inc.

Chairman
John Massey
President
John Massey, Inc.

Jury
Stephen Frykholm
Creative Director
Herman Miller, Inc.

Marjorie Katz
President
Marjorie Katz Design

Tomoko Miho
Principal
Tomoko Miho Co.

Woody Pirtle
President
Woody Pirtle, Inc.

The American poster today is fighting for space on a visually polluted landscape. The electronic media —television, video, even "spectacolor"—are replacing it as popular selling tools. The poster's traditional outlets are fewer and new ones are slow in coming—and when they do, the results are not always so satisfying. For instance, luminated bus stalls—the kiosks of the Eighties—are *tabula rasas* offering excellent visibility, which should inspire better work than is being done at this moment.

Is the poster in big trouble? The Chicken Littles among us say that the quality is falling. The sages say that the form is evolving; hence, changes result which need getting used to. Yet, in the end, not all the changes are for the best.

The most ubiquitous, though not necessarily the most aesthetically pleasing posters today are the graphic equivalents of the 10-second T.V. spot. They are immediately eyegrabbing on billboards, bus sidings, and construction sites, selling all manner of goods, food and entertainment. Some are, indeed, well done, but most, as evidenced by what is on the street, are as bad as the commercials they emulate. Ironically, the subjects that traditionally lend themselves best to inventive poster art—theatre and film, among others—are generally designed by committees and look it. In fact, they have been replaced by more esoteric themes or messages. Cultural events and various design-rooted industries —including fashion and furniture— have been the sources for alluring posters. A high percentage of experimental designs emerge from here. Oddly, many contemporary posters are not made to be posted at all, but, rather, are conceived as oversized mailers—modern-day proclamations—invitations and announcements. These are often high-gloss productions, with emphasis on the gloss. Those without directorial constraints can be beautiful, while those with constraints often suffer. This show surveys the best of the varied approaches from the past five years. That there are many surprises herein is its strength, although there are some questionable choices. However, if this exhibit accomplishes nothing else, it clearly supports the notion that changes in popular perception stemming from the recent media revolution have markedly affected the substance and form of poster design, as well as the practitioner's vocabulary—both for better and for worse.

That this competition had the largest number of posters ever submitted (3000) and the fewest number selected (87) suggests, at first, a qualitative decline. However, according to the jurors, the contrary is true. As an entity, the show, as viewed by its selectors, is "electric." Says John Massey, the chairman: "When you look at a graphic work—whether a poster, a package or a page—it's conceived to solve a problem. When it does so well, it's considered a success. But when it lives beyond its immediate purpose, then it has an extra dimension—I call it *electricity*." The work here suggests that diversity was also a major virtue. "I don't think there are more than two of any one approach," continues Massey. "Moreover, most are intelligent, rather than clichéd, responses to difficult problems. As a jury, we were pleased to see such abundance."

Amidst the relatively small number of inclusions, illustration and type design are favored forms, and there is minimal use of photography. There are a fair number of consistently good, veteran poster artists represented once again, and quite a few designers were selected for the first time, yet some familiar names (particularly illustrators) present in the last show are absent, or have a poor showing in this one. Has the work of these consistently good practitioners become too familiar, or has their output not substantively grown in the past five years? Was this jury disposed to elevating new *stars*, or were the old ones simply not bright enough? While highly visible or long-running posters competing in a show of this chronological scope run the risk of being eschewed as too familiar, which is unfair, the stalwarts of poster design also, as a rule, are scrutinized more harshly, which is just. In this case, those rejected did not live up to their own high levels.

That this show has a serendipity is the result of some governing biases, including: a nostalgic appreciation for the Golden Age of poster art; an aversion to the overproduced; a proclivity for things big; and a knowledge—perhaps an *overfamiliarity*—with what has been done recently in poster design. While personal preference enters into the above, some objective tenets of poster design were also applied: A good poster must be designed as a poster and not simply be a blowup; it must economically and succinctly convey a message; and it must be pleasing to the senses, yet attention-grabbing.

"We unanimously rejected poster caricatures," says Massey, "the so-called poster/announcement in which a painting or other image was simply enlarged without regard for the poster form." Also eliminated were those images employing overdone techniques (such as slick and shiny airbrushing), and overused, and now contrived, styles (such as postmodernist and punk). Obviously, the prerequisites for inclusion were tough, yet a curious phenomenon took place in the decision-making process.

A clear definition of the *modern* poster emerged which mitigated against a parochial ideal of beauty or orthodox view of problem solving. Catholicity underscores the modern poster. Today, it is injudicious to compare the contemporary poster in relation to the past. Although the function remains constant, the prerequisites are quite different—as are the outlets. The technology has changed, the viewer's perceptions have been altered, and the poster has been adapted to the Eighties. As evidenced here, though, adaptation does not mean conformity, for some very inventive approaches have been added to the melting pot of American design.

Therefore, it is even more surprising that no significant trends emerged. "While many New Wave posters were submitted," says Massey, "they didn't surface as the best work." No doubt, in part, due to the fact that the overriding definition of the *best* is those with 'lasting integrity.' The inclusion of numerous black-and-white and two-color posters also adds to the serendipity of the show. In the past, extravagant color was king; now, megaproductions are out and simplicity is in. As Massey states: "It is not just simplicity, but *spontaneity* that makes the difference." Also of note is the fact that, when derivation was evident, it was not penalized when used to solve a problem well.

In the end, the rejects say as much about the field as the show itself does. For there is, as stated in many other essays about many other shows, a high percentage of very competent, well-executed work being produced today. However, a lot of production and conceptual gymnastics are tried simply to wrest attention from the aforementioned media. Like television computer graphics, though, these are *only* tricks when content and craft are secondary. And with the highly advanced modes of technology available today, glitz is often the primary result. Since this is not a trade show, few if any of the "state of the art" technics are visible here. Chosen are only those the jury deemed to be excellent according to their strict precepts. Some viewers will rightfully question the rationale behind inclusion of some of the work here, but the show itself indicates, decidedly, that the poster is not in grave trouble, that its best practitioners are applying both classical and inventive approaches, and that it is apace with the changing times.

Poster:
The Zoo Comes to You
Designer:
Terrence Zacharko
Edmonton, CAN
Design Firm:
Zacharko Design
Client:
Alberta Art Foundation
Typographer:
Contempratype
Printer:
Europe Offset
Dimensions:
18″ × 23″

Poster:
Endangered
Art Director:
The Graphic Workshop
Designer:
Agusta Agustsson
Boston, MA
Design Firm:
The Graphic Workshop
Publisher:
The Graphic Workshop
Letterer:
Agusta Agustsson
Printer:
The Graphic Workshop
Dimensions:
29″ × 39″

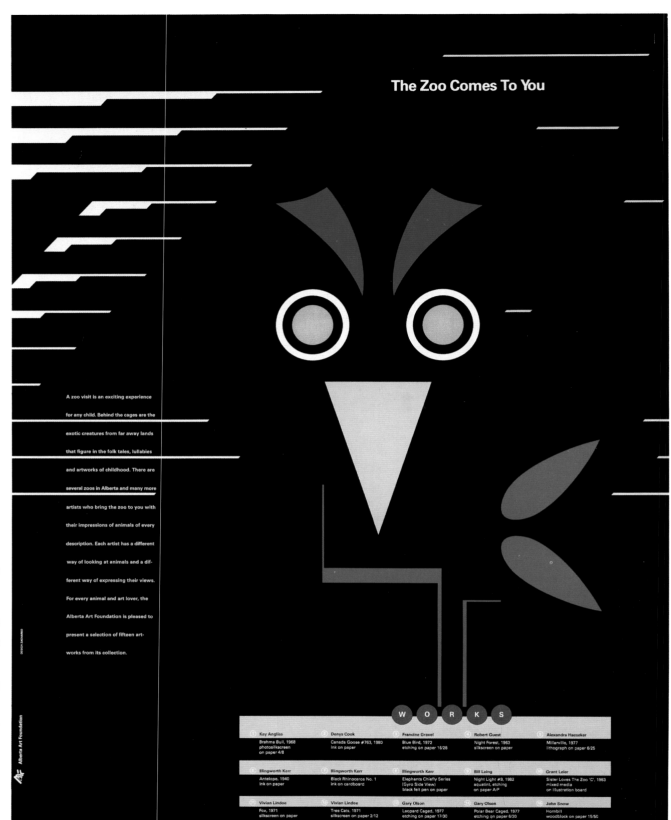

The Zoo Comes To You

A zoo visit is an exciting experience for any child. Behind the cages are the exotic creatures from far away lands that figure in the folk tales, lullabies and artworks of childhood. There are several zoos in Alberta and many more artists who bring the zoo to you with their impressions of animals of every description. Each artist has a different way of looking at animals and a different way of expressing their views. For every animal and art lover, the Alberta Art Foundation is pleased to present a selection of fifteen artworks from its collection.

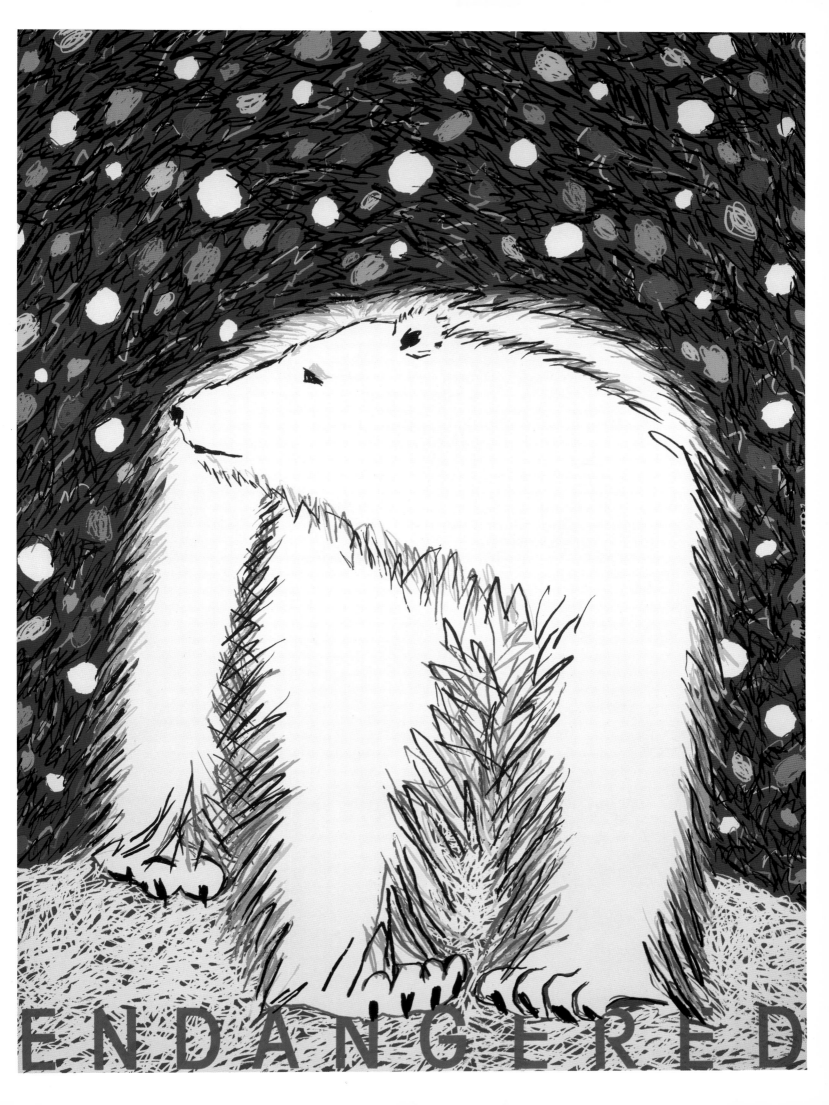

ENDANGERED

Poster:
Hampton Classic
Art Director:
Tony Hitchcock
Designer/Illustrator:
James McMullan
New York, NY
Design Firm:
Visible Studio, Inc.
Client:
Hampton Classic
Horse Show
Letterer:
James McMullan
Printer:
Rally Graphics
Dimensions:
30" × 26"

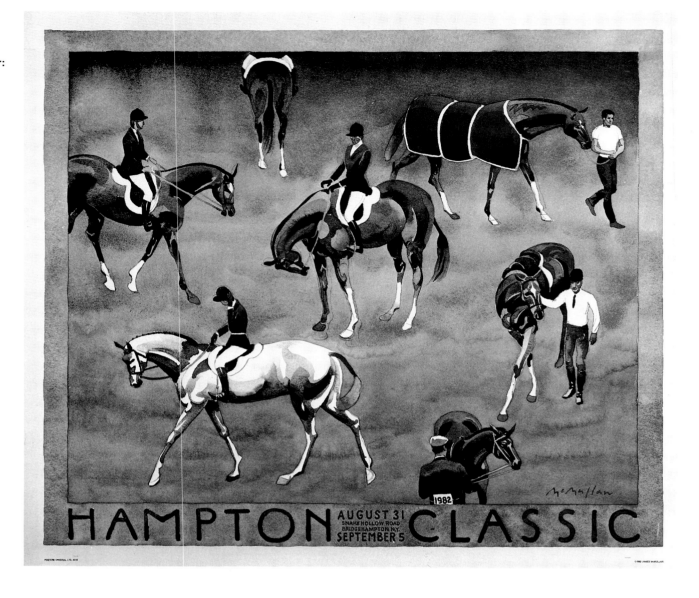

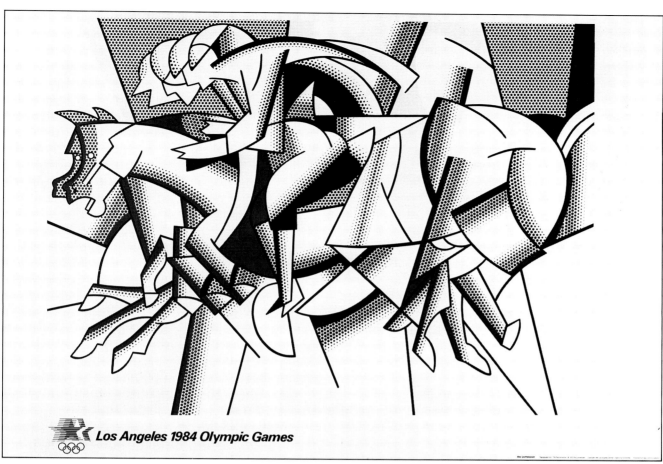

Los Angeles 1984 Olympic Games

Poster:
Los Angeles 1984
Olympic Games
Designer:
Knapp Communications
Artist:
Roy Lichtenstein
New York, NY
Client:
Wilshire Marketing
Printer:
Alan Lithograph, Inc.
Dimensions:
24″ × 36″

Poster:
Hampton Classic
Designer:
Richard Mantel
New York, NY
Design Firm:
Richard Mantel, Inc.
Client:
Hampton Classic
Typographer:
Haber Typographers
Dimensions:
24″ × 33″

L'HISTOIRE DU SOLDAT
IGOR STRAVINSKY
CONCERTO FOR CONTEMPORARY VIOLIN
PAUL HOFFERT

PAUL HOFFERT, CONDUCTOR STEVEN STARYK, VIOLIN

Available on ultraFi Records & Tapes.

SON Records Limited, 144 Front Street West, Toronto, Ontario, Canada M5J 1G2 Sole Qua Non Productions, 25 Mill Street, Providence, Rhode Island, 02904 U.S.A.
Printed in Canada • Imprimé au Canada

Poster:
Igor Stravinsky/
Paul Hoffert
Art Director/Designer:
Heather Cooper
Toronto, CAN
Artist:
Heather Cooper
Design Firm:
Burns, Cooper,
Hynes, Ltd.
Client:
SON Records
Typographer:
Cooper & Beatty, Ltd.
Printer:
Herzig Somerville, Ltd.
Dimensions:
22″ × 28″

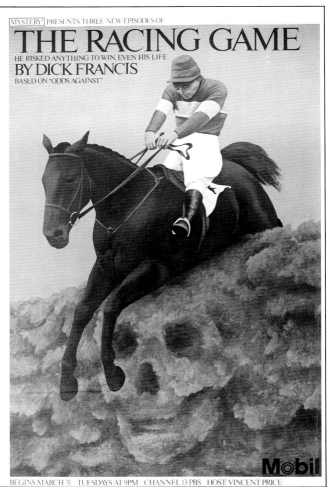

Poster:
San Diego Jazz Festival
Art Director/Designer:
Milton Glaser
New York, NY
Artist:
Milton Glaser
Design Firm:
Milton Glaser, Inc.
Client:
San Diego Jazz Festival
Calligrapher:
Milton Glaser
Printer:
Metropolitan Printing
Dimensions:
24″ × 36″

Poster:
Voyager 1 at Saturn 1980
Art Director:
Josh Young
Designer:
Dave Fischer
Tucson, AZ
Photographer:
NASA
Publisher:
University of Arizona
Graphics Dept.
Typographer:
Tucson Typographic
Services
Printer:
Isbell Printing Co.
Dimensions:
23″ × 37″

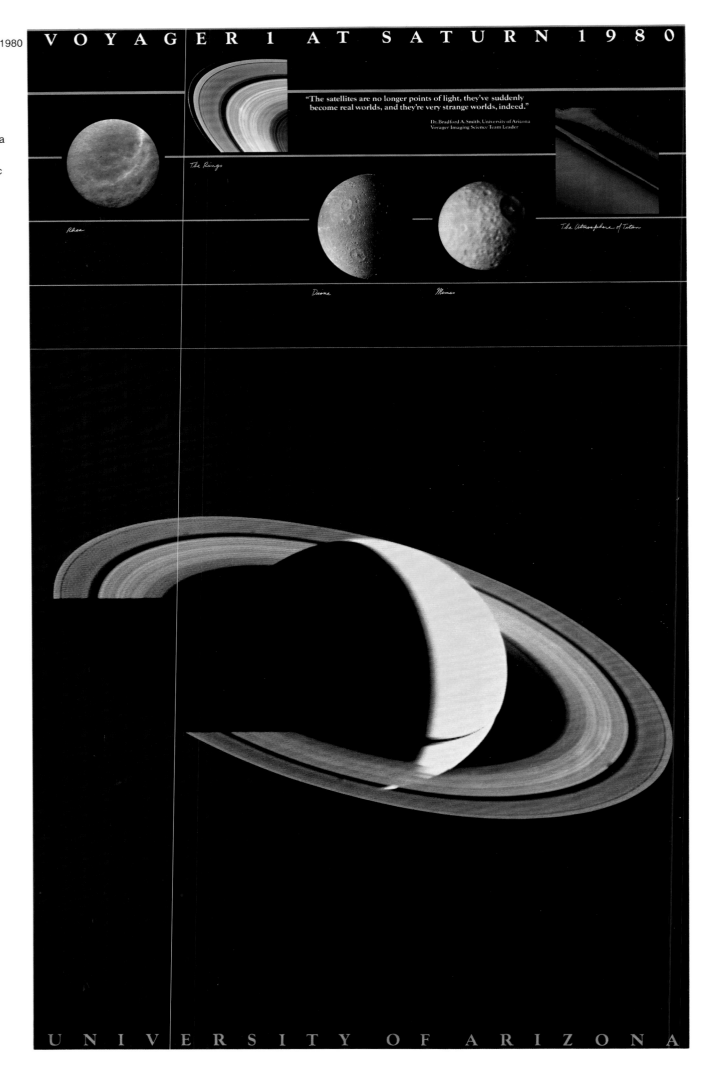

VOYAGER 1 AT SATURN 1980

"The satellites are no longer points of light, they've suddenly become real worlds, and they're very strange worlds, indeed."

Dr. Bradford A. Smith, University of Arizona
Voyager Imaging Science Team Leader

The Rings

Rhea

The Atmosphere of Titan

Dione

Mimas

UNIVERSITY OF ARIZONA

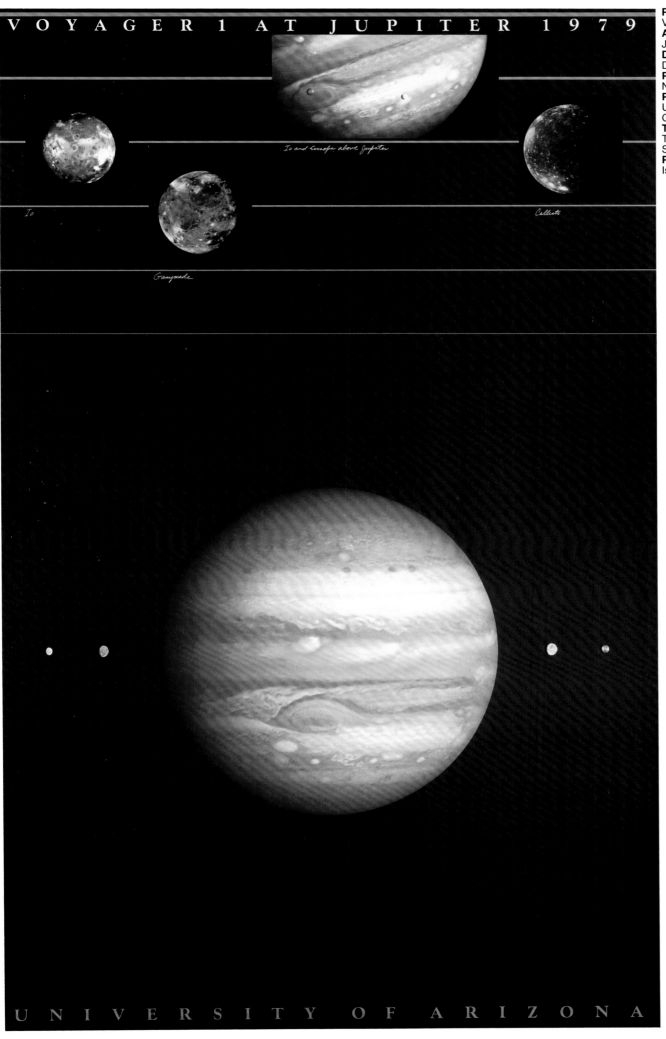

VOYAGER 1 AT JUPITER 1979

Io

Ganymede

Io and Europa above Jupiter

Callisto

UNIVERSITY OF ARIZONA

Poster:
Voyager 1 at Jupiter 1979
Art Director:
Josh Young
Designer:
Dave Fischer
Photographer:
NASA
Publisher:
University of Arizona
Graphics Dept.
Typographer:
Tucson Typographic
Services
Printer:
Isbell Printing Co.

Poster:
Dallas Museum of Art
Art Director/Designer:
Woody Pirtle
Dallas, TX
Artist:
Claes Oldenburg
Design Firm:
Pirtle Design
Client:
Dallas Museum of Art
Typographer:
Southwestern
Typographics
Printer:
Brodnax Printing
Dimensions:
25″ × 39″

Poster:
Matrix
Designer:
Marianne Tombaugh
Dallas, TX
Design Firm:
Cunningham & Walsh/
Dallas
Publisher:
Women in
Communications, Inc.
Letterer:
Marianne Tombaugh
Printer:
Brodnax Printing Co.
Dimensions:
22″ × 31″

Poster:
HBF: Hickory Business
Furniture
The New Tradition
Art Director/Designer:
Michael Vanderbyl
San Francisco, CA
Artist:
Michael Vanderbyl
Design Firm:
Vanderbyl Design
Client:
Hickory Business
Furniture, Co.
Printer:
Dimensions 3
Dimensions:
24″ × 30″

Poster:
A Color System for
Systems Furniture
Art Director/Designer:
Barbara Loveland
Zeeland, MI
Photographer:
Effective Images
Design Firm:
Corporate
Communications Design
& Development
Client:
Herman Miller, Inc.
Printer:
Burch Printers, Inc.
Dimensions:
12″ × 27″

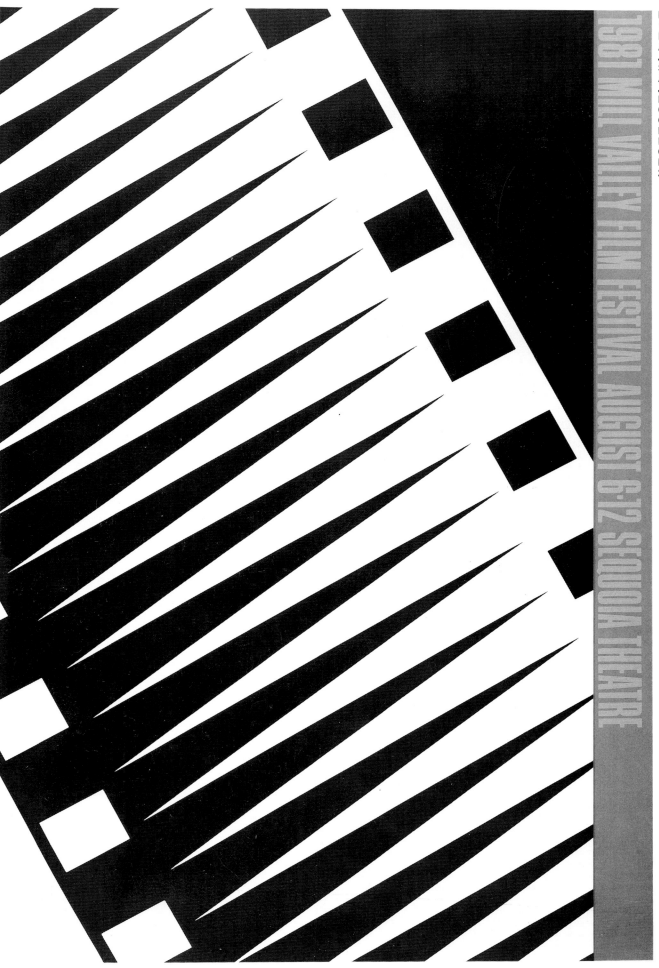

Poster:
1981 Mill Valley
Film Festival
Art Director/Designer:
John Casado
San Francisco, CA
Artist:
John Casado
Design Firm:
Casado Design
Client:
Mill Valley Film Festival
Printer:
Clyde Engle
Dimensions:
24″ × 36″

1981 MILL VALLEY FILM FESTIVAL AUGUST 6-12 SEQUOIA THEATRE

Poster:
1982 Mill Valley
Film Festival
Art Director/Designer:
John Casado
San Francisco, CA
Artist:
John Casado
Design Firm:
Casado Design
Client:
Mill Valley Film Festival
Printer:
Pischoff Signage Co.
Dimensions:
24″ × 36″

Poster:
1983 Mill Valley
Film Festival
Art Director/Designer:
John Casado
San Francisco, CA
Artist:
John Casado
Design Firm:
Casado Design
Client:
Mill Valley Film Festival
Typographer:
Display Lettering & Copy
Printer:
Pischoff Signage Co.
Dimensions:
22½″ × 38″

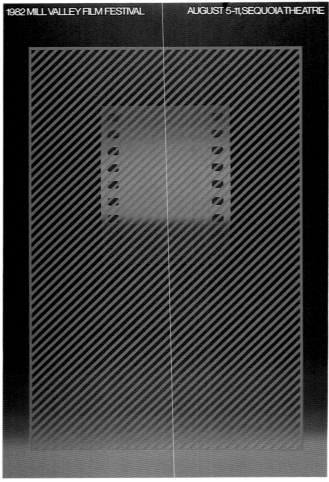

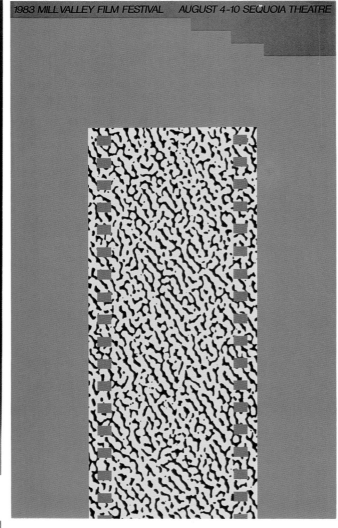

Poster:
1980 Mill Valley
Film Festival
Art Director/Designer:
John Casado
San Francisco, CA
Artist
John Casado
Design Firm:
Casado Design
Client:
Mill Valley Film Festival
Printers:
California Printing
Clyde Engle
Dimensions:
24″ × 36″

Poster:
1984 Mill Valley
Film Festival
Art Director/Designer:
John Casado
San Francisco, CA
Artist:
John Casado
Design Firm:
Casado Design
Client:
Mill Valley Film Festival
Typographer:
Display Lettering & Copy
Printer:
Seriphics
Dimensions:
24″ × 36″

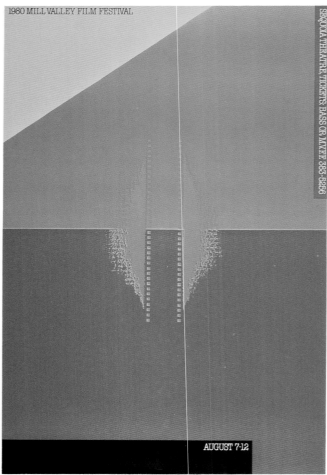

Poster:
Cousin Bette
Art Director/Designer:
Ivan Chermayeff
New York, NY
Artist:
Ivan Chermayeff
Design Firm:
Chermayeff &
Geismar Assoc.
Client:
Mobil Corp.
Typographer:
Pastore DePamphilis
Rampone
Printer:
Crafton Graphic Co., Inc.
Dimensions:
30″ × 46″

Poster:
National Offshore
Powerboat
Art Director/Designer:
Stephen Frykholm
Zeeland, MI
Design Firm:
Phillips & Frykholm
Client:
Ocean Promotion
Typographer:
Typehouse St. Joseph
Printer:
Continental Identification
Products
Dimensions:
39½″ × 25″

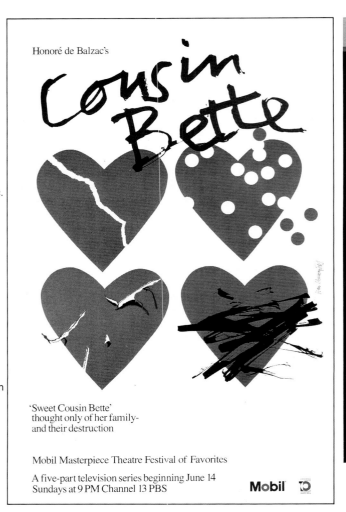

Poster:
Hot Seat: Knoll
Art Director/Designer:
Woody Pirtle
Dallas, TX
Artist:
Woody Pirtle
Design Firm:
Pirtle Design
Client:
Knoll International
Typographer:
Southwestern
Typographics
Printer:
Harvey DuPriest
Dimensions:
23″ × 35

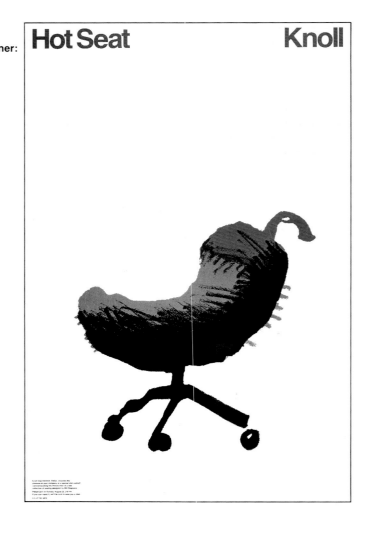

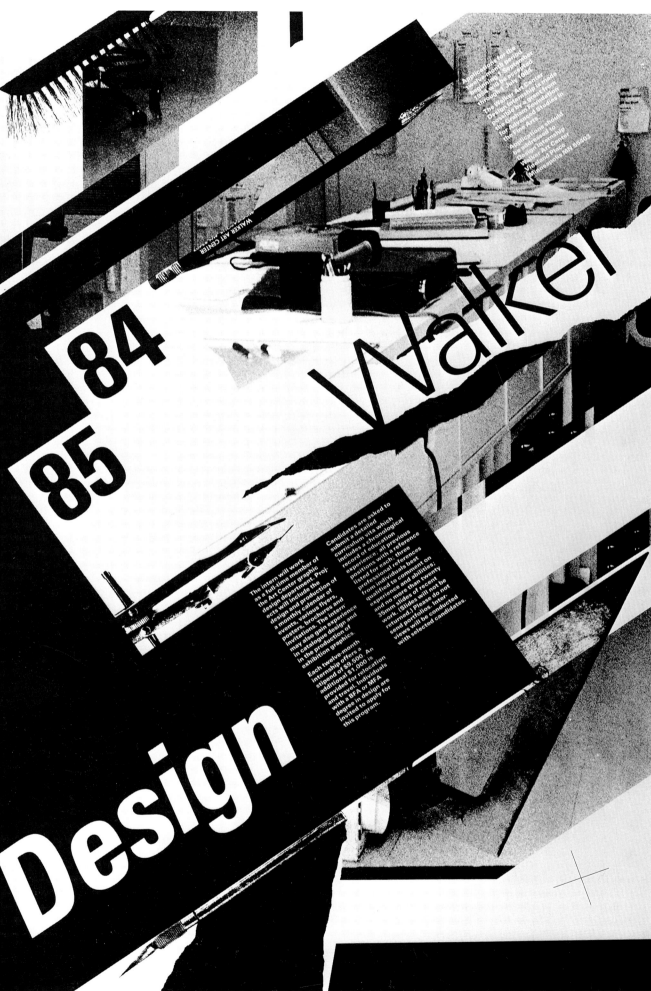

Poster:
84/85 Walker Design
Art Director:
Robert Jensen
Designer:
Lorene Lee
Minneapolis, MN
Design Firm:
Walker Art Center
Client:
Walker Art Center
Typographer:
Julie Condecon
Printer:
Northstar Printing Co.
Dimensions:
23″ × 35″

HOUSE & GARDEN

VIEW FROM THE HOUSE OF SCULPTOR JUAN HAMILTON, ABIQUIU, NEW MEXICO • PHOTOGRAPHED BY SHEILA METZNER • DESIGNED BY LLOYD ZIFF • COPYRIGHT CONDÉ NAST PUBLICATIONS INC.

Poster:
House & Garden
The View from Abiquiu
Designer:
Lloyd Ziff
New York, NY
Photographer:
Sheila Metzner
Publisher:
The Condé Nast
Publications, Inc.
Dimensions:
25″ × 34″

Poster:
Boston Waterfront
Art Director/Designer:
John Massey
Chicago, IL
Design Firm:
John Massey, Inc.
Client:
Boston Society of
Architects
Typographer:
Ryder Types
Printer:
Accurate Silk Screen Co.
Dimensions:
32″ × 50″

Boston Waterfront

Citation recipient of the
Boston Society of Architects
First Annual Urban Design Citation
1980

Design John Massey Container Corporation of America

Poster:
Double Shakespeare
Art Director/Designer:
Woody Pirtle
Dallas, TX
Artist:
Mike Schroeder
Design Firm:
Pirtle Design
Client:
Shakespeare Festival
of Dallas
Typographer:
Southwestern
Typographics
Printer:
Williamson Printing
Dimensions:
22⅛″ × 30″

Double Shakespeare

Double Shakespeare

The Shakespeare Festival of Dallas Presents
King Henry V
In Repertory August 3-19. 1984
Band Shell. Fair Park
Gates Open 7:15 p.m.
Curtain 8:15 p.m.
Admission Free
No Performance Mondays

THE ALDER MARKET

& CATERING COMPANY

151 West Alder Street Stockton, California

Poster:
The Alder Market
& Catering Company
Designer:
Michelle Manos
Stockton, CA
Design Firm:
Michelle Manos, Inc.
Client:
The Alder Market &
Catering Company
Typographer:
Ad Type Graphics
Printers:
Fruitridge Printing
DeCrevel, Apex Die
Dimensions:
24″ × 26″

Poster:
Pitts Special S-1S
Art Director:
Barry Deutsch
Designer:
Piper Murakami
San Francisco, CA
Artist:
Ivan Clede
Design Firm:
Steinhilber Deutsch &
Gard
Client:
Christen Industries
Typographer:
Headliners/Identicolor
Printer:
San Rafael Graphics
Dimensions:
31½" × 23"

Poster:
Tulip Time '83
Art Director/Designer:
Stephen Frykholm
Zeeland, MI
Design Firm:
Herman Miller, Inc.
Client:
Tulip Time, Inc.
Printer:
Continental Identification
Products
Dimensions:
39½" × 25"

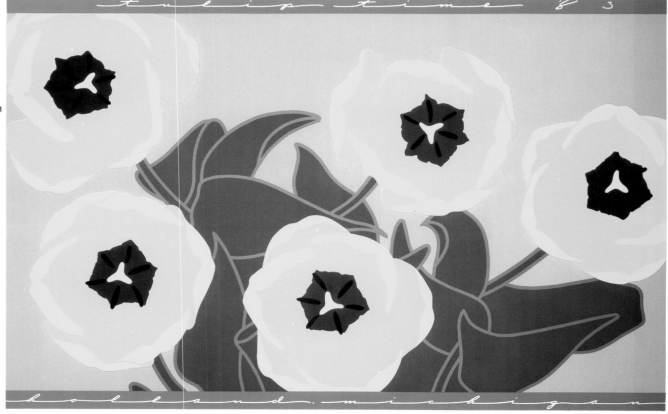

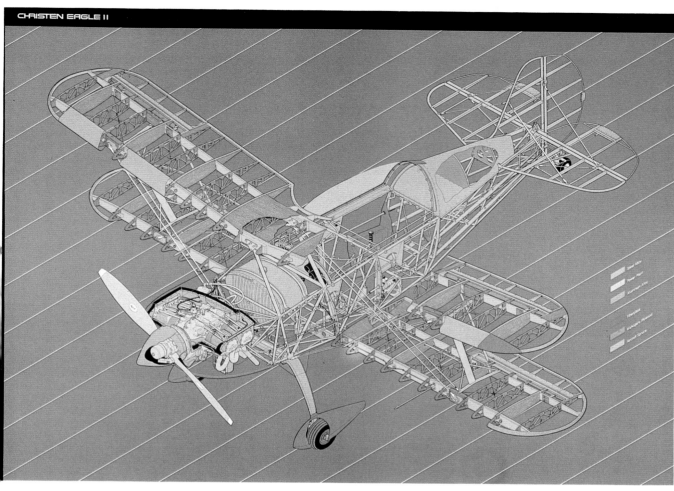

CHRISTEN EAGLE II

Poster:
Christen Eagle II
Art Director:
Barry Deutsch
Designers:
Myland McRevey, Karen Tainaka
San Francisco, CA
Artist:
Ivan Clede
Design Firm:
Steinhilber Deutsch & Gard
Client:
Christen Industries
Typographer:
Headliners/Identicolor
Printer:
Pacific Lithography
Dimensions:
31½" × 23"

Poster:
Tulip Time 1982
Art Director/Designer:
Stephen Frykholm
Zeeland, MI
Design Firm:
Herman Miller, Inc.
Client:
Tulip Time, Inc.
Printer:
Continental Indentification Products
Dimensions:
39½" × 25"

Poster:
Houston: A Celebration
of Architecture
Art Director:
Woody Pirtle
Designers:
Alan Colvin,
Woody Pirtle
Dallas, TX
Photographers:
Joe Baraban,
Arthur Meyerson
Design Firm:
Pirtle Design
Client:
Houston Institute of
Architects
Typographer:
Southwestern
Typographics
Printer:
Heritage Press
Dimensions:
24″ × 36″

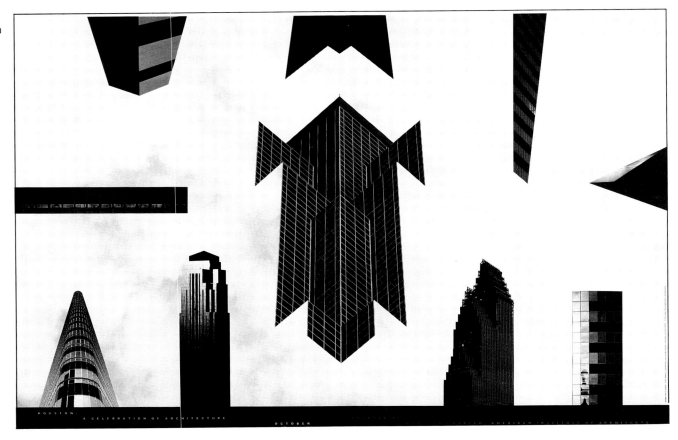

Poster:
Innovative Furniture
in America
**Art Directors/
Designers:**
Stephen Frykholm,
Barbara Loveland
Zeeland, MI
Design Firm:
Corporate
Communications Design
& Development
Client:
Herman Miller, Inc.
Printer:
Continental Identification
Products
Dimensions:
25″ × 39½″

The Writer's
New York
City
Source
Book

City of New York
Edward I. Koch, Mayor
Department of Cultural Affairs
Henry Geldzahler, Commissioner
Arts Apprenticeship Program

Poster:
The Writer's New York
City Source Book
Art Director:
Toshiaki Ide
Designer:
Seymour Chwast
New York, NY
Design Firm:
Pushpin Lubalin Peckolick
Publisher:
New York City Department
of Cultural Affairs
Typographer:
Toshiaki Ide
Printer:
Collier Graphic Services
Dimensions:
25½″ × 39½″

Poster:
The New Yorker
Designer:
R. O. Blechman
New York, NY
Design Firm:
R. O. Blechman, Inc.
Publisher:
Municipal Arts Society
Printer:
MacNaughton
Lithograph Co.
Dimensions:
42⅛″ × 29″

Poster:
XIV Olympic
Winter Games
Art Director/Designer:
Milton Glaser
New York, NY
Design Firm:
Milton Glaser, Inc.
Publisher:
Proscenium, Inc.
Typographer:
IGI/Innovative Graphics
International
Dimensions:
24″ × 36″

XIV OLYMPIC WINTER GAMES SARAJEVO 1984 YUGOSLAVIA

Poster:
Clank, Bang, Boom
Design Director:
John Massey
Designer:
Joseph Hutchcroft
Chicago, IL
Photographer:
Ron Seymoure
Design Firm:
Container Corporation
of America
Publisher:
Container Corporation
of America
Typographer:
Ryder Types
Printer:
Accurate Silkscreen Co.
Dimensions:
30″ × 46″

Poster:
A.M.
Art Director:
Woody Pirtle
Designers:
Woody Pirtle,
Mike Schroeder
Dallas, TX
Photographer:
Arthur Meyerson
Design Firm:
Pirtle Design
Client:
Arthur Meyerson
Photography
Letterer:
Mike Schroeder
Printer:
Brodnax Printing
Dimensions:
22″ × 32″

Poster:
Art in Los Angeles
Art Director/Designer:
April Greiman
Los Angeles, CA
Design Firm:
April Greiman, Inc.
Publisher:
Los Angeles County
Museum of Art
Typographer:
RS Typographics
Printer:
Alan Lithograph Co.
Dimensions:
21½″ × 34″

Poster:
The Best of Jazz
Art Director:
Paula Scher
Designer:
Paula Scher
New York, NY
Design Firm:
CBS Records Design
Dept.
Publisher:
CBS Records
Typographer:
Haber Typographers
Printer:
Peter Dreyfuss/
Atwater Press
Dimensions:
26¼″ × 35″

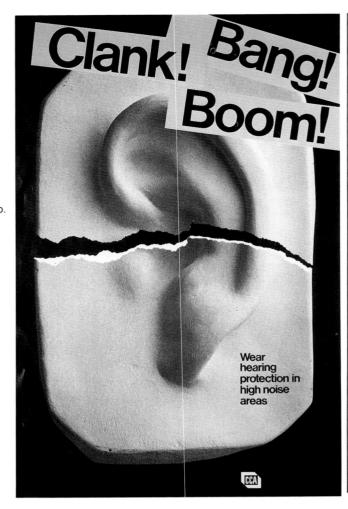

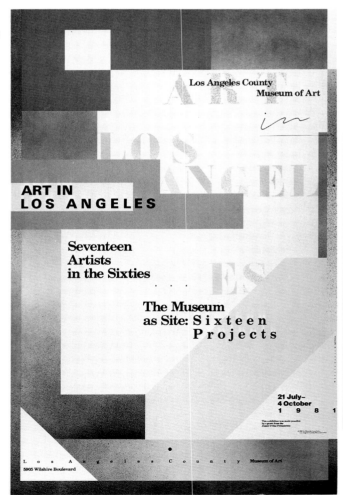

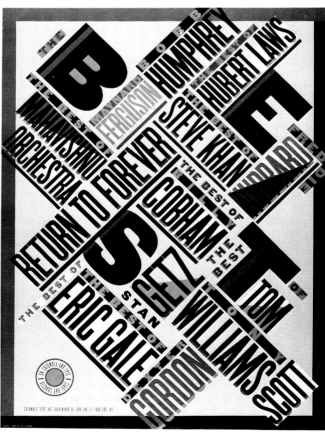

Poster:
I pledge allegiance
to Helvetica . . .
Designer:
Nathan Felde
Boston, MA
Design Firm:
Implement, Ltd.
Publisher:
Origin Posters
Typographer:
Lettergraphics
Printer:
Action Graphics
Dimensions:
24½″ × 36

Poster:
Opera
Art Directors/Designers:
Warren Wilkins,
Tommer Peterson
Seattle, WA
Artists:
Warren Wilkins,
Tommer Peterson
Design Firm:
Wilkins & Peterson
Client:
The Seattle Opera
Typographer:
The Type Gallery
Printer:
Heath Printers
Dimensions:
36½″ × 23¾″

Poster:
Gala d'Italia
Designer:
Michael Patrick Cronan
San Francisco, CA
Design Firm:
Michael Patrick Cronan
Design, Inc.
Publisher:
San Francisco
Symphony
Typographer:
Display Lettering & Copy
Printer:
Dimension III
Seriphics
Dimensions:
34¾″ × 22¾″

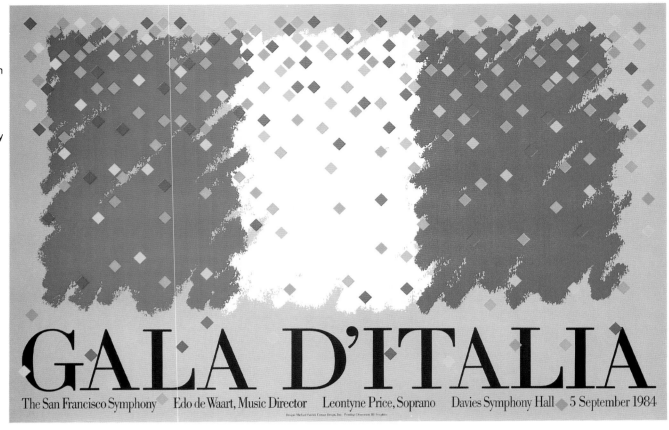

GALA D'ITALIA

The San Francisco Symphony · Edo de Waart, Music Director · Leontyne Price, Soprano · Davies Symphony Hall · 5 September 1984

Design: Michael Patrick Cronan Design, Inc. · Printing: Dimension III Seriphics

Poster:
Ikko Tanaka:
Colors of Japan
Designer:
Ikko Tanaka
Art Director:
Charles Michael
Helmken
Washington, DC
Artist:
Ikko Tanaka
Design Firm:
Stephenson, Inc.
Publisher:
The Shoshin Society
Typographer:
John Michael
Printer:
Stephenson, Inc.
Dimensions:
39″ × 25″

Poster:
Can Opener
Designer:
Jeff Barnes
Chicago, IL
Design Firm:
Container Corporation
of America
Publisher:
Container Corporation
of America
Typographer:
Ryder Types
Printer:
Accurate Silkscreen Co.
Dimensions:
25″ diameter

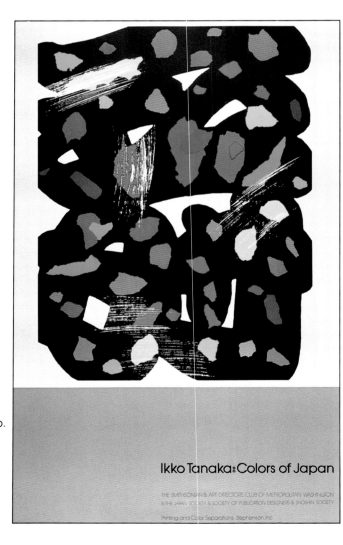

Ikko Tanaka: Colors of Japan

THE SMITHSONIAN & ART DIRECTORS CLUB OF METROPOLITAN WASHINGTON
& THE JAPAN SOCIETY & SOCIETY OF PUBLICATION DESIGNERS & SHOSHIN SOCIETY

Printing and Color Separations: Stephenson, Inc.

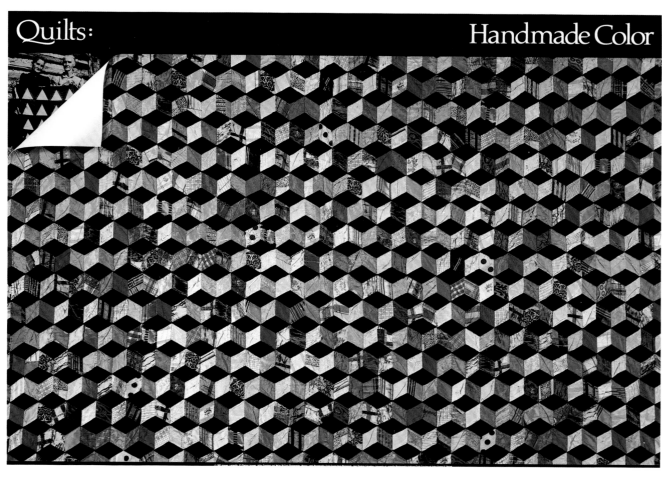

Quilts: Handmade Color

Poster:
Quilts: Handmade Color
Art Director:
Julius Friedman
Designers:
Walter McCord
Julius Friedman
Louisville, KY
Photographer:
Craig Guyon
Design Firm:
Images
Publisher:
Images
Typographer:
Adpro
Printer:
Pinaire Lithographing
Corp.
Dimensions:
23″ × 32″

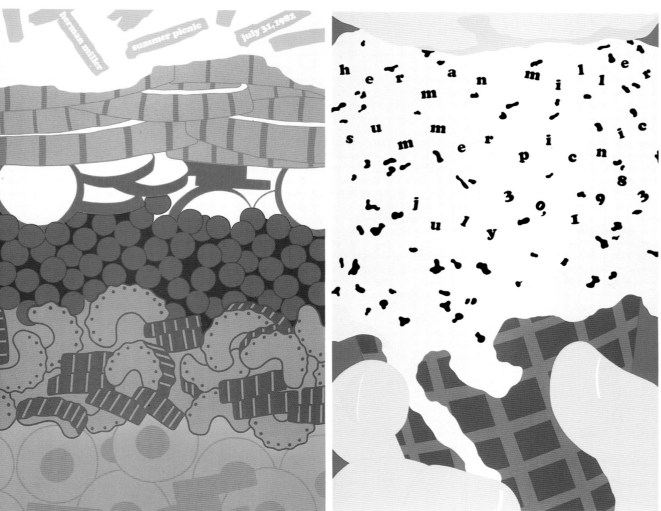

Poster:
Summer Picnic 1982
Art Director/Designer:
Stephen Frykholm
Zeeland, MI
Design Firm:
Corporate
Communications Design
& Development
Client:
Herman Miller, Inc.
Printer:
Continental Identification
Products
Dimensions:
39½″ × 25″

Poster:
Summer Picnic 1983
Art Director/Designer:
Stephen Frykholm
Zeeland, MI
Design Firm:
Corporate
Communications Design
& Development
Client:
Herman Miller, Inc.
Printer:
Continental Identification
Products
Dimensions:
39½″ × 25″

Poster:
100th: Williamson
Printing Corp.
Designer:
Brian Boyd
Dallas, TX
Artists:
Brian Boyd,
Robert Forsbach
Design Firm:
Richards, Brock, Miller,
Mitchell & Assoc.
Client:
Williamson Printing Co.
Typographer:
Typographics
Printer:
Williamson Printing Co.
Dimensions:
22½" × 37½"

Poster:
1812 Ouverture
Solennelle
Art Director/Designer:
Brian Boyd
Dallas, TX
Artist:
Brian Boyd
Design Firm:
Richards, Brock, Miller,
Mitchell and Assoc.
Publisher:
Dallas Symphony
Orchestra League
Typographer:
Chiles & Chiles
Printer:
Heritage Press
Dimensions:
22" × 33"

Poster:
Quebec/Canada
Art Director/Designer:
Ernst Roch
Montreal, CAN
Design Firm:
Roch Design
Client:
Imasco Ltd.
Letterer:
Ernst Roch
Printer:
Up-North Advertising
Dimensions:
33" × 23½"

Poster:
If we'd been around
in 1885 . . .
Art Director/Designer:
Stephen Frykholm
Zeeland, MI
Design Firm:
Corporate
Communications Design
& Development
Client:
Herman Miller, Inc.
Printer:
Kal-Blue
Dimensions:
24" × 36"

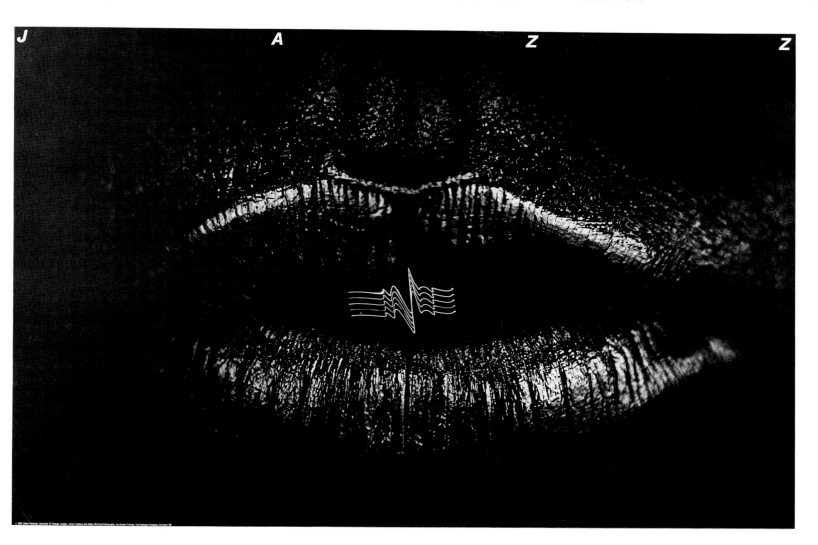

Poster:
Jazz
Art Director:
Julius Friedman
Designers:
Julius Friedman,
Walter McCord
Louisville, KY
Photographer:
Jon Brown
Design Firm:
Images
Publisher:
Images
Typographer:
Adpro
Printer:
The Hennegan Co.
Dimensions:
24″ × 36″

Poster:
The New CH-22
OF Chair
Art Director:
Peter Bradford
Designer:
Lorraine Johnson
New York, NY
Artist:
Brian Sisco
Design Firm:
Peter Bradford & Assoc.
Publisher:
Zographos Designs, Ltd.
Typographer:
IGI/Innovative Graphics
International
Printer:
Studio Type & Screen
Dimensions:
36″ × 26″

Poster:
Knoll Venturi Collection
Art Directors:
Harold Matossian,
Takaaki Matsumoto
Designer:
Takaaki Matsumoto
New York, NY
Design Firm:
Knoll Graphics
Publisher:
Knoll International
Typographer:
Susan Schechter
Printer:
Christopher G. Sterling
Dimensions:
23½″ × 21⅛″

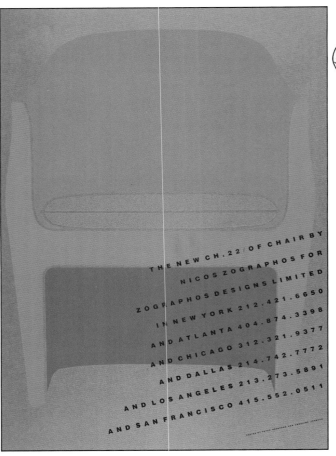

Poster:
Coppélia
Art Director:
Tom Philion
Designer:
Peter Good
Chester, CT
Design Firm:
Peter Good
Graphic Design
Client:
Pennsylvania Ballet
Typographer:
Typographic House
Printer:
Independence Press
Dimensions:
20″ × 30″

Poster:
The Barber of Seville
Designer:
David Jenkins
Photographer:
John Katz
Dallas, TX
Agency:
Ogilvy & Mather
Client:
Texas Opera Theatre
Printer:
San Jacinto Press
Dimensions:
17″ × 22¼″

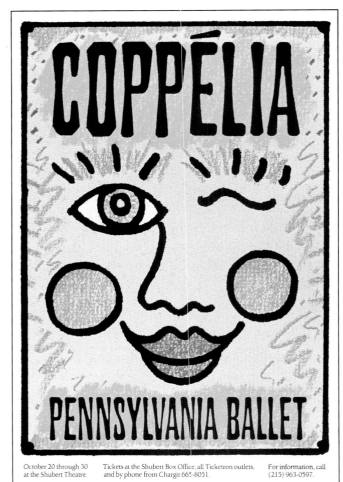

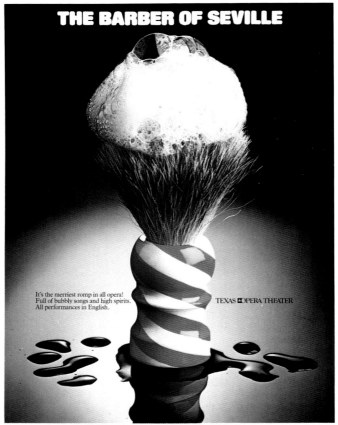

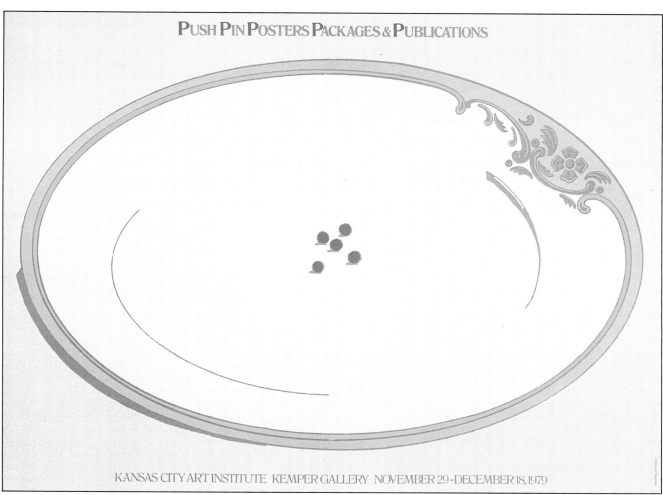

PUSH PIN POSTERS PACKAGES & PUBLICATIONS

KANSAS CITY ART INSTITUTE KEMPER GALLERY NOVEMBER 29–DECEMBER 18, 1979

Poster:
Push Pin Posters
Packages and
Publications
Designer:
Seymour Chwast
New York, NY
Design Firm:
Push Pin Studios
Publisher:
Kansas City Art Institute
Kemper Gallery
Letterer:
Seymour Chwast
Dimensions:
18″ × 24″

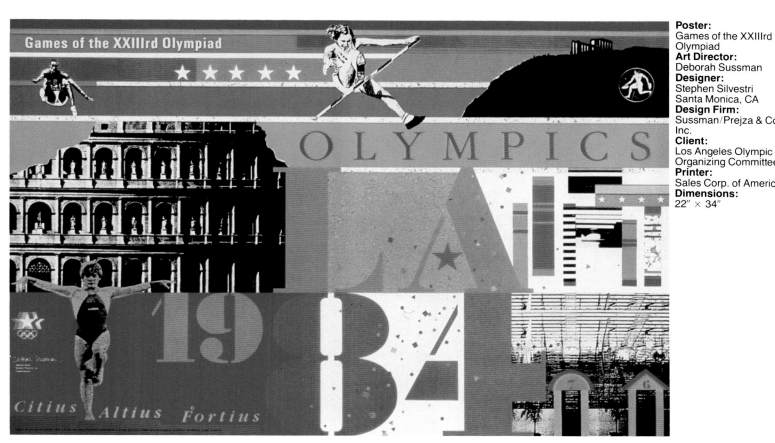

Games of the XXIIIrd Olympiad

OLYMPICS

1984

Citius Altius Fortius

Poster:
Games of the XXIIIrd
Olympiad
Art Director:
Deborah Sussman
Designer:
Stephen Silvestri
Santa Monica, CA
Design Firm:
Sussman/Prejza & Co.,
Inc.
Client:
Los Angeles Olympic
Organizing Committee
Printer:
Sales Corp. of America
Dimensions:
22″ × 34″

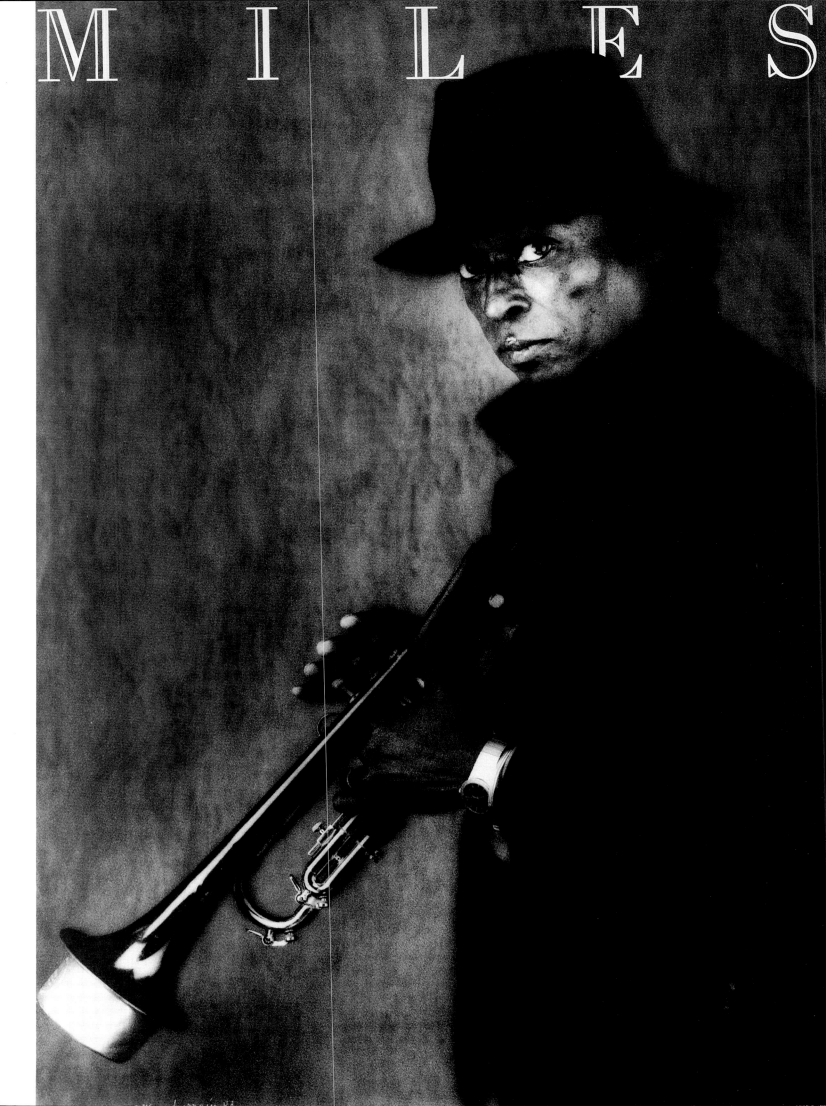

MILES

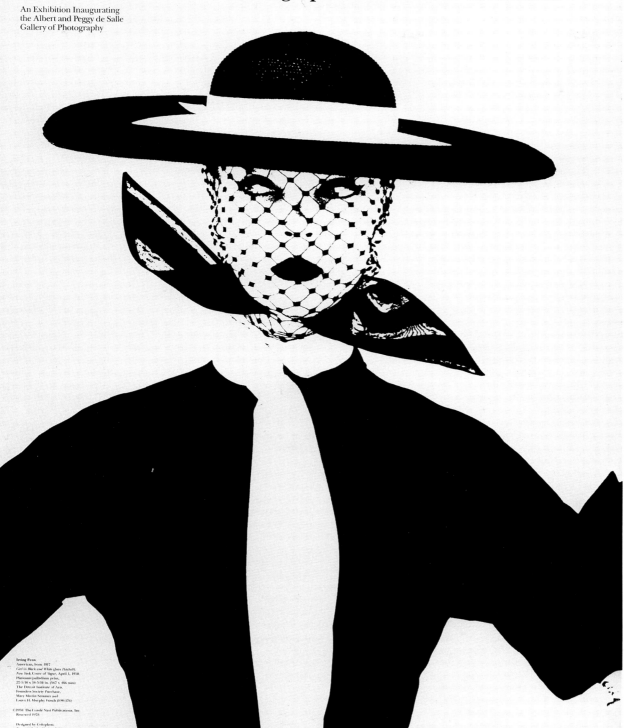

The Detroit Institute of Arts
October 4-November 27, 1983

An Exhibition Inaugurating
the Albert and Peggy de Salle
Gallery of Photography

Photographs from Detroit Collections

Irving Penn
American, born 1917
Girl in Black and White (Jean Patchett),
New York, Cover of *Vogue*, April 1, 1950.
Platinum/palladium print,
22-5/16 x 16-5/16 in. (567 x 466 mm)
The Detroit Institute of Arts.
Founders Society Purchase,
Mary Martin Semmes and
Laura H. Murphy Funds (1:80.476)

©1950 The Condé Nast Publications, Inc.
Renewed 1978.

Designed by Colophon.
Typography by Marino & Marino.
Printed by Young & Klein, Inc.

Poster:
Photographs from Detroit
Collections
Designers:
Chuck Byrne,
Yvonne Vanden Noort
Cincinnati, OH
Photographer:
Irving Penn
Design Firm:
Colophon
Client:
The Detroit Institute of Arts
Typographer:
Marino & Marino
Printer:
Young & Klein
Dimensions:
22″ × 28″

Poster:
MILES
Designer:
Kenneth R. Cooke
New York, NY
Photographer:
Gilles Lorrain
Design Firm:
Landor Assoc., NY
Client:
CBS
Letterer:
Taro Hiroishi Yamashita
Dimensions:
48″ × 33″

Poster:
Museum Mile Festival
Designer:
R.O. Blechman
New York, NY
Design Firm:
R. O. Blechman, Inc.
Publisher:
Museum Mile
Letterer:
R. O. Blechman
Printer:
Eilbert/Appleton Printer
Dimensions:
24″ × 20⅜″

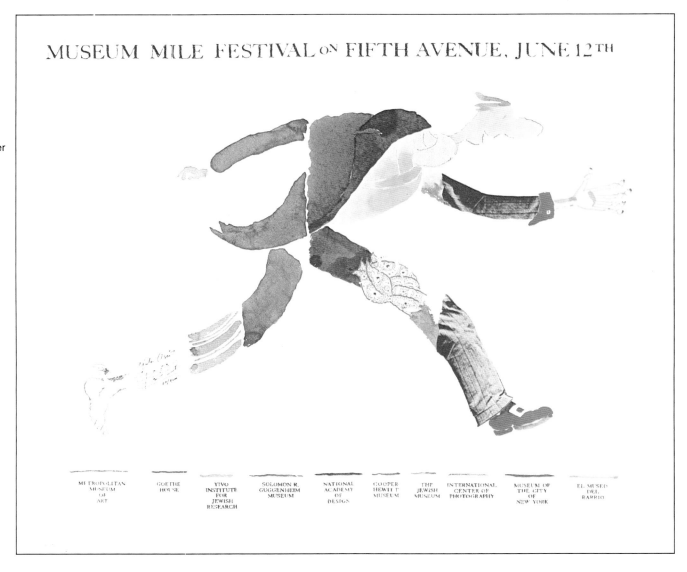

Poster:
Nantucket Whaling
Museum
Designer:
Kate Emlen
Hanover, NH
Design Firm:
Kate Emlen/Graphic
Design
Client:
Nantucket Historical
Assn.
Typographer:
Handset
Printer:
Sirocco Screenprints
Dimensions:
30½″ × 22″

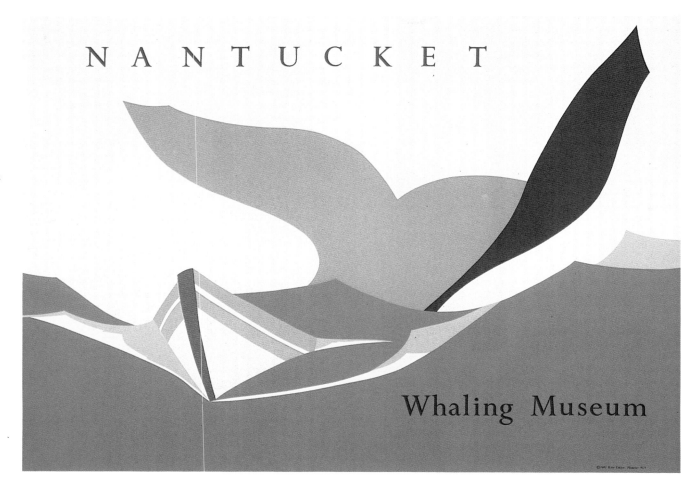

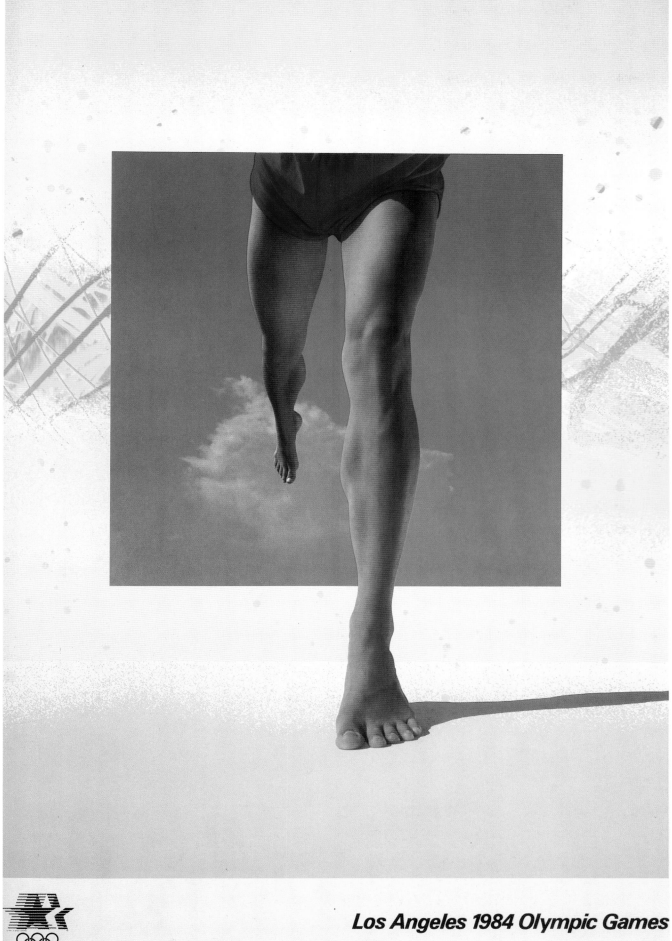

Poster:
Los Angeles 1984
Olympic Games
Designer:
April Greiman
Los Angeles, CA
Photographer:
Jayme Odgers
Design Firm:
April Greiman, Inc.
Publisher:
Knapp Communications
Printer:
Gardner/Fulmer
Lithograph Co.
Dimensions:
24″ × 35″

Los Angeles 1984 Olympic Games

Poster:
The Soldier's Tale
Designer:
R.O. Blechman
New York, NY
Design Firm:
R.O. Blechman, Inc.
Publisher:
EXXON Great
Performances
Typographer:
Terry Berkowitz
Printer:
Benchmark Press
Dimensions:
25″ × 38½″

Poster:
Fun Run
Art Director/Designer:
McRay Magleby
Provo, UT
Artist:
McRay Magleby
Design Firm:
Brigham Young
University
Graphic
Communications
Publisher:
Brigham Young
University
Printer:
Graphic
Communications
Dimensions:
14″ × 26″

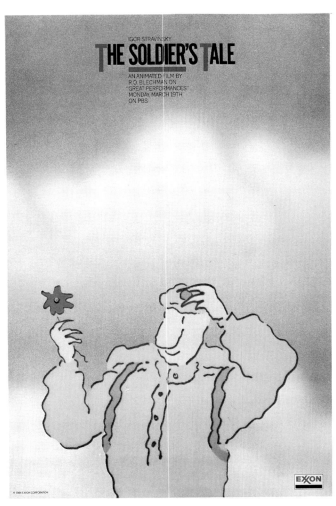

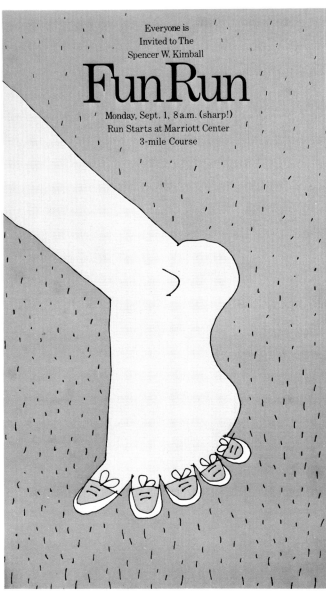

Poster:
Los Angeles 1984
Olympic Games
Designer:
Knapp Communications
Artist:
Martin Puryear
Chicago, IL
Client:
Wilshire Marketing
Printer:
Alan Lithograph, Inc.
Dimensions:
24″ × 36″

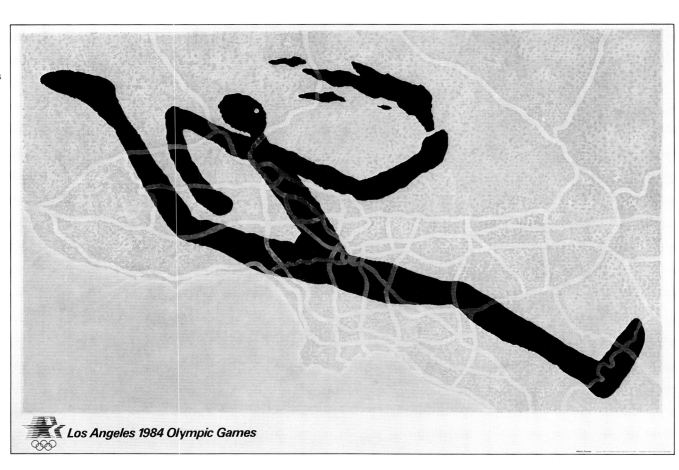

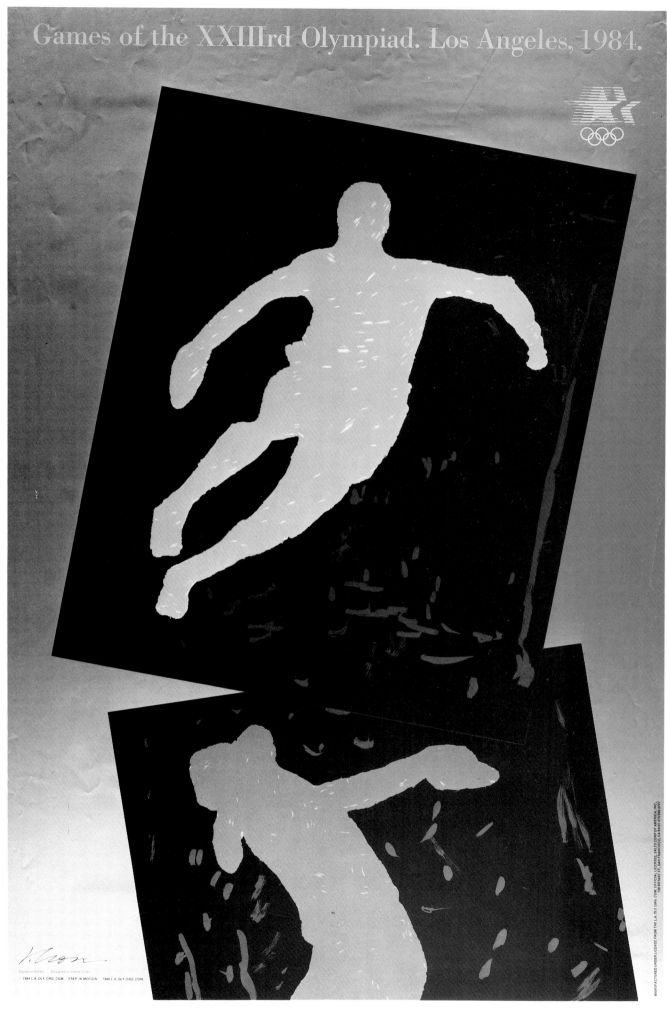

Games of the XXIIIrd Olympiad. Los Angeles, 1984.

Poster:
Games of the XXIIIrd
Olympiad
Art Directors:
James Cross/
Cross Assoc.
Los Angeles, CA
Larry Klein,
Darrell Hayden/
L.A.O.O.C.
Los Angeles, CA
Design Firm:
Cross Assoc.
Client:
Los Angeles Olympic
Organizing Committee
Printer:
Sales Corp. of
America, Inc.
Dimensions:
34″ × 22″

Poster:
Beethoven Festival
Designer:
Michael Patrick Cronan
San Francisco, CA
Design Firm:
Michael Patrick Cronan
Design, Inc.
Publisher:
San Francisco Symphony
Typographer:
Headliners
Printer:
Pischoff Signage Co.
Dimensions:
23¾" × 38¼"

Poster:
Watch Waste
Designer:
Jeff Barnes
Chicago, IL
Design Firm:
Container Corporation
of America
Communications
Client:
Container Corporation
of America Container
Division
Typographer:
Ryder Types
Printer:
Accurate Silkscreen Co.
Dimensions:
35" × 48"

Poster:
Christo
Art Director:
Victor Valla
Designers:
Deb Robinson,
Victor Valla
Basking Ridge, NJ
Design Firm:
Kean College of
New Jersey:
Design Production
Studio
Client:
Kean College of
New Jersey
Co. Curricular Board
Letterer:
Christo signature
Kean College of
New Jersey
Silk Screened:
Deb Robinson
Handwrapped & Tied:
Kean College Student
Committee
Dimensions:
16" × 20"

Poster:
Rufus Porter
Rediscovered
Designers:
Rudolph de Harak,
Frank Benedict
New York, NY
Design Firm:
Rudolph de Harak
& Assoc.
Client:
Hudson River Museum
Printer:
Georgian Press, Inc.
Dimensions:
23" × 36"

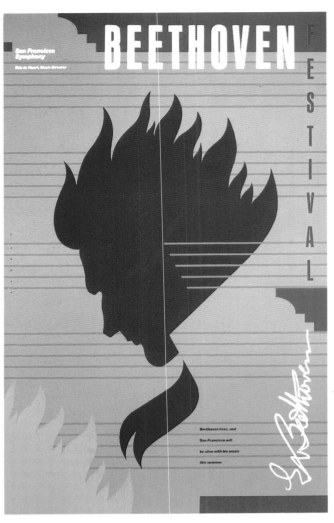

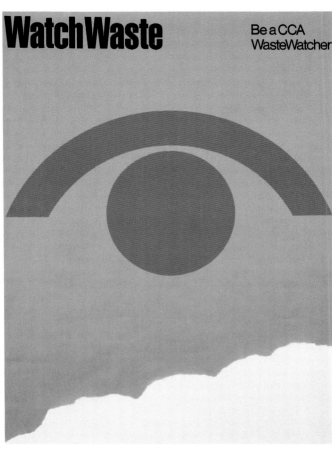

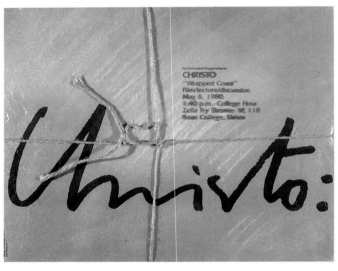

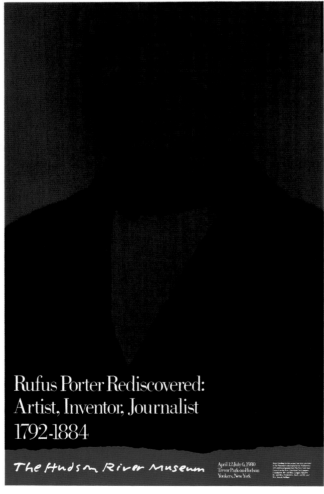

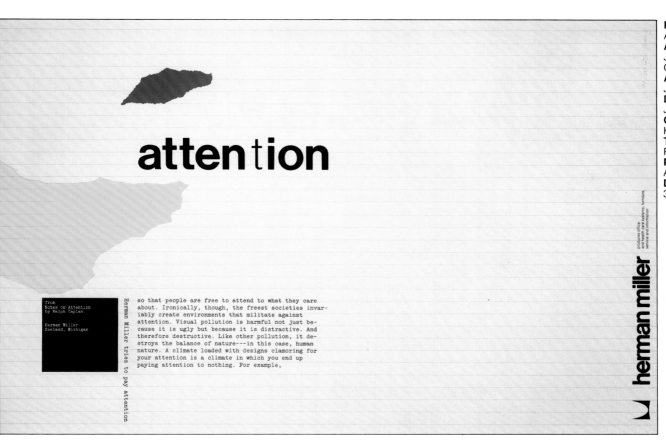

Poster:
Attention
Art Director/Designer:
John Massey
Chicago, IL
Artist:
John Massey
Design Firm:
John Massey, Inc.
Client:
Herman Miller, Inc.
Typographer:
Ryder Types
Printer:
Accurate Silk Screen Co.
Dimensions:
35″ × 23″

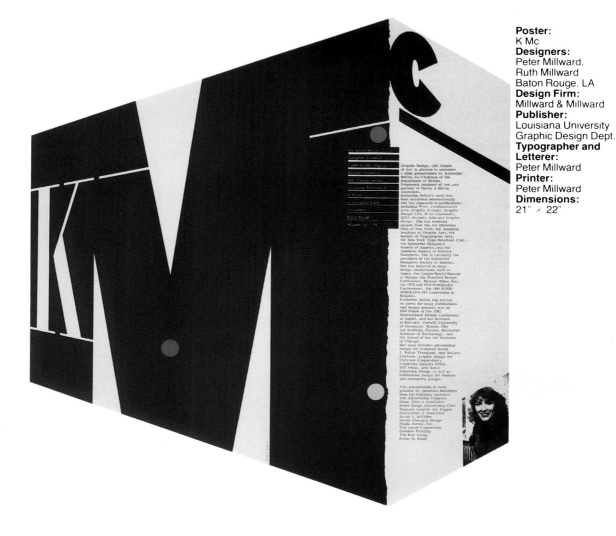

Poster:
K Mc
Designers:
Peter Millward.
Ruth Millward
Baton Rouge. LA
Design Firm:
Millward & Millward
Publisher:
Louisiana University
Graphic Design Dept.
**Typographer and
Letterer:**
Peter Millward
Printer:
Peter Millward
Dimensions:
21″ × 22″

Poster:
Jeanne Marc
Art Director/Designer:
John Casado
San Francisco, CA
Artist:
John Casado
Design Firm:
Casado Design
Client:
Jeanne Marc
Typographer:
Display Lettering & Copy
Printer:
Clyde Engle
Dimensions:
18¾" × 27½"

Poster:
Winston Churchill:
The Wilderness Years
Art Director/Designer:
Ivan Chermayeff
New York, NY
Artist:
Ivan Chermayeff
Design Firm:
Chermayeff &
Geismar Assoc.
Client:
Mobil Corp
Typographer:
Pastore DePamphilis
Rampone
Latent Lettering
Printer:
Tempo Creations
Dimensions:
30" × 46"

Poster:
Rumpole of the Bailey
Designer:
Seymour Chwast
New York, NY
Design Firm:
Pushpin Lubalin
Peckolick
Client:
Mobil Corp.
Letterer:
Seymour Chwast
Printer:
Crafton Graphic Co., Inc.
Dimensions:
30" × 46"

Poster:
Nicholas Nickleby
Designer:
Seymour Chwast
New York, NY
Design Firm:
Pushpin Lubalin
Peckolick
Client:
Mobil Corp.
Letterer:
Seymour Chwast
Printer:
Crafton Graphic Co., Inc.
Dimensions:
30" × 46"

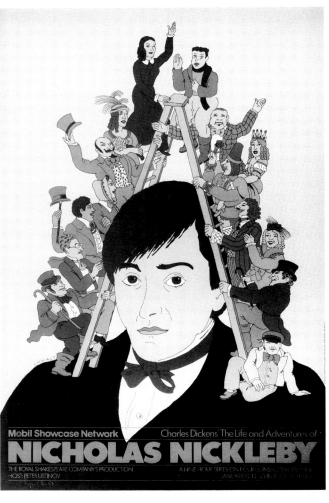

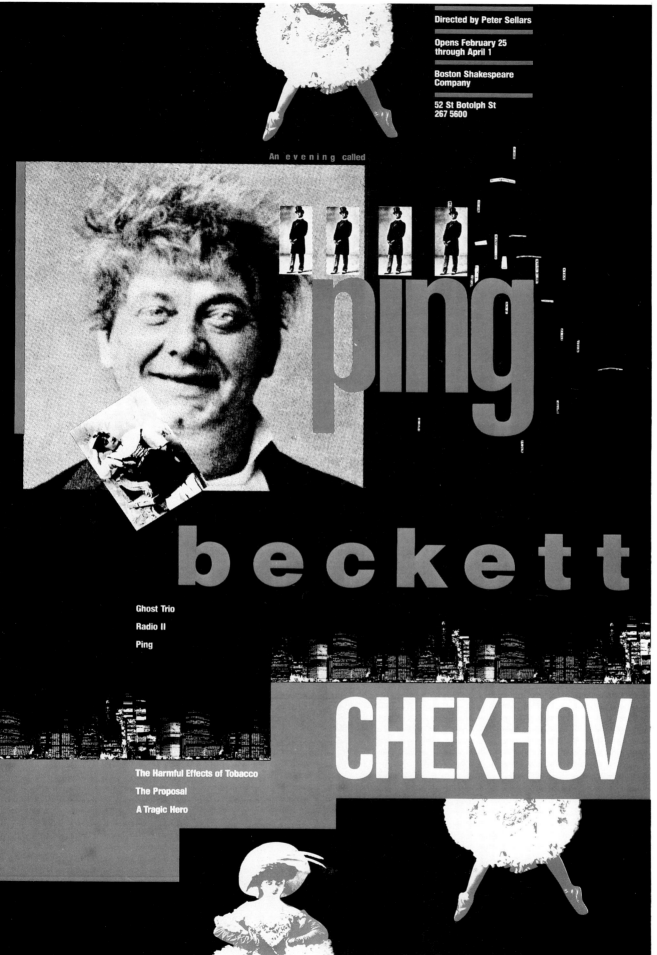

An evening called

ping

beckett

Ghost Trio
Radio II
Ping

CHEKHOV

The Harmful Effects of Tobacco
The Proposal
A Tragic Hero

Directed by Peter Sellars

Opens February 25
through April 1

Boston Shakespeare
Company

52 St Botolph St
267 5600

Poster:
Ping, Beckett, Chekhov
Designers:
Mark Laughlin,
Ellen Winkler
Boston, MA
Design Firm:
Laughlin/Winkler
Client:
Boston Shakespeare Co.
Typographer:
DDS
Printer:
Sam Johnson
Dimensions:
2′ × 3′

Poster:
Great Dance,
Great Music...
Designer:
Ann Pitts
Photographer:
John Katz
Dallas, TX
Agency:
Ogilvy & Mather
Client:
Miller Outdoor Theatre
Dimensions:
17 × 22¼"

Poster:
10th Anniversary
Shakespeare Festival
of Dallas
Art Director/Designer:
Woody Pirtle
Dallas, TX
Artist:
Frank Nichols
Design Firm:
Pirtle Design
Client:
Shakespeare Festival
of Dallas
Typographer:
Southwestern
Typographics
Printer:
Williamson Printing
Dimensions:
16⅜" × 38½"

Poster:
Puccini Festival
Designer:
Seymour Chwast
New York, NY
Design Firm:
Pushpin Lubalin
Peckolick
Client:
New York City Opera
Letterer:
Seymour Chwast
Dimensions:
16" × 24"

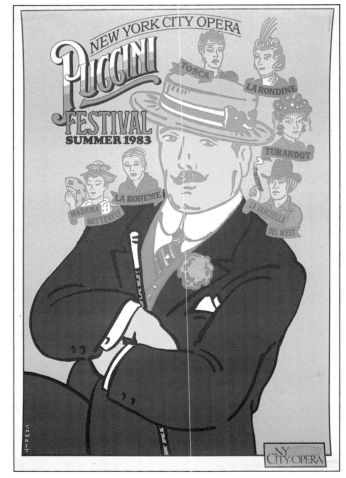

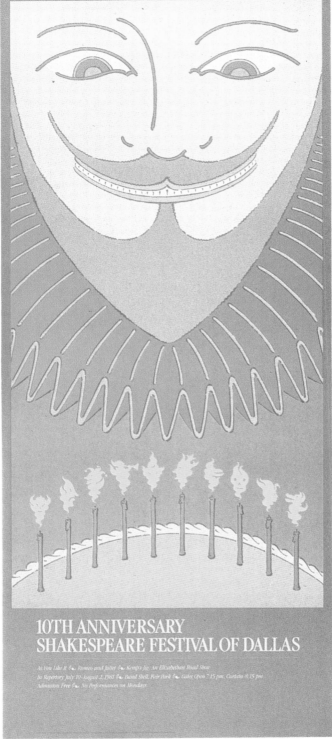

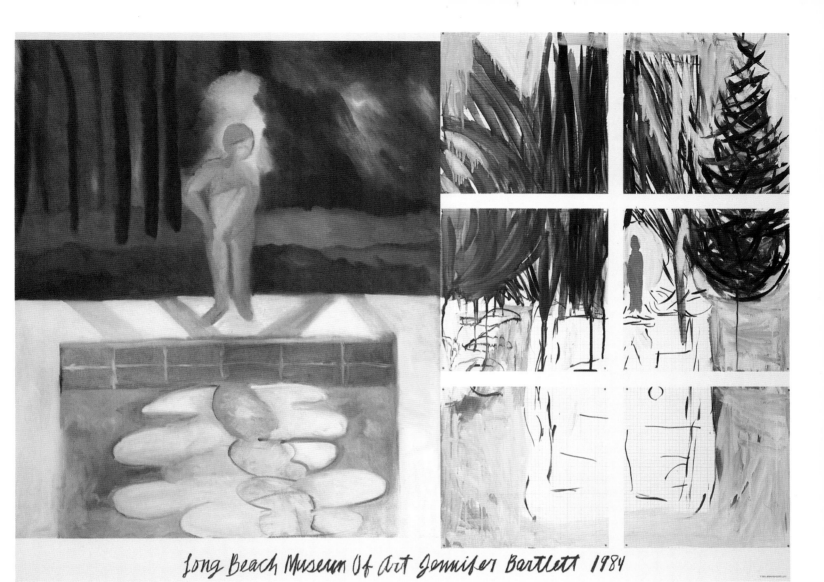

Long Beach Museum Of Art Jennifer Bartlett 1984

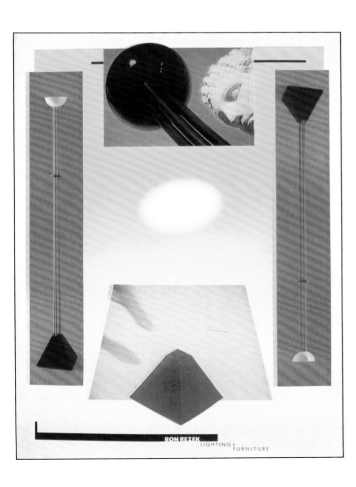

Poster:
Long Beach
Museum of Art
Jennifer Bartlett 1984
Artist:
Jennifer Bartlett
New York, NY
Publisher:
Museum of Art
Long Beach
Printer:
Alan Lithograph, Inc.
Dimensions:
25″ × 34″

Poster:
Ron Rezek Lighting
and Furniture
Art Director/Designer:
April Greiman
Los Angeles, CA
Video Artist:
April Greiman
Design Firm:
April Greiman, Inc.
Client:
Ron Rezek
Printer:
Aztlan Multiples
Dimensions:
35″ × 47″

Index

Art Directors, Designers, Illustrators, Artists, Photographers, Authors, Editors, Copywriters and Production Managers

Design Firms and Agencies

Publishers, Publications and Clients